THE SACRED
WISDOM
OF THE
NATIVE
AMERICANS

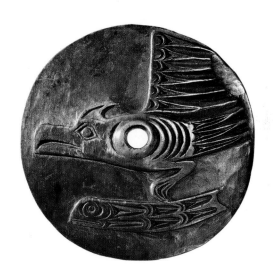

"Knowledge was inherent in all things. The world was a library and its books were the stones, leaves, grass, brooks and the birds and animals that shared, alike with us, the storms and blessings of the earth."

Luther Standing Bear, Lakota tribe

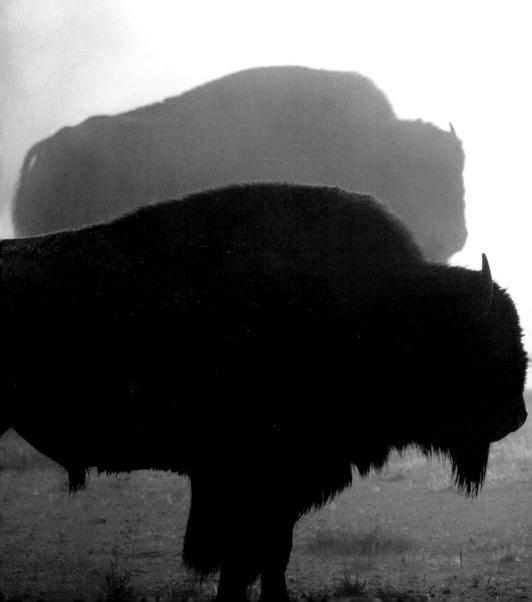

THE SACRED
WISDOM
OF THE
NATIVE
AMERICANS

LARRY J. ZIMMERMAN

CHARTWELL
BOOKS

Brimming with creative inspiration, how-to projects, and useful information to enrich your everyday life, Quarto Knows is a favorite destination for those pursuing their interests and passions. Visit our site and dig deeper with our books into your area of interest: Quarto Creates, Quarto Cooks, Quarto Homes, Quarto Lives, Quarto Drives, Quarto Explores, Quarto Gifts, or Quarto Kids.

Previously published as *The Sacred Wisdom of the American Indians*
Larry J. Zimmerman

This edition published in 2016 by
Chartwell Books
an imprint of The Quarto Group,
142 West 36th Street, 4th Floor,
New York, NY 10018, USA
T (212) 779-4972 **F** (212) 779-6058
www.QuartoKnows.com

The Sacred Wisdom of the Native Americans

Managing Editor: Christopher Westhorp
Managing Designer: Suzanne Tuhrim
Picture Research: Julia Brown and Emma Copestake
Production: Uzma Taj

ISBN: 978-0-7858-3390-1

10 9 8 7 6 5 4 3

Typeset in Scala
Color reproduction by Imagewrite
Printed in China

This edition published by arrangement with and permission of Watkins Media Ltd.

Notes:
Abbreviations used throughout this book:
CE Common Era (the equivalent of AD)
BCE Before the Common Era (the equivalent of BC)

▲▲ **Page 1. A Coast Salish spindle whorl, collected along the Lower Fraser River in about 1912, carved in relief with a thunderbird and whale design.**

▲ **Pages 2–3. American bison grazing in Yellowstone National Park, Wyoming. It is thought that in the early 1800s there were 65 million bison ranging the continent. By 1902 there were fewer than 50 left in the Yellowstone area, but today there are about 3,500.**

▶ **Opposite. A Northwest Coast holy man's bone charm, carved in the form of a killer whale and inlaid with abalone shell.**

CONTENTS

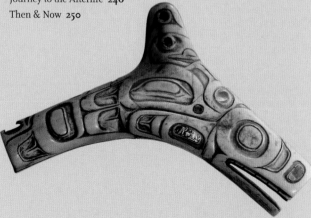

PREFACE

Dipping into any book about the native peoples of North America, you are more likely to come across stereotypical fantasies than contemporary realities. Even this book, in looking at traditional cultures, runs the risk of appealing to those who entertain the stereotypes and surround them with a rosy glow of nostalgia. However, I hope that most of my readers will soon come to a clear understanding of my mission: to inspire an appreciation and understanding of the history, art and beliefs of the indigenous peoples of North America, not as relics of the past but as a distinctive and diverse part of the contemporary world. As I tell my students, "Indians are from now, not just back then!"

▶ *Comanche Dancers*, by Josefa Roybal, from San Ildefonso Pueblo, one of few female Pueblo artists at the time (about 1930). Her work is rendered in a simple and direct, yet colourful, style. The dancers, from the sedentary Pueblo culture, are imitating the migratory, sometimes raiding, Comanche warriors, which is a symbolic re-enactment of the historical relationship between these two Indian peoples.

We have a responsibility to understand the origin of particular stereotypes and the processes by which they continue to exist. As a reader you have the right to know that although the title of this volume may imply a backward glance (it is a book that traces roots, among other things), the content certainly does not. Although this book contains a great deal about the past, there is also a significant proportion of material about contemporary Native Americans, and a great deal of effort has been made to reveal their immense cultural diversity.

Many Indians feel that non-Indians should not be writing about their religions, which they see as being no one's business but their own. They consider those who do so to be exploiters, following in a long tradition of colonialism. Especially exasperating are the followers of so-called "New Age" religions who take the religious beliefs and rituals of other cultures out of context, and even try to practise the ceremonies. As some Indians say, "Our religion is not for sale!"

In this book complex religious beliefs are put into appropriate cultural contexts, and at no time is it suggested that the author is anything other than an outsider and an academic, whose knowledge is different from that of a Native

American. My previous book, *Native North America*, has been remarkably successful, selling well internationally to a wide range of publishers: it has been reviewed as balanced and sensitive by Indians and non-Indians and has been used in school and university classrooms as a text. I am proud of *Native North America*, and much of its content has been reproduced here. If some of its editions veer towards the stereotypical (a Plains Indian) in their choice of cover image, that reflects the realities of commercial publishing: covers, I'm told, need to be eyecatching to the uninitiated.

The reality is always going to be more complex than a cover alone can suggest. The popular image of the Indian is of a *tipi-living*, horseback-mounted, buffalo-hunting, ecological Sioux warrior – like the Indians portrayed in the movie *Dances with Wolves*. In this oversimplified formula, native religion is mostly Mother Earth, thunderbirds, sweatlodges, smudging with sage and smoking peace pipes. These are at best partial truths. Read this book, enjoy it and learn about Native American realities – forget the stereotypical fantasies that lock Indians in the past.

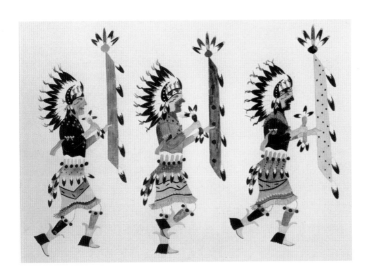

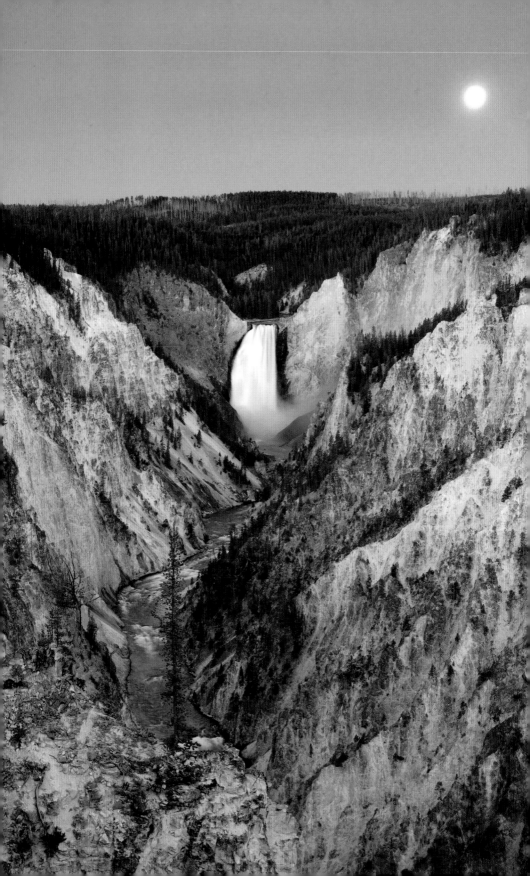

INTRODUCTION

According to the holy people, North America was never an empty land. It came into being when the first humans scrambled up to the surface from other worlds within the womb of the earth, or descended from parallel worlds that existed above the sky. Whether they lived on the rocky coasts or on the vast, endless plain, in the forests of the Northeast or the deserts of the Southwest, each group of people recognized its own spiritual homeland, a place where they could see the evidence of their beginnings.

Archaeologists searching for the origins of the earliest North American cultures have found the remains of hearths, animal bones and distinctive, finely flaked stone tools more than 10,000 years old. These were left by hunters whose forebears in the last Ice Age had followed mammoths and other large animals from Asia into the Americas. During the great freeze, sea levels sank so low that what are now Siberia and Alaska were linked by a stretch of land that scientists call Beringia. Hunting bands probably ranged freely back and forth across Beringia before it was reclaimed by the sea; others may have come in skin-covered boats along the rim of the Pacific. Only gradually did the hunters penetrate deeper into the Americas. However, by c.8000BCE, human beings had established themselves in almost every part of the continent.

THE FIRST AMERICANS

In accepting the scientific view, it is tempting to overlook the fact that the first North Americans never thought of themselves as migrants who left one continent for a new life in another. They simply lived as they had always done, moving from place to place in pursuit of game.

There is another explanation of the human presence in America: that people have occupied the land since the beginning of time. This idea occurs in many Native traditions and remains an important issue to this day. The mythologies of many present-day peoples, such as the Hopi (see page 15), recount how the first people wandered from a place of origin to their eventual homeland. Creation stories (see pages 150–155) often reflect ways of life. For example, the Pueblo Indians, who are settled farmers, tell of emergence from the earth at precise places in the landscape. Those of many traditional hunting and gathering peoples reflect their traditional questing lives, searching for game or seeking visions.

Native North America has a confusion of names, recalling a time when there was a mosaic of societies that had developed for millennia. Identity was strong and exclusive, because each group lived in its own world, with a distinct territory and language (or dialect), and unique traditions. The people referred to as Ojibwe, Ojibway or Chippewa, for example, call themselves Anishinabe, and Arctic hunters known around the world as Eskimos might speak of themselves as Inuit or Aleut. Many of these names, such as Anishinabe and Inuit, translate as, simply, "the people". Some groups acquired their tribal names only recently from missionaries, explorers and traders, who were struck by distinct characteristics of people such as the Nez Percé (French for "Pierced Nose"; their own name is Nimípu). Europeans sometimes adopted names used by other groups: "Sioux" is derived from the Ojibwe language; the Sioux (or their western Teton division) call themselves Lakota.

▲ Page 8. Yellowstone Falls in Wyoming. The most famous story about these rapids concerns an event in 1870 when it is said that a group of 18 Crow Indians floated over them, to their deaths, on a raft while fleeing from their pursuers.

▶ A quartzite effigy of a buffalo. This mighty animal was sacred and was honoured in ceremonies. A likeness such as this may have been used in rituals intended to give humans a measure of control over the herds.

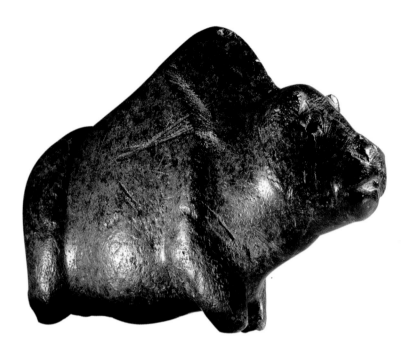

FROM HUNTERS TO MOUND CULTURES

At the time of the first European contact, several million indigenous people inhabited the continent. They were grouped into as many as a thousand distinct nations or tribes, with a variety of ways of life adapted to the varying climate and topography. The earliest Americans adopted a generalized hunting and gathering lifestyle, but some herding and farming cultures developed over time. For example, by 700CE the area encompassing much of present-day Arizona, Utah, Colorado and New Mexico had become home to the ancestors of the peoples known now as the Puebloan. They lived in adobe (mud brick) villages near rivers, which fed irrigation canals, enabling them to cultivate biannual crops of corn (maize), as well as plentiful beans, squash and cotton. At around the same time, communities living in the fertile Mississippi and Ohio river valleys built the first large North American towns and great earth monuments. The most

widely studied of these pre-Columbian "mound cultures" is Cahokia, which was inhabited at its zenith by at least 20,000 people, and where elaborate religious beliefs were developed and spectacular art created. But most of these sites were abandoned, probably by about 1450CE, before the first Native American contact with Europeans.

The peoples of North America were by no means static or isolated in the millennia before the arrival of Europeans. They traded materials, such as stone (for tools) and shells (for ornamentation), over great distances. As groups moved from place to place, languages multiplied and spread, revealing the scale of this resettlement activity. For example, the Navajo (Diné) and Apache languages of the Southwest are related to the Athabaskan languages of hunters in Alaska and the Yukon.

MODERN NAMES AND IDENTITIES

The term "Indian" derives from Columbus's famous blunder in mistaking for Asians the aboriginal Americans whom he encountered. As a name applied to the diversity of Native peoples, it still symbolizes for some a lack of understanding. To redress this wrong, at least symbolically, there are now a number of alternative names: Native Americans, Native Canadians, Native North Americans, aboriginal people, Native people and First Nations people. However, these names are largely used by officialdom and non-Native society. Most Native people, sensitive to their own specific identities, prefer to use tribal names, and many also freely call themselves Indians.

The question of Native identity is an important social issue involving an interweaving of ancestry, politics, economics and spirituality. It is further complicated today by the intermixing of tribal groups and the injection through intermarriage of European, African and Asian blood. One group, the Métis, a people with an identifiable history and material culture in Canada, was produced by the union of French fur traders with Native women. The Métis are today recognized in Canada as

The term "Indian" derives from Columbus's famous blunder in mistaking for Asians the aboriginal Americans whom he encountered.

THE WHEEL OF TIME

Many Indians conceive of the passage of time as circular, marked by the birth, growth, maturity, death and regeneration of all things – a pattern echoed in the lunar and solar cycles. The rising and setting of the sun form the basic rhythm of Native daily life, and the passage of longer periods is often charted by observing a calendar whose markers are the changes in nature, such as the flowing of maple sap or the return of the salmon. It is probable also that some peoples measured time by observing heavenly bodies. For example, the enigmatic "medicine wheels" (below, the Bighorn wheel in Wyoming) may have been used to chart astronomical events.

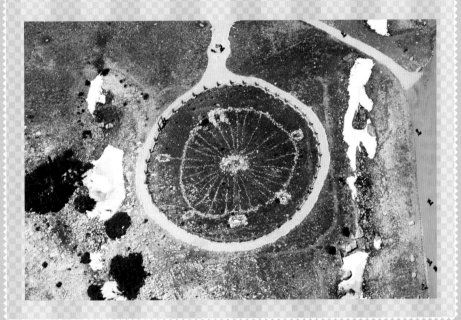

a distinct people with rights. Native identity may also be subject to legal tests. In 1990 the US government passed a law allowing only Native Americans to produce Native American crafts. The legal definition of Native American depends not on ethnic ancestry, but on acceptance as an Indian by a legally constituted tribe or nation. Thus, being a Native North American is a question of social identification and sympathy, involving participation in a certain kind of life and a particular view of the past and future.

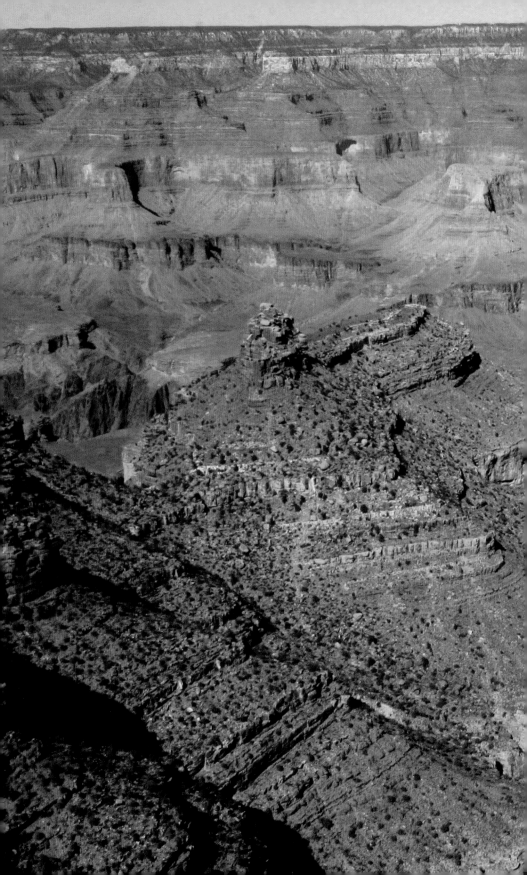

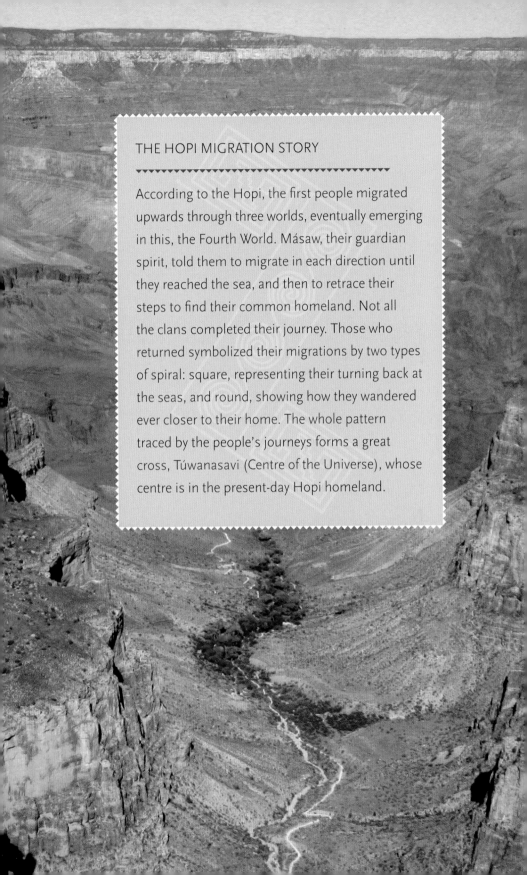

THE HOPI MIGRATION STORY

▼▼▼▼▼▼▼ ⧫ ▲▲▲▲▲▲▲

According to the Hopi, the first people migrated upwards through three worlds, eventually emerging in this, the Fourth World. Másaw, their guardian spirit, told them to migrate in each direction until they reached the sea, and then to retrace their steps to find their common homeland. Not all the clans completed their journey. Those who returned symbolized their migrations by two types of spiral: square, representing their turning back at the seas, and round, showing how they wandered ever closer to their home. The whole pattern traced by the people's journeys forms a great cross, Túwanasavi (Centre of the Universe), whose centre is in the present-day Hopi homeland.

DISPOSSESSION

On the eve of the European invasion North America was a place where humans had thrived for at least 15,000 years. The devastating changes that followed were due in part to vast differences in perception. As far as Native North Americans were concerned, the land was occupied, managed and familiar. But Europeans saw empty wilderness, waiting to be conquered.

The size of the continent meant that the effect of small groups of Vikings on the northeast coast, and the first Spanish, French and English explorers, did little to disturb the established cultures. When the first trading posts, missions and settlements appeared, they were like tiny islands in a great sea. However, although some Native groups controlled hunting or gathering grounds, and all respected the boundaries of sacred places, none had any acquisitive concept of territory as lines on a map, to be divided, bought and sold. The settlers imposed this concept with vigour and within 400 years they had completely dispossessed most aboriginal people.

The European invasion was physical, spiritual and material. Native people were driven out, swindled by unobserved treaties, subjugated, shattered, plied with alcohol, indoctrinated with Christianity and confined to reservations. But their culture was not totally destroyed. Under the influence of inspired leaders, traditional Native cultures have survived into the modern world.

FROM HELPFUL TO A HINDRANCE

The first Europeans settled near the coasts and navigable rivers, but later began to move into the wooded hinterland in search of furs and land to farm. The territorial ambitions of the white settlers soon brought them into conflict and, although alliances with indigenous peoples were formed that were expedient for both parties, they were ultimately to cause

▲ Pages 14–15. The Grand Canyon is known to the Hopi as Ongtupka and it was in the Little Colorado River Gorge where the Hopi people first emerged into this, the fourth, world.

▶ The Native American Algonquian Indian fortified village of Pomeiock, Gibbs Creek, North Carolina, showing huts and longhouses inside a protective palisade. The sketch is from observations made by the English expedition under John White in 1585.

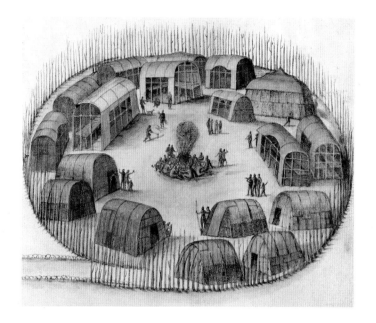

the displacement of many Native peoples. For example, the fur trade was lucrative to some Indians, but it created upheaval for others. In its early days this trade was dominated by five Iroquois groups (the Cayuga, Mohawk, Oneida, Onondaga and Seneca), who were armed by Dutch and English settlers. The Iroquois dispersed the Huron and drove the Ojibwe southwards from Lake Superior, and they in turn pushed others onto the Plains. The Iroquois themselves were later displaced, to British Canada, as a punishment for their alliance with Britain during the American War of Independence (1775–1783). But in Canada, too, Indian land effectively ceased to exist as the Crown assumed ownership of all land.

In 1787, the US Congress passed the Northwest Ordinance, which declared that "[the Indians'] lands and property shall never be taken from them without their consent". However, the continuing presence of Indians was felt to be a hindrance to settlement, and by the 1820s these fine words soon rang

CREATING THE RESERVATIONS

In 1851, the US Congress passed the Indian Appropriations Act, moving the tribes of the West onto reservations, but even by the 1830s there were executive orders that authorized relocating the eastern tribes in order to open up their ancestral territory to settlement. Originally, one aim was to keep Indians apart from white society. Later, it was hoped that Indians could be assimilated into the dominant society and prepared for citizenship.

The first modern reservations were created in the Northeast after US independence. They tended to be portions of a group's homeland, but as demand for land increased, the authorities abandoned all pretence of retaining tribal integrity. What ultimately happened in Indian Territory was that it became a dumping ground – forest foragers, river valley farmers, Plains hunters, friends, enemies and strangers alike were forced there.

The loss of territory was hastened by the allotment of tribal lands to individuals. The Dawes Act (1887) was alien to Indian traditions of communality. The result was the loss of 95 million acres (38 million ha) of reservation. In 1953, the US Congress "terminated" several tribes, subjecting reservation lands to taxation. Before this policy ended, 19 tribes lost more than 2.5 million acres (1 million ha) of land.

The trend has been reversed in recent decades with the settlement of some land claims. Today there remain about 300 reservations in the USA, with less than 2.5 percent of the total land area of the United States.

hollow, from the Carolinas to California. Growing European incursion into the continent's interior during the nineteenth century saw Native peoples forced westwards, removed from areas earmarked for settlers and pushed onto small plots of marginal land. The Indian Removal Act, passed by the US Congress in 1830, compelled five tribes to leave their homelands in the southeast and move west of the Mississippi to reservations. The act provided for a new enclave of "Indian Territory" in an area covering present-day Kansas, Oklahoma and parts of Nebraska, Colorado and Wyoming, but even this was encroached upon after mineral wealth was discovered in the region. (During the gold rushes of the late 1840s onwards the populous Shoshoni, Ute and Paiute were all greatly affected.) For a time Indian Territory thrived but the disruption of the American Civil War in the 1860s brought economic

◀ A portrait, c.1820, of the Oneida Shikellamy, also known as Swatana, an overseer for the Iroquois confederacy. He was an important figure during the earliest days of Pennsylvania, serving as an emissary between the Iroquois and the colonial government in Philadelphia. Although Shikellamy converted and sought coexistence with the colonists, he argued that the Indians had to retain their ways of life to remain masters of their own destiny.

▲ The Jefferson Indian peace medal was the first to bear the image of an American president. Thomas Jefferson was depicted in profile on the obverse of the medal, with this image and inscription (above) on the reverse. The new US government was continuing the British, French and Spanish practice of presenting American Indian leaders with silver medals, as tokens of distinction and allegiance.

ruin, and by war's end the tribes had been compelled to agree new treaties and give up land to many other groups, including the Comanche, Kiowa and Cheyenne, as well as Indian peoples from the north. The "inviolable" Indian lands were gradually organized as states, and in 1907, when Oklahoma achieved statehood, the Indian Territory ceased to exist. By 1975 Oklahoma's thirty-odd tribes controlled only 65,000 acres (26,000 ha).

Any resistance to dislocation was met with military action. For example, when the Navajo fought back in the 1850s, the New Mexico Volunteers, led by Colonel Kit Carson, ravaged their country. In 1864, the Navajo surrendered at their stronghold of Canyon de Chelly. More than 8,000 people – most of them on foot – were forced to cross 300 miles (480km) of mountain and desert to Fort Sumner, New Mexico. Many died en route. After several years of intense suffering, the survivors were allowed to return to a reservation within their original lands.

Prior to the arrival of Europeans, the lives of many Native Americans had revolved around seasonal hunting. This was especially true of those who inhabited the vast plains in the middle of the continent. Initially, European influence brought prosperity by making big-game hunting easier when horses were acquired from Spanish settlers in the seventeenth century. By the mid-1700s, the horse, known to some Native peoples as "Medicine Dog", was allowing Cheyenne, Lakota (Sioux) and Pawnee buffalo-hunters to range across vast areas. However, as the nineteenth century progressed, European frontiersmen exterminated the buffalo population – for their meat and hides and to protect new railway development – and eroded the basis of Plains culture. In one three-year period alone (1872–1874), some three million animals were killed. By the 1880s only a thousand or so remained, mostly in Canada.

THE DEVASTATING IMPACT OF CHRISTIANITY

The Huron were suspicious of the black-robed, celibate European men bearing gifts and the promise of eternal life. They lived in their villages and learned their language, but they did not want to live Huron lives. Instead, they urged people to accept an alien religion. The men were Jesuits and over time they won converts, but for many tribespeople this was a matter of economic opportunism. Adopting the trappings of French culture won the Huron greater access to the fur trade. Similarly, it was the prospect of an alliance with the French that prompted Membertou, a Micmac chief, to be baptized by the French missionary Recollets in 1610 at Port Royal.

For the Timucua of Florida, conversion represented one means of easing the depredations of their Spanish overlords. Similarly, the Mohawk of the Northeast requested missionaries after the French had destroyed villages in a punitive raid in 1666. In New England, the Wampanoag were prosecuted for fishing on the Sabbath, and using traditional medicines.

In concert with the eradication of the animals on which they depended, the Plains peoples faced a sustained onslaught on their religious observances. In the 1880s many rites, including the Sun Dance, were outlawed by the Bureau of Indian Affairs (BIA) because they were seen as obstacles to assimilation. At around the same time, the Canadian government prohibited the potlatch.

The BIA also promoted policies that prohibited the use of Native languages. Boarding schools were established to inculcate Christian values. As the founder of the Carlisle Indian School in Pennsylvania put it, the goal was to "kill the Indian ... and save the man". Pupils had to learn English and reject their native dress, language and religion.

GREAT FIGURES OF THE INDIAN PAST

All Native cultures have celebrated the wisdom, strength and courage of elders, chiefs and holy people of recent generations – many of the best-remembered figures being those who attempted to resist the troops, settlers and politicians of the incoming Europeans and their American successors.

However, Native traditions make no clear distinction between what Western anthropology would define as mythology, legend and history. A discussion of Native North American "leading figures" from an Indian point of view would include mythological characters such as Raven, Glúskap, Coyote and others, who were all remembered as real beings who brought great benefits to the people (see pages 180–195). Also, confining the discussion of leadership to humans who have upheld Native integrity in the face of white incursion poses its own difficulties. Because Native history is an oral tradition, the nature of many contributions to indigenous life is now largely lost, since the relevant families and communities were wiped out during the European onslaught. Notable exceptions include Black Elk, an Oglala Lakota holy man who lived through the triumphs and sorrows of the last days of Plains Indian freedom (see page 262).

FROM POWHATAN TO PONTIAC

The exploits of leaders such as Geronimo, Sitting Bull, Chief Joseph and others were recounted by their descendants, recorded in official documents and covered by white journalists, writers and photographers. This was especially the case during the Indian Wars of the Plains in the late nineteenth century. However, the first Native leader to become widely known to outsiders was Wahunsonacock, or Powhatan, chief

▶ Born into the Sauk people in what is now Illinois, Ma-ka-tai-me-she-kia-kiah, is better known as Black Hawk (1767–1838). His status was acquired as a young man during war parties. In 1832 he led the Sauk during the so-called Black Hawk War directed against settlers in Illinois and Wisconsin. Portrait of Black Hawk by Homer Henderson, c.1870 (oil on canvas), after Charles Bird King (1785–1862).

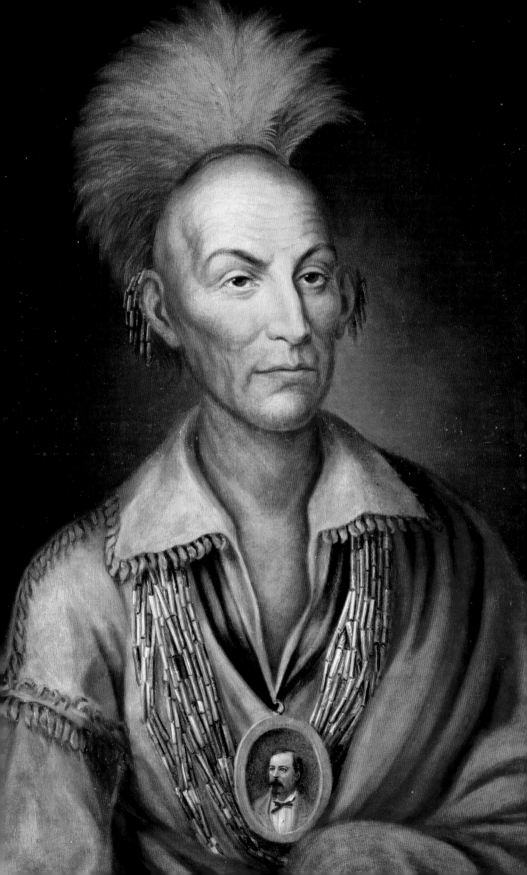

INDIAN HEROES PAST & PRESENT

Sitting Bull (Tatanka Iyotake) of the Hunkpapa Lakota (Sioux) has become a symbol of the Indian virtues of generosity, bravery, tenacity and resistance. Recognized as a *wichasa wakan*, or holy man, he was also in the Strong Heart Warrior Society. From 1863 he resisted intrusion into his people's hunting grounds and he was named principal chief of the Teton Sioux nation in 1867. In 1876, Sitting Bull had a vision of a victory over white soldiers – and weeks later, at the Little Bighorn River, Custer's cavalrymen were annihilated. He took his people to Canada, but returned and toured for a time with Buffalo Bill's Wild West Show before retiring to a reservation. In 1890, he was shot dead by tribal policemen who were sent to arrest him for involvement in the Ghost Dance.

The Chiricahua Apache chief Geronimo is synonymous with brilliant military strategy through guerrilla warfare tactics. His Apache name was Goyathlay (The One Who Yawns); his Spanish name was given after a number of daring raids on Mexico. He was not a hereditary leader, but often acted as his people's spokesman. After the Chiricahua were forcibly removed in 1876 to arid land at San Carlos, he and a band fled to Mexico, only to be returned to the new reservation. In 1881, he resumed his raids, only to surrender in late 1886. The army sent him to Florida and then to Fort Sill, Oklahoma, in 1894. In 1904 he appeared at the Louisiana Purchase Exposition in St Louis, and in 1905 he rode in President Theodore Roosevelt's inaugural parade in Washington, DC.

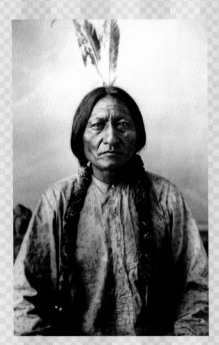

Sitting Bull (1831–1890)

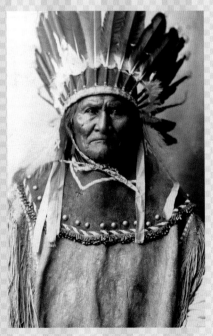

Geronimo (1829–1909)

Chief Joseph (Hin-mah-too-yah-lat-kekt) was a leader of the Wallowa band of the Nez Percé. Granted a reservation in 1855, the government tried less than a decade later to get them to cede ancestral lands in the Wallowa Valley, Oregon. Succeeding his father in 1871, Joseph avoided violence, but in 1877 his people were given 30 days to relocate to Idaho or it would be considered an act of war. Joseph showed great skill and courage in eluding government troops as well as enemy Indian bands for three months while he tried to lead his people to Canada, but the odds were against him and he decided to surrender on 5 October. Joseph is said to have given an eloquent and moving surrender speech including the words: "I will fight no more forever." Many of his followers escaped to Canada.

Despite having negotiated a safe return home, Joseph was sent to Kansas, then to Indian Territory (Oklahoma). He spent his last days in Washington State.

Born in 1939, the Lakota Russell Means (Oyate Wacinyapin – Works for the People) belongs to the 1960s' generation of militant Native peoples. His life was shaped by his childhood experience of being moved from a reservation school to California, where he was taunted for being an Indian. He later became a national media figure by leading many American Indian Movement (AIM) protests. He has appeared in films, notably *The Last of the Mohicans* (1992) and (as the voice of Powhatan) Disney's *Pocahontas* (1995), and although no longer with AIM he remains a foremost spokesman for Indian causes.

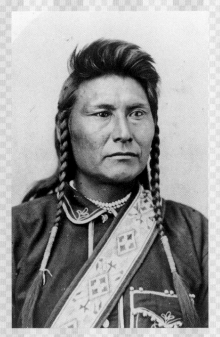

Chief Joseph (1840–1904)

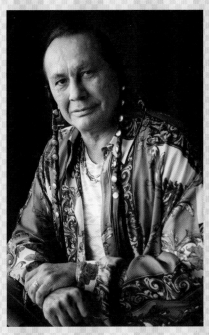

Russell Means (1939–)

of the Powhatan tribe in the early seventeenth century. He forged an alliance of eastern coastal tribes after the English established a colony in Virginia in 1607. Powhatan, diplomatically, even allowed his daughter, Pocahontas, to marry an Englishman, John Rolfe (who took her to England, where she died of smallpox in 1617, aged twenty-one).

Native leaders generally found that diplomacy was to no avail in countering European intrusion. John Ross, the principal chief of the Cherokee in the 1830s, did much to "civilize" his people only to find them ordered to leave their lands under the notorious Indian Removal Act of 1830. Ross successfully fought the order in the Supreme Court, but the ruling was ignored and he was in the last group to be forced west in 1838. In the following years he worked hard to restore the fortunes of the Cherokee in their new homeland.

Many other leaders resorted to armed resistance. In 1763, the Ottawa chief Pontiac, a great orator, joined with a powerful visionary known as the Delaware Prophet to lead northeastern tribes, including the Ojibwe, Huron, Seneca and Delaware, against the British. Forts and trading posts fell, almost 2,000 settlers died, and Pontiac and his forces laid siege to Fort Detroit for several months. Any successes were short-lived. In the century or so after the foundation of the United States, many Native warriors were prepared to fight against overwhelming odds: among them were Black Hawk, a Sauk leader who led a resistance in the Mississippi Valley in 1832; Manuelito, a Navajo leader between 1863 and 1866; Lone Wolf, a Kiowa chief in the Red River War (1874–1875) on the southern Plains; and Dull Knife, a chief of the Northern Cheyenne, who fought in the central Plains and led a dramatic breakout from captivity at Fort Robinson, Nebraska, in 1879. Every rebellion ended in failure, and the shame and suffering of defeat. Some, such as the Lakota Crazy Horse, remained defiant and died in captivity; others, such as Geronimo, had their spirits broken or, like Sitting Bull and Chief Joseph, lived out the rest of their days on reservations, often far from their original homelands.

▶ This famous Orca sculpture by Bill Reid (1920–1998) is titled *Chief of the Undersea World* and was unveiled in 1984 at the entrance to Vancouver Aquarium, in Canada.

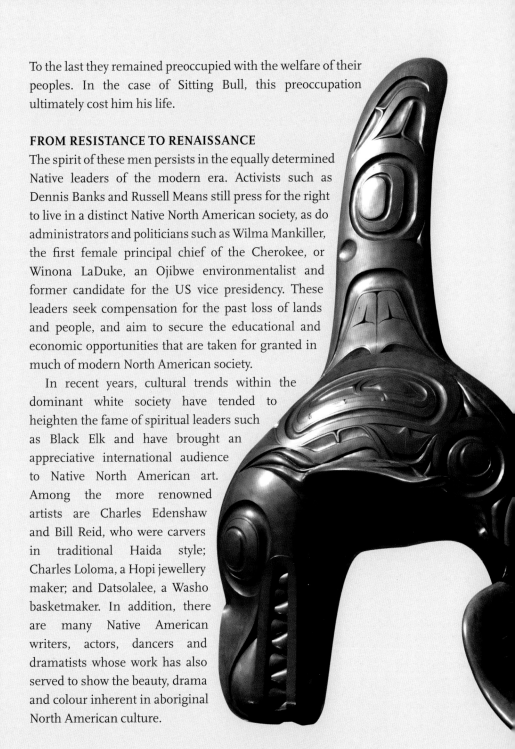

To the last they remained preoccupied with the welfare of their peoples. In the case of Sitting Bull, this preoccupation ultimately cost him his life.

FROM RESISTANCE TO RENAISSANCE

The spirit of these men persists in the equally determined Native leaders of the modern era. Activists such as Dennis Banks and Russell Means still press for the right to live in a distinct Native North American society, as do administrators and politicians such as Wilma Mankiller, the first female principal chief of the Cherokee, or Winona LaDuke, an Ojibwe environmentalist and former candidate for the US vice presidency. These leaders seek compensation for the past loss of lands and people, and aim to secure the educational and economic opportunities that are taken for granted in much of modern North American society.

In recent years, cultural trends within the dominant white society have tended to heighten the fame of spiritual leaders such as Black Elk and have brought an appreciative international audience to Native North American art. Among the more renowned artists are Charles Edenshaw and Bill Reid, who were carvers in traditional Haida style; Charles Loloma, a Hopi jewellery maker; and Datsolalee, a Washo basketmaker. In addition, there are many Native American writers, actors, dancers and dramatists whose work has also served to show the beauty, drama and colour inherent in aboriginal North American culture.

REBUILDING NATIVE PRIDE

In the face of the European and American onslaught, Native North American tribes were overwhelmed and reduced to clinging onto their identity as a form of survival. Having ceded the right to their homelands, been forcibly removed into unfamiliar territories, or confined to reservations and divorced from their traditional ways of life, Native American nations entered a parlous state.

The future for Indian communities was further blighted by poverty and sickness, which challenged the very core of most Native American societies. Indians became objects of scientific curiosity; their bones were collected from battlefields and burial grounds for study. This hardship was ignored by white Americans who, once the Indian "threat" had receded, trivialized their culture, treating it as merely an exotic footnote to frontier history. "Buffalo Bill" Cody's sham "Wild West" pageants, which began even as real Plains culture was being deliberately destroyed in the 1880s and which exploited tragic Native figures such as Geronimo and Sitting Bull, remained popular until well into the twentieth century.

For most non-Indians, if the indigenous people did not succumb to policies of coerced assimilation they simply became "invisible". Official government policy tacitly assumed that Native peoples would become extinct and therefore no strategy was devised regarding their future existence.

▶ A brightly feathered young male dancer whirls to the beat of the drums. Dance remains a powerful cultural tradition among modern Native Americans and a popular form of social gathering, with thousands of powwows held each year across the United States and Canada.

RESTORING TRIBAL INTEGRITY

However, from the 1930s onwards (notably through the Indian Reorganization Act), attempts were made to reverse hostile land reform and restore tribal integrity. More Native Americans were included in the federal government to run Indian affairs, but even then the government tried to terminate federal recognition and assistance, which was a disaster for

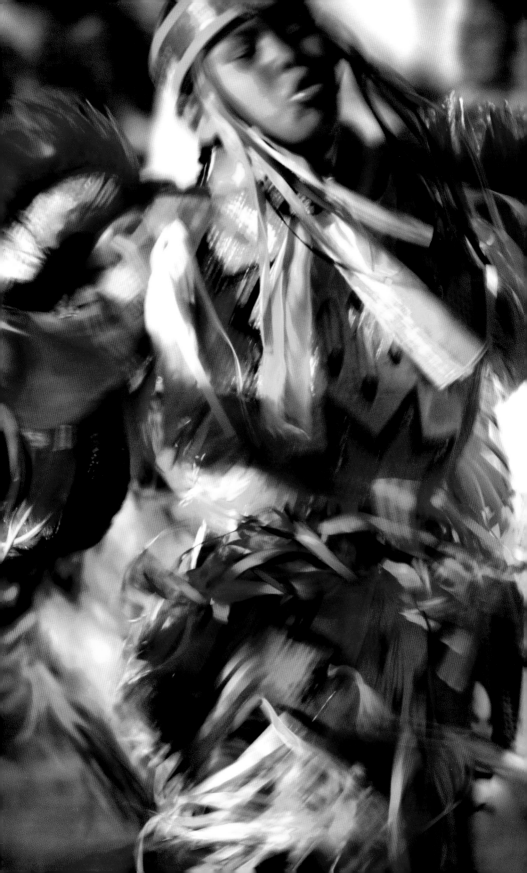

the tribes. In spite of everything, Native populations began slowly to increase after decades of decline, and with the Civil Rights movements of the late 1960s more militant Indian activist organizations such as the American Indian Movement (AIM), founded by Dennis Banks, Clyde Bellecourt and others in 1968, began to raise awareness about Indian problems, most spectacularly with its seizure of the Bureau of Indian Affairs (BIA) headquarters in Washington, DC, in 1972 and the occupation of Wounded Knee in 1973.

Efforts to recover lands or secure compensation for broken treaties have since found their way to the US courts, where the Lakota, Nakota and Dakota (Sioux) secured a Supreme Court ruling that their sacred territory of Paha Sapa (the Black Hills) was taken illegally, although they are still trying to regain the lands rather than accept the compensation. A victory of another sort was achieved in 1990 with the Native American Graves Protection and Repatriation Act, which demanded that human remains and burial goods, as well as sacred objects held by federal institutions, be returned to affiliated tribes. In both the US and Canada, Native peoples are also struggling to save their rapidly disappearing languages by establishing tribal schools in which native language and culture are taught.

CLAIMING THE PRESENT

Although reclaiming the past has become important to many Native North Americans, tribes are now also concentrating on overcoming the problems of everyday life. Economic hardship is a major issue: many of the US reservations and Canadian reserves were purposely set up in desolate areas, and few have resources of any kind. However, some have excellent natural resources, such as timber and mineral wealth, but these assets are either undeveloped or are not under direct Native control. In both countries, sovereignty and rights established by treaties are sources of a great deal of debate.

Much of the activism of the 1970s and later has been geared towards self-determination in daily life, not merely claiming

The Meskwaki and Ojibwe have used revenues to buy back tribal lands, and a number of these purchases have been put to traditional uses, such as sustaining the wild rice crop.

identity and heritage. With the energy crisis of the early 1970s, mineral wealth found on reservation lands provided jobs and capital for a few tribes. In the United States, the most significant economic advance was the development of casinos by a number of tribes, which was permitted by the Indian Gaming Regulatory Act of 1978. By 2010, more than 200 of the 560-plus recognized tribes had viable gaming, and the profit sharing of this income has finally provided tribes with a decent standard of living for their peoples, enabling them to improve their infrastructure, including better housing, roads, medical care, and schools. The Meskwaki and Ojibwe have used revenues to buy back tribal lands, and a number of these purchases have been put to traditional uses, such as sustaining the wild rice crop. Organizations such as the Great Lakes Indian Fish and Wildlife Commission work towards the conservation of resources and public education about treaty rights and Indian ecology.

In both the US and Canada, tribal education programmes have blossomed, with schools teaching indigenous languages alongside the skills needed in non-Indian society, extending from elementary to university education. Growing numbers of Indian people enter professional and scholarly fields, so that medicine and law can be practised in ways more in concert with traditional values. Legal challenges relating to religious freedom appear regularly in the courts. In particular, the protection of sacred sites in the face of land development requires constant vigilance.

To say that American Indians and Canada's First Peoples are winning all these battles would be naive, but today the outlook is at least often positive for the first time in generations. This constant struggle for cultural autonomy may be one key to understanding what it means to be a Native North American, but the resilience of American Indians also owes much to their rich spiritual heritage – and especially the bond between people and nature that forms the bedrock of Indian culture.

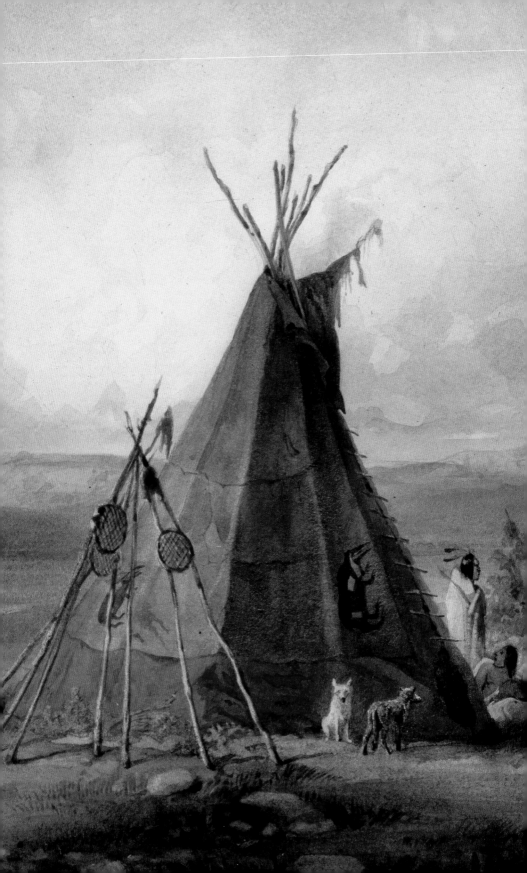

TRIBES & TERRITORIES

2

The land has always been fundamental to Native American identity. Indians dealt closely with the physical world in every waking moment, whether foraging for plants, stalking game or working on the soil. The structure of life and of cultural expression were determined, above all, by the timeless natural rhythms of the particular environments in which people lived, and therefore the Native tribes are normally grouped according to the regions they inhabit.

The cultural diversity of the continent's aboriginal inhabitants stems from millennia of successful adaptation to changes in both the natural and social environments. From frozen wastes to tropical swamps, some groups practised a partly nomadic foraging lifestyle, whereas others lived in permanent villages and practised a mixture of foraging and horticulture – a few were high civilizations centred on sizeable settlements, which were dependent on crop growing. Some groups had egalitarian social structures; others had hierarchical ones. Contact between tribes often transformed each culture involved.

What inspires and unites all these peoples is a view of the world as a place of sacred mystery. Their relationship with the world is rooted in a profound respect for the land and its life-forms. Humans are not above creation but a part of it, and people must form a respectful, balanced relationship with the world around them. The soul of Native North America lies in these ideas, which have remained sufficiently powerful to enable these cultures to survive in the modern world.

THE NORTHEASTERN
WOODLANDS & GREAT LAKES

The Northeast is a region of forests, lakes and rivers, stretching from cold, rocky landscapes scoured out by glaciers north of the Great Lakes and the St Lawrence River, to broad, warm and fertile plains along the Atlantic coast and the Mississippi and Ohio valleys.

People on the northern margins of this culture area, bordering the forests of the Subarctic, lived with late thaws and sharp, early frosts that would have killed the crops grown by their neighbours to the south. So the Ojibwe, Abenaki, Micmac and other northern Algonquian-speaking groups led a nomadic life, guiding their birchbark canoes along seemingly endless lakes and waterways in a seasonal round of hunting, gathering and fishing. The ancestors of the more southerly horticultural tribes almost certainly once followed this way of life too.

When Algonquian-speakers travelled through their territory, they often set up simple conical *tipi*s or tents clad with bark or animal skins. At their more permanent summer and winter camps, from which they ranged to gather food, they built wigwams – sophisticated dome structures of saplings covered with sewn birch or elm bark or animal skins.

A wide variety of plant foods were gathered, from wild rice – a seed-bearing grass of lake margins – to blueberries. Animals such as deer and moose were hunted and honoured as gifts of animal spirits, who were sometimes recognized as ancestors of the hunters themselves. The Micmac built weirs to trap eels and used seagoing canoes to hunt porpoises.

Semi-nomadism was less necessary south of lakes Erie and Superior, where there is rich soil and the hardy spruce and fir trees are replaced by pine and deciduous forest. Longer summers and milder winters meant maize, beans and squash thrived. Algonquian-speakers such as the Illinois, southern

▲ Page 32. Watercolour depiction by Karl Bodmer of the *tipi* of a Siouan-speaking Assiniboine chief, during the transcontinental trip the painter made in the early 1830s with Prince Maximilian zu Wied-Neuwied.

▶ Boreal forest and lake shoreline near Pickle Lake, Ontario, Canada. Pickle Lake is the most northerly town in Ontario accessible by road year-round.

Ojibwe and Menomini, developed a more settled way of life than their northern neighbours. So too did the Winnebago and other Siouan-speakers, and the Delaware (or Lenni Lenape), Wampanoag and other peoples of the Atlantic coastal plain. Hunting and gathering remained important – some, of course, were able to harvest the resources of the sea – but the agricultural season dominated the rhythm of their lives.

The mound-building cultures that developed from c.500BCE thrived in the Ohio River region. Forests were so abundant that hunter-gatherers such as the Adena were able to develop an elaborate ceremonial life, symbolized by monumental earthworks such as the Great Serpent Mound (see pages 110–111). The Hopewell culture emerged from there with an even more complex society, which, unlike the mostly egalitarian societies around them, seems to have created a social and religious elite. The Hopewell built a grand mound complex and left exquisite examples of artistry in stone, ceramics, wood and metal, and created a trade network that transformed the cultural life of the Midwest from the Great Lakes to the Gulf of Mexico for almost 500 years. With the addition of horticulture after c.800CE, the Mississippian culture that succeeded the Hopewell developed even more elaborate traditions, but outside the Mississippi Valley northeastern agricultural societies conducted their ritual lives on a less elaborate scale.

△ This toad is part of a Hopewell culture animal effigy pipe bowl. The toad may represent the spirit guide of the shaman who smoked the pipe to induce a trance to assist with a healing ritual. The culture is named after the grand ceremonial mound complex that once stood near the present-day town of Hopewell, Ohio.

ALGONQUIAN RIVALLED BY IROQUOIS

In the inland forests running from Lake Huron eastwards and southwards to the Appalachian Mountains, a distinct group of peoples with their own language, Iroquoian, emerged amid the surrounding Algonquian culture. The Iroquoians were farmers, and in spite of their inferior numbers they dominated the Northeast by the late seventeenth century. Most Iroquoian-speakers lived south of the St Lawrence River, in what is now

THE POWERFUL *MANITOUS*

The mythology of the Native peoples of the dense eastern woodlands was rich with accounts of forest spirits, demons and monsters, a supreme being and the idea of an upper and a lower world. Powerful forces of nature called *manitou*s were present everywhere, ranging in character from those that were benevolent to others that were life-threateningly malicious. People learned about the *manitou*s at an early age, and through the teachings of elders and their own dreams they came to understand the spirits' many powers. Even so, such beliefs made the region's vast forests potentially perilous places that reverberated with mystery – and the woodland could hardly be avoided because it was so rich in plant and animal life that its produce could sustain a people all year long.

The most remote *manitou*s were celestial and lived high in the sky, while some lived just below them as the spirits of the birds. Many *manitou*s, including some of the worst, lived in the area's many lakes and streams. The earthly ones often resided in odd features of the landscape, such as rocky outcrops. Those *manitou*s who lived in the forbidding darkness under the canopy of trees were in charge of the animals, and could thus either help or impede hunters. Dangers also lurked in the form of the evil *manitou*s such as Windigo, the cannibal monster who lay in wait for the unwary.

upper New York State; another group occupied the lowlands between lakes Huron, Erie and Ontario. Their village life was centred on rectangular longhouses and the accompanying slashed-and-burned clearings were planted mainly with corn.

Sometime before the fifteenth century, five Iroquois groups (the Cayuga, Mohawk, Oneida, Onondaga and Seneca) formed a confederacy called the Five Nations of the Haudenosaunee ("People of the Longhouse"). This league, extending from the Hudson River to Lake Erie, was joined by a sixth nation, the Tuscarora, in 1714. During the eighteenth century, the so-called Six Nations dominated the fur trade. At the height of its power, the confederacy overran the Huron to the north and pushed back the Algonquians to the east and west. As the foremost Indian power, the league became deeply involved in Anglo-French colonial rivalry. After 1783, it also set an example to the leaders of the new US through its political acumen, diplomacy and command of a vast and complex territory.

THE SOUTHEASTERN WOODLANDS

From the rugged Appalachian Mountains southwards to Florida and the Gulf of Mexico and west beyond the lower Mississippi River to the arid lowlands of southeast Texas, the warm, wet and fertile Southeast supported a cornucopia of plants and animals.

After about 800CE people living in this region became village-dwelling farmers, but unlike their northern counterparts they could raise two crops of corn (maize) a year. Some tribes, such as the Calusans of southern Florida, remained hunters and gatherers, exploiting the abundant wildfowl, reptiles and fish, and edible roots to be found along the subtropical coastal fringes of the Atlantic and the Gulf of Mexico. Inland, there were edible fruits, wild nuts and abundant game in the region's forests and open country, and the rivers teemed with fish. Hunting often demanded special techniques, because there was less likelihood of snow to slow down the deer. For example, most southeastern hunters perfected deer calls to attract the animals within the range of their weapons.

Typical dwellings, such as those of the Creek people, consisted of rectangular, gabled summer houses and conical winter houses, partly set in the ground for insulation. Housing in hot subtropical areas was exposed: the Seminoles lived in open-sided dwellings thatched with palm branches.

The abundance and variety of the plants that grew around them suggests it is likely that the Indians of the Southeast had many herbal medicines and used numerous plant substances for ritual occasions. People certainly grew tobacco, which they smoked in pipes during ceremonies and conjuring rituals or rubbed on the body as a healing medium.

When the Spanish arrived in the region at the end of the fifteenth century, Southeastern tribes still bore many features

▶ Autumn in the woodland along the southern portion of the modern-day Appalachian Trail in Virginia, traditional home to the region's Muskogean-speaking peoples.

of the Mississippian culture, the last of the great river valley civilizations of ancient North America (see page 36). The area's dominant tribes spoke a diversity of languages: the Creek, Choctaw and Chickasaw peoples spoke Muskogean dialects, the Catawba were Siouan-speakers, and the Cherokee spoke Iroquoian. Stickball games, of ancient origin and epic in scale, were a national pastime among the Southeastern peoples, whose names for them were translated in warlike terms – for example, the Cherokee referred to the "companion of battle" and the Choctaw to the "little brother of war".

It is difficult to obtain a more detailed picture of the region's cultural complexity, because these peoples bore the brunt of early European contacts, beginning with a Spanish expedition in 1513. Successive intrusions of Spanish, French and English colonists and then American settlers brought war, disease and dislocation to the Indians and ensured their decline.

THE FIVE CIVILIZED TRIBES

By far the heaviest blow to the Southeastern tribes was dealt by President Andrew Jackson's Indian Removal Act (1830), which authorized the forcible removal of Indians from east of the Mississippi to a new Indian Territory far to the west. Ironically, the measure was aimed mainly at the peoples whose affluence and adaptability had led to the Cherokee, Chickasaw, Choctaw, Creek and Seminole being described as the "Five Civilized Tribes". However, the decision of the Indians to reach an accommodation with the invading white men did not prevent their displacement, and after legal challenges and some squalid political dealing most tribespeople were sent west, often on

▲ **Mississippian art used many falcon-man and raptorial bird design motifs, which were maintained in the Indian arts of the Southeast. The craft of basketry has also continued from prehistory to the present. This 18th-century woven fibre serving basket reveals a mastery of colour and features a bird emblem.**

▼ **Pages 42–43. The Great Smoky Mountains, historic heartland of the Cherokee.**

STICKBALL: THE "COMPANION OF BATTLE"

The modern-day game of lacrosse, a rough sport played with sticks, a ball and with much body contact between two teams occupying opposite ends of a large field, is derived from a warlike game called stickball that George Catlin famously recorded (below) in 1834 being played among the Choctaw, who called it *ishtaboli*. The Indians regarded the contest as a gift from the Creator and they played it between towns and tribes to settle intercommunal disputes or during ceremonial occasions, such as planting and harvest rituals, as a way of propitiating spirits. Preparation for the game was attended by prolonged purification rituals and many ceremonies were directed by a priest, all with the aim of increasing the chances of their own town winning and conjuring up the right magic to ensure the opposition would lose.

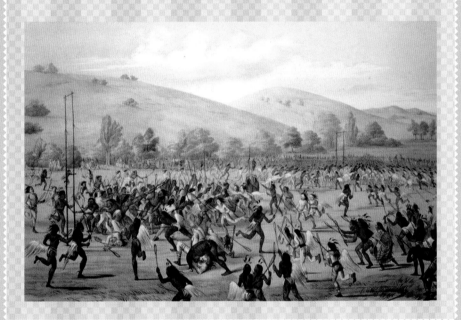

forced marches that left about one-quarter of the Cherokee people dead. The Cherokee called their own trek "the Trail of Tears", a phrase that other nations adopted to describe similar ordeals. However, several hundred Cherokee remained in the east, hiding out in the remoteness of the Great Smoky Mountains and forming communities who were the ancestors of what is now the Eastern Band of the Cherokee nation.

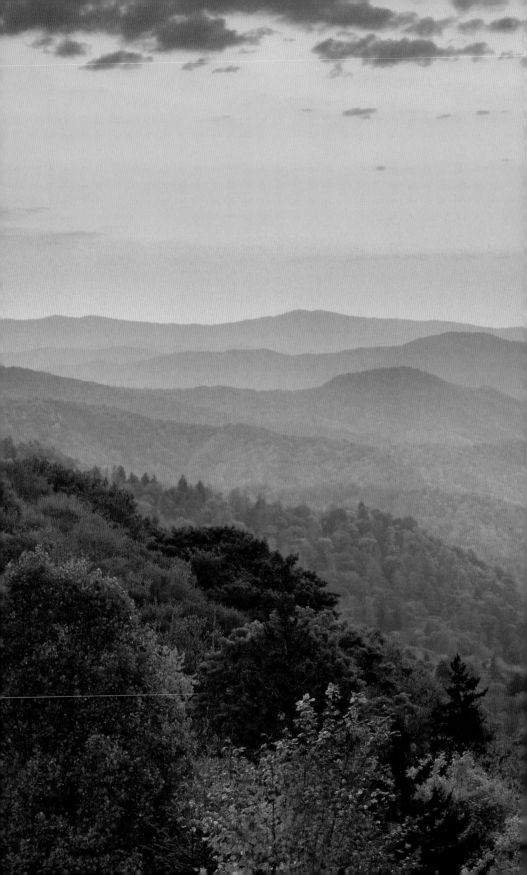

You say: "Why do not the Indians till the ground and live as we do?" May we not ask, why do the white people do not hunt and live as we do? The Great God of Heaven has given each their lands... he has stocked yours with hog, ours with bear; yours with sheep, ours with deer. He has indeed given you an advantage, in that your cattle are tame and domestic while ours are wild and demand not only a larger space for range, but art to hunt and kill them.

Corn Tassel, Cherokee, 1785

A single twig breaks, but the bundle of twigs is strong.

Tecumseh, Shawnee

THE GREAT PLAINS

Between the Mississippi River and the Rocky Mountains are the grasslands known as the Great Plains, or prairies, stretching from the parklands below the ancient granite rock of the Canadian Shield in northern Manitoba, Saskatchewan and Alberta to the lowlands of Texas.

▼ *Buffalo Hunt, Surround*, a depiction of the buffalo and life on the plains by the English lithographer John McGahey in 1844, who drew George Catlin's images on stone and wood.

Amid this expanse hills rise up like strange islands in a grassland sea: the Black Hills of South Dakota–Wyoming, the Flint Hills of Kansas and the Ouachita Mountains of Oklahoma. River valleys, hidden until the prairie suddenly drops away, provide water, trees, plant and animal life – and refuge from biting prairie winds. Great herds of animals, mainly buffalo (bison), once swarmed beneath the vast expanse of sky, living off the abundant prairie grasses. Over the last millennium, the Plains have been the home of many tribes, some of whom were more or less permanently nomadic

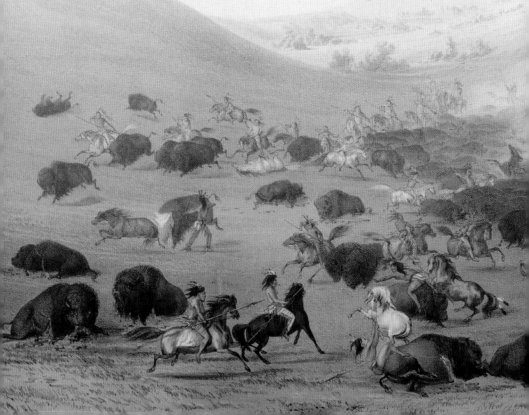

hunters of the multitudes of buffalo (trapping them in valleys and driving them off cliffs), while others alternated between hunting on the Plains and farming on the rich floodplains of the rivers.

THREE PEOPLES OF THE EARTHLODGES

Climatic changes sometimes necessitated adjustments to the village lifestyle when droughts harmed the corn, beans, squash, tobacco and other crops. The ancestors of the Mandan originated in the middle Missouri River Valley. By the late twelfth century, they had come into contact with the ancestors of the Arikara and Pawnee, who migrated from present-day Nebraska and Kansas to escape drought. Some mixing of cultures occurred. By the time the Europeans arrived, most groups lived in large palisaded earthlodge villages along the major rivers. The Pawnee lived in Nebraska, the Arikara in most of present-day South Dakota and the Mandan in North

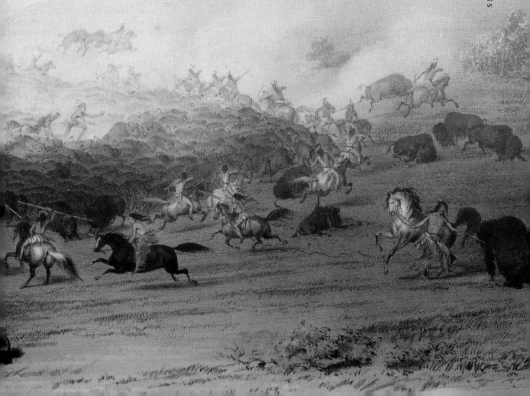

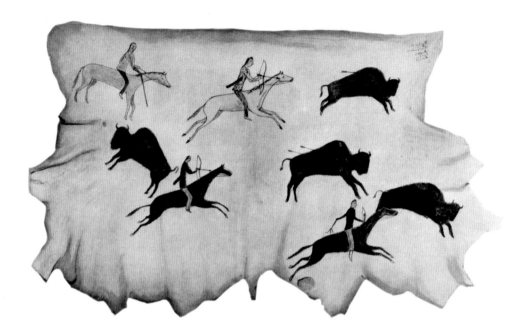

Dakota. These tribes were all highly skilled farmers, whose lives followed a similar rhythm: planting in the spring, buffalo hunting in the summer and early autumn, and harvesting before the long winter.

THE HORSE

Life on the Plains was changed forever when, in the sixteenth century, the Spanish reintroduced the horse, extinct in North America for millennia. By the end of the seventeenth century, the Pawnee and others had begun to range on horseback out of the river valleys. Farmers could more easily carry out their seasonal bison hunts. Some of those who had adopted a settled existence, living in earth and grass houses, abandoned them for the ultra-portable *tipi* dwelling, whose poles and buffalo-hide covers were easily transported by horse-drawn travois.

▲ A 19th-century hide painting depicting a buffalo hunt on horseback.

The tribes most strongly associated with buffalo hunting on the Plains were often newcomers. The Cheyenne moved to the Plains in the early nineteenth century from ancestral

THE BUFFALO JUMP

As grazing animals of the featureless Plains, buffalo needed to see little except the grass in front of them. Their poor eyesight was a boon to the Indians of the pre-horse era, who would stampede bison towards a cliff or precipice, directing them down a natural gully or creating an artificial channel from rocks and brush. The beasts would not see the drop until it was too late, and dozens, perhaps hundreds, of animals might die in a single "jump". At one site in Alberta, Head-Smashed-In, there are bones of hundreds of thousands of animals going back 5,000 years. The presence of full skeletons alongside butchered bones shows that more animals died than were needed. However, the huge bison population of the time could easily withstand such overkill.

homelands near the Great Lakes, and became full-time buffalo hunters. Although migration to the area made it the scene of fierce rivalry between tribes, its peoples shared a profound belief in a supreme creator, the "Great Spirit".

By the nineteenth century, the Plains had become a cosmopolitan landscape. One southern Arapaho chief said that he had met Comanches, Kiowas, Apaches, Caddos, Pawnees, Crows, Gros Ventres, Snakes, Osages, Arikaras and Nez Percés, and communicated with them in the Indian sign language that was once the lingua franca of the Plains.

Although the introduction of the horse brought benefits, the gun was a less positive influence. Armed with guns, the northern Algonquians and the Iroquois league expanded westwards in their struggle to control the fur trade. Under pressure from the east, by the 1700s the Ojibwe had pushed the Lakota (or Teton Sioux) into the Plains from Minnesota. The Lakota then fought for resources with the Mandan, Arikara and Hidatsa along the Missouri River. When breech-loading rifles were introduced in the mid-nineteenth century and non-Natives joined the hunt, the buffalo neared extinction.

White settlement, warfare, disease and the disappearance of their greatest natural resource spelled the end of traditional Plains Indian life. Peoples who had once freely roamed the great expanses were confined to reservations.

THE SOUTHWEST

The Southwest is an arid land of sand and stone, sculpted by millions of years of erosion into flat-topped mesas, dusty plains and deep canyons. Endless shades of red, brown, black and yellow greet the eye, together with the surprising greens of desert plants.

Scarcity of water has long determined the course of human, plant and animal life in this region. Rain accompanies short, violent summer storms that briefly flood canyons, stream out over the deserts and sink into the sands. The rocky wastes are bisected by several large rivers: the Rio Grande in the east, the Colorado in the west, and the Salt and Gila north of Mexico. On higher elevations, pine and juniper cluster in shallow soil among the gullies; on the flat desert plains, desert shrubs, cacti and mesquite thrive in all but the driest places, such as Death Valley, which endures extreme heat and endless drought.

ANCESTRAL PUEBLOANS

Thousands of years ago, people gathered and hunted as they have always done in deserts, making use of every living thing for food, clothing and shelter. But the ancients later raised corn (maize) and squash, using knowledge gleaned from Mesoamerica. The success of these desert agriculturalists is seen in the elaborate art, technology and ritual of the region's pre-contact civilizations. One group, the Mogollon, lived in the mountains, tolerating the extremes of climate in well-insulated, log-framed pit houses, set into the ground. They grew corn, beans, squash, tobacco and cotton, and their creativity is evident in a type of pottery known as Mimbres.

Between c.1200CE and c.1400CE, the Mogollon were absorbed by the Anasazi ("Ancient Ones"), who had first emerged c.100BCE, raising crops on terraced slopes and in irrigated fields. In c.750CE the Anasazi developed a new type of dwelling built of adobe (mud brick), with a roof of sticks, grass

▶ West Mitten Butte in Monument Valley at sunset. Today this area forms part of Monument Valley Navajo Tribal Park. The Navajo know this as Tse'Bii'Ndzisgaii, or Valley of the Rocks. Agriculture flourished in the aridity of the Southwest to an extent that was rare in North America.

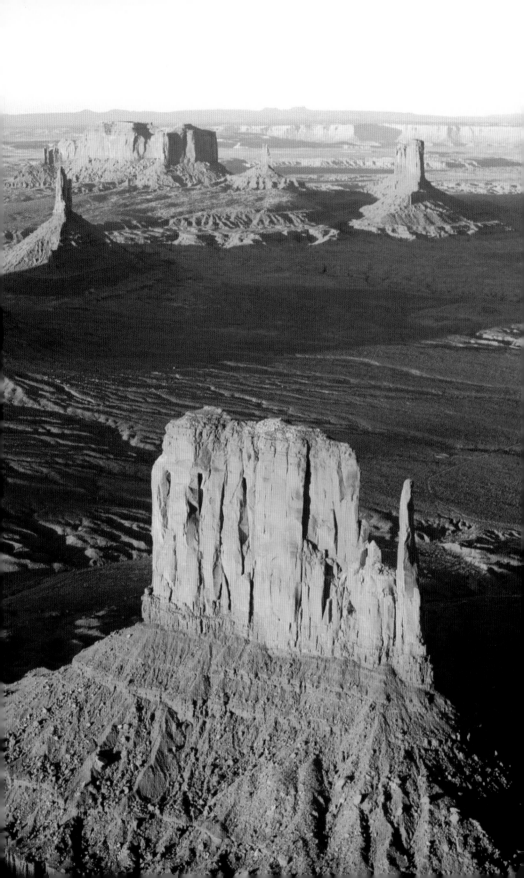

and mud supported by wooden beams. By joining these houses together, the Anasazi built enormous dwelling complexes, or pueblos (Spanish for "villages"), on mesa tops and in the recesses of canyon walls. Each storey was set back from the one below. One such complex, Pueblo Bonito in Chaco Canyon, was begun *c.*900CE and has five storeys and around 600 rooms.

The Anasazi left behind a wonderful array of painted pots, colourful fabrics, mosaics, exquisite turquoise jewellery, feathered clothing and other elaborate finery. But their civilization was brought to an end by droughts lasting several generations. By *c.*1300CE, the Anasazi had abandoned their settlements and either moved closer to the rivers or reverted to a nomadic hunting and gathering lifestyle.

▲ Mimbres pottery is characterized by striking black-and-white geometric designs and living things. This 10th-century bowl painted with two figures, is possibly representing the contrast between male and female or life and death. Such bowls were intended as burial offerings and were ritually "killed" at burial with punctures to their base. This helped release the vessel's spirit into the next world.

PUEBLOANS AND ATHABASKANS

When the first Spanish arrived in 1539 and 1540, there were several Native groups in the region. These included the Puebloan Indians, among them the Hopi and Zuni, and the Pima and Tohono O'odham (Papago). Their rich religious and cultural heritage harks back to the earlier civilizations – both the ideas derived from "emergence" mythology and the masked impersonators of mythic spirits, which remain important to Pueblo religious practice. The networks of adobe houses have underground chambers (*kivas*) used for religious ceremonies. The Hopi had inherited the Anasazi way of life and adapted it to the Colorado River region. At Oraibi, perched high on Black Mesa in Arizona, the Hopi climbed down precipitous tracks cut into cracks and crevices in the sandstone ramparts to farm corn on the plain below. In the deserts watered by the Salt and Gila rivers, the Pima followed a way of

THE WARRIOR CODE TALKERS

Native people have volunteered to serve in the US armed forces in virtually every capacity in the past century, viewing service as a way to preserve their warrior traditions. One distinctive contribution to the US war effort was Indians' ability to communicate in languages unknown to their enemies. During the First World War, Germans who tapped into Allied lines were baffled by the strange words used by Choctaw code talkers. In the Second World War, the US Army Signal Corps used men from several Indian nations, including Cherokee and Comanche. Most significantly, the US Marine Corps deployed 420 bilingual Navajo men to convey important messages in the Pacific theatre. The Japanese were never able to crack these communications. The Navajo continued this work into the Korean War but the practice was ended during the Vietnam War. In recent decades there has been official belated recognition of the role played by code talkers from all the Native American tribes.

life established by another ancient people, the Hohokam, who constructed irrigation canals up to ten miles (16km) long in the desert in order to water their corn, beans, squash, tobacco and cotton. In the drier uplands, the Tohono O'odham of the Sonoran Desert harvested cactus and hunted small game.

The second group consisted of the Navajo and the Apache, two nomadic, Athabaskan-speaking peoples who had migrated into the region. The Apache generally continued to live the nomadic lives of their northern cousins, hunting on the Plains and in the mountains, and gathering wild plants. However, the Jicarilla Apache of northern New Mexico learned agriculture from, but did not integrate with, the Puebloans. The Navajo retained their hunter-gatherer lifestyle until they acquired domesticated sheep from the Spanish, when they turned to herding and became expert spinners and weavers. Unlike the restless Apache, the Navajo settled in small, widely scattered groups and adopted the desert as their home. Both groups adopted various elements of the local mythology and ritual. Today the Navajo, or Diné, Nation is not only the most numerous tribe in the region but the second-largest Native American group in North America (behind the Cherokee).

CALIFORNIA

The southwestern edge of North America is enclosed by mountains: a range that follows the coast and runs down into the sea south of Baja California, with the towering Sierra Nevada to the east. The boundaries of Native California correspond to those of the modern US state, whose fertile valleys are watered by the warm Pacific air that sheds its moisture there.

People found the abundance in this environment to be irresistible and they settled on rivers, uplands and coastal shores. The sea sustained the Chumash and Pomo, who traded with Yuma hunter-gatherers inland. The mixture of languages shows that Indians migrated from many places. In general, each of them occupied a small territory that combined uplands and either a river or a stretch of coast. The area contained all they needed to thrive.

The Chumash picked shellfish from the sands, and caught tuna, halibut, bonito, albacore and many other fish. They also put to sea in large plank boats to hunt whales, seals, sea lions, dolphins and otters. Inland, deer, rabbits and other small game roamed the landscape, fish swarmed in rivers and streams and the land yielded a cornucopia of wild plants. The autumn acorn harvest provided a staple food.

▶ This coiled basket from the Cahuilla tribe depicts a rattlesnake, which represents the endless natural cycle of death and renewal. Many tribes in California associate the rattlesnake with rebirth.

The Luiseño, who lived north of Baja California, could easily harvest the bounties of land and water in one place, but for most Californians, the seasonal cycle involved a longer journey to and from the sea.

There was some group control of land where resources – from wild plants to fish – were particularly rich. In some places, extended families combined to form larger entities with definite territories, each with a main village and chiefs.

With such plenty, trade was common. The Hupa bartered acorns and other interior foods with the Yurok for seaweed, dried fish and redwood dugouts. Dentalia shells provided a currency for trade, as well as a symbol of power and status.

However, from the mid-eighteenth century onwards, the Californian peoples' seasonal routines were disrupted by the activities of Spanish Christian missions on the coast. Gradually, the tribes were divested of their language and religious traditions. The discovery of gold in 1848 proved to be the undoing of the first Californians, accomplishing what the missions did not. Floods of settlers came in search of gold and discovered the riches of the landscape, then their presence led to widespread disease and dispossession. The Hupa managed to survive, protected in their isolated river valley, but for the Chumash, Luiseño, Pomo and other peoples, the life of plenty came to an abrupt end.

THE GREAT BASIN

The Great Basin is the area between the Rockies and the Sierra Nevada Mountains where there was once a series of huge lakes, full of the meltwater from ice-age glaciers. But thousands of years of intense summer heat transformed the region into rocky desert, and the rivers from the surrounding uplands became trickles that formed small, alkaline lakes or simply disappeared into the ground, or evaporated.

Survival is not easy in this parched land of sagebrush, pinyon trees and juniper. The terrain favours small game, such as ground squirrels, gophers, rats and jackrabbits, which can burrow or shelter among the rocks and live on seeds, grass and only a little water. Deer and antelope are scarce in the region and keep to the river and lake margins where they can graze and browse. This inhospitable landscape is also the traditional home of hunting and gathering peoples of the Shoshoni, Ute and Paiute nations, and around Lake Tahoe were the Washoe, unrelated to the other Shoshonean-speaking tribes and thought to be the region's earliest settlers.

In the more arid parts of the Basin, the people spent most of the year ranging across the desert in small family groups. No one place could yield enough food to support village life, and people had no strong sense of territoriality. Paiute dwellings were most often simple, open-topped, conical structures made from willow frames covered with brush or reeds. They hunted and gathered what the desert yielded in its seasonal round, from small game, pine nuts and seeds thrashed from grasses, bushes and trees, to ants, grasshoppers, horned toads and lizards. This subsistence on roots and seeds meant the Paiute became known dismissively as "Digger Indians". Their need to collect fruits and nuts meant that the Paiute became such excellent producers of finely woven basketry that they even "exported" to the Southwest region.

Through ceremony and the sharing of tasks, the people reasserted their collective identity and tribal integrity.

The Shoshoni and other people of the more arid country had relatively meagre food supplies, but followed the subtle rhythms of the desert to exploit seasonal bounties. In the spring, ground squirrels and groundhogs were still fat and slow after hibernation. Sage grouse were preoccupied during spring mating and could be netted. For those who lived near lakes and streams, fish were available all year round.

As autumn approached, the scattered families began to come together for cooperative harvests of pine nuts. What was not eaten was stored in pits for the winter. The Shoshoni constructed great corrals up to two miles (3km) long of sagebrush, stones and wood, in order to trap antelope, which could not leap over them. Rabbits were flushed from bushes and from the sagebrush into nets. This time of plenty was critical to survival over the winter and also to spiritual well-being. Through ceremony and the sharing of tasks, the people reasserted their collective identity and tribal integrity. There was enough moisture in the region occupied by the Ute to support large game such as elk, bison and mountain sheep, while the Paiute on the eastern Sierra Nevada could irrigate meadows and maintain their food stocks for longer.

As elsewhere, Europeans had a profound affect on the Basin and its peoples. With the introduction of the horse by c.1700 the Shoshoni in particular turned to the Plains for resources and adopted Plains traditions (see pages 44–47). When gold was found in California and western Nevada, the people remaining in the Basin could not resist white incursions, as they had nothing to fight with and no warrior tradition. In 1864, the US government simply annexed the region. By 1874 those Indians who had not died from disease were involved in waged labour or had become fully dependent on the government. The religious traditions of the Great Basin region strongly emphasized immortality and in 1889 it was a Paiute holy man, Wovoka, who had a vision that led to the Ghost Dance movement (see pages 260–261).

PLATEAU

Between the Rocky Mountains and the Pacific Northwest Coast region is a large plateau where coniferous forests are broken by a hilly terrain of open grassland and sagebrush, dotted with oak. Glacier meltwater from surrounding mountains, such as the Blue and Bitterroot, feeds scattered lakes and the many rivers, including the two great river systems of the Columbia and the Fraser, that are the lifeblood of the land and its people.

▶ A depiction of unidentified Indians fishing by torchlight, engraved by H. Merke and published by Edward Orme in 1813.

▼ Pages 58–59. Mount Rainier, Washington, with wild flowers in the foreground. Known as Tacoma ("Mother of Waters") to the Puyallup, one of a number of tribes that came into the area on a seasonal basis – others included the Nisqually and Yakima.

The Plateau area stretches from central British Columbia and across eastern Oregon and Washington into Idaho and straddles the Continental Divide into northwestern Montana. Inland, people lived in villages and were skilled hunters and gatherers, relying on fish, deer, elk, mountain sheep, rabbits and other small game, and on grassland and forest plants. However, they were not entirely isolated from the cultures around them. Pacific Coast culture had been brought to them in trading canoes probably since ancient times, as suggested by stone carvings of human and animal effigies. The clear, cold, highly oxygenated waters of the rivers are rich in fish, especially the salmon which migrate from the Pacific via tributaries of the Fraser and Columbia and proved a major means of subsistence. Salmon were speared from projecting platforms, netted, hooked or trapped using weirs constructed across streams. (The number of salmon in the river basin today has been reduced by the building of dams to generate hydroelectric power. Annual salmon runs that once reached an estimated 16 million fish now total fewer than 1 million.)

Many languages were spoken but two major linguistic groups of peoples dominate: Salishan-speakers, such as the Flathead, Lillooet and Thomson; and Sahaptin-speakers, such as the Cayuse, Nez Percé and Yakima. Groups such as the Nez Percé (Nimípu) found that the horse was ideally suited to the grasslands of the Plateau, and consequently they emulated the

lifestyles of the Plains peoples by becoming seasonal buffalo hunters on the western Plains.

Every year many of the Plateau tribes would gather at an autumn trading fair called the Dalles Rendezvous, held where the salmon fishing was easy as the Columbia River cuts through the Cascade Mountains some 75 miles (120km) southeast of Mount St Helen's. The location – on the famous Oregon Trail – was in the territory of the Chinookan-speaking Wishram and Wasco peoples who were noted middlemen between the Plateau and the Pacific tribes. In this manner buffalo robes were exchanged for dentalium and suchlike – or, increasingly, European goods.

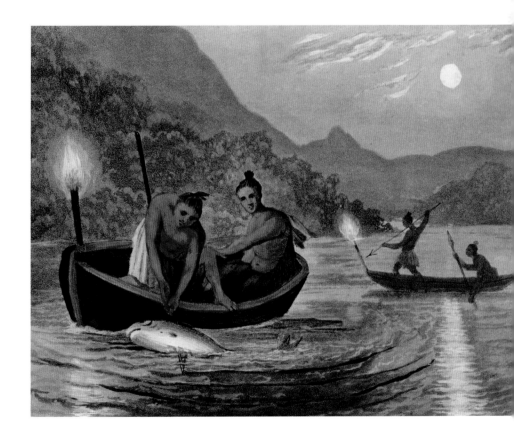

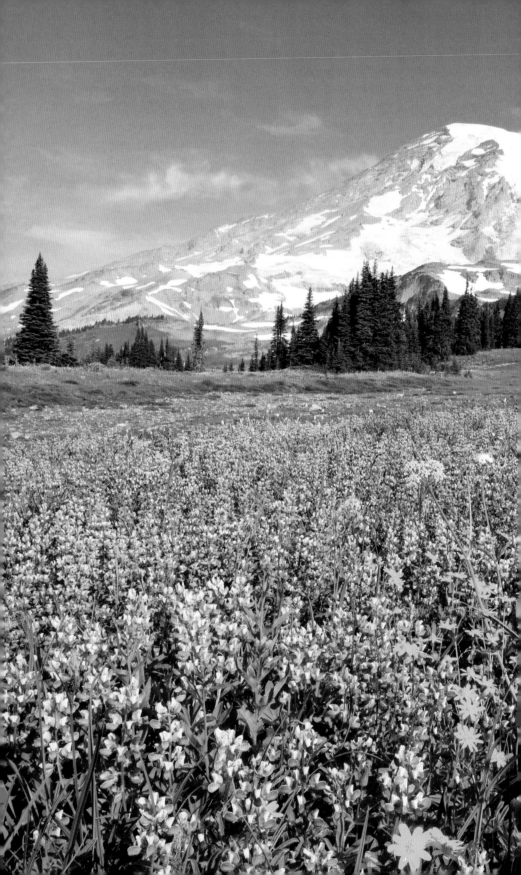

THE NORTHWEST COAST

From northern California to southeast Alaska the western mountains sweep down to the sea along the coast and provide a home to numerous cultures. This is a prosperous region: the sea and rivers teem with fish and sea mammals, while the thick forests yield an abundance of game and berries.

The climate is mild and, where there are no large offshore islands to offer protection, the Pacific surf crashes against the steep and densely wooded slopes and the tides surge many miles up steep flooded valleys into cool inland forests. Warm ocean currents weave among the islands and along the coastal plains, creating lush temperate rainforests fringed by sand and smooth rock beaches.

Although the only agriculture in the fertile river deltas and on the coasts was some scattered tobacco growing, obtaining something to eat was not difficult. Even without salmon, which as a food source was as predictable as the seasons, food on the coast was abundant: trout, cod, halibut, herring, smelt and other fish. One small fish, the oolichan, contained so much oil that it could be dried, run through with a wick and burned like a candle. Sea mammals also flourished. The Nootka and Makah hunted whales, and all peoples took seals, porpoises, sea lions and sea otters. Clams, mussels, sea urchins and oysters were so plentiful that ancient village sites are marked by shell-heaps many feet deep. The surrounding woods were full of starchy roots and berries, as well as deer, beavers, bears, marten and other small game. Hunters at higher altitudes could pursue elk, goat, wolf and grizzly bear.

CRESTS, CLANS AND CEDAR

The peoples of the Northwest lived in villages of large wooden houses. Natural abundance meant people were able to devote much time to ceremonies and the production of ceremonial

The Nootka and Makah hunted whales, and all peoples took seals, porpoises, sea lions and sea otters. Clams, mussels, sea urchins and oysters were so plentiful that ancient village sites are marked by heaps of shells many feet deep.

THE POTLATCH SPECTACLE

In communities where each individual had a defined rank and status, people would demonstrate the extent of their material wealth by giving part of it away – or even burning it – at a potlatch ceremony. A clan chief or noble would entertain sometimes hundreds of guests with spectacular dances and huge feasts. The wealth involved was truly impressive: goods given away or piled up in bonfires might include cloth, furs, clothing, basketry, utensils, beads and canoes. A potlatch was traditionally held to mark rites of passage such as birth, puberty, marriage, inheritance and death.

At a potlatch, a clan would display its wealth, strength and continuity with the past. Each song, dance, image and costume represented the clan's inheritance and vitality. Potlatching reached great heights with the arrival of cheap mass-produced European trade goods: on one occasion, 33,000 blankets were given away. When traditional life came under pressure, potlatches took on such huge proportions that the Canadian government banned them in 1885 as anti-progressive. However, they continued in secret in many places before the ban was lifted in 1950.

materials, nurturing a culture that became elaborate, with complex social structures. Some peoples, such as the Haida, even owned slaves, captured on maritime raids. Most peoples of the region were divided into clans, each of which had a mythical animal founder and its particular crest, such as the Killer Whale, Wolf, Raven and Frog. Representations of these were carved or painted on the cedarwood houses and "totem poles" that characterize the region. Another distinctive feature of the plentiful Northwest Coast life was the potlatch, a public ceremony in which clans asserted their property rights and prestige by giving away or destroying possessions.

The raw material of this society was the soft but durable red cedar. In the north, houses were often carved and painted, and they had log uprights sheathed in overlapping cedar planks, with a large ridgepole holding up a gabled roof; in the south of the region, houses were bigger, but they had shed roofs and little or no decoration. A number of related families shared the windowless interior, each family occupying a shelf-like space around a large, communal central area.

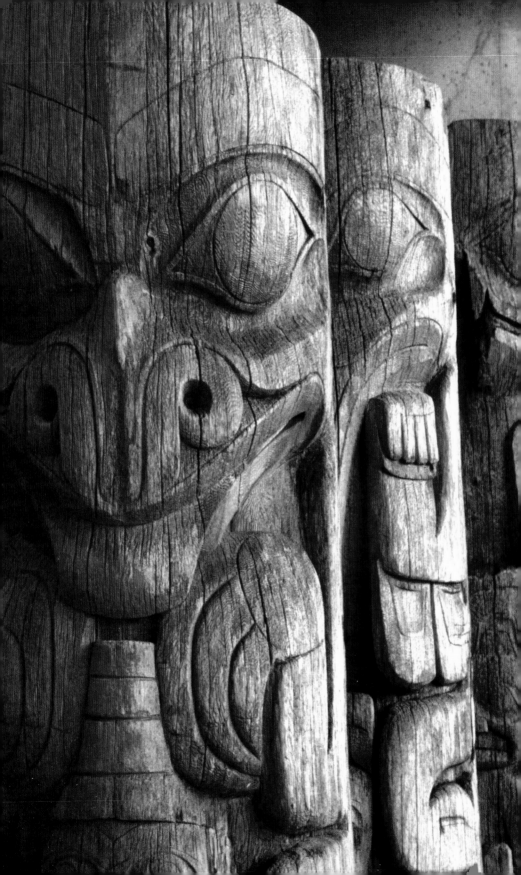

THE VALUABLE CEDAR TREE

The lush, dense rainforests that cover the islands and mountain slopes along the Pacific Coast were once dominated by red cedar trees. Unlike the straight and sober Douglas fir and the gnarled arbutus, the mature red cedar was a shaggy giant, its massive ribbed and lined trunk rising high out of the dense undergrowth. Shredded cedar bark was a valuable source of fibre that was woven into a wide range of objects, such as baskets, ropes, mats, capes and various other forms of clothing.

Cedarwood itself is soft and easily worked, but also highly resilient, resistant to the wet climate and salty sea air. Elaborately carved cedar totem poles survived longer than the villages in which they stood. Large logs were sometimes dug out, widened in the middle by a process of steaming and stretching, and chiselled to produce streamlined, ocean-going canoes – those of the Haida could be up to 70ft (21m) long. Carvers transformed wooden blocks into dramatic masks and elaborate feast bowls, and they reproduced the dense and complicated styles of Northwest Coast painting on wooden panels.

The grain of cedar is so straight that the wood can easily be split into long, thin planks and shingles, ideal for the construction of the large communal houses typical of the Northwest Coast. The softness and straightness of the wood were also exploited to make "bentwood" boxes, which were steamed and bent into shape from a single plank of cedar.

Northwest Coast societies are renowned for their artistry. Carved and painted poles, house fronts, boats and everyday utensils with heraldic crests were produced in distinctive styles. So-called "totem poles" were the most vigorous expression of a belief in fundamental creative forces, especially among the Tlingit, Haida and Tsimshian. This artistic energy went hand in hand with the highly class-conscious nature of much of regional society. In those places where people were either nobles, commoners or slaves, the material representation of status was essential. Individuals, families and clans owned and displayed images of animal ancestors and other mythological figures. They held the rights to names, titles, songs, dances and myths, as well as to fishing and hunting grounds and shellfish beds. In less socially stratified areas, such as among the Salish and Chinook, there were fewer status symbols, and artists confined their work mainly to religious objects.

◄ Weathered Haida totem poles taken from Ninstints, a village on the Queen Charlotte Islands abandoned in 1885 and also known as Skungwai, which are now on display at the Museum of Anthropology in Vancouver, British Columbia, Canada.

THE SUBARCTIC

East of the Rocky Mountains and sweeping around Hudson Bay, is an immense forest, interrupted by innumerable lakes, bogs, streams and rivers. To the west lived the Athabaskan-speaking Chipewyan, Dogrib, Kutchin and Slave, while the glacier-scoured granite landscape around Hudson Bay and eastwards to the Atlantic Ocean was home to the Algonquian-speaking Cree, Montagnais, Naskapi and Ojibwe peoples.

In this Subarctic area hardy pine, spruce and fir thrive on thin, rocky and infertile soils, and in sheltered spots aspen, willow and birch tolerate the long and extremely cold winters. Lichens and mosses are everywhere, clinging to trees, rocks and the ground. Further north, the forest gives way to a frigid tundra. Subarctic summers can be warm, but in the tundra and the adjacent forests the air becomes clogged with blackflies, mosquitoes and other biting insects. Under a thin mantle thawed by the sun, the ground remains permanently frozen.

The people in this rugged land lived in small family bands, varying their way of life according to the season. Hunting groups followed the game, and in the winter they lived by frozen lakes to ensure a supply of fish, setting up lean-tos or small *tipi*s. But they also moved about, either on foot with snowshoes or by sled and toboggan. Some groups recognized family hunting and trapping territories, and all returned year after year to favoured hunting, fishing or gathering spots. It was easy to pursue caribou, moose and other game that left tracks in the snow. When the spring thaw turned the land into bog, the people kept to the rivers and lakes in birchbark canoes.

Life in the northern Subarctic revolved around the migratory caribou, or reindeer. People used all parts of the animal, making everything from hide *tipi* covers to weapons and tools made from bone and antler. Caribou spend the winter inside the tree-line, but in the spring they move to

▶ The Northern Lights (aurora borealis) put on a display above an Inuit stone cairn or *inukshuk* near Churchill, Hudson Bay, Manitoba, where (in 2006) most people were Chipewyan or Swampy Cree. In the 1700s the hunting economy began to diversify with the growth in demand for fur, particularly beaver pelts, in Europe.

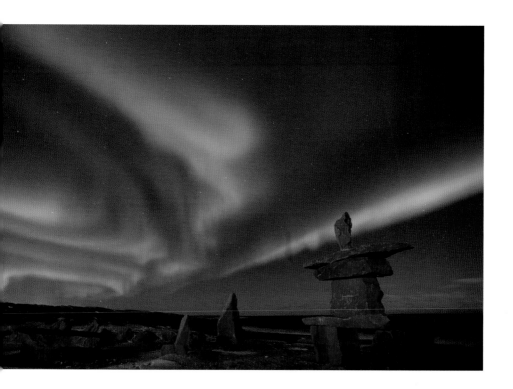

calving grounds in the far north, trekking back south in the brief summer. Other game included moose, musk ox, deer, fur-bearing animals such as beaver, mink, hare and otter – and in the forests north of the Plains, bison. The western mountains of the Yukon and Alaska had Dall Sheep and mountain goats. Porcupines provided meat, as well as quills, which were used as ornamentation. Wildfowl were plentiful. Plant foods were most common in the southern forests – berries, roots, wild rice and the soft inner bark of poplar.

Farther north, the Chipewyan lived mainly on meat and fish. Despite their isolation they maintained networks of relations over great distances, exchanging marriage partners, gathering for caribou hunts or making contacts through trade in the copper, flint and quartzite needed for tools.

THE ARCTIC

The vast Arctic encompasses Siberia, Alaska, northern Canada and Greenland – its shores bounded by the Pacific, Arctic and Atlantic oceans. For three months in the summer people live in endless sunshine, but in winter the sun slips below the horizon for three months of perpetual night, lit only by the moon and stars, the northern lights and the glimmer of twilight in the south.

In winter the temperature remains below freezing for up to nine months, transforming both land and sea into an indistinguishable expanse of craggy ice and wind-whipped snow. But as the land warms in the rising sun, the snow melts to reveal a treeless, stony tundra covered with lichens and mosses, hardy flowering plants and grasses, and small patches of dwarf willow and other scrub. Sea ice retreats from the mainland coast and southern offshore islands. Animal life emerges: seals climb onto ice floes to bask in the sun, walruses gather along the shore, herds of caribou return to calve and musk oxen browse new growth on the bushes. The air is full of the sounds of birds. Grizzly bears, wolves, foxes and weasels prowl for ground squirrels, lemmings and other small game.

People began to hunt and fish along the Arctic coasts around 4,500 years ago, drawn from the Pacific Coast by the wealth of animals. The first peoples in the central and eastern Arctic are known as the Dorset and the Thule cultures. Several centuries ago, the climate cooled and only the sea adjacent to the warm Pacific currents remained open. Those people remaining became seal hunters.

The present-day Arctic peoples – the Inuit ("people") and the Aleut – are closely related, speaking languages of one family, Eskimo-Aleut. They are physically different from other Native North Americans, closely resembling the peoples of the far northeast of Asia. The Aleut live on the Aleutians, a chain of islands strung out between Asia and North America. They

▶ Reindeer in western Alaska. The herds were introduced in the 19th century and only Native Alaskans are permitted to own reindeer.

resemble the Inuit, and like them they hunt sea mammals. The Aleut and Inuit both used kayaks, burned seal oil in stone lamps and lived in communal houses set partly underground and roofed with driftwood or whalebone and sod.

However, the Pacific gave the Aleut a different way of life. They fished for salmon, gathered shellfish and sea urchins, caught octopuses among the rocks, dug up edible roots and picked berries. The Aleut had extensive contacts with the Tlingit of the Northwest Coast region. Aleut society, like that of its southern neighbours, was highly stratified.

The Inuit live from sea to sea across the extent of the north polar cap. All Inuit peoples, from the Yuit of Siberia to the Kallaalit of Greenland, share both language and lifestyle. The Inuit of the vast region from the Mackenzie River to Hudson Bay, including the Netsilik, Iglulik and Aivilik, led the life that the rest of the world identifies as "Eskimo", although the Inuit dislike this name (it derives from an old Algonquian word for "meat eaters"). To resist the cold they wore thick parkas, trousers of caribou hide (with the hair inside) or polar bear skin (with the fur outside), and boots of caribou or sealskin. They used dog-sleds and built temporary snow houses (igloos) when travelling in the winter. Their equipment included snow goggles that were worn against the blinding reflection of sun on snow and ice in the spring and summer.

In the winter, a number of Inuit families would gather together to hunt seals, the main source of food. Seals must breathe several times an hour, so they keep small breathing holes open by scratching the ice away from beneath the water's surface. Dogs helped the Inuit to locate these holes, and then the hunter waited patiently to spear his prey. When a sealing ground was exhausted, the people moved camp.

As soon as the snow melted on the tundra, the winter camps broke up, and the Inuit ranged in small family groups to take advantage of the brief, intense explosion of life in the spring and summer. They trapped fox and other small game, fished for cod in the sea, set up weirs for char and other fish in

Seals were easier prey as they sunned themselves on ice floes in the open water and gathered in their breeding and feeding grounds.

BOUNTIFUL WHALING

Whale hunters risked the dangers involved because a success meant tons of meat and blubber for many families. The season begins in spring, when bowhead whales migrate north along the coasts of Alaska and Labrador to their summer haunts.

Hunters take to the sea in an *umiak*, a boat of driftwood covered in stretched walrus hide or sealskin. It can hold a crew of up to ten. The harpooner uses an ivory bracket (right) to hold his harpoon at the ready, and when a whale surfaces he plunges his weapon into the animal. The wounded whale dives, pulling with it a line to which inflated floats made of sealskin are attached. Each time the struggling animal comes to the surface, the hunters spear it with more harpoons. Finally, exhausted from its injuries and the fight, the whale is despatched. Towed to shore and butchered, any surplus is stored in "larders" dug into the permafrost.

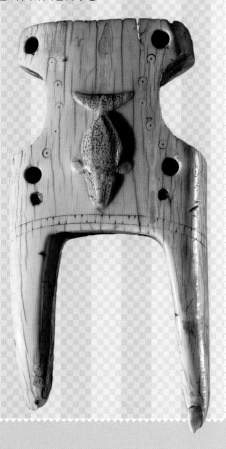

the rivers, hunted birds and gathered eggs. Seals were easier prey as they sunned themselves on ice floes in the open water and gathered in their breeding and feeding grounds. Beluga whales appeared, sometimes in great numbers. The walrus hunt was important, because walrus ivory was essential for tools and weapons. It was also an ideal medium for carving small, intricate human, animal and spirit figures – an artistic tradition going back to ancient times. Some Inuit headed south to hunt caribou at their river crossings. By August, the first persistent snows had arrived, and by September rivers and lakes were frozen. The small family groups returned to the coast to await the ice, the seals and the long winter.

REGIONAL ARTISTRY

Art is used by all the Native North American cultures to express the connection between people, the sacred earth and plants and animals. The symbols and patterns on everything from pots to footwear allow both artist and people to reflect on the world around them and to be reminded of its religious and secular significance.

Historically, while Native American craftspeople tried to make things which were aesthetically pleasing, they were also looking to maximize their use of the mineral, animal and vegetal abundance around them, developing and tailoring their artistry according to the environmental requirements of their cultural area – balancing the availability of materials with a particular practical need, such as waterproof clothing. Those natural materials that were in rich supply in a particular area – be they ivory, furs, feathers or porcupine quills – often came to characterize the craft output of that area; these were then used to produce objects that were essential to the life of the people and these often also were a medium for significant social, religious and mythological comment.

PATTERNS AND SYMBOLS

Decorative patterns and symbols can be applied to almost any material. The motifs are influenced by the medium: baskets, beadwork and woven fabrics commonly have geometric patterns, which are the easiest to execute in these media. Where naturalistic figures are used, the limits of the material may result in a degree of stylization. Greater naturalism may be found in painting and carving, but realism is not an artistic or cultural ideal. Individual artists work inside established traditions, but may experiment within acceptable limits.

Symbols and patterns often reflect the artist's surroundings. For example, woodlands art often uses floral and other plant motifs, while coastal groups tend to depict sea animals. Other

▶ *Stu-mick-o-súcks, Buffalo Bull's Back Fat,* a portrait by George Catlin in 1832. A commanding and noble presence, Buffalo Bull's Back Fat (named after a prized cut of bison) was the head chief of the Blood tribe, part of the Blackfeet confederacy. Magnificently attired, he wears a shirt decorated with feathers, dyed hair and porcupine quills.

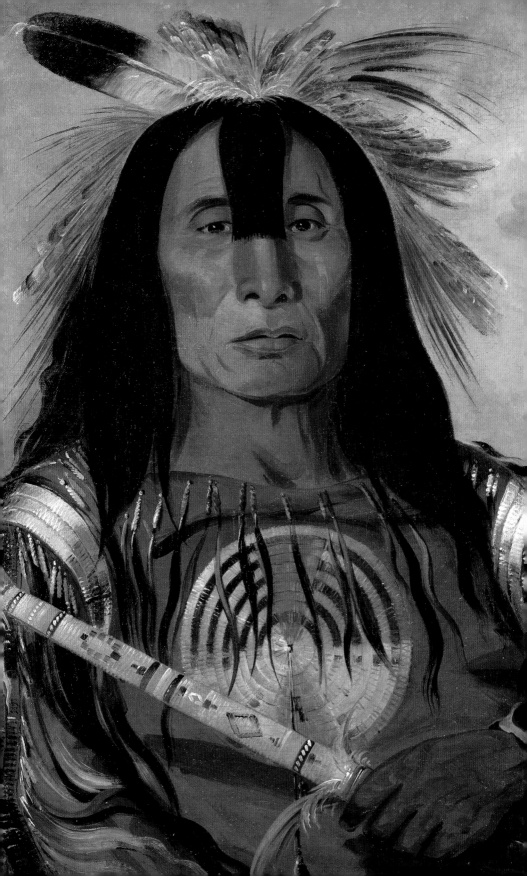

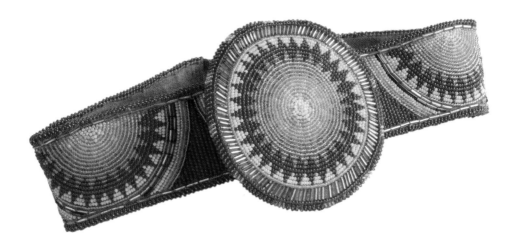

motifs are drawn from cosmology, and mythical creatures such as thunderbirds, serpents and other supernatural beings are frequently encountered.

FROM BASKET-MAKERS TO CARVERS

A few regions are renowned for their baskets. California Indian basket-weavers have one of the world's great textile traditions. Drawing on techniques and patterns that are 5,000 years old, California's craftspeople combine beauty and utility to reflect a diversity of materials, techniques, forms and a rich palette of distinctive and stimulating designs which draw upon a range of geometric, anthropomorphic and animal motifs. Baskets were used in every activity and over time a market developed for "art" baskets. By the early nineteenth century these items were a sought-after American art form.

Pueblo potters are also celebrated for the elegance and intricacy of their work, which continues a tradition with its roots in the great pre-contact cultures of the region, such as that of the Anasazi. Geometric and traditional animal motifs, such as serpents and thunderbirds, are depicted in black, white and rich natural reds, browns and creams.

Navajo women were famed as weavers and their rugs show an astonishing variety. According to Navajo legend, the weavers learned their craft from Spider Woman (see pages 158–159),

▲ A colourfully beaded headband from the Cree, a people better known traditionally for their quillwork. Beads were introduced as trade items by Europeans in the early 19th century and distinctive tribal styles quickly developed.

a being who instructed them how to weave grass, yucca, cedar bark and cotton. However, as the Navajo became shepherds, wool came to be the dominant material. There are several regional styles of patterning: for example, the "crystal" style basically uses stripes, with many variations; Yei and Yeibicheii rugs employ holy people motifs from sacred sandpaintings (see page 221), although the rugs have no ritual significance of their own. Although weaving remains a respected art, far fewer women possess the knowledge and skills today.

Around the Great Lakes, skilled workers flatten porcupine quills and dye them with plant pigments. The quills are then used to decorate bags and moccasins. Women of the Huron, Micmac and other Northeastern tribes embroidered skins, cloth and birchbark with dyed moose-hair. As colourful glass beads were traded into the area by Europeans, they were combined with traditional materials or even replaced them altogether. Intricate floral motifs are most common, but simple geometric patterns may adorn a utilitarian object such as a knife sheath or pouch.

The people of the Plains also used quillwork for their pipebags and moccasins. Bison-hide *tipi* covers and individual hides may bear naturalistic images of buffalo or horses, but otherwise, Plains patterning tends to be more geometric, with circles, rectangles and triangles. Circles may symbolize a domed earthlodge or the floor of a *tipi*, as well as being an expression of the relatedness of everything on the Earth and of the eternal cycles of nature.

Much Northwest Coast art is described as representational – that is, key elements or characteristics of an animal or person may be emphasized, sometimes to the exclusion of any other feature. For example, a beaver may be represented only by two large front incisors and a broad, cross-hatched tail, and ravens and seahawks by their characteristic beak and eyes. In the three-dimensional carvings on totem poles, the representation might be more complete than on two-dimensional objects. Animal figures are often anthropomorphized.

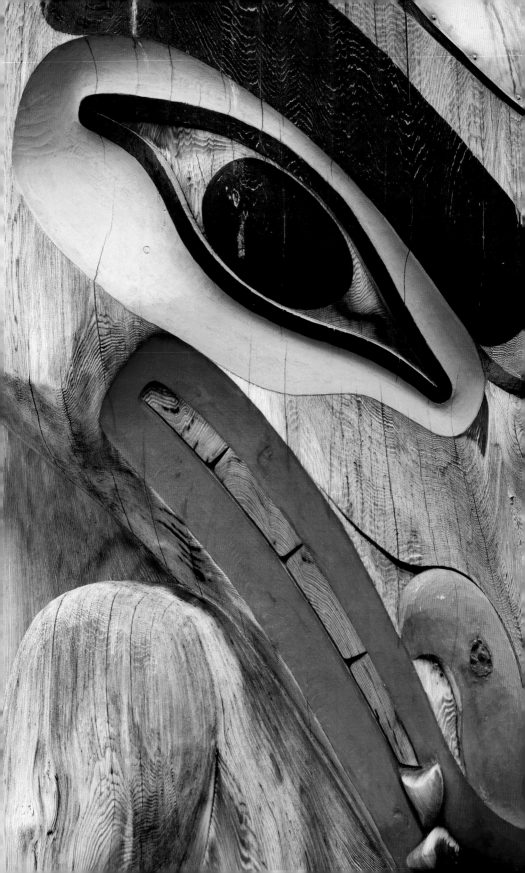

THE LIFE OF THE SPIRIT

 According to Native American traditions, everything that the Creator made, whether animate or not, has been endowed with a spirit. There is no separation between the spiritual and the material, between the real and the supernatural, or between the animate and the inanimate, because everything and everyone is endowed with spirit power, or "medicine". Relationships between humans, Mother Earth (who provides everything to sustain life and more), other creatures and the ancestors are well defined. The Earth provides for the "two-leggeds" – the people – and for all others who were put on it by the Creator. People are therefore expected to respect the Earth. Many "four-leggeds" – the animals – sacrifice themselves to feed and clothe people, who are therefore obliged to show respect for them. An extensive lore carefully explains the relationships between people, animals, plants and the land. The ancestors, who dwell in the realms of the spirits, gave life to those who now live; thus, the living must respect the ancestors. Humans must also respect their living kin, and must provide and care for each other in order to survive. This complex system of mutual respect is expressed not only in rituals and ceremonies (see Chapter 5), but also in daily life, celebrating the spirit that unites all things on Earth and reaffirms the sacred relationships and links between the world that people inhabit and the realm of the spirits. Mother Earth is both the everyday and the sacred – to be cherished and respected.

FOUNDATIONS OF THE SACRED

It is inappropriate to speak of Native North American "religions" or "belief systems", which implies a formally structured spiritual life conducted alongside, but distinct from, everyday secular existence. However, in Native North American societies the threads of ordinary life and spirituality are so tightly interwoven that the sacred and the secular are indistinguishable.

Indian sacred life extends beyond rites of passage and the communal festivals and ceremonies that punctuate the year. For many Indians, the simplest everyday act has spiritual meaning and it is rooted in the sense of community that a people develops with the local landscape and climate, and with the beings and spirits that are perceived to dwell around them.

Most Native American origin stories give people no more power than the other parts of creation; people are the Earth's partners and know it intimately as the source from which they sprang. The lands on which Indians live reflect the creation and there is a rich body of stories that detail how things came to be. The places where peoples are believed to have originated are always revered, and the accompanying tales typically intertwine the mythical with the real. Taken together the stories constitute a canon of themes in which the complex relations between land, weather, plants, animals and people are described. The land is filled with mystery and power – it has existed since the beginning of time and will last for as long as the people are there to tell the stories.

HOLY HOMELANDS

Many origin stories describe Native people as coming from a dark place – some emerge from beneath the ground, others from under the waters. Some experts have suggested that this dark place is an allegory for being born. However, most Indians list precise sites as their people's point of origin.

▲ **Page 74.** Detail of a totem pole at the Teslin Tlingit Heritage Centre in Yukon, Alaska. The Tlingit have two moieties (or descent groups), Raven and Eagle, each of which has clans with additional animal crests.

▶ A Plains *tipi* is silhouetted by Wi, as the life-giving sun is called in Lakota.

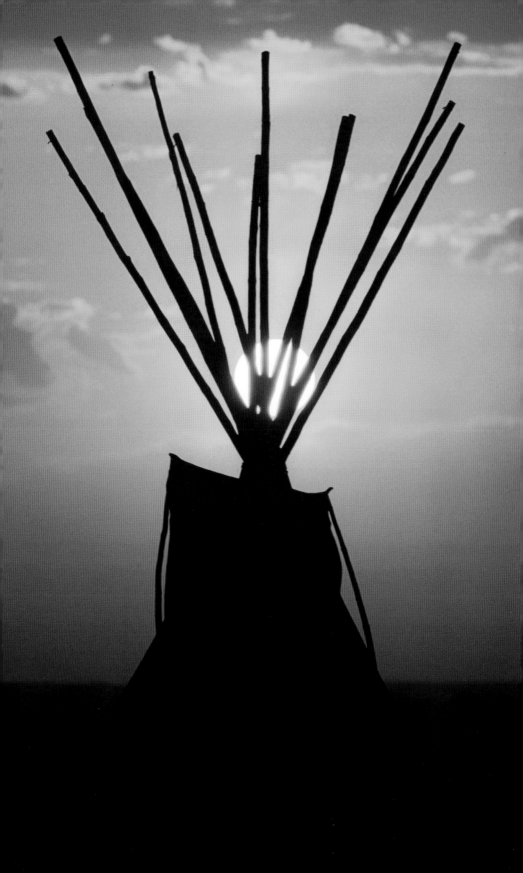

The Puebloan peoples of the Southwest all have a similar term to denote the place of origin: for Keresan-speakers, such as the community of Acoma, it is *sipap*, for the Uto-Aztecan-speaking Hopi it is *sipapu*, and for the Tanoan-speaking Tewa it is *sipophene*. The actual location of *sipophene* was a dark realm beneath Sandy Place Lake far to the north, where people, animals and supernatural beings lived together as immortals. The Corn Mothers of the Tewa asked a man to find a way for the people to leave the lake. The man went to the four directions, only to find mist and haze. He returned saying that he had seen the world and that it was *ochu*, meaning green or unripe. The second time he went into the world, he encountered fierce animals but they eventually became his friends and sent him back bearing gifts. The people rejoiced, saying "we have been accepted", and followed the man to the lake's surface – and the area where they emerged is enclosed by four sacred mountains and four sacred hills. For the Hopi, who came into the world in a similar way near the Grand Canyon's Colorado River, the underworld emergence place is commemorated by an opening on the floor of a ceremonial *kiva* (see pages 214–215).

Themes like these appear among the origin stories of the neighbouring Navajo, who emphasize the power that certain places derive from their links to the creation. According to the Navajo, the holy people created First Man and First Woman, who journeyed through several dark underworlds before emerging through a hollow reed. First Man stored soil in his medicine bundle, along with other magical substances, and from this soil the couple created four sacred mountains in

▲ An Inuit serving dish of wood which would probably have been used during ceremonial feasts. The handles are in the form of masked human heads. The basin is decorated with a mythological design and the rim is enhanced with ivory inlaid beads.

WISDOM OF THE STORYTELLERS

Knowledge of the diverse spirit forces that were believed to pervade the physical world was essential to Native Americans. This wisdom was conveyed in the form of myths and legends narrated by storytellers or community elders. Myths were far from being fantastic "fairytales" even when, as was common, they involved magical phenomena, such as animals talking to one another or people conversing with animals and spirits. Rather, the audience believed these to be accounts of real events that took place at the dawn of time. The dual purpose of myths and legends was to instruct and to entertain. For example, a familiar character from many stories was the trickster. This ambiguous figure was both sacred and profane, and his antics were intended to provoke both thought and laughter.

Storytelling occupied a seminal position in Native American cultures. It was not a purely spoken art: singing and drumming were often involved. Moreover, details from myths were often depicted on daily objects. Pottery, baskets, blankets, storage boxes and robes were decorated with patterns or symbols that had their origin in narratives. In the Northwest Coast region, carved masks and totem poles portrayed many characters from mythology and history. In the same way, the *katsina* (formerly *kachina*) figures created by the Hopi people in the Southwest represent an extensive range of mythical and ancestral spirits.

what is now the Four Corners area. Each peak, direction and colour became associated with special powers: white lightning in the east; blue sky in the south; yellow for the sun in the west; and black for the storm clouds to the north. Atop Gobernador Knob in New Mexico, First Man and First Woman found Changing Woman, who begot the Navajo people by mixing her skin with water and corn.

The same powerful sense of a rootedness in place can be found throughout the continent. The Cherokee use a word, *eloheh*, for land, which also means history, culture and religion. It emphasizes how the people conceive of themselves as inseparable from their homeland. However, the history of the Cherokee is a tragic one of displacement and forced relocation (see also pages 40–41). Only in 1865 did the state of North Carolina grant a homeland, at Qualla in the Great Smoky Mountains, to those Cherokee who had resisted deportation. They know it as Shaconage, or "place of blue smoke," in

reference to the mists caused by the pine oil and water vapour emitted by the vegetation (see illustration, pages 42–43).

Further north, on a peninsula near Georgian Bay in southern Ontario live the Huron. They call themselves the Wendat, which is usually translated as "Dwellers in a Peninsula" or "the Islanders". While this may refer to the Huron's traditional homeland, it also reflects their belief that the Earth is an island on the back of a turtle. In Wisconsin, all the clans of the Winnebago, or Ho-Chunk, claim to be from an area close to the Red Banks near Green Bay in Lake Michigan. The Bear Clan's creation story tells of a bear that came walking across the ocean. Upon reaching the shore it became a raven and a gathering of all the clans was held at the spot.

MAINTAINING THE WORLD

Although linked to the quite specific environments described, Native traditions share certain common underlying concepts and attitudes. Spirit power – "medicine" – is believed to reside in all things. Every plant and animal, even the soil itself, possesses a soul that is mutually dependent on other souls. The cycles of nature, such as the seasons and the passage of the sun and moon across the sky, are evidence of the eternal circle of existence and the timelessness of Creation.

Some peoples view the powers that maintain the world as entities that reveal themselves in the form of natural phenomena, such as winds, rivers, corn (maize) and buffalo. These are relatives, and community life is structured around the rights and obligations due to such kin. For other peoples, these controlling powers are formless, mystic energies, such as *manitou* of the Algonquians (see page 37) and *wakan* of the Lakota (see pages 84–85).

Each Native culture has its own ways of conducting its relationship with the cosmic entities, of controlling and harnessing the "medicine". Some individuals seek the power to deal directly with the spirits; others acquire it by accident of birth or through a life crisis. However, everyone must pay due

... everyone must pay due heed to the spirits every day as part of his or her obligations to them just for being alive.

THE EVOLUTION OF RELIGION

Syncretism, the hybridization that occurs between religious beliefs when cultures come into contact, was always part of Native North American life – witness the slow spread of the Sun Dance complex across the Plains (below, a depiction on deerskin of a lodge being erected by the Kiowa). However, when the settlers brought Christianity, change was abrupt and unstoppable. The Native American Church began in the late 1800s and today it is the most widespread indigenous religion in the US. Blending traditional beliefs and the use of the hallucinogenic peyote cactus, services are often held overnight in a *tipi*, feature Christian objects, such as crucifixes, and are filled with elements that appeal to Native American members.

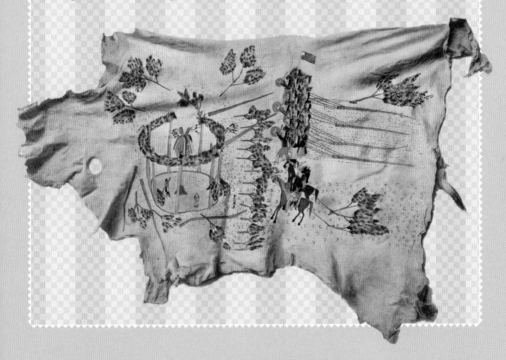

heed to the spirits every day as part of his or her obligations to them for having life. The notions of good or evil are expressed largely in terms of whether or not obligations to the spirits are being met. To fail is to disrespect, which upsets the balance and harmony of the world. Most virtues taught by elders, such as wisdom, bravery, generosity and selflessness, aim to ensure proper respect, so that the cosmic balance may be maintained or restored and the community's survival guaranteed.

RESPECTING NATURE

According to many Native North American traditions, nature and spirit are inseparable and mutually dependent: spirit resides in all things. The Native American world was therefore one where a multitude of invisible forces were at work.

The Earth is at the centre of this scheme, respected as the source of an endless cycle of generation, destruction and regeneration, through which all things are believed to pass. The idea that the Earth is a powerful nurturing force is expressed in the common Native concept of Mother Earth, but scholars argue as to whether this imagery predates contact with Europeans or is essentially a European construct.

Fundamental to many Native narratives is an understanding that the Earth acts as a host to human beings. Many indigenous traditions view humans as spiritually rooted in the Earth, which gave life to them just as the soil gives life to a plant. But people are seen as no more important than any other living or non-living thing. All beings must share the Earth as equal partners, each responsible to the other.

THE GREAT MYSTERY

Although all Native Americans recognize that nature is imbued with spiritual significance, spirits of nature vary considerably in their power and significance. In the realm where the worlds of humans and the spirits intersect, the relationship between them can be complex. Some spirits are seen as vast and even universal potencies, while others may hold sway over more specific aspects of the world, essentially maintaining the world and revealing themselves in the form of natural phenomena, such as weather, wind, lakes, plants, and animals. These spirits are regarded as kin, and as such they have certain rights and obligations to each other as well as to the humans in whose proximity they live. Still other

▷ A majestic elk, at dawn in Castle Geyser, Yellowstone National Park, Wyoming. Large game animals such as elk and deer were popular as food among the Plains Indians, and they also featured in Native American beliefs. The ability of the bull elk to attract amorous female elk did not go unnoticed. Many young men sought to become associated with the elk through dreams and thereby receive his abilities to attract females.

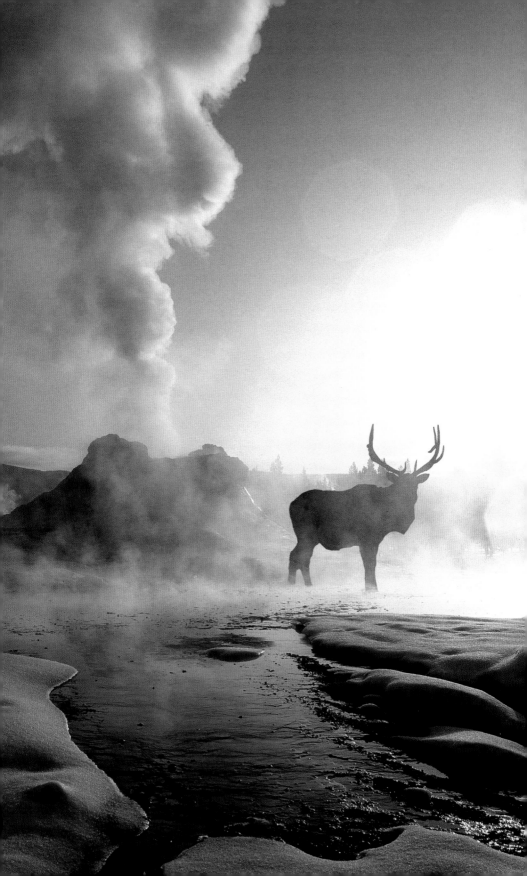

▲ A Plains Indian shield painted with the symbols that gave its owner spiritual protection. This design is of a bear coming out of a den with bear tracks and flying bullets.

spirits may be minor ghosts or sprites, appearing only in restricted localities. According to the Ojibwe, when the Earth was made, four major spirits were put in place for the benefit of humankind. These spirits lived in each of the four directions and also held up the corners of the heavens. The spirit of the north brought ice and snow, which helped people to track animal footprints. The spirit of the south provided the conditions for the cultivation of maize, pumpkins, melons and tobacco. The western spirit controlled rain. And the spirit of the east brought light by commanding the sun to travel round the world. Other Native American peoples also attributed spirits to the four cardinal points: the Iroquoian Wind Giant, Ga-oh, had four different animals – a bear, a panther, a moose and a fawn – at the mouth of his cave.

Among some peoples, the power that controls the world is a more formless, mystical energy, such as *wakan* (meaning "sacred" or "sacred power"), among the Lakota and other Siouan-speaking peoples of the Plains, or *manitou* ("spirit"), among the peoples in the Great Lakes and Subarctic regions. For the Lakota, every human act is imbued with spiritual significance and pays homage to the omnipresent and omniscient Great Mystery or Great Spirit, a transcendent god-like power pervading people, animals, places and phenomena.

The Lakota account of the creation begins with the supreme being Wakan Tanka (Great Mystery), whose spirit was in the first god, Inyan (Rock). Nothing else existed except Han (Black of Darkness). Inyan desired to show his powers, but there was nothing to exercise them upon, so out of his blood he created

THE IMPORTANT ROLE OF ANIMALS

Some Native peoples believe that animals created the world. For many, the creator was an earthdiver, a turtle or other small creature which brought up mud from the depths of the primeval waters and fashioned land from it. A Crow story tells how Old Man Coyote made the Earth by blowing on a small lump of mud that ducks had brought to the water's surface.

In Native belief, animals have spirits and enjoy a complex reciprocal relationship with people, plants and the earth. Animals often play an important role in teaching people how to behave. For example, tricksters, who frequently appear in the form of animals, provide their human neighbours with valuable moral lessons (see pages 186–195).

the goddess Maka (Earth) and the blue waters. From the waters the great blue dome of Skan (the Sky) was created, his edge forming the Earth's boundary. Skan used his energy to create Earthly darkness from Han, and then created Wi (the Sun) from Inyan, Maka, the waters and himself. He ordered Wi to shine and the world became hot. The four "superior gods" – Skan, Inyan, Maka and Wi – assembled and Skan, the most powerful, addressed them: "Although we are four we have one source, Wakan Tanka, which no one, not even the gods themselves, can understand. He is God of Gods."

These four aspects of Wakan Tanka grew lonely and created other manifestations of the god. First they created the "associate gods" (Moon, Wind, Falling Star and Thunderbird). They then caused the creation of the "kindred gods": Two-Legged (humans and bears, which are seen as relatives of humans), Buffalo, Four-Winds and Whirlwind. The fourth group, the god-like, relate to the soul, spiritual essence and sacred powers: Nagi (shade or ghost of the dead), Nagila (shade-like), Niya (life or breath) and Sicun (spiritual power). These four groups of four aspects, or Tob Tob ("Four-Four"), make up Wakan Tanka, who is manifested through his sixteen aspects but is greater than their sum. In prayer, the Lakota use the term "Father" to address any of these individual aspects. The transcendent deity is addressed as "Grandfather".

IN PRAISE OF NATURE

Not only do landforms, plants and animals have a spirit, they can actually be the spirit. An eagle is an eagle, but it can also be a thunderbird with special powers for protection; coyote is a coyote, but it can also be a manifestation of trickster, willing to lead a human or other animal astray or to teach them a lesson. It is imperative for people, who have to live alongside these multitudinous spirits, to know this and behave accordingly. If one obeys certain rules, there may be benefits; if one doesn't, there may be dire consequences. This concern with the spirits of nature does not in any way mean that either the spirit or nature is venerated; rather, nature is praised at the same time that one lives with and uses these invisible powers.

Elders teach children about how to deal with nature spirits, in the hope of ensuring a proper respect. Some individuals seek to harness and direct the power, or "medicine" – normally in a modest way, perhaps by using a talisman (see box, opposite) in a medicine bag or a bundle. Others might become one of several types of specialist (see pages 132–137).

Many activities are group obligations. Clans may have to maintain a sacred medicine bundle that an ancestor or totemic being entrusted to the eternal care of descendants. A whole tribe may be responsible for performing ceremonies that ensure the annual renewal of the world. Good and evil may be determined by whether obligations to the spirits are met, which makes people careful to show respect at all times. Everyone must pay some level of attention to the spirits or the world becomes unbalanced and threatens people's survival.

For example, in order to ensure a continuation of their blessings on hunting grounds and gardens, the spirits of nature had to be honoured. For this reason the Tuscarora people in the northeast always gave thanks and acknowledged the spirit of corn, instructing each new generation by telling the story of Dayohagwenda. He was the only villager who had given thanks for his harvest and stored his corn securely, while his fellow villagers had become lazy and careless, expecting to

▼ Pages 88–89. One of the first native words learned by missionaries in the northeastern woodlands was *manitou*, an Algonquian term meaning "power, spirit, mystery" (see page 37). Belief in this force made the vast thick forests into places that reverberated with mystery. Earthly *manitou*s were often said to reside in oddities of the landscape – such as this rocky outcrop in the Shawangunk Mountains, New York.

furnish all their needs through hunting. Soon people found themselves on the verge of starvation, until Dayohagwenda recounted to them an encounter he had had with a weeping old man who had turned out to be the spirit of corn, distressed that he had been neglected and forgotten. From that time on the people carefully planted, weeded, harvested and stored, and never forgot to honour the spirit of corn.

To the hunters and fishers of the Arctic and the Northwest Coast the spirits of living animals were of primary importance. Successful hunters did not simply slaughter their prey; if a hunter did not promise to acknowledge an animal's spirit by offering it the appropriate death rite the animal would ignore him. Among the Alaskan Inuit, the whale's soul, which lay in its head, had to be returned to the sea with the head intact; otherwise the soul could not return to its place of origin and be reborn. Other significant animals, such as caribou and wolves, had to be ritually butchered to allow their spirits to escape from their lodgings in the neck. Provided that men and women performed these rites, the animals would help them by "lending their bodies" – that is, by continuing to allow themselves to be hunted.

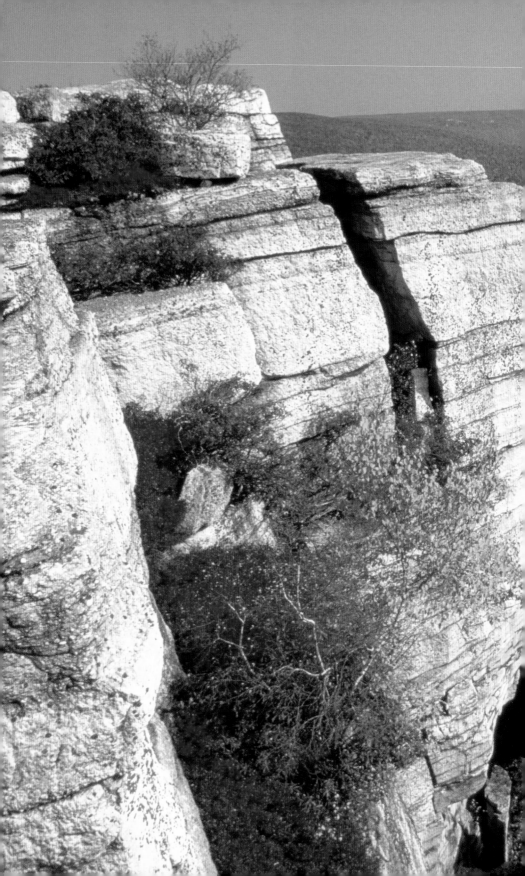

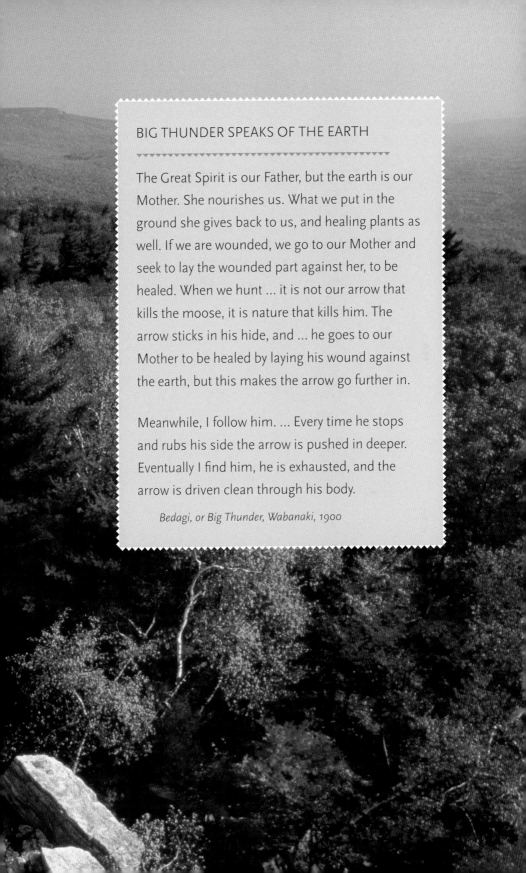

BIG THUNDER SPEAKS OF THE EARTH

The Great Spirit is our Father, but the earth is our Mother. She nourishes us. What we put in the ground she gives back to us, and healing plants as well. If we are wounded, we go to our Mother and seek to lay the wounded part against her, to be healed. When we hunt ... it is not our arrow that kills the moose, it is nature that kills him. The arrow sticks in his hide, and ... he goes to our Mother to be healed by laying his wound against the earth, but this makes the arrow go further in.

Meanwhile, I follow him. ... Every time he stops and rubs his side the arrow is pushed in deeper. Eventually I find him, he is exhausted, and the arrow is driven clean through his body.

Bedagi, or Big Thunder, Wabanaki, 1900

THE POWER OF KINSHIP

For many Indian people, kinship was the key to the stability, integrity and survival of the community. For example, to be a nephew or a daughter was to possess a distinct role with well-defined rights and obligations to others. Those who came to villages as strangers – even if they were white captives – were often adopted as "cousins" or "brothers", which made their social position unambiguous and kept the integrity of the group intact.

A particularly important role in society is played by elders. (The qualification for entry to some secret societies – see pages 96–101 – was based on age.) Traditionally, most child-rearing was done by grandparents, because it was considered that parents were too busy with daily life and did not yet possess enough accumulated wisdom to pass on to their children. Elders were, and are, the source of nurture and moral training, and, as storytellers, they are the repository of a people's mythological and spiritual inheritance. The older generation, above all, is responsible for handing down the sacred traditions of a community.

Because Indian peoples often see their communities as an extension of the spirit-rich natural world, animals play a major part in Native American mythology and are believed to possess a close kinship with humans. In ancient times, it is said, before some break occurred that fixed them in their present identities, people and animals were indistinguishable and could change appearance at will. Tricksters frequently appear in the form of animals to provide their human neighbours with valuable moral lessons (see pages 186–195). There are also numerous myths of marriages between humans and beasts. For example, in Alaska, the Aleut creation story relates how the first man and woman came down from the sky and had a son who played with a stone that became an island. Another of their sons and a female dog were then placed on

... their ancestors were animals that had landed on the beaches, taken off their animal guises, become human and established the various clans.

the island and set afloat. This became Kodiak Island, and the Kodiak people who inhabit it believe they are the descendants of that son and his dog-wife.

CALL OF THE CLANS

Many Native North American peoples are divided into kinship groups or extended families, known as clans. Although most tribes believe that animals and people are closely related, only a few clans see themselves as the direct descendants of an animal spirit or totem, a word that anthropologists derived from the Ojibwe *odem*, which may be translated as "village". Those clans that do have stories about how they came to have a totem animal. The Hopi say that after their emergence (see pages 153–154), they decided to play a name game while they hunted and moved across the land in bands of relatives. Because the first band came across a bear skeleton, it decided to be called Bear Clan; another found a nest of spiders and became Spider Clan. Similarly, the Iroquois peoples now have up to nine such groupings, including the Turtle Clan, the Bear Clan and the Wolf Clan, each one of which is matrilineal and headed by a "clan mother".

The origin may be even more direct: certain animals came back after their death (whether they had died of natural causes or had given their lives to a human hunter), stripped off their animal fur or feathers to look and act like humans, and then established their own clan or village among the people. For example, some peoples of the Northwest Coast believe that their ancestors were animals that had landed on the beaches, taken off their animal guises, become human and established the various clans.

A totem animal may have assisted an ancestor in a hunt or helped him or her to find the way home. In other cases, a member of a clan may go on a specific quest to find an animal to adopt as the clan totem. Members of the Osage Spider Clan relate that a young man once went into the forest on just such

an expedition. He was following some deer tracks when he fell over a large spider's web. The spider asked the man how he had come to trip over the web. He replied that he had been tracking a deer, because he was looking for a strong animal to be the symbol of his clan. The spider replied that, although he seemed to be a small, weak creature, he had the virtue of patience. Furthermore, the spider said, all creatures came to him sooner or later, just as the man had done. Impressed by these words, the man returned to his clan, which duly adopted the spider as its totem.

Individuals who did not belong to a totem-based society or clan could develop their own relationship with a totem animal, which became their personal spirit guide (see page 87).

Clans and individuals were often thought to assume the characteristics of their spirit totem. For example, members of a Bear Clan might be said to possess great individual strength and ferocity, while those of a Wolf Clan might be said to be the ones who would seek out new things and places for the benefit of the group.

The relationships within and between clans might reflect those that are thought to exist between their real-life animal namesakes, implying that clanspeople share its characteristics. For example, in the past, the Winnebago usually chose chiefs from the Thunderbird Clan, but it was members of the Bear Clan who policed the community, because bears are vigilant and all-seeing. Among the Cherokee, members of the Bird Clan acted as messengers, those of the Deer Clan served as runners and men from the Wolf Clan fought as warriors.

ARTISTRY OF THE TOTEMS

A great deal of Native North American ritual and art is in imitation of totem animals, and representations of a clan animal are revered as a source of power. Help might be sought from an animal spirit by putting an emblem or fetish of the animal's power on a tool or weapon, or on their person. The Inuit engraved images of wolves on harpoons to evoke the

▶ Three of the eight carved cedar poles at Vancouver Stanley Park, British Columbia. In the last few decades a new generation has dedicated themselves to the preservation of the ancient carving skills of the Northwest Coast. The central pole (right) is a Thunderbird housepost, carved in 1987 by Tony Hunt as a replica of one carved in the early 1900s by Charlie James. Below the Thunderbird is a Grizzly Bear holding a human.

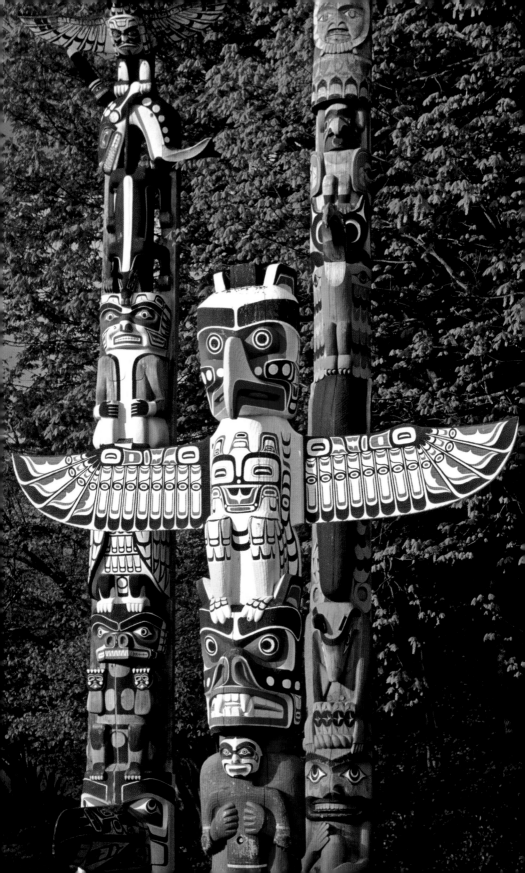

wolf's predatory abilities, while the Crow covered their arrows with rattlesnake skin to allow them to strike swiftly.

Representations of mythic beings have attained a particular richness of expression in the Northwest Coast region, where people honoured the totem animals of their clans by incorporating them as family crests in almost all their carving, weaving or painting. Neither the images nor the creatures they represent were worshipped but instead marked a family's history and powers, thereby linking clans to the distant past. Northwest Coast art is visually stunning and executed with bold colours; most of the art is representational and portrays the animal's salient attributes in stylized ways.

Some traditional designs were painted onto the end of the large, rectangular cedar plank houses, known as a "big house", which were large enough to shelter several related families and their possessions, provide workspace, and accommodate visitors for a ritual, a feast or a potlatch (see page 250). The dominant figure in such a painting can often be hard for outsiders to identify, with eagles, thunderbirds, and ravens difficult to differentiate; however, this is not a problem for the local residents, who know from the clan's name and reputation which animal totem spirits are depicted in such designs.

The villages of the Haida people, whose home in British Columbia is the Queen Charlotte Islands (an archipelago they call Haida Gwaii – "Islands of the People"), were once the most prosperous of the Northwest Coast and all 7,000 Haida lived in about 30 villages that consisted of sturdy cedar-plank houses. Some settlements consisted of a small scattering of houses, while others extended along the shore for more than a mile (1.6km). A typical house had corner posts, interior posts to support the roof beams, and walls, roof and a floor of cedar planks. The planks were either lashed to the beams with rope or fastened with wooden dowels. There were sitting and sleeping platforms around the inside walls, with each family group separated by partitions of wood or cedar matting. Families were arranged by status, with the chief in the

The elaborate nature of Northwest Coast art was most evident on totem poles, whose carved images represent the animal beings that founded and assisted the clan and gave it its power.

favoured location, at the end furthest from the door, and slaves by the doorway. Traditional Haida houses had a single, central hearth and no openings except a doorway and a smokehole in the roof. The doorway was sometimes cut through the body of a figure that was painted on the house front or carved in a totem pole. Such openings reflected the womb-like nature of the dwellings. Villages were mainly occupied in the winter. In the summer, people moved to temporary camps to harvest foods as they came into season.

An outsider arriving at a Haida village such as Ninstints, in the southern Queen Charlotte Islands, in the nineteenth century would have been struck by the forest of tall carved cedar poles among the houses. The elaborate nature of Northwest Coast art was most evident on totem poles, whose carved images represent the animal beings that founded and assisted the clan and gave it its power. Totem poles are basically heraldic emblems, representing status, wealth or ownership. "Memorial poles" are erected on the waterfront of lakeside villages (where they can be seen by anyone approaching by water) by a chief's heir as part of the procedure of inheriting the chief's title and prerogatives. Another type is the "mortuary pole", which is set alongside the grave of a deceased chief. A third type is the house "portal pole", erected on the front of the clan house and bearing clan symbols. It has a large opening forming the gateway, which represents the symbolic entrance to the supernatural world.

Tragically, disease and resettlement programmes led to the depopulation and abandonment of many such villages, and by 1900 most surviving Haida had relocated to the missionary-run towns of Massett and Skidegate in the north of the Queen Charlotte Islands, leaving the villages to decay. Carved poles were cut down by settlers for firewood, shipped out to museums or simply left to rot. The village of Yan ceased to be inhabited after 1890, but in 1991 descendants of the last residents gathered at the old village for the ceremonial raising of a new totem pole representing the Bear Clan.

SACRED SOCIETIES

All but the smallest cultures tend to have ways of organizing themselves in groups other than those based primarily on kinship. For Native North Americans, such groupings most commonly took the form of sacred societies – associations that were based on a particular sacred ideal, ritual, being or object.

These societies were sometimes directly linked to particular clans, but as often as not they cut across kinship structures. Although the individual and his or her personal ritual life was important, membership of a group provided a more distinct social identity. The entire culture viewed the duties of each sacred society as crucial to the survival of the whole, because their efforts kept the world in balance.

The constitution and duties of a sacred society could be as variable as the tasks it performed, but all of them drew their power from the spirit world. Sometimes a society's power was centred on a bundle of holy objects, entrusted to its care, which were the focus of special ceremonies. The Pawnee had sacred bundles that were closely associated with the stars (see also pages 115–117) and contained symbols of the cosmic forces; the bundle might also represent the psychological or elemental characteristics of the divinity to whom it was consecrated. The bundle itself might be a piece of hide painted with star patterns that was wrapped around objects such as ears of corn, representing the annual renewal of the Earth.

Societies of healers were prominent in the Northeast. The Huron set great store by their curing societies and each had a leader whose office was hereditary. One curing society was the *atirenda*, which had about 80 members, including six women. In its principal dance, the *otakrendoiae*, the members pretended to kill one another with charms such as bears' claws, wolves' teeth or stones. The *atirenda* was especially skilled at curing ruptures.

▶ This Apache dancer is at the annual National Indian Festival held at Chehaw Park in Albany, Georgia. He is impersonating the *gahan*, or mountain spirits, who have the power to help or harm people. The four *gahan* were once sent to Earth by all-powerful Usen to teach people how to live reverent lives.

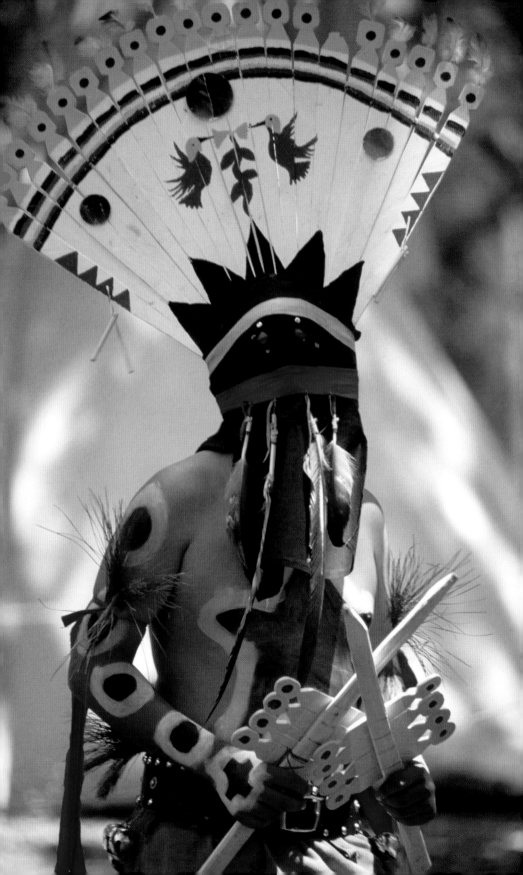

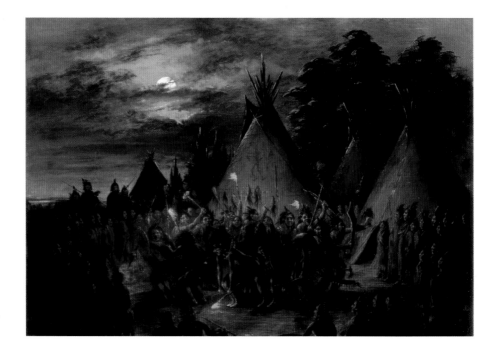

The Iroquois False Face Society played an important role as healers who could sing away sickness. Members wore "twisted face" masks to commemorate their guardian, a giant who had once challenged the Creator to a test of strength by moving a mountain. The giant could barely shift it, but the Creator was so successful that the mountain hit the giant in the face before he was able to get out of the way. Chastened, the colossus agreed to look after the health of the people from then on. However, his face remained in a permanent twisted grimace. The masks of a False Face healer were the same in form, but each possessed distinctive features derived from the wearer's dreams and imagination.

▲ George Catlin's depiction of a scalp dance among the Lakota was painted in the 1840s from a sketch made a decade earlier. Such activities were not celebratory amusements but were filled with religious meaning.

INSTRUMENTS OF GOVERNMENT

Sacred societies provided an effective way to educate youth and to allocate civic responsibilities and sacred obligations. Among some peoples, the societies played a central role in the running of the tribe. The Eastern Cherokee (those who had

GAMES WITH THE SACRED HOOP

Sometimes sacred societies specialized in playing a particular sport. Team games certainly functioned as recreational activities, but like most aspects of Native life they also served a broader social and religious purpose.

The most widespread example of such a sport is the hoop and pole game. Played across the entire continent, the game was for men only and consisted basically of throwing a spear or shooting or throwing an arrow at a hoop or ring as it rolled along the ground. The hoop in particular possessed symbolic significance. In the Southwest, the Zuni version of the game used a hoop strung with netting that symbolized the web of an ancestral protector being called Spider Woman.

The game was of great antiquity and there was remarkable diversity in both the implements used and the rules of play. The number of players varied, but there always seem to have been two teams, perhaps representing some fundamental duality, such as "we" (the people) and "they" (the unseen forces). When gambling was involved, as with the Arapaho, the takings were redistributed among team members.

The timing of matches was sometimes significant. For example, the Wasco near the Columbia River played the game to mark the first salmon run of the season.

remained in North Carolina) closely coordinated their political activities with the cycle of major religious ceremonies. Tribal officials belonged to one of two sacred societies, the White Peace Organization or the Red War Organization. Chiefs of the White Peace Organization, together with their assistants and seven counsellors, formed a town's civil and religious tribunal. They were in charge of a ritual cycle that included several corn ceremonies and the Reconciliation, New Moon and Bounding Bush ceremonies. They also performed civic duties, acting as a criminal court, controlling marriage and divorce and training boys to hunt.

The Red War Organization ran all aspects of warfare, from the initial call-up of warriors to a body-count of the slain, and conducted purification rites before and after battle. The society was headed by a chief who was aided by various counsellors, surgeons, messengers and scouts, as well as by some older, respected matrons (the "Pretty Women") who had an important say in the conduct of warfare and in the fate of captives.

▲ In the Northwest Coast region it was believed that spirits took part in initiation rituals and ceremonies in the form of masked puppets or impersonators. This human-looking mask is from the Nootka people and may have belonged to the Tlokwalle Society for use in their winter curing rituals.

Among the Blackfeet of southern Alberta, women were acknowledged as the foundation of humanity and ceremonies could not be run without them. Women kept the people's sacred bundles, without which the most important ceremonies, including the Sun Dance, could not take place. Only women were permitted to open the bundles and hand the sacred objects over to men, and only women could call up the spirits. Prior to the Sun Dance, members of the Old Women's Society built a ceremonial lodge in the shape of a buffalo corral. On the fourth day of the ceremony, they re-enacted a buffalo drive into the corral, with some members wearing bison headdresses and mimicking the animal. The event was staged in honour of the Creator spirit, the buffalo and the history of the people.

Sometimes sacred societies controlled very specific ceremonies. For the Crow people of the northwestern Plains, the ceremony conducted by the Tobacco Society was thought crucial to the prosperity of the tribe. It was also thought that the Crow would survive only if they continued to plant seeds from the originally cultivated plants. The ceremony began with the ritual planting of seeds by a Tobacco Planter. This role was hereditary, but a person could purchase the right to become a Planter. The planting ritual included abstention from food and water for several days, as well as cutting or burning the arms and chest. In exchange for the honour of planting the seeds, a Planter had to give up all worldly possessions.

This interaction with other forces is found throughout Native North America – at certain Mandan rituals, spiritual

SNAKE DANCERS OF THE HOPI

In the parched lands of the Southwest, rainmaking ceremonies have special significance. Among the Hopi, the Snake Dancers (below) belong to a sacred society that conducts a week-long rite held every two years. The Hopi believe that the snake, with its zigzag shape, is related to the lightning that heralds rain. The dances are intended as a show of communal respect towards the snakes, so that they will bring enough rain for the growing harvest.

For the first four days of the ceremony, members head north, south, east and west into the desert in order to catch snakes. For the next two days and nights primordial events are ritually re-enacted in a *kiva* (see pages 214–215). The remainder of the festival is taken up with races, dances (in which priests hold snakes in their mouths) and a final blessing. The snakes remain unharmed throughout the ceremony and are released back into the wild at the end.

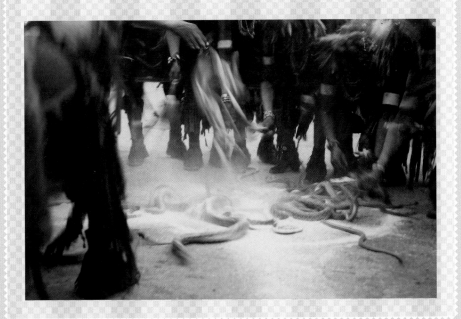

beings actually participated in ceremonies through human impersonators; something similar happened on the Northwest Coast. The rituals a society performed were often acts to obtain divine blessings for the tribe: for example, members of the Cherokee Booger Society dance to maintain the precarious harmony of the Cherokee people with their environment.

WISDOM PLACES

According to the Cibecue Apache, "wisdom sits in places". Whether it involves a knowledge of sacred history, being able to locate important natural resources, or having an intimate understanding of one's place in the grand scheme of existence, the wisdom that imbues major sites lies at the root of the Indian world view.

Each native group knows its landscape intimately. For nomadic tribes, such as the Dogrib of northwestern Canada, the land is crossed by trails and countless places have a unique story that provides the means to navigate the region. The names of wisdom places often relate to key resources that can be found there: for example, Blood Rock is known as the birthplace of Yamosh, a Dogrib culture hero, but it is also where to quarry a red stone that is used to produce tools.

Sites can become important because of their unusual appearance, or because they were once the site of a cataclysmic event, such as an earthquake. Places at a high altitude are closer to the juncture of earth and sky, and it is therefore thought that certain spirits may be more accessible here. The Acumawi people say that a spring on Mount Shasta in northern California contains the tears of all the deer, so that

▼ Devil's Tower, according to the Cheyenne, is where their culture hero Sweet Medicine had a vision that predicted the disappearance of the buffalo and the impact of the white man.

deer won't cry out when killed by hunters. Some places become intertwined with oral tradition and tribal myth because "history," and thus the tribe's "character," is thought to have originated there. Wind Cave in the southern Black Hills is where the Lakota people were tricked by the spider Iktomi into emerging. Bear Butte is where the Cheyenne culture hero Sweet Medicine received the four sacred arrows that brought blessings to his people.

Wisdom places have many uses: some are where holy people conduct their rituals or where individuals seek a vision (see pages 228–229); others may be sites of pilgrimage for specific clans or tribes. Wisdom places are varied in form and associated belief, yet the single, overarching theme that unites them is that they provide a people with its identity. The mysterious rock formation of Devil's Tower in Wyoming is known to more than twenty native tribes by a variety of names, but the Crow, Lakota, Kiowa, Arapaho and Cheyenne all share similar tales about its origins. Mato Tipila ("Bear's Tipi" in Lakota) is said to be the lair of a large grizzly bear. Some stories tell how Bear was chasing seven sisters and the rock grew upwards in order to carry them to safety, out of his reach. In frustration, Bear tried to climb the rock – the marks on the sides of the stone were made by his claws – but the sisters eluded him and became the stars of the Pleiades star cluster.

MOTHER EARTH

The idea of the Great Spirit as a father and the Earth as a mother (eloquently stated by Big Thunder, see page 89) represents an awareness of the cosmos characteristic of Native Americans. To live on the Earth, to breathe and drink and feed from its resources, to be among the plants and animals, is to be part of a sacred cosmic unity.

The numerous myths and rituals that surround the figure of Mother Earth bear witness to an ancient and indissoluble sense of kinship. Every aspect of creation within the Native American cosmos has a spiritual dimension, but the Earth, which is home to all living and growing things, is regarded as having special sanctity. Stories reveal this mythical Earth Mother as having faces as numerous as her landscapes are diverse, and all of her children affirm their kinship with her. Early in the nineteenth century, the visionary Shawnee chief Tecumseh tried to rally a number of tribes against the white men's incursions when he declared: "The sun is my father, and the Earth is my mother; on her bosom I will rest." When Tecumseh spoke of the Earth as his kin, he was speaking on behalf of every Native American.

"SHALL I ... TEAR MY MOTHER'S BOSOM?"

As they saw the immigrants' frontier creep ever further westwards, Native Americans had to defend the integrity of their sacred Earth against alien ways. In the 1850s, Smohalla, the Wanapum holy man whose prophecies anticipated the Ghost Dance movement of the Plains (see pages 260–261), reminded his own people of their sacred pact with the Earth. To save themselves from ruin, Smohalla's followers had to refuse the white men's ways. When the white men ploughed and mined and fenced the land, they were not simply destroying Native American habitats, they were murdering a cherished body. "You ask me to plough the ground! Shall

▶ A Navajo (Diné) farmer carries a bundle of corn she has just picked from ripe stalks. To the Navajo, corn is a sacred plant. Many Navajo food dishes are prepared using corn, but the husks are also used to make clothing and basketry, and the pollen is used as offerings during prayers and rituals.

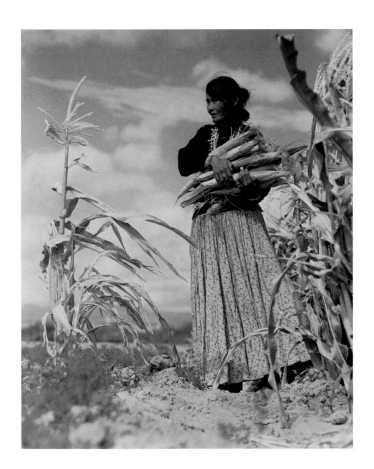

I take a knife and tear my mother's bosom? You ask me to dig for stone! Shall I dig under her skin for bones? You ask me to cut grass and make hay and sell and be rich like the white men! But how dare I cut off my mother's hair?"

A similar anguish caused Young Chief of the Cayuse, in Washington Territory, to ask: "I wonder if the ground has anything to say? I hear what the ground says. The ground says, 'It is the Great Spirit that placed me here. The Great Spirit tells me to take care of the Indians, to feed them properly.' The water says the same thing. The grass says the same thing. 'Feed

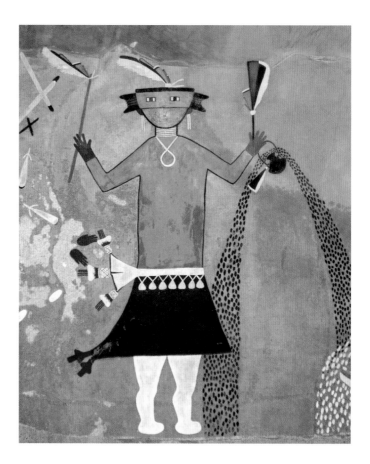

▲ A ceremonial figure accompanied by rain, in a pre-contact fresco on a *kiva* interior wall, circa 1500, from Kuaua pueblo in the Rio Grande valley, New Mexico. (Kuaua is a Tiwa word meaning "evergreen".)

▼ Pages 108–109. A herd of buffalo crossing Yellowstone River.

the Indians well,' the ground says, 'the Great Spirit has placed me here to produce all that grows on me, trees and fruit.' In the same way the ground says, 'It was from me man was made. The Great Spirit, in placing men on earth, desired them to take good care of the ground and to do each other no harm.'"

Again and again, the Native Americans proclaimed their belief in the indivisibility of land and human existence – and history rode roughshod over the landscape of Native America. However, in the myths and ritual that continue to tell of its sacred past, the Earth lives on as the ultimate cosmic gift. It is this intimate relationship that has led to Indians being

stereotyped as close to nature. "Noble savages" was the description once used, but in more recent years Native Americans have been labelled the "first ecologists". Protecting the land is part of daily life and many see it as a limitless responsibility. In fact, Indians are ecological in the truest sense – that is, they know nature's cycles and understand its tolerances. They see themselves as a part of the land itself, no better than the other creatures that live on it. To Native Americans, ecology is a matter of balance and respect.

Indians have had to pay careful attention to the land's ability to sustain them. Hunting and gathering peoples, especially in areas where there were limited resources, have generally understood that they needed to keep their own population levels low. The Mistassini Cree hunters around what is now called Hudson's Bay kept a record of the animals they took so that they did not overhunt. If the Cree thought that game numbers were declining, they moved into hunting territories that had not been exploited recently. Similarly, farming tribes, such as the Mandan and Hidatsa, knew that the land could only sustain crops for a few seasons before it needed fallow time. Because eagle feathers were an important part of rituals, many tribes took care to protect local populations of these sacred and rare birds. This was done by building eagle-trapping lodges – when an eagle landed there, brave hunters held its legs and plucked a few feathers before the bird was released.

This harmony between humans and nature was changed by the settlement of Europeans in North America. By the late 1800s, the buffalo was nearly extinct. Tribal lands have since been cleared of forests and waters have been polluted. Many Indians have stepped forward to speak out against this desecration and have become eloquent spokespeople for a range of contemporary environmental causes. For example, Winona LaDuke is a well-known Anishinabe (Ojibwe) environmentalist, economist and writer, who has even run twice as Green Party candidate for the US vice presidency.

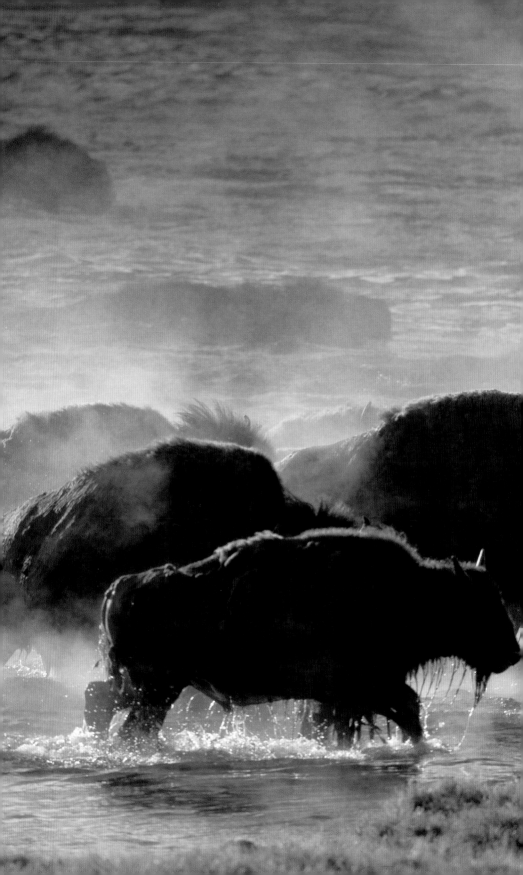

The country knows. If you do wrong things to it, the whole country knows. It feels what's happening to it. I guess everything is connected together somehow.

Koyukon Indian, central Alaska

What is life? It is the flash of a firefly in the night. It is the breath of a buffalo in the winter time. It is the little shadow which runs across the grass and loses itself in the sunset.

Crowfoot, Blackfeet warrior – his last words, 1890

We are part of everything that is beneath us, above us, around us.

Winona LaDuke, Ojibwe, 1999

MOUNDS & EFFIGIES

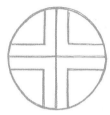

Mother Earth's countless hills and mountains rise towards the heavens and mark important places where Indians can go to touch both the earth and sky. Native American people seem to seek out these elevated places, and sometimes they have artificially created them.

Among the earliest examples of this in North America were the mounds built from around 1000BCE by Indians east of the Rocky Mountains. Many more such mounds – which were used to bury the dead, to mark clan territories and to serve as platforms for temples – later appeared all over the Woodlands and Plains (see also Cahokia, page 121). By the time they were surveyed in the nineteenth century, many mounds had been destroyed, although in 1890 around 10,000 still remained.

Burial mounds are generally conical or linear. Conical mounds are cone-shaped, although rounded on top, and sometimes more elliptical than round at the base. Linear mounds tend to be long and narrow. Burial mounds vary in size: their diameter or length ranges from just a few feet to more than 100ft (30m); their height varies from about 3ft (1m) to more than 30ft (10m). Such mounds often contained the remains of more than one individual, perhaps many members of the same clan, placed in the mound at different times. In some cases mounds were built slowly over many years as more bodies and baskets of soil were added. The recently deceased would normally be buried in an extended or flexed (fetal) position, but sometimes bodies were placed on scaffolds open to the sky and only after the bones had fallen to the ground were they picked up and then buried in the mound.

Geometric and effigy mounds were important variations on the theme. In some cases, burial mounds were accompanied by large enclosures with multiple ridges of earth, in circular, octagonal, or square shapes. Effigy mounds, most of which were built around 650CE–1100CE, contain no

▶ An aerial view of the Great Serpent Mound, which is so long (1,250ft/381m) that it can be seen in its entirety only from the sky. The scale of the construction would have taken an enormous communal effort to produce. The serpent appears to hold an oval object (like an egg) in its jaws. It is possible, though there is no evidence, that the mound is the work of the Adena culture, which definitely built a nearby burial mound.

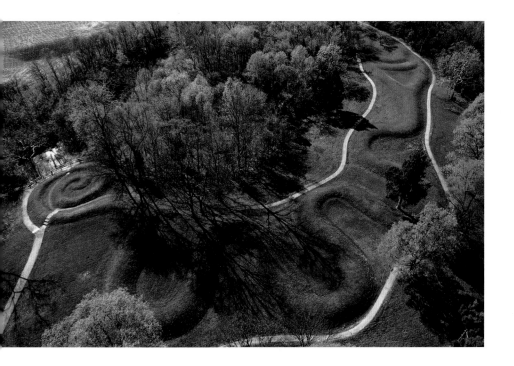

burials and, given their location on ridgelines, it is thought that they may have marked clans' territorial boundaries. These mounds tend to be low (about 3ft/1m) high and are shaped like creatures, such as bears, birds or panthers. Most surviving effigy mounds can be seen along the hills and ridges of the Mississippi River, where the states of Iowa, Minnesota, Illinois and Wisconsin come together. On one terrace above Brush Creek in Adams County, Ohio, a long earthwork known as the Great Serpent Mound (above) loops its way along a bluff.

By 1200CE, probably influenced by cultures from Central America, some groups began to construct platform mounds, most of which appear along the Mississippi River and its tributaries in the Southeastern culture area. These truncated earthen pyramids crowned by a temple were used to conduct rituals that helped sustain the world and the social order.

THE DOME OF THE SKY

The celestial world of American Indian belief systems is alive with spirits, which manifest themselves as night and day or as the life-giving elements of every season. Many myths reveal the origins of these sky spirits, their place in creation and the parts they play in life on Earth.

The mythical firmament of Native North America has a variety of "geographies". For the Native peoples of California, the sky is like a roof, supported by pillars of rock that sometimes collapse with age and wreak havoc on Earth, whereas for the Ojibwe and the Puebloan peoples the upper world is a sequence of layers, one above the other.

Interaction with the heavens is inescapable and people take care to heed its many messages. On an everyday level, by watching the sky Indians are able to see bad weather coming and take proper action – but the supernatural is never far away; the Koyukon, for example, regard thunderstorms as transformations of a human spirit from the Distant Time. Storms are believed to possess awareness and can therefore be influenced; a Koyukon hunter might paint a red circle on his paddle and wave it towards the west as the dark clouds approach, ordering the storm to go out to the coast.

The sky is a place of both origins and endings – a domain inhabited by many beings, some benevolent and some wicked. For the Netsilik, an Inuit people of Pelly Bay in Arctic Canada, the sky is the home of Narssuk, a weather god who takes the form of a strong and malevolent giant baby. Wrapped in caribou skins tied with thongs, he is a wicked spirit who detests humans. Whenever Narssuk gets loose, a blizzard is unleashed. In order to restore good weather, shamans have to enter a trance state and ascend into the sky to fight Narssuk, then retie his loosened thongs. Tatqeq, on the other hand, is a gentle, people-loving moon spirit who has little power but brings luck to hunters and fertility to women.

▶ A few of the jagged peaks of the Teton range, beneath the Milky Way and the planet Jupiter. The name is derived from the French for "breast", but the Shoshoni once called the range Teewinot or "many pinnacles".

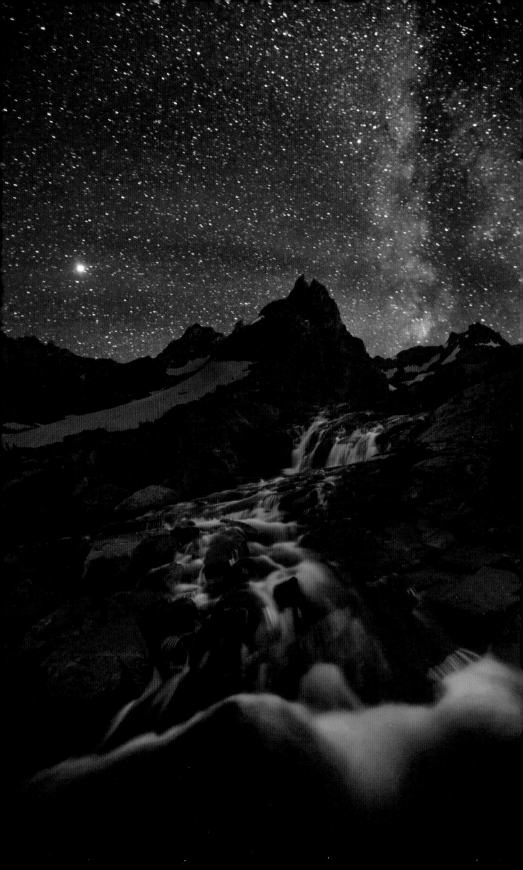

The night sky is a source of important information. In the risings of stars, Native North Americans looked for patterns to indicate the shifts of seasons that are so crucial to planting. Relatively rare celestial events such as eclipses, comets, or supernovas might be read as good or bad omens, requiring special rituals to be held either in celebration or to forestall evil. However, many celestial events are regular and predictable, thus certain ritual cycles were keyed to star movements.

A BALANCED FIRMAMENT

Sheet lightning and low, rumbling thunder starting in the west and rolling around the entire sky, combined with the proper position for the Pleiades, represent significant milestones for the Skidi Pawnee of the Plains. This announces the transition between winter and summer, reproducing the creation of the world in miniature and signalling that it is time for the Evening Star bundle ceremonies.

The Skidi Pawnee have a highly detailed conception of the firmament and believe in intimate relationships between themselves and celestial objects: fixed stars are thought to have great power – they even created people and gave each band of the tribe a medicine bundle (see also page 96). The stars are either gods or people who have become stars.

The sky world that is described in the myths of the Pawnee consists of three layers, or circles. At the level of the clouds is the "circle of visions". Above that is the "circle of the sun"; and, highest of all, is the circle of Tirawa, or "Father Heaven". Tirawa, the Great Spirit who created and informs every other spirit, is the husband of the female spirit who presides over the vault of the sky.

Tirawa and his spouse live beyond the clouds and play little or no part in the dynamics of Earthly existence. Instead, Tirawa rules through a hierarchy of other spirits. Before he made people, Tirawa specified the place and purpose of each heavenly body. The sun and the "Great Star" of morning (Venus) were placed in the east; the moon and the "Bright

◀ A Yankton Sioux (or Nakota) rawhide drum, c.1860, with a Navajo blanket. (The Navajo say that the gods had placed the stars on a blanket on the ground; while they decided where to put them, Coyote flipped the blanket into the air, scattering the stars.) The drum is decorated with horns, a buffalo face and the sun and moon. Obtained from a man called Black Chicken, it has been claimed that the drum once belonged to the Lakota Sitting Bull.

Star" of evening (again, Venus) were located in the west. The pole star, in the north, was ordained by Tirawa as the "Star-chief of the Skies", while the "Spirit-star" (Sirius), intended to be visible only occasionally, was placed in the south. The four stars of the quartered regions – northeast, northwest, southeast and southwest – were positioned so as to hold up the heavens. Tirawa's stars were also required to manage other phenomena – the spirits of clouds, winds, lightning and thunder. Having given these forces their roles, Tirawa dropped a pebble into their midst. It rolled about in the clouds and then the waters of the lower world appeared. It was from these waters that the Earth itself emerged. In this cosmos the day-to-day destinies of men and women were determined by animal spirits who came together in sacred lodges to make or mar their fortunes.

Historically, the Skidi Pawnee worshipped Tirawa and the lesser spirits in long annual rituals. They acted out the ways of the animals in dance ceremonies and as a means of affirming their power over them in the hunt. Other ceremonies, which were always conducted in a great lodge built specially for the purpose, involved the sacred bundle that each village kept as a ritual object. Every village owned a unique bundle given to its ancestors by the Great Spirit. (The village chiefs and holy men who supervised the rituals took up positions in the lodge that reproduced those of the spirits and stars in the firmament.)

The Pawnee called their bundles *chuh-raraperu* ("rains-wrapped-up"). Their contents varied, but all of them held at least one pipe and most would contain tobacco, paints, sacred bones and feathers, as well as the maize that Pawnee women cultivated. Laid out in front of the chiefs, the bundles would receive ritual offerings both of smoke from a ceremonial pipe and of buffalo tongues. Until 1818, a human sacrifice in the shape of a girl as a mate for Morning Star was among the offerings. Singing led by holy men and chiefs accompanied these rituals, which were intended to show the community's humility before Tirawa.

According to some Cherokee storytellers, the moon is a ball that was thrown into the sky in a mythical game.

CELESTIAL DUALITY

Native North Americans have many stories to account for the origins of celestial objects. For most tribes, the heavenly bodies of the sun and the moon represent the dualities of creation, such as life/death, man/woman and good/evil. The unchanging sun and the variable moon are used to represent phases of the cycle of existence. Tribes have many ways of incorporating the sun and moon into different aspects of culture – including housing, where the roundness of a *hogan* or a *tipi* simulates the sacred circle of the cosmos. This Plains Cree shield (right) is adorned with dream- or vision-derived sun and moon motifs.

THE CHEROKEE AND THE "SUNRISE PLACE"

The Pawnee conception of a balanced hierarchy of celestial spirits contrasts with the dense sky world of the Cherokee, whose myths tell of a sky made of rock, above which live the spirits of thunder. The sun, as in Pawnee myth, lives in the east, the moon in the west. Above the sky vault dwells the Great Thunderer and his two Thunder Boys, beautifully garbed in lightning and the rainbow. Other thunder spirits inhabit the mountains and cliffs of the sky; they travel on invisible bridges from mountain to mountain where they have their houses. Some of these auxiliary thunder spirits are benign, responsive to prayers and appeals from people, but other weather spirits are less sympathetic. According to some Cherokee storytellers, the moon is a ball that was thrown into the sky in a mythical game. Long ago, two villages were playing against one another when the leader of one team broke the

rules that forbade contact between hand and ball, and picked it up. Trying to throw it into goal, he tossed it so high that it hit the solid sky and stuck there as a reminder not to cheat.

For the Cherokee, the sky-vault was not only solid, but came down to the ground at "the sunrise place" where it could be touched. Once, a party of young men decided to visit this place and gain access to the sky. They travelled east until they reached the spot where the sky meets the ground. There they found that the sky was a dome of solid rock that was suspended above the Earth and swung up and down. Each time it swung up, an opening appeared, which closed as the dome swung down again. At sunrise, the sun appeared through this gap and proceeded to rise up the inside of the dome. The young men had waited for this moment to climb up on to the outside of the dome. But the first to attempt the feat was crushed by a falling rock, whereupon the others gave up and headed home.

SEXING THE STARRY SKIES

Native American mythology abounds with stories concerning the birth of the sun, moon and stars, which are assigned different personality traits according to their impact on the culture – thus, on the baking-hot Plains, the sun is unquestionably male and predatory, while in the far north, where the spirit of the sun is shy and female, the moon is dominant and male. In most Indian cultures, the sun is seen as male and the moon is seen as female.

Different peoples emphasize different celestial bodies. Among the Omaha, the Inshta-thuda, or Sky People, are the counterparts of the Hon'gashenu, the Earth People. These two groups together form a circle that reflects the Omaha idea that creation is ongoing through the union of male and female.

Among the Navajo of the southwestern deserts, the sun is seen as more than just the giver of light: all living and growing things require the energy that is provided by the mighty sun deity. The Southeastern peoples similarly propitiate this vital celestial body.

The Arctic sun, often spotted with molten-looking orange and red when it briefly appears in midwinter, is identified by the Inuit as the sun sister rising up to display her terrible wounds.

RELEASING DAYLIGHT & THE STARS

Many Northwest Coast myths explain the creation of daylight, the moon and the stars, which usually involves a raven Trickster and a being who hoards the light. A Tlingit myth tells how Raven (below, a dance mask from the Kwakiutl or Kwakwaka'wakw), part bird and part human, tricked his way into the light-hoarder's house by magically making the man's daughter give birth to a raven-baby. Raven was then able to see the bundles that hung on the walls of his grandfather's house. Using ruses, Raven was able to obtain bags containing the stars and then the moon, which he released through the smokehole. Finally, he got hold of the strongbox containing daylight, whereupon he opened it and flew up through the chimney while uttering his raucous raven cry "Ga!". This was how daylight, or sunshine, arrived on the Northwest Coast, together with the moon and the stars.

By contrast, in the cosmology of the Inuit people of the Arctic, as well as among the Tlingit and Tsimshian peoples of the Northwest Coast, the sun is a female. The Inuit have a tragic story that the spirit of the sun was once a young woman. Abused by her brother, she mutilated herself in grief and fled to the sky where she became *siqinim inua*, "the sun person". The Arctic sun, often spotted with molten-looking orange and red when it briefly appears in midwinter, is identified by the Inuit as the sun sister rising up to display her terrible wounds. Although she only plays a relatively minor role in Inuit myth, in Alaska she was the provider of energy to children. Women who were nursing infants used to stand on the tops of their igloos on winter mornings and expose their children's legs to the rising sun. This was intended to let them absorb the sun's rays, so giving them strength and making them fast runners and good hunters.

SPACE, TIME & THE DIVINE

Indian cultures were not timeless and unchanging. As with any living culture, changes took place in reaction to different natural and social environments, and over the millennia populations flourished creatively wherever the environment allowed.

People experimented with the foods found around them in nature and in doing so they created new crops, which, in the right conditions, provided them with surpluses. Excess food enabled the population to expand and freed many people from the constant quest for nourishment, even allowing some the time to pursue knowledge and the arts and crafts.

One of the best examples of cultures flourishing in a sympathetic environment is that offered by the lush

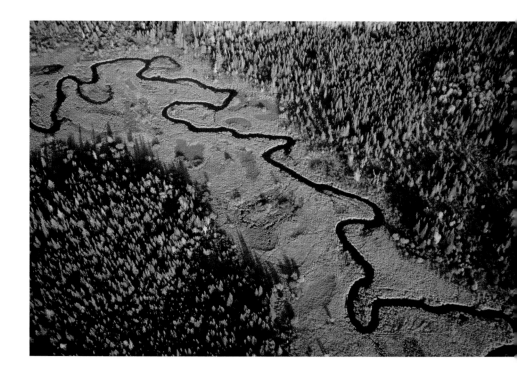

bottomlands of the Mississippi River, which provided abundant natural resources and rich soils for growing maize, beans and squash. The largest centre of the Mississippian archaeological tradition was Cahokia, which reached a peak between 1050CE and 1250CE, when it may have had 20,000 residents. The city's layout reflected sacred geometry, being dominated by a plaza surrounded by the giant Monk's Mound and sixteen other platform mounds. Monk's Mound, once crowned by a temple, is the largest prehistoric structure in the United States, with four platforms rising 100ft (30m) from a base that is 1,040ft (316m) long by 920ft (241m) wide.

THE CIRCLE OF THE SEASONS

Cahokia symbolizes a major shift from nomadic to settled cultures and from populations that were relatively small to ones that were large and needed to be organized more like a state. No doubt people always have observed nature for clues about the weather, but as cities like Cahokia became more dependent on agriculture to sustain the lives of thousands, it became desirable to be able to predict growing seasons. Cahokia's priests did this by building a woodhenge to mark the solstices and other key celestial events. A tall centre pole and shorter poles around the outside circle marked the current position of the seasonal cycle.

These new cultures essentially echoed the age-old concern of many historic cultures with the cycles of time, the seasons and life itself. The structure of Cahokia's woodhenge is not dissimilar to that of the ancient medicine wheel, which consists of a circle with a cross through it. Scattered across the plains and prairies of North America, these stone circles were built out of the small boulders left on the ground by retreating glaciers. The "hub" of each medicine wheel is a pile of stones or cairn and other cairns may be positioned around the circumference. Lines of stones may radiate like spokes from the central cairn to the outer ring.

◀ The headwaters of the mighty Mississippi River meander near Itasca State Park in Minnesota. Although the river was known to the various Indian tribes by many different names, the modern name is derived from one of two Ojibwe words, *misi-ziibi* ("great river") or *gichi-ziibi* ("big river").

The best-known of these structures is Wyoming's Bighorn wheel (see illustration, page 13), which is nearly 100ft (30m) in diameter with twenty-eight spokes and six small cairns around the rim. When, why and by whom it was made is unknown. A widely held theory is that the "spokes" of a medicine wheel are (or were originally) aligned with astronomical events, such as the position of the sun at dawn on Midsummer's Day.

Another theory is that medicine wheels are more purely symbolic, perhaps intended as visual representations of sacred cyclical principles that bind the universe. They resemble forms found in Native American dance and the shape of some lodges. Many are on high ground, so their form may symbolize the dome of the heavens.

As utilized by the Lakota people, the medicine wheel's design is simplicity itself on one level, but on another it contains a whole cosmology. The quadrants created by the cross are red, black, white and yellow – the sacred colours of humanity. The medicine wheel symbolizes a universe that is much more complicated than non-Indians might imagine. The circle signifies the cyclical nature of all creation, while the cross marks the four cardinal directions from which the four winds blow. The Lakota cross also represents the four seasons they recognize, which implies a temporal feature that gives the circle a "vertical" dimension. One way to look at this is to think of the cosmos as a sphere containing every material element and event that happens. Because all events have been, are or will be contained inside the sphere, they become timeless, although linked to a spatial element. The cross has not only a horizontal dimension through the centre of the circle, but also a vertical dimension via a centre pole. Things can be placed on layers within this space and everything can be connected. This connectedness constitutes a sacred quality.

THE CARDINAL DIRECTIONS

The medicine wheel's pattern of the circle and the cross is highly visible in Indian culture – numerous dwellings and

▶ Dawn light bathes a cornfield bordered by the beautiful colours of trees during the fall. By the 17th century about 15,000 Iroquois lived in the Northeast region. Well provided for by nature, the Iroquois flourished in harmony with the cycle of the seasons: hunting, fishing and gathering, as well as cultivating crops such as corn, beans and squash – these main foods, their sustainers of life, they knew as the Three Sisters.

▲ Sa'lakwmana (Salakamana) is a tall slender Hopi *katsina* (formerly *kachina*) maiden whose headdress represents clouds. She is the female companion of the Shalako *katsina*. As spirits of the invisible life forces, *katsinas* were impersonated in Pueblo culture during masked ceremonies conducted from the winter solstice until July, their main purpose being to bring rain for the spring crops.

ritual structures mirror its cosmology almost exactly. For example, the lodges of the Pawnee, Arikara, and others replicated this round, celestial structure. Built out of cottonwood trees and earth, the spacious lodges had a hemispherical dome, which was usually supported by four central poles, and a hearth in the centre with a smokehole above it.

The interior of these lodges is often divided into segments based on the cardinal directions and specific activities take place in those delineated areas. In similar vein, many of the more thoroughly nomadic Plains tribes, who erected circular *tipi*s to shelter in their encampments, build a temporary circular lodge for one of their most sacred renewal rituals, the Sun Dance (see pages 233–235). In the centre of the lodge stands a tree or a centre pole, from which hangs a buffalo skull that is carefully aligned with the eastern sun. Twelve smaller poles stand around the perimeter, indicating the orbiting movement of the Earth and a twelve-moon year.

The cardinal directions are also an important feature of other Native American domestic structures, including the rectangular Haida plank houses built throughout the Northwest Coast region. Each of these dwellings represents the centre of the universe for the kinship group that resides there. The houses stand on the shore facing the sea, with their entranceways flanked by towering carved totem poles; the back of the building looks to the forest (where the remains of the ancestral dead lie in wooden grave houses). The smoke

from the hearth escapes skywards via a central smokehole. Women utilize the left side of the house and men the right. The front of the building is for low-ranking people, while the rear is a place of power that is used ceremonially by the house chief. The vertical directions, up and down, are also crucial. The Haida believe in three worlds: an underworld, the world on which people live and a sky world – during some ceremonies, a cedar sky pole is raised through the smokehole to be climbed by a shaman drawing upon his sky powers.

Native people, then, are adapted in intimate ways to their landscapes, but their outlook is one of timelessness – they do not see the world in terms of linear sequences of cause and effect, nor in a temporal framework that has a beginning and an end. Extraordinary events are always tied to place, and with them comes a constellation of symbols that transcends normal temporal dimensions. Such events have creative force, and so do their symbols, which are timeless. Although the human actors may change, the fundamental principles of events never do: the sun always moves in the same direction; the stars always rise in the same pattern; and people are born and die. Events take on the character of immutable natural laws that are eternal realities of life in the passage from day to day and season to season. Time needs to be renewed through rituals that complete the cycle. This does not mean that American Indians do not understand or ever use chronological or calendrical time – of course, they do – only that life's most important events are not connected to that way of thinking.

Throughout Native North America the seasonal round of activities for daily life and ritual follows the pattern of the natural cycle. Nowhere is this better demonstrated than among the peoples of the Southwest. Pueblo, Hopi and Zuni life is oriented around events that are synchronized with the agricultural cycles, from summer solstice to winter solstice and back. The Zuni word for solstice, *itiwana*, means middle or centre, a name the Zuni also apply to their village, the centre of the world.

TRANSFORMATIONS

For Native North Americans, the boundaries between the world of the spirits and the world of living people were not clearly defined: a third, "in-between" world of transition separated them. Every entity to some degree inhabited all three of these worlds. If a human carried out appropriate rituals, he or she could be transformed into a being from one of the other two worlds.

Such transformations often duplicated events of the "beginning time", when the world came to be as it is through the agency of culture heroes and tricksters (see pages 180–181). On ceremonial occasions, an individual might assume the appearance of such a figure and be thought, literally, to become that being. When a Blackfeet holy man put on a yellow bear hide, for his audience he actually was the bear.

For many of the peoples of the Northwest Coast, the supernatural beings that shaped the world in the beginning time often changed themselves into animal or human form or took possession of people. Such beings were not always benign. In some dances, elaborately painted two-layered masks were used to illustrate the shapeshifting. The outside mask might depict the head of a salmon. During the dance, the dancer pulled a string to open the mask and reveal an inner mask depicting the *sisiutl*, a fearsome double-headed primal creature with a human face in the centre of its body. It can turn people to stone or make them vanish, but if it is killed properly and made into a belt it has awesome protective power.

Such masks were not just exquisitely carved, different-looking masks. They often depict humans possessed by supernatural beings. It is said that the dancer can feel the spirits, who are believed to be carved into what he wears. A three-stage mask might show a bull seal becoming first a sea raven and then a man, while a two-stage mask could be Raven becoming Raven of the Sea, accompanied by sharp-

▶ Transformation masks were used by many Northwest Coast tribes. They were opened at appropriate moments in the dance to reveal different aspects of the figure the dancer was impersonating. This Haida Thunderbird mask (shown opened) opens to reveal a human face, expressing the dual human/animal nature of the spirits.

Many groups possess respected specialists referred to as "sacred clowns", who at sacred ceremonies would undergo transformation into disruptive, clownish figures. For example, during the Mandan Okipa ceremony (see page 212), a figure called Foolish One would bring great delight to the audience by imitating a mating male buffalo bull before being unceremoniously driven from the village. The behaviour of the clowns was often intended to be instructive – teaching by bad example. The Zuni Koyemshi warned against greed by their grotesque gluttony. The Lakota Heyoka were more obviously comic – for example, they might ride a horse while facing backward or swim in icy water and complain how hot it was.

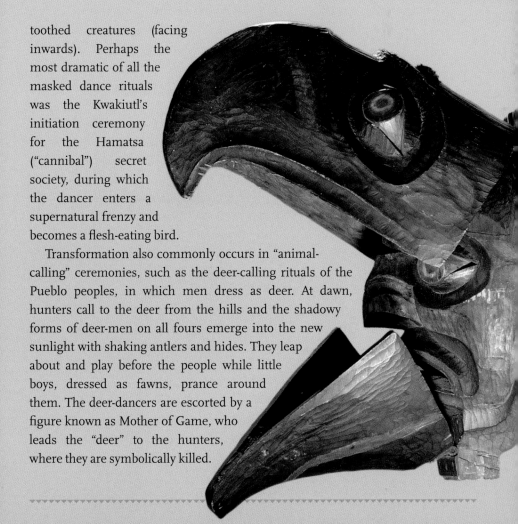

toothed creatures (facing inwards). Perhaps the most dramatic of all the masked dance rituals was the Kwakiutl's initiation ceremony for the Hamatsa ("cannibal") secret society, during which the dancer enters a supernatural frenzy and becomes a flesh-eating bird.

Transformation also commonly occurs in "animal-calling" ceremonies, such as the deer-calling rituals of the Pueblo peoples, in which men dress as deer. At dawn, hunters call to the deer from the hills and the shadowy forms of deer-men on all fours emerge into the new sunlight with shaking antlers and hides. They leap about and play before the people while little boys, dressed as fawns, prance around them. The deer-dancers are escorted by a figure known as Mother of Game, who leads the "deer" to the hunters, where they are symbolically killed.

THE POWWOW

The word powwow refers to a traditional large tribal or intertribal secular gathering that encompasses singing, dancing, giveaways and honouring ceremonies. The modern meaning is a specific type of event where people socialize and honour Native American culture.

Powwows are dramatic public expressions of Indian identity. Sometimes they are open to the general population, but more often they are geared towards Indians themselves. Intertribal powwows are obviously larger than tribal ones, but whatever its size, the powwow is an important vehicle for handing down Indian traditions from one generation to the next.

There is a well-established "powwow highway", or circuit, and Indians travel across the country from late spring to early autumn in order to take part in intertribal powwows. As pan-Indian events, these powwows enable tribal members to foster close relations with other tribes and they are therefore a demonstration of Native North American solidarity as well as a powerful expression of Indian culture.

The event, which is focused on a central arena, or "arbour", usually begins with a grand entrance when the various categories of dancers – traditional, grass, fancy, female, jingle dress and youngsters – enter the arena dressed in all their finery. The opening procession is often led by military veterans, who will conduct a flag-raising ceremony and a brief invocation. The honour guard will probably be bearing the Stars and Stripes and the feathered staff, to represent the combination of United States patriotism with traditional Indian values.

War dances usually follow, along with other types of dances, such as round dances, grass dances and rabbit dances. Many of these dances are specifically designated as intertribal affairs. With colourful regalia of shawls, beadwork, bustles or elaborate headgear, powwow dancers proceed gracefully

▼ Pages 130–131. Dancers in colourful feather bustles at a Native American powwow, whirling to the steady pulse of the drums and the powerful falsetto melodies of the traditional Indian male singers.

around the arena, a steady drumbeat directing their movements. Many powwows include dance competitions (see page 131). Contestants often travel great distances to attend these events, which offer substantial cash prizes for dancers and drummers.

HONOUR AND FRIENDSHIP

Another powwow highlight is the giveaway, at which one individual or family presents another with gifts that may be as elaborate as the handmade "star" quilts of the Lakota or as simple as kitchen utensils. A giveaway is one way of acknowledging people who have distinguished themselves, such as university graduates, military personnel and community leaders. Someone who has helped a family during a crisis, such as a period of mourning (including those lost on active service for the military), might also be honoured. Giveaways usually take place in the afternoon, between dances. The powwow announcer will state the reason for the giveaway, who the donors and recipients are, and will then call for an honour dance. The participants then shake hands and the programme of powwow dancing resumes.

At a powwow, socializing is as important as dancing. It is an occasion for Indians, who may belong to many different tribes, to renew old friendships, and they may sit down together for a feast at which traditional Native American foods, such as bison, venison, corn stew and fry bread, are served. There may be prayers and political speeches, and people sometimes take advantage of the occasion to make extra money by selling handicrafts.

Dance and musical styles, foods and regalia vary between tribes and regions, but Plains styles are now the most common. Powwows have become so popular that today they are practised in parts of North America that never had such cultural events before, as far north as Alaska.

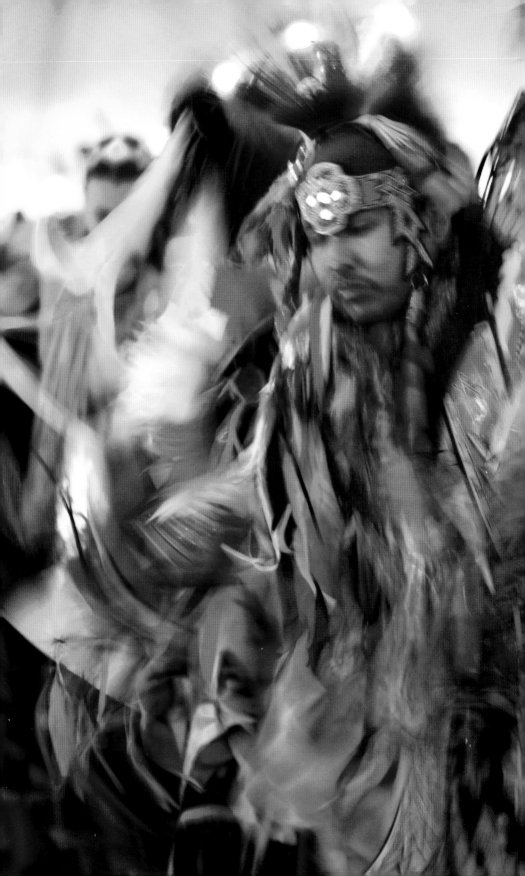

CELEBRATING NATIVE LIFE & TRADITION

American Indian dance competitions have categories that may include "traditional", "fancy", "grass", "shawl" and "jingle dress". Entrants dress in an appropriate style: for example, a male fancy dancer dons feather bustles and beads, while a female shawl dancer wears a long-fringed shawl over a beaded dress, moccasins and leggings. Jingle dress dancers get their name from the tinklers adorning their regalia. The judges, who are usually former powwow dance champions, mingle among the competitors and judge mastery of style as well as the ability to keep time with the song and to end on the last drumbeat. A winner often dances a solo in front of a cheering crowd.

HOLY PEOPLE

Direct contact with the world of the gods and spirits is important in most traditional cultures, and religious practices that are based on a personal totem play a vital part in the daily lives of many Native Americans.

Communication with the spirit world is achieved principally through the "vision quest", a process of solitary fasting and prayer in a remote place, by means of which a person hopes to attain a vision of a guardian, which generally appears in the form of an animal or one of the elements (see pages 228–229).

Although many individuals may experience visions or acquire power from guardian spirits, only the most powerful will become healer-priests who are the chief intermediaries between human beings and the sacred world (usually after he or she has been "seized" by spirits). Many Indians dislike the term "shaman" because it derives from a foreign culture – the Tungus people in eastern Siberia – and does not reflect the diversity of Native specialists, who are probably best referred to as "holy people". (Weather doctor, medicine man/woman and curandero are other terms, depending on skill/speciality.)

Holy people range from a person who, without especially seeking it, has a powerful vision of the future, to a busy practitioner who is in touch constantly with the spirits and attempts to influence or even impose his or her will on the supernatural. The path to this sometimes begins when the individual falls ill and undergoes a visionary death and rebirth, during which he or she acquires sacred knowledge from the spirits and is then apprenticed to a holy person to learn skills.

The relationship between a holy person and the spirit world is almost that of a personal religion. The first meeting with the spirits becomes the personal myth, and the power of this myth is important for establishing the holy person's credentials with the tribe, on behalf of which his or her skills are used to locate game, find lost objects and, above all, treat the sick. The

▶ A portrait of an Arikara medicine man, taken in 1908 and published a year later in volume five of *The North American Indian* by Edward S. Curtis. The man is called Kunuh-Kananu, or Bear's Belly, and he is wearing the skin of a bear he has killed. This act meant that he had received shamanic powers from that sacred animal's spirit. Bear's Belly is also identifying himself as a member of the Bear Clan.

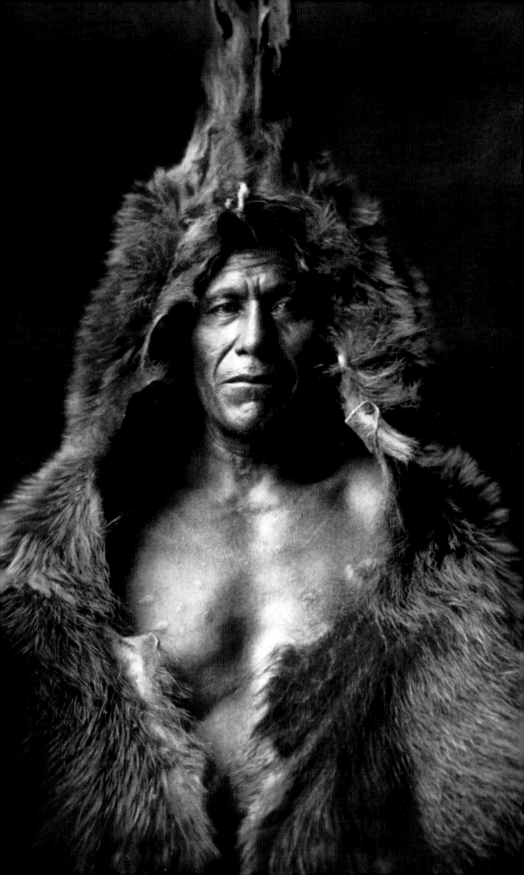

holy person can enter a trance at will and journey to the sacred world. Visible representations of the spirits are found in the "medicine bundle", a collection of spiritually significant objects used in curing rituals. In general, holy people act for the good of their people, but they may use their abilities to harm those identified as enemies of their people.

CURER OF SICKNESS

Among the most important tasks of a holy person is to provide for their people's well-being by preventing, diagnosing and curing illness. The Western Apache believed that some of the most serious maladies were due to improper behaviour towards holy things, striking when someone violated the taboos associated with things in which sacred power was believed to dwell. For example, boiling a deer's stomach, eating its tongue or cutting its tail off a hide offended Deer. Stepping on a snake's tail or leaning against a lightning-struck tree also caused sickness. Some taboos (against urinating in water or defecating in a cornfield) had an obvious practical value.

When someone fell ill, a holy person was called in to find the cause and to cure the sickness. Curing ceremonials among the Western Apache were community endeavours. The holy person or another elder would tell stories surrounding the origin of the ritual in order to focus the minds of the audience and to reaffirm their belief in the powers that were at work. The ceremony itself began dramatically, with fires and beating drums. Following this, the holy person would enter the patient's home, sit by the fire and chant, while the patient sat motionless for nearly two hours. There was then a break, in which the curer and the audience ate and drank *tulpai*,

◢ A Haida raven rattle, originally a powerful instrument that was used by a holy person, but over time it became associated with the dance regalia of chiefs. The rattle is carved from wood in the shape of a raven with a figure of a holy man on its back. The man is joining tongues with a small figure, indicating an exchange of potency with a spirit familiar. The head of a hawk is carved on the lower part.

THE MEANS TO HOLY POWER

Among the Crow of the Plains region, most adult men actively sought visionary power. They would engage in bodily deprivation, even self-torture, to induce visions and there was no social stigma attached to failure. If they succeeded, they would expect to gain special power in battle or to become wealthy (by, say, acquiring horses).

For the Washo of the Great Basin, holy power came unsought and unwanted. The first signs appeared in a series of dreams in which an animal or a ghost might feature. This vision would offer power for life. The Washo feared such power because it was dangerous, and the better defined the power the more dangerous it became. A man might ignore the offer, but in this case a spirit being, or *wegaleyo*, might inflict ailments on the dreamer. When the subject finally relented, the *wegaleyo* would instruct him in dreams, telling him his own unique holy song or chant, the objects to be used in ceremonies, and the location of a secret pool for ritual ablution and other sacred practices. The subject would be required to seek out a recognized holy man who could instruct him in the arts of sleight of hand, ventriloquy and other skills needed for ceremonies.

Among the Upper Skagit of the Plateau, shamans became known only when they practised publicly. They themselves chose whether or not to become shamans, after acquiring the necessary spirits through fasting or visions. Many Upper Skagit holy people waited until middle age to acquire the power, when they might inherit the shamanistic spirit of a deceased relative.

a fermented corn beverage, while the patient struggled to remain awake. In the small hours of the morning, the chanting started again, invoking the powers of the black-tailed deer and the beings known as the *gahan*. As dawn broke, the holy person stopped chanting, sprinkled the patient's head and shoulders with cattail pollen and then stroked his or her forehead with lightning grass. Exhausted, the holy person then sang two more chants, and the ceremony came to an end.

Among the Athabaskan Tanaina of the Subarctic, a curing involved a ceremonial performance to frighten away the evil spirits that caused sickness. Crucial to the process was an ability to go into a trance and converse with the spirit world. With the help of a particular guardian spirit, the holy man was able to ascertain which spirit had caused the problem; he would then intimidate it with a show of his power.

Many holy people use medicinal plants in their practice. He or she possesses a substantial knowledge, gained through apprenticeship, of pharmacologically active herbs and plants that can effect medical cures.

THE ART OF DIVINATION

Another type of holy person is the diviner. Divination, the art of finding things out, is an esoteric religious activity. A diviner can discover the cause of witchcraft, help to find something that has been lost or stolen and predict the outcome of a hunting party. The diviner might help a healer to discover which taboo the patient has broken and might also prescribe the correct procedure for treatment, down to the timing of rituals and which holy person to call upon for assistance.

In the Northeast, the Huron had three types of diviner, all highly respected and well paid. One type found lost objects, another could predict future events and the third cured sickness. The diviner might seek revelations by gazing into a bowl of water or into a fire; some went into a frenzy, fasted or secluded themselves in a dark sweathouse.

The most common form of divination among the Navajo is "hand-trembling". When a person falls ill, a visit is arranged from a holy person known as a hand-trembler. The hand-trembler sits down by the patient. After washing his or her hands and arms, the hand-trembler takes pollen and, working from right to left, puts it on the soles of the patient's feet, then on the knees, palms, breast, between the shoulders, on top of the head and in the mouth.

Next, the curer sits about three feet (1m) to the right of the patient and, starting at a vein on the inside of his or her own right elbow, traces pollen along the arm, down to the fingertips. As the curer does this, he or she prays to the underworld serpent Black Gila Monster to tell the curer what is wrong. When he or she sings a "gila monster song", a hand and arm will tremble, sometimes violently. The curer then interprets the trembling to discover the information that is being sought.

▶ A modern Indian mask on display in the Epidemic Memorial Exhibit at the state history museum in Tacoma, Washington. Contact devastated the Native American population (who called it "The Big Sick") as communities were ravaged by influenza, measles and smallpox. More recently, problems such as alcoholism and suicide have plagued Native populations still dealing with the loss of their lands and cultural heritage.

AS SWIFT AS "SKY DOGS"

When the Blackfeet of the northern Plains first saw a horse, they thought it was like a dog, except larger and swifter. The Blackfeet thought of it as a wondrous gift from the spirits and decided that Old Man, the creator, must have sent the creature from the sky as a gift.

The Blackfeet called the horse "Spirit Dog" or "Medicine Dog" because, as a Spaniard travelling with Francisco de Coronado wrote in 1541, the Plains Indians traditionally transported their goods by dog, using it to haul a device that the French called a travois, which consisted of two long poles with the load suspended between them. Although dogs had long been companions to humans, those small animals could not match the capabilities of the "sky dogs", which could carry a grown man, pull a transport of *tipi* poles loaded with possessions and run as fast as the buffalo. The Lakota chose to call them *shunka wakan*, or "holy dogs," reflecting the seemingly supernatural potency that a horse's physical power exuded.

The Plains horse, a short, stocky, shaggy descendant of the mixed Andalusian and Arabian breeds introduced by the Spanish, was a liberating force in the agricultural villages and hunters' camps of the Plains. The new animal brought a fantastic increase in power and mobility, quickly becoming indispensable to hunter and warrior alike.

The Spanish had first introduced horses to the Southwest, but it was on the vast, open Plains where the animal had the greatest impact on the lives of the peoples that acquired them. Tribes that had hunted buffalo communally on foot shifted to fast-paced outings conducted by individuals on horseback, which enabled a good hunter to kill a number of animals quickly. Among many Indian tribes, horses became a measure of wealth and status. The Crow were renowned for their quantity of horses, while the Comanche and Cheyenne gained a formidable reputation for their riding abilities.

▼ **Pages 140–141.** Shoshoni men in traditional warrior dress on horseback at sunset. By the beginning of the 19th century, a horse was a highly prized belonging among warriors in the Plains and Plateau regions. Some war chiefs owned herds of more than 1,000 horses, and there was a Comanche band of 2,000 people that had 15,000 horses.

WHY WARRIORS REVERED THE RAPTORS

Although all birds are honoured, raptors are accorded particular respect, with eagles the most revered. Soaring high in the sky, many peoples associate the eagle with the sky gods and the weather. Seasonal rituals, perhaps featuring eagle dancers, are one way that homage is paid. The eagle's swiftness, endurance, keen eyesight and ferocity as a hunter made it an obvious icon of the warrior – eagle feathers symbolized achievements in battle, while parts of an eagle might feature in a medicine bundle or be used to adorn a *tipi* and thought to bestow spiritual power on its owner.

Horses were most often used by men, who were warriors and buffalo hunters, but many women also owned them. Horse and rider had to be agile for the buffalo hunt and for competitive intertribal struggles, such as horse raiding, that became a feature of Plains Indian life. People and horses grew together: children rode ponies and quickly learned how to master the equestrian skills useful in adult life. The ability to slip down the side of a galloping horse was an essential skill, because in battle the side of a horse was a vital shield.

Hunters and warriors rode bareback or used small, light saddles stuffed with buffalo hair or grass. For more casual riding, Plains people also made a heavy wooden saddle. Reins were made from braided rawhide and a bit from a piece of rawhide looped through the lower jaw. A man's skill at handling his mount gave him considerable standing in his community, and the younger generation today has proudly tried to maintain this aspect of tribal culture.

By the beginning of the nineteenth century, a new, dynamic Plains culture had emerged in which the horse was a potent tool, a symbol of status and wealth, and an expression of tribal pride. The horse was a prestigious possession. A man presented horses to a woman's family when he married her; horses bore the symbols of the warrior and tribe into battle. Like the battle honours painted on the sides of a fighter plane, a horse might display hoofprints to represent previous raids, and handprints to signify enemies killed in combat.

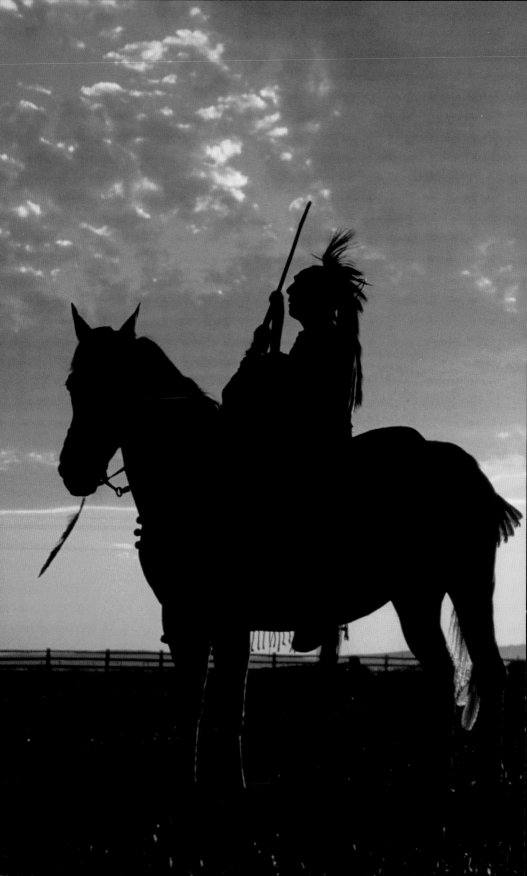

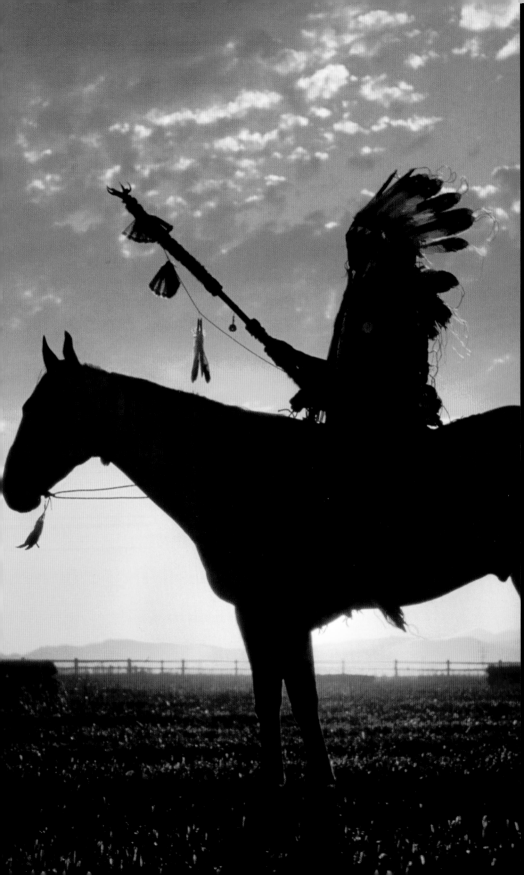

DREAM VOYAGES

Dreams come unbidden when one is asleep and the soul is roaming free of the body. Many Indian tribes regard dreams as a layman's form of the more purposeful and specialized soul journey undertaken by holy people.

Native Americans make no rigid distinction between dreams and waking visions. The Zuni of the Southwest region regard dreams as having a bearing on real events. An action in a dream is incomplete until its counterpart has taken place in waking life, and many crucial actions are based on a preceding dream. People thus try to influence events. After receiving a good dream, they tell no one until it has been fulfilled; on the other hand, a bad dream is shared in the hope of forestalling its fulfilment.

In the Northeast, the Huron believed that there was little difference between the world of daily life and that of dreams. The soul had intense hidden desires that were often revealed in dreams, which were said to be the language of the soul. Dreams were seen as real, because during sleep the soul was thought to leave the body and travel to the place where what was being dreamed about actually existed. The dreamer might be given information, instructions, messages, or even be shown the future. If the dreamer failed to heed the dream, the soul became angry and caused illness and misfortune. As a result, the Huron paid particular attention to any dreams that occurred just before they went hunting, fishing, trading, or to war. So much did they rely on dreams for guidance in everyday life that the first Jesuit priests to contact the Huron described dreams as the tribespeople's main god. Sometimes advice received in dreams was followed in preference to advice given by the tribal chiefs. However, not all dreams were assumed to be reliable – public confidence in an individual's dream varied according to his or her social status and how many of that person's earlier dream predictions had come true.

The soul had intense hidden desires that were often revealed in dreams, which were said to be the language of the soul. Dreams were seen as real, because ... the soul was thought to ... travel to the place where what was being dreamed about actually existed.

DREAMCATCHERS

In Ojibwe (Chippewa) culture, a dreamcatcher is an object based on a willow hoop, on which is woven a loose net or web. (The Ojibwe words are *asabikeshiinh*, the inanimate form of "spider", or *bawaajige nagwaagan*, meaning "dream snare".) During the pan-Indian movement of the 1960s and 1970s dreamcatchers were adopted as a symbol of unity and general identification with Native American culture. However, some Indians regard them as over-commercialized.

Originally, the Ojibwe hung a protective charm called a "spiderweb" on the hoop of an infant's cradle board. The small wooden hoop was filled with fine yarn, in imitation of a spider's web, usually dyed red. Two "webs" were usually hung on the hoop and it was said that, just as a spider's web catches and holds whatever comes in contact with it, these would catch any harm that might be in the air.

Later, the Ojibwe made dreamcatchers by tying sinew strands in a web around a small frame of willow (similar to their method for making snowshoe webbing). The resulting "dream-catcher" was hung above the bed as a charm to protect sleeping children from nightmares. The willow and sinew was not meant to last for ever but was intended to dry out and collapse as the child grew older.

In the course of acquiring popularity well beyond the Ojibwe, "dreamcatchers" are now made and sold by those in the New Age movement, which many traditional Native peoples regard as an undesirable form of cultural appropriation (these examples, below, are pictured in the Southwest region's Monument Valley).

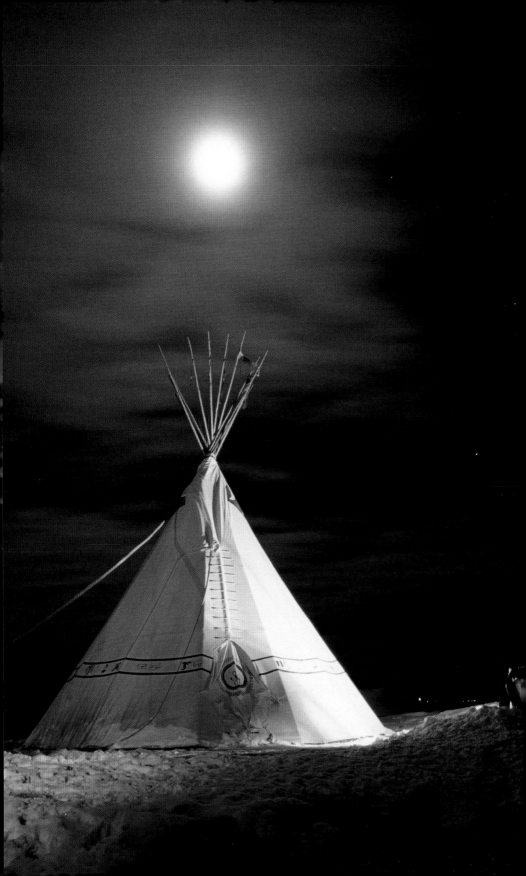

SYMBOL, MYTH & COSMOS

In spite of the variety of Native North American belief systems, the continent's many indigenous peoples share a great deal of sacred history and wisdom. From creation stories to the part played by natural cycles in influencing their world-views – the cultural narratives that explain the relationship between the natural and supernatural – certain important themes recur. Interaction with the environment and all its life-forms has fundamentally shaped Indian life, domestic culture, artistic practices and decorative techniques. The result is a sacred unity of all things – an interdependent cosmos whose richness and variety are celebrated in order that things might continue to exist in their bountiful and harmonious cycle.

For many Indians, the stories that relate the history of the Earth, the origin of the people and the lives of the ancestors and sacred beings are real. These figures and the great events of long ago have left enduring marks on the landscape, and they are celebrated in songs, dances, stories and artistry. Accounts of the struggles of the first people may tell of supernatural beings that helped the people on their sometimes arduous journey to their homeland from their place of origin, or brought them light and fire, or protected them from the wrath of destroyers, or bequeathed essential skills. And once established in their domains, people learned how to exist harmoniously with the plants and animals so that they could continue to flourish for generations to come.

WORLDMAKERS & EARTHDIVERS

Native North American creation stories are filled with people, animals and supernatural beings in human or animal form. Cosmic events draw upon the full range of human experiences as the narratives attempt to make sense of the beginning of the world.

Despite the diversity of cultures in North America, there are relatively few types of myth about the creation of the world. Most Native American peoples attribute the conception, if not the making, of the universe to a supreme divinity or "Great Spirit". This being is greatly revered, but is too passive and vaguely defined to be regarded as a distinct personality (see also pages 82–85). Often its role is only to create more definite figures, such as the widespread deities Mother Earth and Father Sky, who are charged with further acts of creation while the supreme god withdraws to heaven.

Accounts of creation were maintained by oral tradition, and Native holy people and storytellers recreate them during the course of repeated tellings, often incorporating new elements acquired from dreams, visions and contemporary experience. In the last five centuries the teachings of Christianity and pan-Indian religious movements have also influenced the stories about the beginnings of the world.

Some tribes believe that the beginning was a featureless void, and the actions of gods brought the world into existence. In Apache accounts, Black Wind made the Earth and Yellow Wind gave it light, and a host of other gods contributed forms of life and the features of the landscape. Other peoples believe that the world has always existed, but that in the beginning it was a flat, featureless plain, shrouded in darkness until the intervention of a Creator or Great Spirit. For the Shasta of California this figure was Chareya (Old Man Above), who bored a hole through the sky and climbed down to the Earth on a pile of ice and snow that he pushed through the hole.

◢ **Page 144. *Tipi* under a full moon, Colorado.** Traditionally, *tipis* were mainly painted with battlescenes, animals or geometric portrayals of celestial bodies.

▶ A detail of a shield decorated with a turtle and eagle design. The amphibian turtle links land and water; capable of flight, the eagle links humans to spirits and the sky. Plains Indian, Cheyenne.

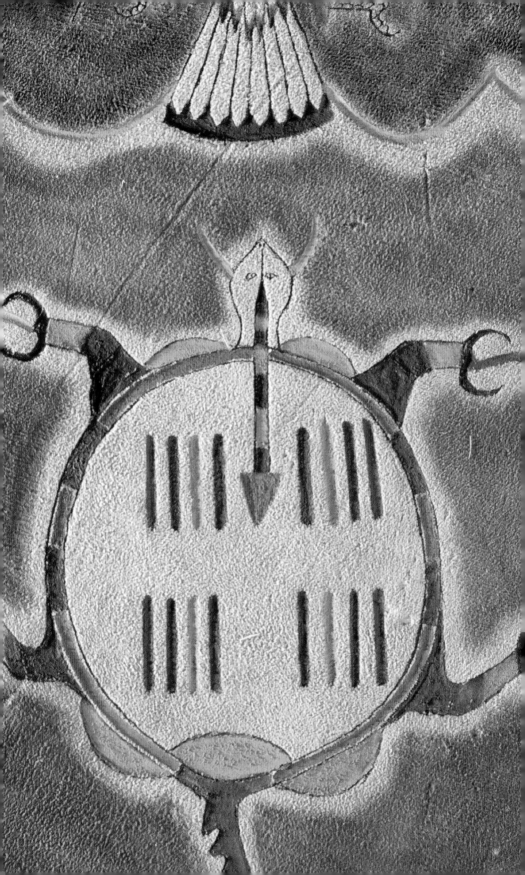

The sun shone through the hole and melted the ice, creating the sea, lakes and rivers. Chareya planted trees, and from their leaves he created birds.

For the Salishan-speaking peoples in the interior of British Columbia the view of the Earth as a living essence personified as Mother Earth is a genuinely ancient tradition. They relate that a great spirit, Old One, made the Earth out of a woman. This woman lies spread out on her back and people live on her. The trees and grass are her hair, the soil is her flesh, the rocks are her bones and the wind is her breath. When she feels cold, winter comes, and when she feels hot, it is summer. When she moves, there is an earthquake.

LAND FROM THE ENDLESS SEA

It is common for Native Americans to look around them for clues to the sacred images, voices and events of the time when things came into being. Familiar animals are often said to play a crucial role in the creation process – for example, in scattered parts of the West the Spider is said to have woven a web which eventually formed the Earth. According to others, this creative change was due to the action of a hero or trickster (see pages 182–195), usually in animal form. A tale from the Nez Percé features Coyote, who can be both trickster and hero. After slaying a terrible monster, Coyote decided to celebrate by creating human beings. He scattered pieces of the monster's body, and in each spot where a piece of corpse landed, a tribe of Indians appeared. When his friend Fox pointed out that Coyote hadn't created a tribe at the place where he killed the monster, he was sad because he had no parts left. He cleverly wiped the blood from his hands and let it drip to the ground, declaring: "Here I make the Nez Percé; their numbers will be few, but they will be strong and pure."

But probably the most common heroic creation story is the "earthdiver" myth, which is found all over the world and most often told by hunting and gathering peoples, who draw upon their rich and profound relationship with the creatures of the

People lived in a sky world above this one, where there was a great sacred tree. After the sky chief's wife dreamed that the tree was uprooted, the ... woman fell through the hole to the world below.

THE MUD-CARRYING TURTLE

The Arapaho tell how Flat Pipe was tired of being in water all the time. He asked some ducks to help; they dived down and brought up some mud, but it was not enough. Flat Pipe then asked Turtle and he brought up enough mud, which is how dry land came to be. The Cheyenne have a similar story about Maheo ("All Spirit"), who created the Great Water together with water creatures and birds. The birds grew tired of flying and took turns to dive to look for land. They failed, until finally the coot tried. When he returned, the coot dropped a little ball of mud into Maheo's palm. As Maheo rolled the mud it expanded and soon there was so much only old Grandmother Turtle could carry it. On her back the mud continued to grow; in this way the first land was created.

woods, deserts or grasslands. That farming groups, such as the Iroquois, also share this tradition suggests that the story predates their adoption of an agricultural way of life.

In many Native American versions of the genre, the Earth begins as an endless watery chaos with no dry land. A being asks various creatures to dive to the bottom of this primeval ocean to bring up mud. Eventually, one succeeds, and the dry land (our world) is formed from the mud it has retrieved. These animals are sometimes small, unassuming heroes. For example, in the Cherokee account the earthdiver is a water-beetle, while the Chickasaw say it is a crawfish, the Iroquois a turtle and the Cheyenne a coot.

According to an Iroquoian story, there was once no earth, only an endless sea. People lived in a sky world above this one, where there was a great sacred tree. After the sky chief's wife dreamed that the tree was uprooted, the chief heaved it out, leaving a hole where the roots had been. The woman fell through the hole to the world below. Two swans caught her, but there was no place to put her down. Several birds and animals took turns to retrieve soil from the bottom of the sea. They all failed, but then the muskrat tried, and when it floated back to the surface, almost dead, it had a little mud in its paw. A turtle took the mud on its back, and the soil grew into a new world, upon which the swans gently let the sky woman down.

PEOPLING THE EARTH

Common to most Native American origin myths is the sense that human beings were created as the companions rather than the masters of other creatures. In the mythical time, people, animals, all things that grow, and the rocks and earth of the world itself, are created equal.

Some Native American cultures portray a world in which people are made before anything else comes into being, while in other traditions human beings are made at the end of a long process that involves the creation of plants, animals and natural features. These primal days are seen as a time when people and animals often shared thoughts and language; when vast, often vague, creative powers could achieve anything; when creators such as Raven, Coyote or Old Man walked the earth and made natural features, animals and people as they are today.

THE PEOPLE-MAKER GODS

Most typically, making the first people is attributed to a divinity involved in the creation of the world. The Pawnee relate how Tirawa, their primordial divinity, ordered the Sun and Moon deities to unite and produce the first man, while the Morning Star and Evening Star were told to bring forth the first woman.

Among some peoples of the Southwest, the supreme divinity is said to have created the gods Mother Earth and Father Sky, who in turn mated to create the first living beings, including people. The Hopi ("The Peaceful Ones") tell how twin deities first created the animals and then moulded humans from clay, bringing them to life with a ritual chant.

According to the Iroquois and Huron of the Woodlands, the first human ancestor was a woman called Ataensic, who was the offspring of the Sky People, vague beings who are neither real people, nor spirits, nor gods.

▶ Spindle whorls were used by the Coast Salish people during spinning to prevent the wool slipping from the spindle. This wooden whorl is decorated with a human figure in a foetal position, a common motif in Northwest Coast design, and two otters.

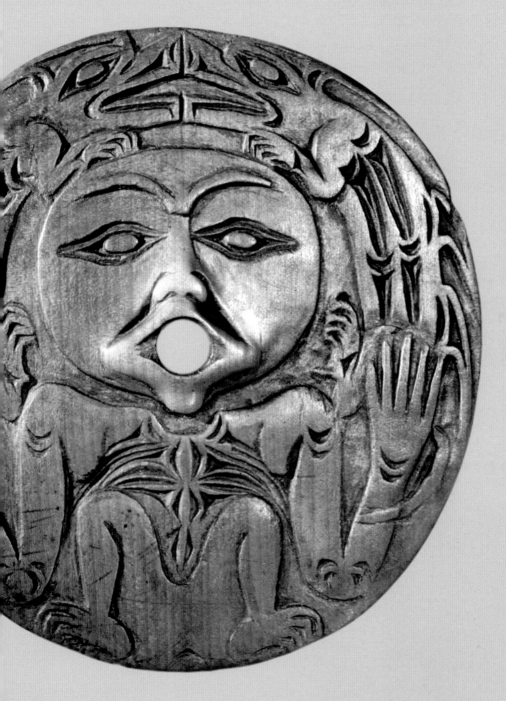

Many origin stories describe the first people as helpless beings, physically deficient or technologically naïve. In these myths there are several variations: an all-powerful creator brings people to perfection; the people have to sort themselves out; or human survival depends on the outcome of a struggle between rival spirits. The origin myths of the Blackfeet of the Plains describe how people were made by Old Man, the master spirit who "travelled around making things as he went". The first people he created were a woman and child, whom he fashioned from clay. They were poor and naked, and Old Man had to teach them how to gather food and hunt. However, the people had no arms and the buffalo would chase them. Scornful of the people's timidity, Old Man gave them arms and taught them to make weapons. From this time on, they were able to hunt the buffalo for food and leather.

The early people described by the Cheyenne of the Plains are placed by their creator, Great Medicine, in a "beautiful country" where people, animals and birds, who were all friends and had a common language, came into being at more or less the same time. The people went naked and were never hungry until the Earth was struck by floods and earthquakes. The ancestors were then forced to dress in skins and hunt for their food. Great Medicine eventually took pity and brought them corn to plant and buffalo to hunt.

HUMANS AND ANIMALS

This image of a primeval idyll, in which the first people are often no different from other animals, share the same food and land and speak the same language – an age without sickness and death – exists in various cultures. It lasted until a trickster changed things and made life as later humans have always known it. Some Inuit in Alaska tell a creation story in which Raven-man harpooned the land and pulled it up from the water. On the land he found a small dwelling with a man and woman in it. People, the story suggests, were simply there all the time, from the beginning of creation.

▷ A 10th-century Mogollon culture ceramic bowl in the Mimbres style with a drawing representing the miracle of childbirth.

Expressing a similar view, that people have always existed, are many of the stories of the Great Lakes area Winnebago Indians, in which people, animals and a semi-divine trickster all live together at the beginning of time. And although people and animals may take on different roles in particular stories, human and animal natures are not essentially different from each other. The beings who existed at the dawn of time combined human nature with that of the creatures whom later Native Americans knew and often hunted. This vision of the first people is sometimes set in a blank and featureless landscape, such as the one produced by the Alaskan Raven-man, and sometimes in a primeval world presided over by a god-like creator. In this world, often half water and half land, the creator thinks, dreams or sings the people into existence.

EMERGENCE FROM BELOW

Other stories relate how the first people emerged from the ground, as crops do, before spreading out to their present habitats. Such accounts are more common among agricultural peoples – for example, the Hopi and Pueblo peoples of the Southwest, whose tales describe a struggle for existence that takes the form of a migratory journey upwards through several levels of the underworld to the present sunlit world (see page 15). No doubt the necessary preoccupation of peoples with the life-giving crops that pushed up through the aridity of the Southwestern scrub gave a vivid plausibility to mythical images of the first people "coming up" from a deep and dark

underworld – a place of suffering, and one that had become ever more uncomfortable and unsatisfactory.

Like the Hopi, the Navajo story of creation tells of an upwards migration through three worlds. The dark First World was the home of Begochiddy, First Man, First Woman, Salt Woman, Fire God and Coyote. Begochiddy, child of the sun, created insects, plants and five mountains. The six beings tired of this world and climbed the stem of a reed into a Second World, where Begochiddy created more mountains, clouds, plants and various life forms. Conflicts with other beings forced the six to climb the reed into a Third World, which had light, rivers, springs and abundant life.

Begochiddy created human beings, but evil magic caused men and women to fight, and Coyote stole the child of the Water Monster, who angrily caused a great flood. Again, the group climbed the reed, but it did not quite reach the next world. However, with the help of the Spider People and Locust, Begochiddy finally arrived in the Fourth World – this one – and found that it was an island in a vast sea. Four gods caused the waters to recede and winds dried the land. Begochiddy then created the world as the Navajo know it today.

Both the Hopi and the Navajo narratives often contain implicit moral guidance, with the need to travel and search for a homeland being a result of humans' own misbehaviour. In some versions, this delinquency causes the destruction of the lower worlds, leaving few survivors. Reflecting the concerns of a farming society, these myths portray the Earth as a fertile mother and all-powerful nurturer who gives birth to humans, animals and plants.

Like the ceremonies and beliefs of the Pueblo people, these Southwestern emergence myths are highly complex and detailed. The main participants are human beings who seek emergence from the underworld, and deities, including the primal creator, the sun god and the twin children of the sun. In addition, two semi-divine beings come to the aid of emerging people: Spider Woman (see pages 156–161), whose

Animals such as moles, badgers and locusts also play a part in facilitating the epic journey, burrowing through the earth or climbing the plants that rise from the lower to the upper realms.

ingenuity, or even her own silk thread, provides a path on the upwards journey, and Coyote (see pages 192–195), a trickster whose energy and skill help the travellers to overcome obstacles. Animals such as moles, badgers and locusts also play a part in facilitating the epic journey, burrowing through the earth or climbing the plants that rise from the lower to the upper realms.

In the Caddo origin story, the first man, Moon, is said to have created thousands of people in a single village in a world of darkness. With the help of Coyote, he led them up through a hole into the present world. Many of them went astray on the journey to the Caddo homeland and these people were the ancestors of other Indian tribes. Those who remained with Moon established their homeland in a place called Tall-Timber-on-Top-of-the-Hill, where, with the help of Moon, Coyote and other special beings, they gradually developed into the Caddo tribe. Over time, the speech of those who had strayed developed into different tongues, but originally the first people had all spoken Caddoan.

Because many stories about creation explain only the origin of limited, albeit significant, parts of a tribal homeland (see pages 76–80), for most Native North Americans the landscape preserves the memory of these great events so that the people may always be reminded of their identity (see box, above).

SPIDER WOMAN'S BLESSING

In the origin myths of some cultures, a female spider often plays an important role in leading the first people from their dark subterranean realm and out into the sunlight. Her friendliness results in the humans being taught useful skills, including a knowledge of weaving.

According to the Hopi, at the dawn of time Spider Woman controlled the underworld, which was the home of the gods, while the sun god Tawa ruled the sky. The pair used their thoughts to create the Earth between those two other worlds. Spider Woman moulded both animals and people from clay, before singing a song with Tawa that brought them all to life. She arranged the animals and people into the groups we still see today. She also determined that women should watch over the home, while men pray and make offerings to the gods.

"In the underworld all the people were fools." Thus begins a creation story of the Hopi people from the mesas of the Arizona desert. The people were fools because men and women could not stop quarrelling. And when the feuding sexes decided to separate onto opposite banks of a river, their society became sterile. Furthermore, the lower world was unpleasant; it had contracted; the horizon curved in on it disagreeably; it was dark; and finally it began to flood. Faced with such adversities, the people tried to find an escape route, a doorway to the sky. A prayer stick was made for Spider Woman, and by this religious act of connection with her, the people earned their ascent to "a good place to go, the good houses".

Spider Woman facilitated the emergence by breaking down the barrier between the world of darkness and water below and the world of light above. First she planted a spruce tree, but when that failed to penetrate through to the sky, she planted a reed, which did reach the upper world. Various animals then set out on an exploratory ascent. Eventually it was the locust, carrying his flute, who was the first to emerge into the open.

▶ Red was an especially popular colour with Navajo weavers. This clothing blanket can be dated to around 1870 because of the use of diamond designs. Navajo weavers have achieved international recognition for their remarkable artistic ability and spirit.

He was immediately attacked by the "Cloud Chiefs" of the four directions. After testing the locust's courage by bombarding him with lightning, the chiefs relented because he had not been distracted from calmly playing his flute. "Your heart and those of your people must be good. Go tell them to come, and all this land shall be theirs", they cried. So the people began an ascent that took them eight days.

The story expresses the Hopi people's religious beliefs: *hopi* itself means "peace" and, in accordance with this, all action should properly lead to balance, harmony and integration. The Hopi ideal is to live peacefully in a sacramental relationship with all the living things within creation. Thus it is after an act of reverence – the offering of a prayer stick – that the chief and his people come to the upper world. To this day Spider Woman remains a revered deity in the Southwest, and not just among the long-established Puebloan peoples – late incomers, such as the Navajo, also accord her high status.

THE DIVINE WEAVER

Spider Woman connects the mythology of the Navajo (in their creation story, she helps the warrior twins Monster Slayer and Child of Water to find their father, the sun), the landscape, the gift of artistry and everyday culture. The Navajo explain that Spider Woman used her supernatural powers to protect them as they emerged into the world. She is said to reside in a cave at the top of Spider Rock (see illustration, pages 160–161).

Spider Woman's husband (Spider Man) created a loom for her out of elements of the cosmos, and with this loom Spider

A SPIDER'S QUEST FOR THE SUN

A Cherokee story explains how the first people were aided by animals in their quest to dispel the gloom. The red-headed woodpecker said that someone should go to the other side of the world, where people had light, and get it from them.

Possum said he could hide the light in his bushy tail. So he travelled east, his eyes screwed up against the brightness. When he arrived, he grabbed a piece of the sun and hid it. But the sun was so hot it burned all the fur from his tail, and when he came home, he had lost the light.

Next, Buzzard went on the quest. He dived out of the sky and snatched a piece of the sun in his claws. Setting it on his head, he started for home, but the sun burned off his head feathers, and he also lost the light. When Buzzard returned home bald, they despaired. Then a small voice in the grass said: "You have done the best a man can do, but perhaps a woman can do better." They asked who she was, and she replied: "I am your Grandmother Spider. Perhaps I was put in the world to bring you light."

She rolled some clay into a bowl and started towards the sun, leaving a trail of thread behind her. When she was near the sun, Spider was so little that she wasn't noticed. She reached out gently and took a tiny piece. Placing it in her bowl, and following the thread, Spider returned from east to west. And as she travelled, the sun's rays grew and spread before her.

To this day, spiders' webs are shaped like the sun and its rays. And spiders always spin them in the morning, as if to remind people of their divine ancestor.

Woman taught the people to weave. Historically, the Navajo were almost certainly taught the art of weaving by the Pueblo Indians, who had worked with cotton for generations. Navajo women began to practise in earnest during the seventeenth century, using wool from sheep imported by the Spanish. Weaving was partly a religious ritual, its repetitive acts being accompanied by chants. In the early days of commercial weaving, women still left a small hole at the centre of their work in honour of the spider's web, but as trade increased in importance the practice was replaced by a "spirit outlet" (a thin flaw from the centre to the edge). The ability to weave remains an important part of female Navajo life and traditional culture advocates that young girls be prepared for their future by having a spider's web rubbed on their hands and arms so that their fingers will never tire of weaving.

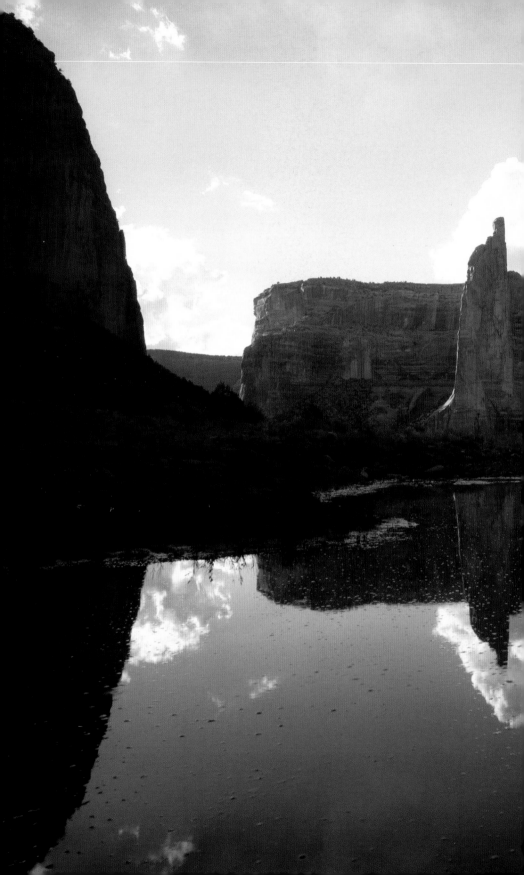

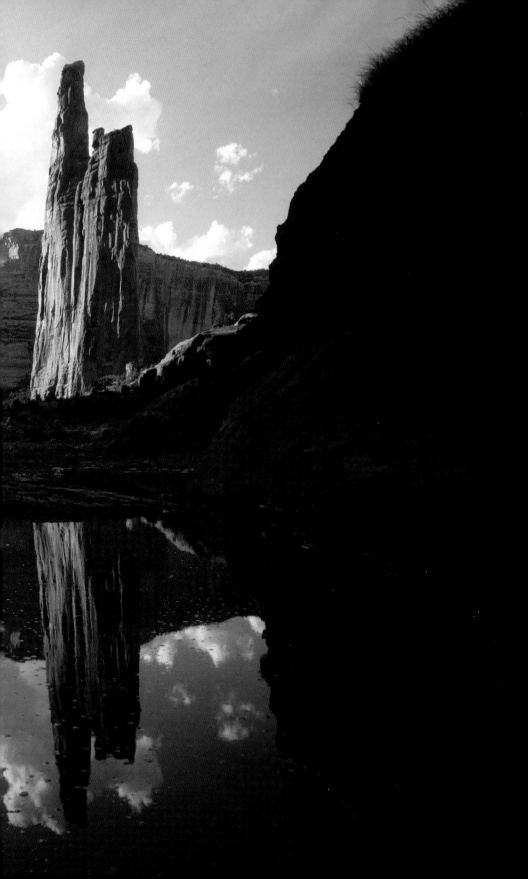

ELEMENTAL POWER

Native Americans believe that the forces of nature – which include summer, winter, rain, lightning and "the four winds" – are controlled by elemental gods and spirits to whom the various powers of the Great Spirit are delegated. Many peoples of the Great Plains think in terms of spirits of earth, fire, water or air (thunder, one of the mightiest forces, is an air god).

▼ Thunder beings are usually associated with violent weather. The Lakota believe that the Black Hills are home to their form of the thunderbird, Wakinyan, which lives at the top of Harney Peak. Its voice is the thunderclap and the voices of its children are rolling thunder.

Elemental entities feature in the lore of most tribes, but they are understood in divergent ways. The Woodland peoples divide theirs into those living above the earth and the waters and those living below. The underworld spirits, headed by dragon-like deities that are usually represented as panthers or horned serpents, are generally regarded as malevolent. The divinities of the Pueblo peoples consist of elemental gods on the one hand and ancestral spirits – intermediaries between humans and the gods – called *katsinas* on the other hand.

There are places that are said to possess a voice with a sound like thunder or crashing waters. Believed to exist at a juncture between the sky and either the earth, the seas or the forests, such sites are believed to derive their unsettling aural effects from the fact that they are inhabited by thunder beings.

FROM NIAGARA FALLS TO PILOT MOUNTAIN
The thunder beings can be mischievous, and although their residence varies it is usually a site of immense energy; this may be a general location in the sky or the mountains, but the link with the weather means it is often in the west, where most storms originate. The place may also be a location at the source of life itself. The Iroquois identify the sound of Niagara Falls as the voice of the thunder being Hinum. According to the Lakota, parts of sacred Paha Sapa once thundered mysteriously, a phenomenon that ended when the mining of gold began there. These holy hills are also home to Wakinyan, the Lakota form of the thunderbird (see page 165).

In North Carolina there is Red Man, at Pilot Mountain, which is known to the Cherokee as Tsuwatelda. The name Red Man is due to his beautiful dress of lightning and rainbows. He and his two sons introduced the Cherokee to the gift of fire, and can be helpful provided that the people pray to them.

THE THEFT OF FIRE

While unpredictable weather such as thunder, lightning and torrential rain tend to be personified by the Thunderbird, the properties of fire are expressed in stories of a primal robbery. Often, as in stories about the theft of daylight, the intrepid fire-robbers are led by a trickster animal.

The starting point of most such stories is that fire existed as a phenomenon in heaven before it reached the Earth. Many tales describe how a team of animals climb a high mountain and make off – sometimes in relay – with fire. In a southern Paiute myth, Coyote leads some birds on a mission to steal fire. By pretending that they have come simply to gamble with their hosts, the fire-thieves trick their way into the fire-owners' realm. Coyote then makes off with some blazing cedar bark tied to his hair. When chased, Coyote passes the fire first to the Crested Jay and then on to the other birds until they have outrun their pursuers. In order to demonstrate an altruistic motive, Coyote finally announces: "Let's give heat and fire to all the trees and all the rocks!" Thus wood and stone, in the form of fire-drills and flints, have produced fire ever since.

This echoes a story of the Californian Maidu people whose creator figure, Great Man, made a world which was hot. The heat melted everything, and even today there is fire in stones and trees. The Maidu tell another story that casts a being called Thunder as the fire-keeper; he has stolen it from Earth and the animals set out to win it back. After he was tricked into parting with his fire, he enlisted rain, wind and hail as quenchers of the fire-thieves' booty. Skunk then killed Thunder, calling out: "Now you must stay up in the sky, and be the thunder." Thus, fire remained on the Earth and Thunder is in the sky.

Anything struck by lightning was said to exert a particular spiritual power – to be avoided or venerated, depending on local tradition.

LORD OF THE SKIES & BRINGER OF STORMS

Among the Iroquois the fierce and sudden power that is thunder took on human form as Hino, guardian of the sky. In many other places, the spirit of thunder is believed to manifest itself as the Thunderbird, often represented as a huge eagle-like beast. This immense mythical creature, whose wings beat to make thunderclaps and whose eyes and beak generate and flash lightning, was credited with awesome powers of creation and destruction, though primarily associated with the rain that brings fertility.

Worshipped as a creator of new life, the Thunderbird was thought to inhabit craggy mountain peaks, from where it surveyed its vast hunting grounds. The Northwest Coast peoples believed it was among the chief gods of the sky, and large enough to swoop down on the ocean and carry off whales in its talons, flying inland to devour them.

People in that region believed Thunderbird was engaged in a continual battle with the malevolent spirits or serpents of the underworld – clashes which caused nature's most violent phenomena such as earthquakes, floods and great storms.

In many Plains cultures, the Thunderbird, which was known to the Lakota as Wakinyan, was regarded as a senior deity, second in rank only to the Great Spirit. There was a strong cult associated with personal experience of meeting him and images of the Thunderbird were frequently painted on shields, weapons, clothing and tents in order to inspire courage (below, a Pawnee drum, c.1890). Anything struck by lightning was said to exert a particular spiritual power – to be avoided or venerated, depending on local tradition.

HUNTERS & PREY

For most Native American peoples, survival without animals would have been impossible. Meat, skin, bone, sinew, feather and ivory supplied almost all the essential needs of daily existence.

Aside from their usefulness, animals played a vital role in the spiritual life of American Indian communities. Animals, after all, had been present at the creation and were thought to embody certain aspects of that mythical time. In some regards, animals were even envied: whereas humans had to hunt and gather in order to feed and clothe themselves, animals fed at relative leisure and did not need to make clothing or weapons. Importantly, all animals were believed to possess souls. Some

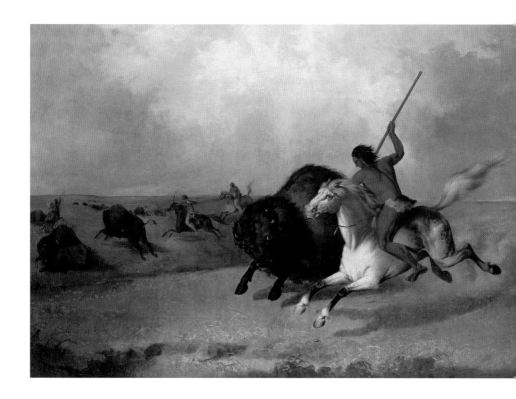

– notably the buffalo, eagle and bear – had powerful spirits that could help people or harm people according to how they were treated. Animals were therefore revered as holy beings. However, there was no contradiction in the universal Indian view that the sacred and beautiful must also be hunted, killed and eaten.

THE CODE OF THE HUNTER

It was essential for human beings to gain an intimate knowledge of the animal kingdom. From an early age, every Native American growing up in a traditional society acquired an immense store of wisdom about the natural history of the fauna in his or her locality. This included an understanding of animal behaviour, anatomy, feeding patterns, breeding habits and migratory cycles. Combined with this knowledge was a repertoire of specialized hunting techniques, and to learn these required intense intellectual and physical application. To hunt successfully meant adapting knowledge to specific situations, together with a detailed understanding of topography and environment. The consummate hunter knew where and when to stalk his prey, and at what precise moment to strike in any given weather conditions.

Moreover, this body of practical knowledge was supported by a rich fund of myth, legend, songs, rituals and local history. Without it, a hunter could not place his actions in context. To Native Americans, therefore, hunting combined a high degree of individual flexibility and initiative with a strict observation of social and religious conventions. More than simply killing and eating, hunting was an activity fraught with complex rules of conduct and spiritual significance.

It is a central belief of Native Americans that for people to survive and stay warm, animals understand that they must be eaten and their pelts worn. It is thought that in exchange for their sacrifice animals wish to be honoured at all times and

▲ The barbed head of an Eskimo walrus harpoon. The foreshaft would have been longer and probably decorated with walrus motifs to invoke success in the hunt.

◀ John Mix Stanley's *Buffalo Hunt on the Southwestern Prairies*, 1845. The horse changed Indian hunting practices, but not the respect that people had for the buffalo.

that they observe how humans behave towards them, which is why hunters show their respect for their prey. For example, among the Mistassini Cree the strongest spirits, such as that of Bear, had to be treated with particular consideration. When a bear was killed, its bones were placed on a platform in a tree so that dogs and other scavengers could not get to them. The Cree also honoured smaller creatures, such as beavers and rabbits, by tying the dead animals' skulls and feet into bundles, which they hung from trees. (These traditions also made practical ecological sense: the numbers of platforms or bundles visible allowed hunters to keep track of the quantity of animals taken and thus avoid overhunting their territory.)

HOW GAME WAS RELEASED

There are many accounts of how game was first released. The Navajo people, who were primarily hunters before migrating to the Southwest from much further north, told a story in which, before humans were created, the Holy People met in a sweatlodge to discuss how to locate all the game animals, which had disappeared. A mysterious black figure entered the lodge: no one knew who he was. Two Holy People hid and saw him put on the coat of a crow and fly away.

The assembled company decided on a ploy to retrieve the game. They would transform one of their number into a "puppy" and allow him to be carried away too. Crow duly came and carried the "puppy" to a place called Rim Hill, which was the home of Black God, to whom all the game animals belong.

The gatekeeper of Black God's house was Porcupine, who had a turquoise rod for stirring the fire and opening the gate. The "puppy" knocked him out and opened the gate with the rod. Inside, there was game everywhere: they had been herded inside by Crow, who was really Black God in disguise. With the gate open, all the animals quickly escaped into the wild.

The myth goes on to relate how, as the first four deer ran through the gate, the "puppy" touched them between their legs to create odours there. As all the other animals came

▶ A Bering Sea region hunter's birchbark shade to protect the eyes from the Arctic sun. The ivory "wings" and the visor helped make the wearer birdlike, while the amulets pleased the spirits of prey, serving as magical aids for a bountiful hunt.

CAIRNS OF THE ARCTIC GIANTS

Even the frozen lands of the far north provided rewards for resourceful hunters. Some Inuit mounted communal hunts of the migratory caribou that were central to their cultural and spiritual life, an importance reflected in the decoration of everyday objects such as bowls. Stone cairns, called *inukshuks* and meant to resemble giant humans, are placed across the herds' main migratory routes, which drives them into places where hunters can ambush them (see page 65). *Inukshuks* are also used to navigate, signal where food is cached and denote ground that is sacred.

through, "puppy" touched their noses with the wind to make them sensitive to these smells. That is the origin of an animal's ability to sense what is approaching before it appears.

TATANKA THE MIGHTY PROVIDER

On the vast grasslands of the Plains, the American bison was the source of life for the Indians who lived there. Buffalo were among the first animals hunted by the original inhabitants of the continent, and in their death they helped to sustain Indian nations for countless generations. In addition to meat, either fresh or in storable pemmican form, there was seemingly no limit to what *tatanka* (the Lakota word for buffalo) yielded: hides could be made into robes and *tipi* covers; horns could be formed into spoons; the bladder could be used to carry water; and sinew could be used for bows.

The Plains tribes centred much of their culture on this huge, black-haired animal, which was one of their most sacred spirits. There were ceremonies that called them to be hunted, renewal rituals such as the Sun Dance in which they

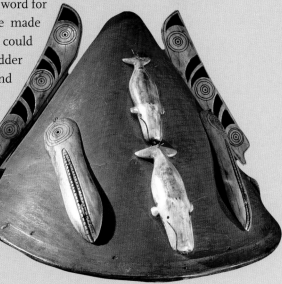

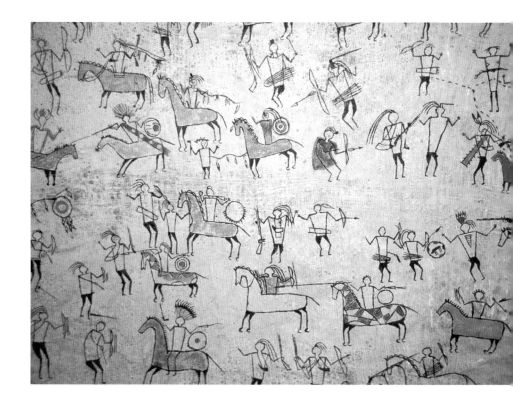

featured, and acts of veneration, such as those featuring the figure of White Buffalo Calf Woman (see pages 236–237).

For a major undertaking such as a buffalo hunt, people undertook spiritual preparations that were as detailed as the tactics of the chase itself. Plains Apache hunters were typical in taking meticulous care over the correct hunting and butchering techniques. The Apache would begin by praying that the guardian spirit of the buffalo would ensure a plentiful supply of animals. The hunters lit a sacred pipe and petitioned the animal's spirit with the following wish: "There will be many. There will be much meat. We will camp among them." The people would then sing and dance in honour of the buffalo, mimicking the animal's horns by putting their hands to their heads.

△ Aspects of the tribal history of the Shoshoni recorded on a stretched buffalo skin, one of the countless uses to which the Native Americans put body parts "gifted" to them by the bison.

At times when the herds were scarce, the Apache tried to lure prey by observing a special hunting ritual. A piece of level ground was prepared, on which a holy man would scatter dung and pollen. As the people prayed, he performed four songs and imitated the bellowing of buffalo. Other tribes would attempt to call the buffalo by displaying fetishes or performing a special dance. The Mandan would offer bowls of food to the head of a dead buffalo in the hope that a show of generosity would encourage other buffalo to give themselves to the hunters. Pueblo Indians called deer by performing a ritual in which men wearing deer costumes would act like the prey and would then be symbolically "killed".

At the conclusion of a successful hunt, butchering of the buffalo had to be conducted according to a stringent procedure, lest the animal's soul be offended and its companions avoid future hunters. First, the hide was cut along the right shoulder. The foreleg and shoulder were then severed. A slice of fatty meat was cut from the back and thrown towards the east as an offering to the animal's spirit. The remainder of the animal was turned into food and clothing.

Care and reverence were shown even in dealing with the rest of the carcass. The feet, in particular, were treated with great respect, for fear of incurring the wrath of the spirit and being trampled by the herd's hooves on the next hunt. "You, O buffalo, are the Earth! May we understand this!" goes a Lakota prayer, demonstrating the importance of *tatanka*.

Herds of buffalo were once so enormous that the ground thundered underfoot as they moved through an area. But by the late 1880s commercial hunters had driven the buffalo close to extinction – and, partly as a consequence, the buffalo-based, nomadic Plains Indian lifestyle came to an end. However, both the Indians and the buffalo have survived and many Native American tribes now raise the animals on their lands. For example, in Custer State Park in the Black Hills there is a herd of more than 1,500 buffalo. It can be said that the Buffalo Nation has returned.

GATHERING THE
EARTH'S ABUNDANCE

Mother Earth provided Indians with astounding gifts, even in seemingly difficult environments. Although fishermen were able to secure a valuable harvest from rivers, lakes and the sea, for most native peoples plants represented the most important source of food.

Gathered from the earliest times, edible seeds had high nutritional value and were a key resource in almost every region except the Arctic. Fruit and berries provided energy and flavour, while roots and greens were useful sources of carbohydrates and fibre. However, some wild plants required complex processing systems: for example, the Pomo people of California managed to produce flour from acorns, but only after they had devised a system that used flowing water to leach out the high levels of tannic acid that the nuts contain. In the Great Lakes area, where wild rice grew in abundance, people would go out after the crop had matured and gather the rice by knocking the grains into their canoes. Back on land, they would parch the rice, pour it into purpose-built, lined pits and then don special moccasins that enabled them to stomp off the hulls of the grains.

THE GIFT OF CORN

By about 700BCE, Native North Americans in several regions had begun to modify plants such as sunflower, amaranth and marsh elder, which grew naturally in areas of disturbed, nitrogen-rich soil near villages and along streams. Squashes and gourds were plentiful in the woodlands of the Northeast and Southeast regions, and they became early cultivated crops. Across large areas of Native North America maize, or corn, domesticated in Central America by 6000BCE and cultivated in parts of southern Canada by 1000CE, is the most important

▶ **Across the continent, from the northeast to the southwest, corn was and remains the main food crop. Colourful varieties of Indian corn on display in Oregon.**

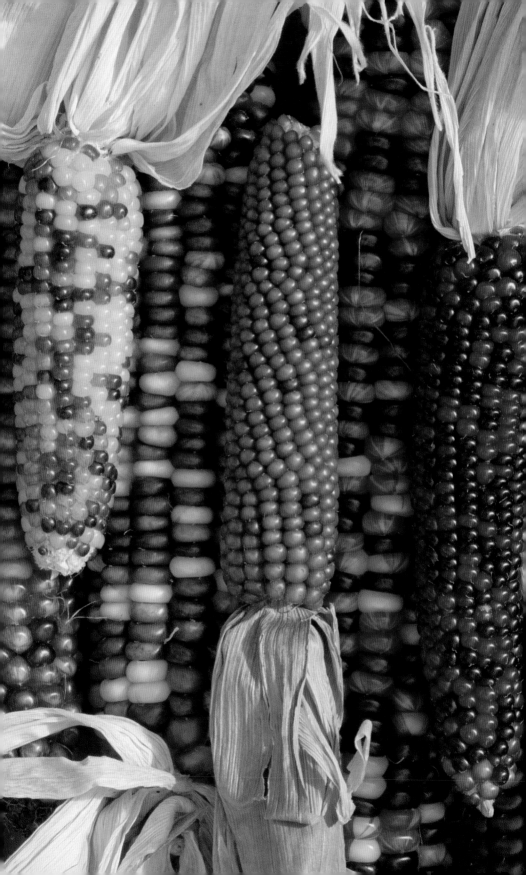

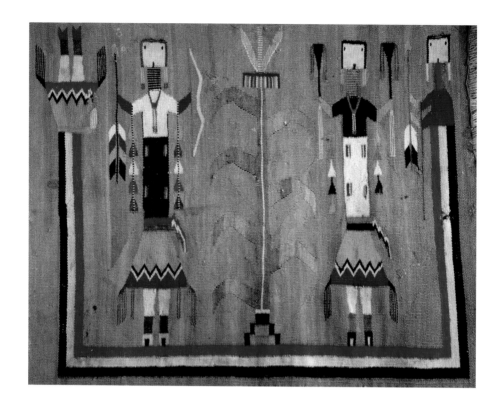

crop in the diet of Native Americans. Beans also originated in Central America and the Southwest. Maize, beans, and squash became such important staples that they were christened the "Three Sisters", and where they grew in abundance, populations thrived.

▲ A 19th-century Navajo weaving depicting two supernatural "holy people" flanking the hallowed maize plant, which was their gift to mortals. The deities are enclosed by a rainbow arc. Corn, beans, squash and tobacco are all believed by the Navajo to be sacred plants.

There are many accounts of the origin of maize, which connects humankind and the gods. The corn myth of the Mikasuki of Florida brings together two common ideas: the important role of two brothers or heroes and the creation of something from part of another being. Two brothers lived with their grandmother, and one day, tired of meat, they asked her for something new to eat. From then on, when they returned from hunting, she served up some corn, which they found delicious. Their grandmother would not say where it

came from, so the younger brother spied on her when she went to the storehouse. To his horror he saw her rub corn from the sides of her own body. That night the brothers refused the corn, and the old woman could tell that they knew her secret. She announced to the brothers that she would have to leave them forever, but would live on as the corn growing from her grave.

Among many other Southeastern farming peoples the origin of corn and beans is also attributed to a magical woman. The Natchez tell a similar story about Corn Woman, who lived with twin girls. Whenever their supplies ran out, Corn Woman went into the corn house and came out with two full baskets. One day, the girls spied on her. Disgusted by the sight of Corn Woman making their food by shaking and rubbing her body, they ran away. Then Corn Woman told them: "From now on you must help yourselves. Kill me and burn my body. When summer comes, plants will come up where you have burned me. These you must cultivate; and when they have grown to maturity, they will be your food."

The divine link with crops is particularly well represented in the arts of the Southwest. The region's stories explain how the maize harvest was bestowed by Mother Earth figures – frequently called Corn Maiden or similar – to whom humankind must repay its debt by conducting seasonal rituals to give thanks. Today, the life-giving bounty of maize has been developed into hundreds of colourful varieties, but even in the most conducive environments the fertility of the soil depends on favourable weather – and these ideal conditions must be induced by prayers, which it is thought creatures such as butterflies will carry up to the gods (this is why there are many butterfly motifs in the Native American art of the Southwest).

THE POWER OF PLANTS

In some tribes, the process of cultivating crops shifted economic and social control towards women, who were often responsible for planting and harvesting. The Iroquois believed

that crops could not grow without female intervention, and this endowed their womenfolk with substantial power. Ceremonial life, which was centred on the agricultural cycle, was controlled by three societies: the Sisters of the Life Supporters performed planting ceremonies; the Sisters of the Three Life Sustainers enacted fertility ceremonies to promote plant growth; and members of the Women Planters Society conducted the Green Corn ceremony at ripening. Matriarchal lineages, called *ohwachira*, controlled property communally, including the longhouses in which the Iroquois lived, the fields, tools, and stored foods. Inheritance of everything, including seeds, went through the *ohwachira*.

As well as providing essential food, plants were widely used for healing (see pages 136) and in ceremonies. In the deserts of the Southwest, the Maricopa and Tohono O'odham peoples gathered edible fruit from cacti such as the saguaro or nopal. The Tohono O'odham marked the start of the rainy season with a ceremonial drink made from this fruit. In many places, wild and cultivated tobaccos, considered to be soothing, were commonly used in rituals, usually by smoking it in pipes.

Plants also provided leaves and fibre to make netting and basketry. Yucca could be used as a soap, and strong fibre could be stripped from its leaves. Cattail (Typha) leaves were transformed into exquisite baskets, woven sandals and even duck decoys for use in hunting. Around the Great Lakes, bark from birch and other trees was used to make all sorts of things, from beautiful baskets to canoe covers.

▶ In the mid-1830s George Catlin recorded the Green Corn Dance among the Hidatsa people of the Great Plains. Here, four medicine men, with a stalk of the corn in one hand and a rattle in the other, with their bodies painted with white clay, dance around a kettleful of the first corn, chanting a song of thanksgiving to the Great Spirit.

THE FRUITS OF THE SEA

In the mythologies of Native America any great body of water – be it the sea, a lake, or a river – is likely to be imbued with spiritual power, a power that may belong to the water itself, or to the life-giving fish or sea mammals it contains.

The waters of the Northwest Coast teem with an abundance of fish and sea mammals, and the traditions of the coastal peoples acknowledge a host of marine spirits. The Haida's

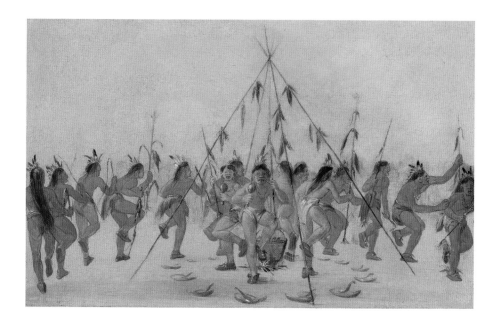

mythical account of their own origins begins on the seashore. One day, when the trickster deity, Raven, was scavenging on the shore, he saw a human face peeking out of a partly opened clamshell. Curious, and eager for company, he pecked it open and the first Haida clambered on to dry land.

However, no marine creature was more important than the salmon, which, during the summer months, makes spawning runs up every inlet of the Northwest Coast. The five types of salmon – chinook, sockeye, humpback, coho and dog salmon – were perceived as five distinct clans of salmon "people". For most of the year these salmon folk looked human and they lived in underwater communities beyond the horizon. Each spring, the salmon clans left their underwater lodges and sailed up inlets and rivers to their summer spawning grounds, where they allowed themselves to be caught as fish. Although all of the salmon clans set out together, the troublesome dog salmon were inclined to capsize the canoes of the coho; this myth explains why this particular species of salmon arrives

later than the others. The generosity of the salmon people, in allowing their bodies to be caught and eaten by humans, was appreciated in the harvest rituals of the peoples of the Northwest Coast. If the spirits of the salmon people were suitably honoured, they would be willing to be born again as fish. The Tsimshian people performed salmon-welcoming ceremonies and the Nootka reverently returned the bones of the first salmon catch to the water.

THE WOMAN OF THE SEA

Among the sea myths of Native America, those of the Canadian Inuit are unique in that they describe an all-powerful deity. Like the sea itself, this deity, personified as the goddess Nuliayuk, is both kind and forbidding, generous and destructive. Nuliayuk's story begins as a tragedy. As a marriageable young woman, she refused to take a husband and was banished by her father to an island. Her father eventually relented and went to bring her home. However, as they returned a storm blew up. Her father blamed this misfortune on his daughter and threw her overboard. As she clung to the boat's gunwale, he severed her fingers, which were transformed into the great sea mammals. Nuliayuk descended to the sea bed where for ever more she exercised control over the sea creatures. Thereafter, the welfare of all coastal Inuit depended on Nuliayuk's goodwill. When she was pleased with the way people were living, she provided ample food, but when people offended her by breaking taboos, she withheld the marine animals and shamans had to travel to the sea bed to bargain for their release.

Other versions of this myth refer to the sea goddess as Takanakapsaluk or Sedna ("The Great Food Dish"), depending on the region.

▲ The salmon was a vitally important resource to the peoples of the Northwest Coast and Plateau. This is a wooden totemic carving from the Kuthouse family of the Gun-ah-ho part of the Tlingit tribe.

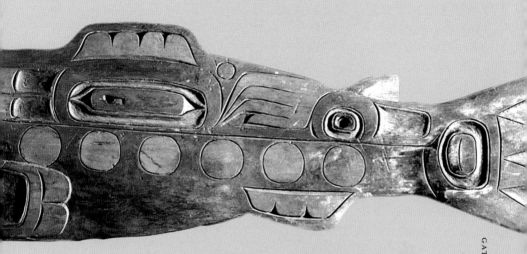

Sedna married a fulmar against her parents' wishes. Later, she became disillusioned with her husband and ran away. Her parents rescued her, but when the angry fulmar found their little kayak on the water, he raised a fierce storm by beating his wings. Realizing that the kayak was about to capsize, the girl's parents started blaming her for their misfortune and told her to cast herself into the sea. Despite her protestations of innocence and her screams for mercy, her parents threw her overboard. As she clung desperately onto the gunwale, her father took his knife and, one by one, cut off all her fingers.

When the fulmar saw that the poor girl was drowned, he allowed the storm to subside and let her parents proceed safely home. As the dying girl sank to the sea bed, her fingers came back to life as sea creatures – for example as a fish, a seal, a whale and a walrus.

It was thus through Sedna's suffering that animals crucial to the Inuit's survival came into being. Together they provide meat, blubber for heating and lighting in the long dark winters and skins for protective clothing. However, humanity's sins accumulate as filth in Sedna's hair, and having no fingers she cannot comb it clean again. When her hair gets dirty, her anger causes epidemics or storms, or makes her withhold the seals and other animals on which the people depend.

WORLD TRANSFORMERS

While the worldmaking Great Spirit reigns over all creation, other powerful figures gave humans the objects and skills needed for their survival.

Once the world had come into existence, more accessible beings transformed it and made it habitable. These characters brought people light and fire and the tools and technologies of their traditional cultures: Sweet Medicine gave sacred arrows to the Cheyenne; Lone Man established the Mandan tradition of leaving a plaza in the centre of the village in which to dance. These imposers of order (a popular activity is vanquishing the primeval world's monsters) are referred to by anthropologists as "culture heroes" – creative beings who transform their surroundings and themselves, while assuming human or animal characteristics and personalities in the process.

Some of these unselfish heroes ensured the survival of the first people and their descendants. For example, in one story told by the Penobscot people of the Northeast, Glúskap killed a monster frog which had drunk all the world's water. Among northern Athabaskan peoples, there is a hero widely known as Beaver Man, who fought many fierce giants – Bear, Wolverine and others – intent on devouring the first humans. These monsters tried to trap Beaver Man, but he always eluded them.

The spider helped to create the world. The Cherokee say that there was no fire until Thunder used lightning to ignite a hollow sycamore tree on an island. Water Spider span a thread and fastened a small bowl onto her back. She then crossed, put an ember in her bowl and brought it back.

Heroes come in many forms and include the extraordinary activities of otherwise normal people. A hero might have been involved in the creation of human beings, have played a part in bringing new technology or beliefs to a group, or in saving the people from catastrophe. Heroes exemplify intelligence, generosity and personal sacrifices made for the good of the

▶ George Catlin's painting of the Bull Dance during the Mandan Okipa ceremony in 1832.

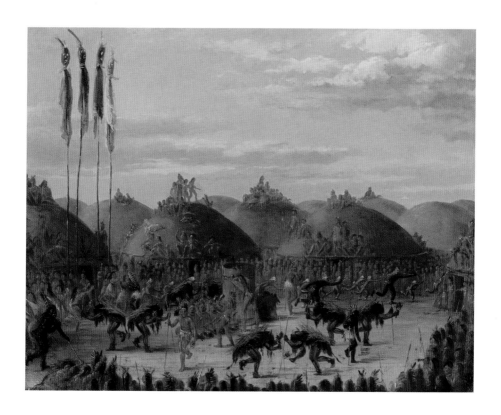

group. Preserved in their basic structure, the stories of culture heroes are often adjusted to meet the needs of each generation.

The counterparts of the culture heroes are the "trickster" figures, whose transformative activities can induce chaos and whose energies often go into mischief-making. A trickster is an unpredictable force, but his or her selfishness and recklessness generally teaches humans about their own foibles. For example, in Northwest Coast stories, Mink constantly invites trouble due to his voracious sexual appetite. However, most of the transformers in Native American traditions – Raven, Coyote and many others – possessed both heroic and trickster-like attributes. These countless stories provide an allegorical form of explanation for how the world works.

CULTURE HEROES

Straddling the worlds of spirits and humans, and endowed with supernatural abilities, a culture hero was an ambiguous character whose actions could change the course of a tribe's history.

Culture heroes often have characteristics in common, from a miraculous conception to their status having been acquired through intelligence and bravery rather than any advantage of background. For example, according to a legend of the Menomini of the Lake Michigan region, Manabozho was the product of a union between a human being and the spirit of the male north wind. His hero story is just one of many that begin with a magical impregnation. But heroes may also be the supernaturally born "grandchildren" of solitary old women. Northwest Coast people often describe the hero-trickster Raven – part human, part bird – as the grandchild and companion of the "earth crone", or primal grandmother, who is believed to have existed from the beginning of time.

FLAWED FIGURES

One of Raven's heroic acts is the bringing of light to Earth (see page 119), but he achieves that through deceit. Many Native American mythical heroes have a complex character. The hero is a human being, whose life on Earth is just like that of legendary early people, but he is touched with divine power, which makes him physically gigantic, enormously powerful and capable of overcoming any enemies. Moreover, the hero may share some characteristics with the trickster. As a semi-divine human, the hero may often have to rid the world of monsters and dangerous spirits. Yet in his guise as trickster, he frequently resorts to subterfuge and violence.

An episode from Manabozho's life illustrates these dual characteristics. He once learned of a forthcoming game of lacrosse between the deities of the sky and the underworld, to

Several Inuit narratives describe how a destitute boy gains social status or becomes a shaman by displaying intelligence or bravery.

take place in a huge area stretching from present-day Detroit to Chicago. On the morning of the game, he turned himself into a pine tree so that he could watch unnoticed. As the game went on, Manabozho became so engrossed in the action that he changed back into a man and began shooting arrows at the underworld gods. Enraged, they chased Manabozho, who narrowly escaped by climbing to the top of a tall tree. As the trickster turned victim, his plan misfires – yet it is in his role as a hero that he intervenes in the contest in the first place, for the benefit of humanity.

POOR BOYS MADE GOOD

At the outset of their adventures, many of these culture heroes are on the margins of society. Several Inuit narratives describe how a destitute boy gains social status or becomes a shaman by displaying intelligence or bravery. These heroes may then be called upon to rid the world of such destructive entities as giant rodents or dangerous witches. Most of the tales end with the death of the animals and the socialization of the women through marriage and childbirth.

One young Alaskan Inuit adventurer is an orphan called Ukunniq, who is so poor that he has holes in his boots. His first encounter is with spirits who have devised a deadly game that involves splitting a log with potentially lethal whalebone wedges. Protected by a magical amulet, Ukunniq terrifies the spirits by threatening them – semi-humorously – with the toes that protrude through his boots. The serious message is that the boy derives his shamanistic power from his poverty. He grows in stature through successive ordeals, and finally crowns his career by marrying a proud woman who has killed all her former suitors. Together they produce children who themselves become heroes.

On the Great Plains, the story of the orphan Sweet Medicine is told by the Cheyenne, and it also involves supernatural abilities. As a child, Sweet Medicine provided a foretaste of his

future powers by causing miraculous disappearances and indulging in grossly antisocial behaviour. One day he performed a dance in which he cut off his own head. His grandmother, who was his guardian spirit, revived him on that occasion, but such eccentric behaviour only served to alienate him from others. His isolation grew deeper as he approached adulthood. In a quarrel over a buffalo skin, Sweet Medicine killed a powerful chief and fled the village. Warriors attempted to hunt him down, but he taunted his pursuers by appearing and vanishing at will, successively transforming himself into a coyote, a rabbit, a crow, an owl and a blackbird.

When the Cheyenne finally succeeded in confining Sweet Medicine to one location, his response was to use his shamanistic powers to retire for four years to the realm of the animal spirits. There he persuaded the spirits to withhold the animals that the Cheyenne hunted, which caused a famine among them. Eventually, he returned and was moved to pity by some hungry children that he encountered. After feeding them, he issued instructions to the rest of the community about how the destructive feud was to be healed. They were to build a special lodge with a buffalo skull in the centre. Once this had been accomplished, he appeared among them, and intoned sacred songs for four days and nights. At the end of this time, the hunters emerged from the lodge to find buffalo grazing in their village.

Having saved the Cheyenne from starvation, Sweet Medicine returned to the realm where the spirits of all living things on Earth coexist peacefully. During his sojourn with the spirits, he was granted long life and presented with a bundle containing four sacred arrows. He came back to the human world with them, and to this day they hang in the communal lodges of the Cheyenne, where they form the basis of their ritual observance and medicine ceremonies.

Sweet Medicine lived a number of lifetimes; his gift of longevity from the spirits meant that he could grow old and regain his youth several times. In a later addition to the ancient

Warriors attempted to hunt him down, but he taunted his pursuers by appearing and vanishing at will, successively transforming himself into a coyote, a rabbit, a crow, an owl and a blackbird.

THE *KATSINA* BEINGS

A *katsina* expresses a belief that everything has a life force, which humans must interact with. These powerful beings are important in Hopi and Pueblo culture.

There are about 400 figures in total, representing concepts as well as natural phenomena such as the sun, the stars, corn and insects. In tribal myth, many *katsina*s taught people essential skills such as medicine or agriculture.

Traditionally, small *katsina* dolls were carved out of cottonwood (such as these carved Hopi dolls, below) and given as gifts to children by the masked dancers who appeared in the villages during the ceremonies which ran from the winter solstice through to July.

*Katsina*s have families just like humans. Accorded the right respect, a *katsina* can use its power for human good.

legend, he made various prophesies, predicting the extermination of the buffalo and the introduction of horses and cattle. In a tone that became progressively more tragic, he foretold the arrival of the white man, prophesying that the Cheyenne would not only fall subject to their control, but would eventually be supplanted by them. Sweet Medicine finally died during one of his recurring periods of rejuvenation.

TRICKSTER FIGURES

The trickster myths are undoubtedly the most widespread and popular tales among Native Americans, as well as being of special importance because they contain lessons about proper behaviour and respect.

COSMOS

186

SYMBOL, MYTH &

Unlike heroes, tricksters deceive others in pursuit of self-gratification; they tend to be mischievous, selfish and rascally, and usually have exaggerated human characteristics. However, a culture hero may at times behave like a trickster, when he uses cunning and stealth to steal fire or outwit a monster.

A trickster commonly appears as a semi-divine but largely amoral presence at the creation, and he may permanently transform such things as an animal's appearance or the course of a river. But as often as he tricks others, a trickster is himself duped and humbled in the end. His reckless behaviour brings change, but however selfish the trickster is his antics usually have a humorous side and will provoke affectionate laughter at the same time as his mythic power inspires awe. He has few morals or values and no control over his desires. Stories abound of tricksters in the form of Coyote, Raven or Hare, but they also appear in human or semi-human form.

Because the trickster and the culture hero are often one and the same, they frequently have the same name: Great Hare, Nanabush or Glúskap in the Woodlands, Rabbit and Spider in the Southeast, Coyote on the Plains and in the West, and so on. Some Northwest Coast and Subarctic groups had Raven (see page 190), who was especially helpful when he worked his wiles on other supernatural beings. The Tsimshian form of Raven is a master changeling, who wears the clothing of a raven that he can take off to reveal his man-form. The Ojibwe's Nanabush can do something similar because he is half man and half spirit, and can appear disguised as an ordinary man. Among the Menomini, the trickster was essentially the same being as the culture hero Manabozho (see page 182).

▶ Indian petroglyphs on Newspaper Rock in Utah. A mixture of human, animal and abstract forms, no one has deciphered the meaning of this ancient art, which dates back more than 2,000 years. Deer, pronghorn antelope, buffalo and humans on horseback can all be identified. The Navajo call the rock Tse Hane, which can be translated as the rock "that tells a story".

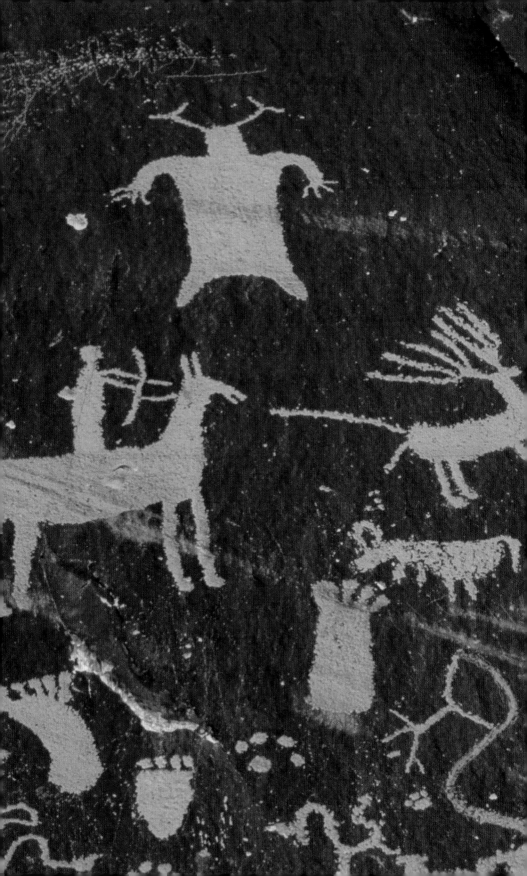

THE CUNNING AND THE FOOLISH

Despite the different guises, the trickster exhibits similar characteristics wherever he is encountered. He can be a crafty joker and a bungler, who is usually undone by his own horseplay or trickery, ending up injured or even dead – only to rise again, seemingly none the wiser for his experience. At times irreverent and idiotic, his doings entertainingly highlight the importance of moral rules and boundaries.

A famous series of stories is that related by the Siouan-speaking Winnebago, in which a tribal chief breaks religious and sexual taboos and then goes on the warpath. Talking nonsense and renouncing his status, the ex-chief embarks on a solitary journey, calling all the objects in the world "younger brothers" and speaking to them in their own tongues. At this point, the chief becomes a trickster, and a series of loosely connected tales relates how he roams the world, mostly interfering in the affairs of animals and people. The exploits of "Older Brother" are variously feared, marvelled at or viewed with indulgence and humour by his fellow beings. The trickster himself is regarded by turns as cunning, intelligent, foolish or unlucky.

These contrasting character traits emerge clearly from two Ojibwe stories about Manabozho. In the first, his subterfuge brings him success in hunting. One day, Manabozho enticed a moose by claiming to be its estranged brother. As the animal drew near, Manabozho asked it whether it had heard the news about the person who killed his brother. Not realizing that the trickster was alluding to its own impending death, the moose was caught off guard and was persuaded to stand with its

▶ The inside of the lid of this Eskimo trinket box is decorated with several sexually explicit images, along with animals, supernatural beings and hunting scenes. Sexual symbolism was not particularly common in Eskimo art, despite the prevalence of sex as a subject of conversation. A common attribute of tricksters is their vulgar inability to control their baser desires.

head averted, at which point Manabozho shot it. The second tale relates how Manabozho once fell asleep, having ordered his rear end to guard some fowl roasting on a fire. When the birds were stolen and no alarm raised, the trickster foolishly set his own hindquarters alight as punishment.

Several Winnebago stories end with the trickster becoming a transformer after a series of mishaps. In one such tale, the trickster suddenly recalls why Earthmaker sent him to the world. As a last sign of his nobler disposition, he goes about removing hindrances to humans, for example by altering the course of rivers and clearing mountain passes of obstacles. Then he retires to heaven, leaving Hare in charge of the Earth. (The Winnebago explain that Hare is born of a virgin who dies. Left in the care of his grandmother, who represents the spirit of the Earth, Hare roams the world, being benefactor and clown. His grandmother often rescues him or excuses his mistakes.)

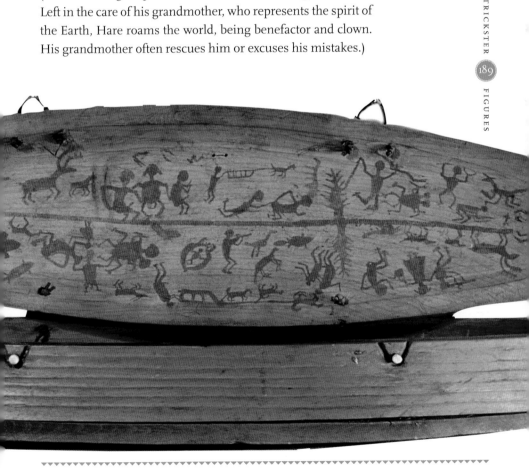

A PARADOXICAL BIRD

Raven is the supreme trickster in many Native cultures – and for the peoples of the Northwest Coast, the Arctic and the Subarctic, Raven remains a heroic creator too.

This seeming paradox may derive from conflicting attitudes towards the bird. For example, in central Alaska the Koyukon Indians regard ravens as clever, but also consider their behaviour unpredictable and comic. Moreover, while ravens are quick-witted, they are also lazy scavengers, living off the food that animals and people have made efforts to hunt.

As a creator, Raven made the world twice over. The first world was a paradise: meat was plentiful, and rivers flowed in both directions, so people never had to paddle their canoes. But Raven thought this world too easy for humans, and so he remade it in its familiar form, with all its hardships and woes. This primal Great Raven is revered along the Northwest Coast as the "grandfather" figure to whom people attribute creative and healing power and to whom they pray for luck in hunting, good health and prosperity. Yet Raven has a negative dimension to his character with his reputation for selfishness and greed. Both ravens and Raven are thought to lead an easy life, and some contempt attaches to them accordingly. Myths describe Dotson'sa (Great Raven) sleeping in blankets of dogskin, the smell and roughness of which repelled people.

These facets are expressed in many myths and legends throughout the region, with Raven as a creator and transformer (the Tsimshian say that the heavenly bodies were kept by a greedy chief until stolen by Raven, who threw them into the sky), as well as a buffoon and dupe. The Haida call him Power-of-the-Shining-Heavens, as he made day and night. Likewise, he created the rivers, the forests that teem with wildlife, the useful trees and berries and the sea with its fish and mammals. Alongside accounts of these achievements are countless comic tales of Raven's mischief-making and humiliation.

▶ Among the Haida of the Northwest Coast, people belong to either the Eagle or the Raven clan. According to tribal myth, Raven released the first people from a cockleshell. Raven is a complex reflection of human behaviour – possessing the ability to be potently creative or destructively debauched. In the Raven tales, achievements are balanced by countless stories of mischief-making and humiliation. This Raven totem is carved out of argillite.

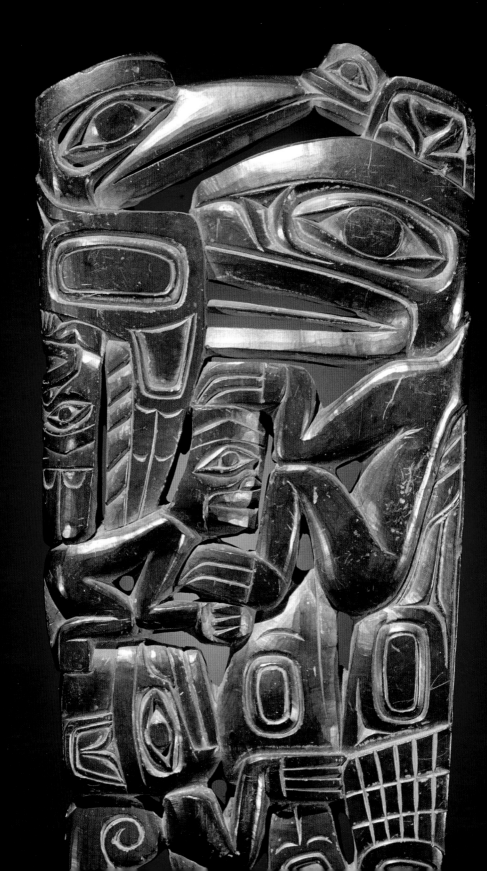

THE SLY "PRAIRIE WOLF"

The coyote thrives throughout most of North America – it is crafty, swift and has an all-embracing appetite. One of this wild dog's ruses is to pretend to be dead in order to catch scavengers, so perhaps it is unsurprising that there are more Native American stories about Coyote as a trickster than about any other animal or character.

A half-animal, half-human Coyote plays a major role in the early days of the Earth, according to some peoples. In the Navajo emergence myth there are three creator figures, First Man, First Woman and Coyote. When they emerged from four underground worlds, Coyote brought seeds with him and gave them to the different tribes as they were created. The neighbouring Apache believe that Coyote can talk, dress and act like a human, but that he often runs around on four legs.

Like the raven, the real coyote is a scavenger, yet it also hunts small rodents and rabbits, cleverly concealing any uneaten food. Many Coyote myths reflect both admiration and

▽ An Indian chasing a coyote, drawn by Galloping Littleman of the Southern Cheyenne in 1894. The coyote is also known as the American jackal or prairie wolf and it features in countless American Indian stories.

contempt for this resourceful beast. On the one hand, Coyote is a hero who helps organize the primordial world; on the other, he is the buffoon whose adventures resemble those of Raven and Manabozho (see pages 188–190).

FROM HERO TO OUTCAST

The Caddo of the Southeast tell how Coyote started his career as hero and transformer, and then changed into a trickster, or even an evil character. Great-Father-Above created the physical world, but it was Coyote who helped people to organize society. In the early world, certain things needed altering. For example, the sun moved too fast, so Coyote decided to intervene. He went to meet the sun, and accompanied it on its westward journey. After chatting with the sun, Coyote went into the bushes on the pretext of relieving himself and asked it to wait. But Coyote never returned, and even though the sun eventually gave up waiting and resumed its journey, it could not make up lost time. In this way, Coyote extended the hours of daylight.

Despite bringing such benefits to humanity, Coyote was usually depicted as bad. The Caddo story ends with the Great-Father-Above threatening to banish Coyote for his mean tricks. Although Coyote repeatedly promises to desist, he cannot overcome his nature and is exiled. Many other tales end in Coyote's exclusion from society, or even his death. Yet he always springs back to life to embark upon new adventures.

Another story told by the Caddo describes how Coyote was distracted from hunting buffalo by a turkey roosting in a tree. He called to the bird: "If you don't come here, I'll climb the tree. Only if you fly towards the prairie will you be safe. I have no power over anything on the prairie." The turkey unwisely took Coyote at his word and made for the prairie, where the trickster easily ran it down and began to devour it. Glancing slyly about him, Coyote thought he caught a glimpse out of the corner of his eye of someone behind him ready to strike. Without waiting to see who it was, he called on a skill he had

been endowed with since the beginning of time, and began to run. He ran ever faster, but could not elude his pursuer. Eventually, he gave up and rolled onto his back to beg for mercy. But as he did so, he heard a crack. This turned out to be a turkey feather that had lodged between two of his upper teeth and, sticking up vertically just behind his right eye, had deceived him into thinking he was being followed. When he realized that he had been fooled by a mere feather, Coyote was furious. Ever since that time, according to the story, the coyote has had a wild appearance, loping away slowly at first and constantly glancing to his right to see if he is being followed.

COYOTE AND THE GIANT

Coyote's cunning is well illustrated by a Navajo myth. Long ago the Earth was roamed by giants who were fond of catching and eating little children. Coyote was crossing a rocky place one day when he encountered one of the giants and decided to teach him a lesson for his cruelty. He persuaded the monster, who was very stupid, to help him build a lodge for a sweat-bath, claiming it would make him as agile as Coyote himself. When the dark interior had filled with steam, Coyote said he would perform a miracle by breaking his own leg and mending it again. He took a rock and pounded an unskinned leg of deer, which he had secretly pushed into the lodge, until it broke with a loud crack. The giant felt the broken leg and, completely fooled, listened as Coyote spat on it and chanted: "Leg, become whole!" The giant reached over, felt Coyote's real leg and was astonished to find it uninjured. Coyote offered to repeat the miracle on the giant's leg, and the monster agreed, screaming in pain as his companion started pounding it with the rock.

Soon the giant's leg broke and Coyote told him that to mend it all he had to do was to spit on it. The giant spat until his mouth was dry, but the pain became no more bearable and the leg refused to mend. Eventually the giant begged for help. "Just keep spitting," said Coyote, reassuringly. Coyote then slipped away, leaving the child-eater with his agony.

Coyote was crossing a rocky place one day when he encountered one of the giants and decided to teach him a lesson for his cruelty.

WOLF, COYOTE & THE ORIGIN OF DEATH

Myths of the origin of death often involve an argument between two beings, as in the following account related by the Shoshoni people. In ancient times, the two most important figures were Wolf and Coyote, who always tried to go against Wolf's wishes. Wolf said that when a person died he could be brought back to life by shooting an arrow into the earth beneath him. But Coyote said that it was a bad idea to bring people back to life, because then there would be too many people. Wolf agreed, but decided secretly that Coyote's son would be the first to die, and by this very wish brought about the boy's death. Soon the grieving Coyote came and told Wolf that his son had died. He recalled Wolf's words: that people could live again if an arrow was shot underneath them. But Wolf countered with what Coyote himself had said: that man should die. Since then it has always been so.

GIANTS & GROTESQUES

North America has scary creatures aplenty, from reptiles to spiders, but Indians often assign them a role in the drama of humans and spirits. Native American primeval monsters are frequently mammoth versions of familiar species or they are fantastical alien beings, both types conducting reigns of terror before they are overcome.

Archaic tales about giant monsters usually feature primeval versions of well-known modern-day species – carnivorous ravens, deer and caribou – or predators with enhanced powers. The story often has a predictable pattern: the creature's phase of predation is followed either by its destruction or an act of transformation that changes the beast into a familiar form.

Many myths feature a giant bird. On the Northwest Coast and in Alaska,

numerous legends tell of eagles so huge that they carry off whales to feed their young. A Southeastern myth concerns a giant turkey that once preyed on humans. At a meeting called to discuss how to destroy the bird, the people chose a black snake and a puppy to lead the attack. The snake rushed forward and tried to whip the turkey, but missed; the puppy then ran at the monster from behind and knocked it over, whereupon the men closed in and clubbed it to death. From then on, turkeys were easy to hunt and kill.

In the myths of a number of peoples, vital aspects of the world as we know it emanated from a monster. A creation legend of the Nez Percé tells of the existence, at the beginning of time, of a primal leviathan whose body covered much of the region. Whenever the creature inhaled, it sucked in everything that stood in its path – grass, trees, animals, even the wind. When the trickster Coyote learned that all the Earth's creatures had vanished, he travelled to where the giant lay, taking with him knives, and tools for kindling fire, which he intended to use as weapons. As he approached the monster, Coyote allowed himself to be sucked inside too. There, he found most of the animals still alive, but driven wild by their predicament.

Coyote eventually succeeded in calming the animals and solicited their help. First, he ordered some children to lead him to the monster's heart, where he began to slice off fat, which he laid under the heart and proceeded to light. As the heat increased, the monster begged Coyote to stop, promising to release him, but Coyote was intent on freeing all the trapped animals. He hacked away at the heart and eventually managed to tear it out. In its death throes, the monster opened all its orifices and the animals escaped. They took with them the bones of those who had perished inside the creature's body, which Coyote had insisted they gather up before they left.

Once outside, Coyote sprinkled blood on the bones and all the dead animals came to life again. Next he dismembered the

◄ A carved-wood Tlingit or Haida dance hat representing an eagle. There are many stories from the Northwest Coast cultures that feature giant birds.

monster, flinging portions of it to all the points of the compass. From these sprang all the tribes of the Plateau, each in their separate domains. However, no sooner had Coyote used up all the flesh than he realized that he had forgotten about the area where he was standing. So, he rinsed his hands, and from the mixture of blood and water, the Nez Percé were created.

Other dangerous creatures of the primordial world were rendered harmless by courageous humans. For example, the Arikara of the Plains tell a story of a man-eating buffalo that terrorized the early inhabitants of the Earth. These first people, who came out of the Earth, hunted and ate many different kinds of animal, but had not yet encountered the buffalo. Eventually, on their travels, they came across a lake, from which emerged a buffalo-like horned monster, which they called Cut-Nose. Both Cut-Nose and the buffaloes that sprang from its body were ferocious, pursuing the people and killing many of them. For a while, the people held them in check by creating deep canyons, but the buffaloes always managed to circumvent these obstacles and slaughter their victims at will.

The slaughter was only halted when people finally learned to defend themselves. A young man, alarmed by overhearing the beasts planning a massacre, fled to the hills. There, he encountered a stranger who instructed him in the use of the bow and arrow and told him to pass this knowledge on to his people. The next time that the marauding buffaloes emerged from the Earth, the people conducted a furious assault on them with the weapons they had made. Many of the animals were killed and the rest put to flight. Ever since that time, buffaloes have been the hunted rather than the hunters.

SNAKE-MAN AND THE MISSISSIPPI

In the Mississippi valley, excavations of many burial sites and temple mounds along the river have uncovered evidence of a cult devoted to a horned serpent. A Cheyenne story tells of two young men who were journeying together when they came across two immense eggs lying on the prairie. One of them

"This is where I belong," said the snake-man. "My body will lie along the river bed for all eternity."

refused to touch the eggs, but the other, overcome with hunger, built a fire and cooked them. The men set off again, but the one who had eaten began to feel sick. Presently his legs grew heavy and he noticed that the skin on each leg had become dark and scaly. As time passed on their journey, the man became more like a snake and was gradually reduced to crawling. He felt a powerful urge to swim and, when the pair stopped by a lake, he spent all night writhing in the water. By this time, only his head and arms were still those of a human. He heard the spirits calling him to the Mississippi River, and asked his friend to help him get there.

After enduring many hardships, the companions finally reached the great river at nightfall. Exhausted, the unharmed man immediately fell asleep. When he awoke in the morning, he heard a voice calling to him from the river. Glancing towards the water, he saw that his friend had been transformed into a great snake with blue skin and two horns protruding from its head. "This is where I belong," said the snake-man. "My body will lie along the river bed for all eternity." Saying this, the serpent told his friend to instruct the people in how he should be venerated: "Everyone who comes to the river should bring with them fine meat and good tobacco, and drop these offerings in midstream. If they observe this courtesy, I will give them my blessing." Thereafter, whenever Cheyenne people crossed the Mississippi they followed these rules, and thus gained the benefit of the river serpent's favour.

HYBRIDS, EVIL SPIRITS AND CANNIBALS

Fantastic creatures are particularly prevalent in Inuit tradition, which venerates several kinds of monstrous or grotesque figures as spirit beings. Some myths are about subterranean or submarine spirit "people", who either help humans by providing them with animals to hunt, or punish those who transgress against sacred laws by ensuring that game animals suddenly become scarce. One such group of spirits was under the control of a hybrid being, half man and half wolf, whose

constant companion was a grotesque, dwarfish creature with immense ears for listening to human activity above ground. Success in hunting involved cooperating with these spirits.

On the Northwest Coast the Kwakiutl (Kwakwaka'wakw) had a shark-like spirit called Yagim; it followed canoes, which it sometimes capsized, eating the displaced humans as they struggled in the waves. When vindictive, Yagim could send a raging storm and waves large enough to destroy a village.

The Algonquian-speaking peoples of the north, notably the Northern Ojibwe and Cree, tell of giant cannibal ice-monsters known as *windigos*. Any human could turn into a *windigo* after they had been driven to eat human flesh through starvation, which was an occasional but real hazard even in the game-filled northern forests. To kill a *windigo* was considered a truly heroic act, although spirits often came to the brave warrior's assistance. The *windigo* had bulging eyes and long, pointed teeth, and it became taller than the tallest trees when it shouted.

A *windigo* might stalk the woods disguised as an Indian, and any stranger who came to the village would be observed very carefully in case he was a *windigo*. The *windigo*'s usual technique was to chase a hunter when he was embarked on a solitary pursuit of moose and other game. Those hunters who did not return to their camps were assumed to have fallen victim to a *windigo*'s insatiable lust for human flesh.

Windigo stories are popular and told for entertainment. Indian children once played a form of hide-and-seek in which a pretend *windigo* covered his head with leaves and hid; and sometimes such stories help to enforce discipline among unruly children.

The *windigo* myth undoubtedly acts as a deterrent against cannibalism, which was viewed as a serious cultural taboo irrespective of the circumstances. The Abenaki had something similar – Cheeno, a powerful cannibal who was once a human being but was turned into a monster because of his greed and hunger. Almost impossible to kill, he roams the land, seeking people to consume.

▶ A skull bleached by the sun sits on the dry, parched earth in the badlands. The disappearance of a food source could herald a crisis. Wishpoosh, the monster beaver of Chinook legend, kept people from fishing in Lake Cle-el-lum by furious slapping. Before Coyote killed him in a vicious fight, Wishpoosh ate all the salmon to increase his strength.

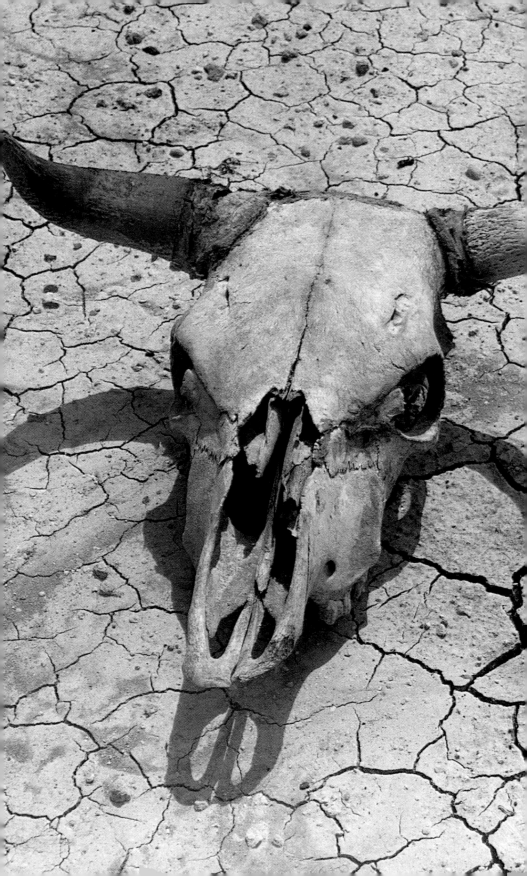

THE PAST IS PRESENT

According to Native North American belief, beings such as culture heroes and tricksters lived in a sacred past that is not a remote, primordial period but a living, invisible parallel world that remains in being.

▼ Pages 204–205.
The city of Toppenish in central Washington State has about 70 colourful wall murals that depict the history of the Yakima Indian nation. The city's motto is "Where the West Still Lives", and the annual mural-in-a-day event ensures that scenes from the region's past continue to be added. This work depicts horse racing among the Yakima.

Such a concept is a difficult one for Westerners to grasp, because it means that although events described in myths – such as the story of the theft of the heavenly bodies by Raven – happened in linear sequence, they have not receded into the past but exist still, together with Raven himself, "out there".

This "present past" is a world in which animals and people live in societies that are similarly structured. They can converse with each other and exchange forms at will. For example, in some Tsimshian stories the Raven is a man (or a man-like being) who wears raven clothes, which he can take off to reveal his human form. In some Apache versions of the widespread stories involving the hero-trickster figure Coyote, he wears Apache dress, speaks and acts like a human being, but also sometimes runs around on all fours. It is only in the visible world that humans and animals have distinctive, fixed forms.

Indians perceive the evidence of this "present past" in visions and dreams, and in the memories retained in oral tradition. The beings of this time often continue to make their presence felt in the physical world. For example, every time there is a thunderstorm a traditional Native North American may perceive the lightning as the flashing eyes of a being called the Thunderbird, and the wind as the roar of the Thunderbird's huge wings (see pages 162–165).

The stories of heroes and tricksters are kept alive through the spoken word. Narratives are recounted in both religious and secular settings, and although they tell of a sacred time, they by no means constitute an inflexible liturgy that is rigid in form and content. Versions may differ substantially in detail. Sometimes two almost wholly different myths may

account for the same phenomenon. One story told by the Washo recounts that a figure called Creation Woman made the tribes of California out of cattail seeds. However, another Washo story says that the ancestors of the California peoples were the three quarrelling sons of Creation Man.

The flexibility and adaptability of Native mythology has also allowed powerful external influences, such as Christianity, to introduce new characters into old stories. For example, in the twentieth century some trickster and transformer stories of the Salish people began to include a hero called Jesus the Traveller. He made fish out of fish bones and showed the people how to fashion axes, hammers and salmon traps.

KEEPING THE HEROES ALIVE

Ancient traditions may have been weakened by such influences, but this has not prevented the appearance of new culture heroes. These may be real people – Indians perceive no distinction between what a European would categorize as "mythical" and "historical". One such hero is Dull Knife, a chief of the Northern Cheyenne, who defied the order to relocate to Oklahoma in 1877 and led nearly 400 poorly armed Cheyenne back to their homeland, eluding the US Army until late October 1878, when he and his followers surrendered. When they were incarcerated in an old barracks at Fort Robinson, Nebraska, Dull Knife led a spectacular breakout in January 1879. Many of the Cheyenne were later killed, but Dull Knife, his family and others survived, and were eventually granted a reservation on the Tongue River in Montana. Dull Knife is remembered vividly by the modern Northern Cheyenne as the saviour of his nation. His triumphs are considered as magical and important as those of Coyote, Raven and other heroes who defied the enemies of the people.

Indian culture has no rigid distinction between myth and history: real-life heroes, like mythological ones, can possess magical powers. Many historical Native Americans have been

accorded legendary status – often those who tried to resist the loss of their lands and ways of life. The earliest great warrior to offer concerted opposition to European colonists was Pontiac, an Ottawa chief who rallied many of the tribes in the Great Lakes region (see page 26). Pontiac's rebellion finally failed after two years, defeated by disease and disunity.

Further opposition was mounted in the early nineteenth century by the Shawnee leader Tecumseh, who fought successfully against American federal forces until he was killed in battle. The mystique surrounding Tecumseh was heightened by a premonition he received of his own death, and by the fact that his body was never recovered.

Along with Dull Knife, several great Indian leaders of the late nineteenth century fought against forced removal, notably Geronimo of the Chiricahua Apache (see page 24). However, perhaps the name that resonates most powerfully of all today

▼ Crazy Horse is commemorated by the controversial monument carved into a mountain in the sacred Paha Sapa, or Black Hills, near where young Curly was born. Today, Crazy Horse is honoured by having several highways named after him, and each year the Lakota undertake a mass ride on horseback in memory of their people's great hero.

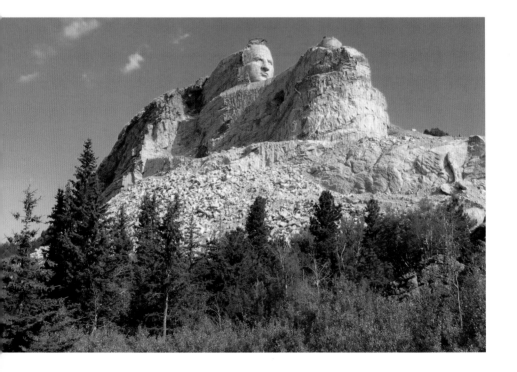

is that of a young Oglala Lakota (Sioux) warrior, whose people offered the most implacable opposition to the settlement of the West from the 1850s onwards.

TASHUNKA WITCO – "CRAZY HORSE"

Many men rose to prominence during the struggle to resist the Plains' incursions. One of the main Lakota strategists of this era was a young Oglala called Crazy Horse, who, together with the Hunkpapa leader Sitting Bull (see page 24), organized the Plains peoples' final stand, between 1876 and 1890, against the destruction of their culture. Crazy Horse is supposed to have declared, "My lands are where my dead lie buried".

Sitting Bull won a reputation for selflessness at an early age, killing his first buffalo calf and distributing the meat to needy people when he was only ten. As a man he invoked the buffalo's protective spirit, and in a vision at Medicine Deer Rock he foresaw the victory at the Little Bighorn in 1876.

Both Sitting Bull and Crazy Horse were "holy men" to the Lakota, as a result of having experienced powerful visions that influenced their future actions. Crazy Horse's childhood name was Curly, and it was at an early age among his mother's people that he witnessed a savagely punitive reprisal raid on a Brulé Lakota settlement, following which he went into the wilderness to undertake a vision quest. A trance that he induced brought him a vision of a warrior who had painted a zigzag lightning bolt on his face and hailstones on his body, and wore his hair long and flowing, with a stone in his ear and red hawk feathers fixed in his hair. His father interpreted it as a sign of his son's future greatness – and when Curly reached maturity he distinguished himself as a fearless warrior, who always went into battle dressed in this special way. In a later vision he obtained the name by which he became famous, Crazy Horse.

Although the heroic stature of such figures is unquestioned, it does not rest on any perceived superhuman powers. Rather, they epitomize the qualities of resourcefulness, honour and bravery, which are held dear by Native American cultures.

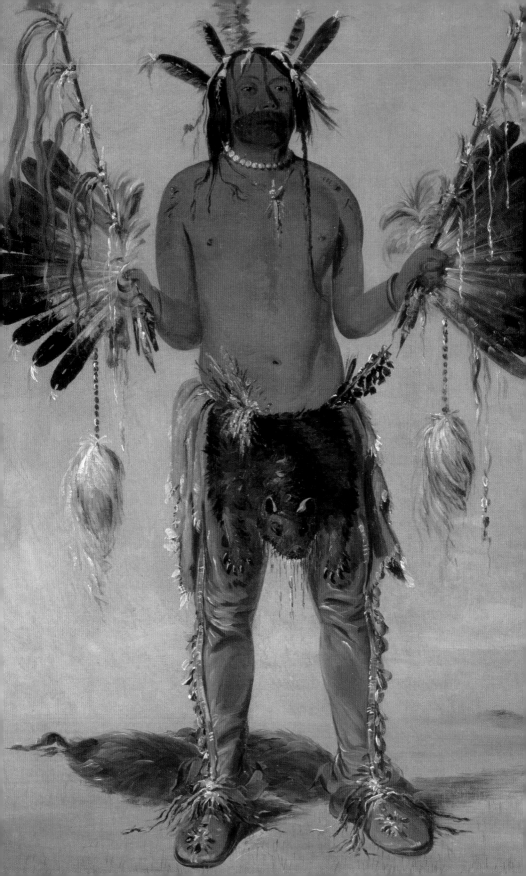

RITUAL &
SACRAMENT

5

Native Americans reveal and affirm their kinship with the sacred totality of the cosmos through a rich body of stories, rituals and ceremonies. From individual quests to communal ceremonies of renewal, rituals for newborns and taboos for the deceased, the key themes of change and regeneration are expressed in countless Native American practices, many of which continue to be observed today.

Invariably accompanied by the rhythmic beat of the drum, the power of the word – whether spoken, chanted or sung – is at the heart of many of these ceremonies, which express the attempt of every Native American tribe to order their spiritual and physical world. Indians believe that constant observation of and interaction with the world around us is necessary if humankind is to maintain order and live in harmony with everything that the Creator has made. Those people who are properly respectful, and know how and when to perform the proper sacraments, become connected to the mysterious and holy, thereby turning what they have learned into "medicine" that has sacred power. This "medicine" may be as simple as a pebble found on a vision quest, which has become a personal talisman, or it may be as complex as a detailed knowledge of nature and the stars learned over a lifetime, which will reveal to a holy person the correct time to conduct those vital ceremonies that revitalize the world and maintain the correct balance between its different spirit personalities.

ACCESSING THE SACRED POWERS

People cannot know how sacred power, or "medicine", truly works, but almost every Native American knew something of its ways. Often seen as a mysterious force that is fluid, transmissible and, importantly, malleable, sacred power can be manipulated by those who possess it – either for better or for worse.

Although some people may never traverse the indistinct line that divides the world of the spirits from the world in which people live, many individuals use sacred or spirit power to some degree. A person may acquire it at birth (because of a physical characteristic that makes them different from their peers); unbidden through dreams; during a vision quest (see pages 228–229); by participating in ceremonies, such as the Sun Dance (see pages 234–235); through ritual purification; or through self-deprivation or pain. In the Native American Church (a blend of Christianity and traditional religions; see pages 81 and 259) taking hallucinogens accompanied by communal singing and drumming can also result in a vision.

Spirits came unsought to people most frequently in dreams (see also pages 142–143). Among groups as widely separated geographically as the Mohave of the Southwest or the Iroquois of the Northeast, it is believed that dreams can channel power directly from the spirits to the individual. For the Menomini of the Great Lakes region, all dreams had significance, and the prophecies or warnings that dreams might contain were to be observed scrupulously. For example, if a man dreamed of drowning, he would make a small canoe as a talisman and carry it about with him at all times. If the meaning of a dream was unclear, a person sought the interpretation of an elder, who, being nearer the end of his or her life, was believed to be closer to the world of spirits. Anyone who had a dream that

△ Page 208. George Catlin's 1832 painting of Old Bear, a Mandan medicine man. His body is painted, his pipes are adorned with eagle feathers and fox tails are tied to his heels.

▷ A Hopi *katsina* shield representing the all-powerful sun. Probably worn on the back by a dancer during a ceremony.

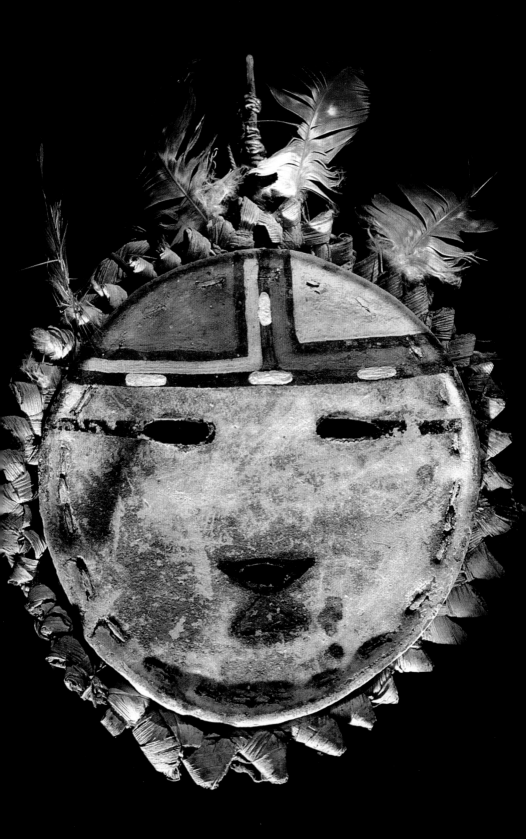

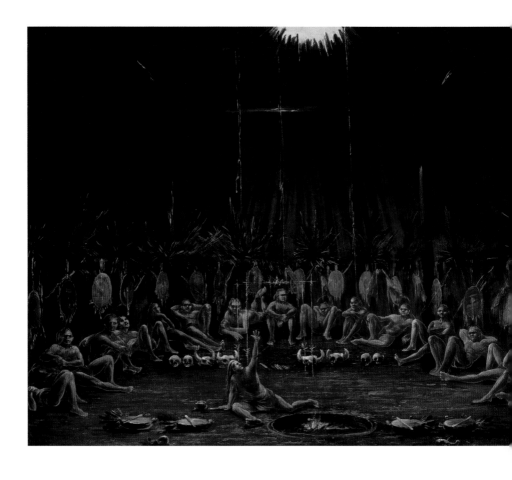

could not be interpreted, or who did not dream at all, was considered to be cut off from the power of the spirits.

Because the spirit world influenced the world of waking consciousness, earthly states – such as sickness or health, starvation or abundance – were believed to be dependent on the proper functioning of the spirits. The ancient bodies of tribal myths, which recounted how things had begun and had functioned properly in the past, were used by many Indian peoples as the basis for those rituals that aimed to maintain the health and the natural cycles of the Earth, its peoples, animals and crops (see pages 230–235).

▲ George Catlin's depiction (1832) of the medicine lodge interior during the Mandan's Okipa ceremony, when an individual would mortify their flesh through suspension as part of a ritual that ensured the annual return of the buffalo.

The rituals themselves were performed by specialists (see pages 132–137) who were believed to possess important gifts, which meant that they experienced no barrier when they sought the indistinct boundary to the spirit world. Although, as explained previously, many Native Americans may achieve some level of communion with the spirits through direct experience, holy people are endowed with a high degree of controlling influence over the spirit world, which enables them to help to change things in the world.

POWERS THROUGH RITUALS AND OBJECTS

However they come by it, the chosen few need to learn how to use and control sacred power, often under the guidance of an elder holy person who may provide detailed training in the form of an apprenticeship or whose greater experience can be of help in interpreting spiritual messages.

In order to wield their power, holy people first have to connect with the spirit world. Some did so through chanting, dancing or bodily deprivation; others might take datura or another hallucinogenic substance and change into an animal spirit. Many such rituals resemble a theatrical performance. After receiving power, a Washo holy person needs to go to a recognized practitioner to learn ventriloquism, sleight of hand and other skills needed to "perform" his rituals.

A man or woman may even find or be given a certain object that bestows "medicine" (see also page 80): for example, many Indian peoples in the Great Plains and Southwest regions believed that the circular, leather-covered frame of a shield, made with the help of a holy person, symbolized the world and could attract the protective power of the spirits. To enhance the shield's potency, it might be adorned with feathers or other sacred objects, or with painted symbols that represented personalized images acquired in a dream or vision (see illustration, page 211). Many Plains warriors carried beautifully crafted shields decorated with eye-catching designs that signified the motif's inner power.

CEREMONIAL SETTINGS

To create a symbolic link to the sacred, important rituals are often held in structures, such as lodges or chambers, built specially for the ceremonial event. Rather than being permanent, the constructions of many peoples are lightweight and intended to be easily transportable. For example, the Lakota sweatlodge – used for the *inipi* purification ceremony – is a simple frame of saplings bent into a small dome and covered with hides or blankets. A pit in the centre contains the heated rocks over which water is poured to produce steam.

The sacred beings, or "grandfathers", are regarded as a very real presence in the life of the Ojibwe, who call on them for guidance and to provide answers to problems. One popular method of coming into contact is to build a special divination lodge, or "shaking tent", which is a barrel-like framework of poles about seven feet (2m) high. It is set up outdoors and covered with canvas, skins or birchbark. In it, divination or conjuring is used to discover the cause of an illness or to find a lost object. After dark, the conjurer enters the tent and calls on the beings that are his own *pawaganak*, or guardian spirits. The souls of living beings (other than humans) and the dead may be invoked, and their arrival is signalled when the tent is shaken by the wind that embodies the spirits. No human action is involved – sometimes the conjurer may even be tied up with rope. Spirit voices are then heard to come from the tent, often naming themselves or singing a song; they might be animals or well-known characters from myths. At this point, those in attendance can sometimes talk directly to the beings to seek answers to their questions.

Groups of Plains Indians often hold all-night services of the Native American Church in a special *tipi* that is larger than traditional residential *tipi*s, and covered with plain canvas. More permanent were the Mandan village farmers' ceremonial earthlodges, similar to those of the Pawnee and built near the centre of the village. During their Okipa renewal ceremony (see illustration, page 212), some participants sought visions

▶ A sunbeam shines through the square opening in the roof of a restored, 13th-century *kiva*, one of eight at Spruce Tree House in Colorado's Mesa Verde National Park.

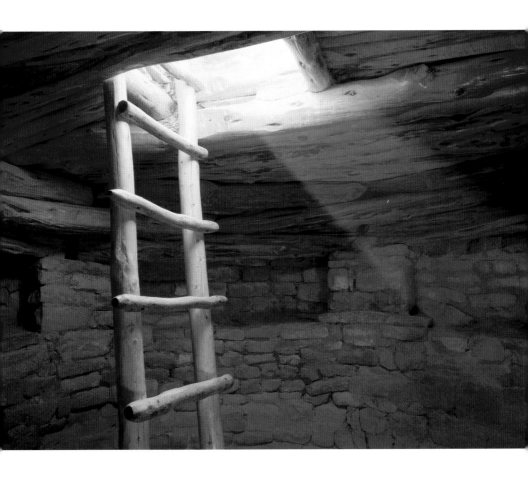

by suspending themselves from the smokehole of the lodge by means of thongs attached to piercings in their backs or chests.

However, almost certainly the best known of all Native American ceremonial chambers is the sacred "underground" *kiva* found among several peoples of the Southwest region, which is accessed from above by descending a ladder into its darkness. A feature of Pueblo architecture for at least a millennium, the *kiva* hosts the *katsina* (spirit beings and essence of all life on Earth – see page 185) ceremonies that are held from February until July to ensure that the universe continues to function harmoniously.

SAVERS OF SOULS

In the Native American world, a person can lose his or her soul while still alive. Reuniting the soul with its human body requires intervention from a specialist.

A patient's symptoms may reveal that their ailment is more deep-seated than a physical malady. The patient's soul may have left their body – by failing to return during the nightly dreaming state, because it has been stolen through witchcraft, or because it has been lured away by spirits. To rescue it, the holy person (sometimes called a shaman) may have to travel to another realm. The Paviotso, or Northern Paiute, people of the Plateau believe that if the soul has not gone too far, it can be pursued, but if it has crossed the boundary into the realm of the dead, then it is lost forever. The Chumash of California maintain that one can sometimes see a soul passing on its way to the land of the dead, trailing a blue light behind it, the fatal disease visible as a ball of fire alongside. If one recognizes the person, there may still be time to cure him. But often it is too late and a distant bang is heard as the gate to the land of the dead (see pages 248–249) shuts behind the soul.

CATCHING THE MISSING SOUL

Only those healers who have the capacity to enter into an ecstatic trance have the power to cure illnesses that have been caused by "soul loss". Such people undertake "soul flights", repeating the feats of mythical heroes as they journey outside their body to the sky or to the bottom of the sea to pursue the missing soul.

Because this quest might involve battling with monsters and hostile spirits, the encounters can be extremely violent, perhaps even requiring the holy person to "kill" the

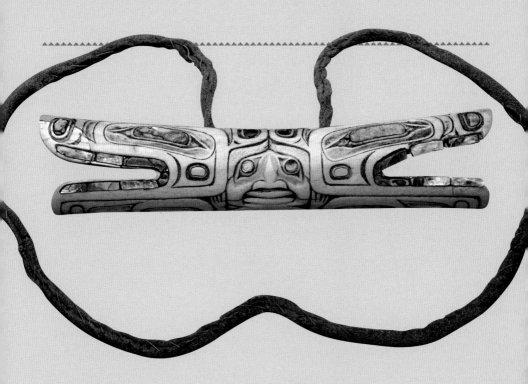

spirit and acquire its power. A holy healer might collapse with blood trickling from their mouth, nose and ears – or they could even drop dead on the spot.

An essential part of the holy man or woman's armoury was an object or substance used to transform a person's state. On the Northwest Coast holy people speak of harbouring a quartz crystal in their bodies, whereas in northern California they refer to this power more abstractly as a "pain". Such objects and pains can leave the holy person's body and attack others; as a result, such holy people are often feared as sorcerers.

The equipment needed usually includes eagle feathers, a small bag with crystals and other stones, and a rattle or drum. Among the Haida and Tlingit of the Northwest Coast, a full costume with a robe and hat is worn. Shamans from this region also employ various kinds of "soul-catcher" – for example, a tube of hollow leg bone (from a bear, for its power) to scoop up souls flying through the air. Wearing the soul-catcher as a necklace, the individual healer, or a group of them, locates the errant soul and sucks it into the catcher, then plugs it with cedar bark. The soul is then returned to the patient by being blown back into him or her.

▲ The most important object owned by a holy healer along the Northwest Coast is a soul-catcher. This is a Tlingit example (possibly acquired in trade from the Tsimshian), rendered in the form of a double-headed sea monster and made out of bone inlaid with abalone shell.

◀ A Tsimshian carving of a holy person, made out of wood and wearing painted hide and bear claws, from British Columbia, Canada.

NAVAJO HEALING WAYS

Many traditional curing ceremonies are still conducted by *hatali*s among the Navajo, or Diné, people, in the Southwest region. The Navajo's dry-painting ceremonials are a form of spiritual art that has evolved over centuries into a highly complex form of ritual.

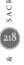
Most Navajo mythology can be said to derive from the creation-emergence myth and the various ceremonial myths that branch off it. Those stories describe how one or more heroic figures become injured or lost and travel in search of the gods in order to be cured. After being healed, and having learned the ceremony in the process, the hero returns home to pass on the knowledge and then he departs to live with the gods.

The Navajo rituals consist of songs, chants and the creation of dry-paintings (often called sandpaintings), which are said to have been taught by Snake Man to a female ancestor of the Navajo. (Other Indian peoples, such as the Hopi, also use dry-paintings, but it is the Navajo who have brought the art to its greatest perfection.) Traditionally, the *hatali* made the dry-painting on the floor of the *hogan*, using coloured powders such as cornmeal, pollen, sand and charcoal to represent a story in Navajo mythology. The objects depicted will range from the sacred mountains where the gods live, to legendary visions, or dances and chants performed in rituals.

The completed painting is effectively an altar, which attracts and exalts the Yeibicheii. The image comes alive with the spiritual energy of the holy figures represented – it is like a pathway connecting the illness to the healing power of the holy people; in the Navajo language the word for the paintings means "places where the gods come and go". The accuracy of the painting will affect its efficacy as a healing tool.

There are believed to be hundreds of painting designs, each one accompanied by its own song. The completed work, which might have a thousand multicoloured constituent elements,

▶ A Navajo *hatali* with a completed design, which is almost certainly inaccurate, because many taboos are observed to protect the holiness of dry-paintings. Authentic ones are rarely photographed, because to do so would interfere with the ceremony. Few, if any, outsiders are permitted at a sacred ceremony, thus to satisfy curiosity some pieces are created for show, using incorrect colours and variations. Real sandpaintings are highly sacred.

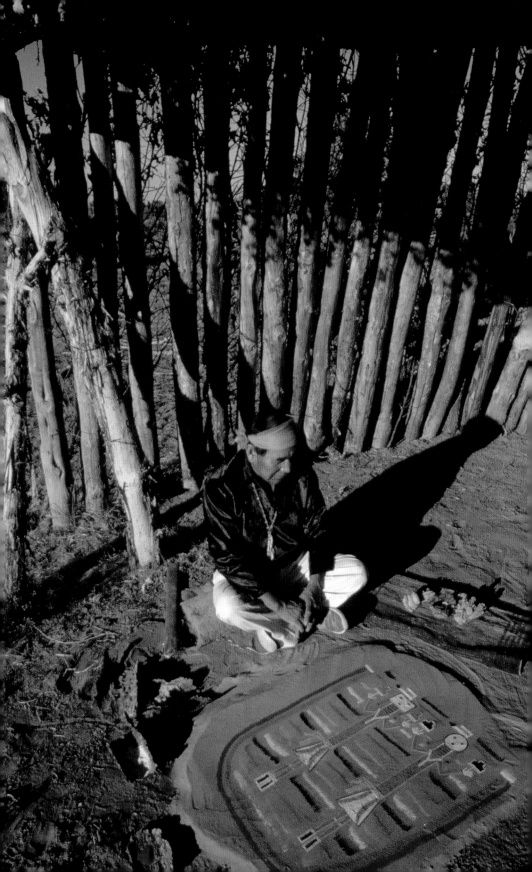

is entered from the east by participants in the ceremony and after it has been used it is returned to the earth, at the north of the *hogan*. Each curing ceremony has its own myth, but because the number of ceremonies has declined during the past century or so, many of the myths have been lost.

The rituals that dry-paintings form a part of belong to one of two Navajo song ceremonial complexes: the Blessing Way, concerned with creation, harmony, peace and healing; and the Enemy Way, held to counter the harmful effects of ghosts and during which the patient identifies with the powerful mythological figure of Monster Slayer.

For example, the Coyote Way is a Blessing Way curing ceremony in which the trickster Coyote is the tutelary spirit. The ceremony can last nine days and is necessary if someone

▲ According to Navajo belief, a sandpainting heals because it is a dynamic, living, sacred entity that enables the patient to transform his or her mental and physical state by focusing on powerful mythic symbols and causing those events to live again in the present.

in the tribe catches "coyote illness", which can result from killing a coyote or even seeing its dead body. The patient sits in the painting and takes the part of the hero of the ceremonial myth; he or she "meets" Coyote, who will appear in the form of a masked impersonator. The ritual restores the patient's harmonious relationship with Coyote and the world, ensuring a return to good health.

THE YEIBICHEII
Many of the figures in dry-paintings will be Yeibicheii or Yei ("holy people"), a class of gods who were prominent in the creation of the world. When they are impersonated during certain curing ceremonies, the masks used are made from deer that have been suffocated by having corn pollen placed in the nostrils (to ensure the deer's skin is undamaged). They are made during a performance of the Night Chant ceremony, when young Navajos are traditionally initiated into the secrets of the Yei, which are ritually consecrated and "brought to life" by having cornmeal "fed" to them and smoke blown over them.

One typical Navajo ceremonial myth tells of twin boys who were the offspring of a Navajo girl and the leading Yei deity known as Talking God. The boys were always wandering away from home and one day they were in a rockfall accident that left the elder son blind and the younger one crippled. Because they had become a burden to their poor family they were asked to leave home. The pair went in search of the gods. Talking God helped them and eventually revealed himself as their father, upon which the gods greeted the boys as kin and prepared a curing ceremony in the sweatlodge. As the cure took effect, the boys cried out in joy, breaking a taboo on talking in the sweatlodge. Everything vanished and the boys were left blind and lame as before. The brothers responded by making a gift to appease the gods, who finally cured them and made them as beautiful as their siblings. The twins returned home and passed on the curing ceremony before they departed to become spirit guardians of the thunderstorm and of animals.

RITES OF PASSAGE

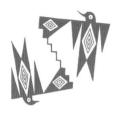

Many Native American cultures mark the times of transition in a person's life with rituals during which the passage from the old state to the new is formally enacted. At such times, the person is believed to be particularly close to the spirit world, which makes their state one that is fraught with both danger and great potential.

Unborn and newborn children are especially vulnerable, and many tribes traditionally observed taboos to keep infants from harm. For example, a pregnant Cherokee woman would not eat speckled trout for fear that her child would have facial blemishes. Apache women avoided eggs, which they believed might cause a child to be born blind, and animal tongue, which might make a child slow to talk. Lakota mothers often made a beaded buckskin pouch in the form of a turtle to contain the baby's umbilical cord, which was then fixed to the cradle. Later in life, the pouch was worn as a talisman.

Rites may be simple, as when the Cheyenne pierce a child's ears to indicate his or her capacity to listen and learn; or they may be more dramatic, such as the rites that usually accompany the individual's passage into puberty. Adolescent males might be separated from their peers and sent for a time into the forest to fend for themselves, either to prove their manhood or to seek a vision (see pages 228–229). Female rites include those held at the onset of menstruation, which are filled with celebration and laden with symbols of fertility.

COMING OF AGE

As with many cultures around the world, some of the most dramatic rites of passage accompany the move from childhood to adulthood. These often include a period of physical isolation, marking the point at which a person severs the links with his or her former status. This brief exile from society represents an interim state of "not-being", and often involves a

▶ Historically, tribal get-togethers were opportunities not only to celebrate victories, renew allegiances or lament deceased relatives, but also to give special honours to individuals in name-giving ceremonies and coming-of-age rites. At a powwow (this is typical male dance regalia, right) wisdom is passed from elders to children – from the older generation completing their journey to the newer generation at the beginning of theirs.

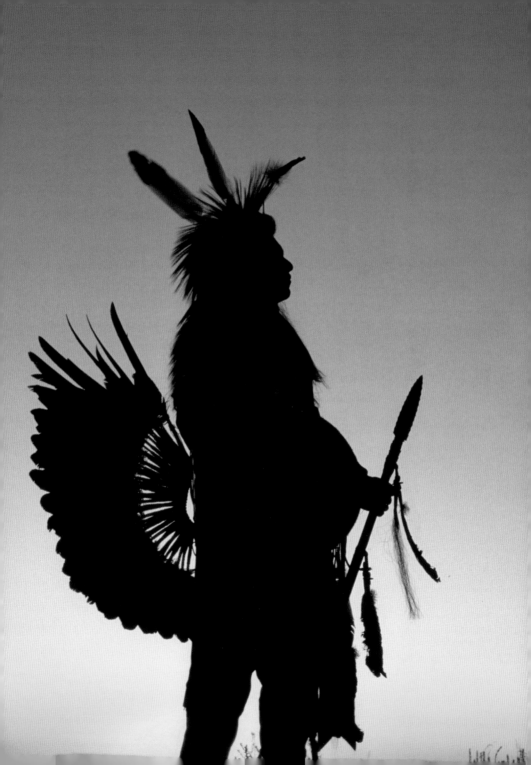

test of physical endurance, pain or deprivation. The whole process usually ends with a ritual completing one's incorporation into the new group and community.

The Nozihzho ("Stand Sleeping") rite of the Omaha included most of these elements. It was a four-day fasting rite undergone by all Omaha adolescent males (and by any female who so desired). The name refers to the trance experienced by the youths in the course of the rite. In it, they became oblivious to the outside world and conscious only of their inner being. The rite re-created the Omaha origin myth. The boy would find an isolated spot, where he would spread clay over his head in honour of the animals who went to the bottom of a great body of water and brought up mud from which the earth was created (see pages 148–149). He prayed to Wakonda, the mysterious power that controlled all of nature. The boy filled his mind with thoughts of health, successful hunting and war, and a happy, long life, but it was taboo to ask for special favours.

Wakonda, it was believed, would respond with a vision or dream that would include a sacred song. Dreams of hawks, elks or thunder might bring great fortune. The song was a good-luck charm connecting the boy to the powers of the universe. He could use it throughout his lifetime as a way to call for help from guardian spirits in time of crisis.

On his return from the rite, the boy would rest for four days before seeking the advice of an elder who had had a similar dream. Next, the boy would find and kill the creature that had appeared in his dream-vision, keeping a part of it as a sacred possession for his personal medicine bundle. He would carry the object to war or use it during rituals.

The Nozihzho ritual was not without its dangers. A dream of snakes could spell trouble. If the boy dreamed of the moon and awoke at the wrong time, he would have to abandon the idea of becoming a man and take up the ways of a woman, living as a *mixuga* who was instructed by the moon. As a *mixuga*, he would dress like a woman and wear his hair long,

▲ A Plains Indian object, possibly a walking stick or hoe, stylized in the form of a crane or loon, a bird that features in the mythology of many tribes. An Ojibwe story says that the call of the loon was the inspiration for Native American courtship flutes. Elsewhere, a Tsimshian story tells how a loon restored sight to a blind man, gaining it the reward of a necklace of white feathers to adorn its neck.

instead of in a man's roach (with the head shaved except for a strip from nape to brow). He would not hunt and fight, but till, plant and harvest like a woman, and practise a woman's crafts.

COURTSHIP AND MARRIAGE

Courtship involved its own special customs. For example, Lakota men serenaded young women with specially made courting flutes, which were frequently carved in the form of animals – usually birds known for their showy courtship "dances", such as ducks, cranes and prairie chickens. Often made by holy people, the flutes were thought to possess powerful magic notes that would cause the woman to travel anywhere with her lover.

Native Americans often viewed marriage as a state that would endure until death, and the marriage rites of some peoples clearly reflect this. Traditional Hopi weddings started at dawn. The couple would sprinkle corn (maize) meal over the eastern boundary of their mesa, towards the rising sun. The groom's family would then weave for the bride two white cotton wedding robes with fringed sashes. The bride would wear only one robe during the wedding: the other was her burial shroud. The twin garments therefore confirmed a woman's marital status and also eased her way into the spirit world at death.

FROM MAIDEN TO CHANGING WOMAN

As the bringer of life, a woman was a microcosm of Mother Earth. For this reason, women were venerated and their power was sometimes feared. Like other periods of transition when the body was in a state of physical and spiritual instability, a girl's menarche was considered to be a time of extraordinary power and potential danger. Many tribes have elaborate female coming-of-age rituals.

Rites of passage marking the first period usually included the girl's isolation in a small menstrual hut set apart from the village. She was also instructed on the many taboos she would

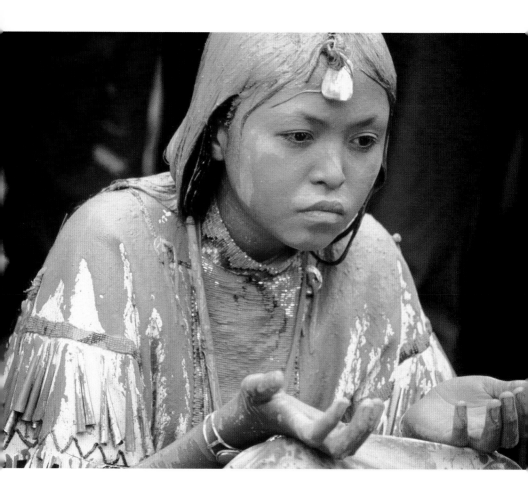

▲ An Apache girl during the *na'ii'ees* ("getting her ready"), or Naihes, popularly known as the sunrise dance. More than 30 songs are sung during the eight ceremonial phases over four days. Pictured here is *baana'ildih* ("blessing her"), the seventh phase, when the girl is blessed with holy pollen.

have to observe during subsequent menstruations. One reason for such segregation was the belief that menstrual blood was an especially dangerous substance, and that if it came into contact with sacred objects it could rob them of power and bring illness. For many women this was a strict regimen, because it meant that there were several days each month when they would be unable to fulfil their daily tasks. However, it was also a time of rest and regeneration.

The Lakota referred to this spell of seclusion as *isanti*, or "dwelling alone". They believed that menstruation was a form

of natural purification, which meant that women did not need to go to the sweatlodge for regular ritual purification as adolescent boys and men did.

The cultural life of the N'dee or Western Apache is enriched by a variety of sacred rituals, of which perhaps the best known is the female puberty rite called the Naihes, which translates as the sunrise dance or sunrise ritual. Training begins about six months before the ceremony, which is an arduous four-day-long ritual in which the participants re-enact the Apache origin myth about Changing Woman – also known as White Painted Woman – who gave birth to the tribe's culture hero twins: Slayer of Monsters, fathered by the sun, and Born of Water Old-Man, fathered by Water Old-Man.

During this time, the initiate girl makes the costume that she will wear to transform herself into Changing Woman, the tribe's first woman, whose life cycle she is imitating. The girl builds a lodge and strengthens herself for the task ahead. Her family gathers food and gifts to give away to those who participate in the ceremony. During the ritual itself, the girl is guided by her sponsor and a *diiyin*, or holy man. She dances for hours, with the number increasing each day, and must run towards the cardinal directions to mark the four stages of life.

Her sponsor moulds her into Changing Woman by massaging her body. She is painted with sacred cornmeal, which she wears throughout the whole ceremony and must not wash off. On the final day, she blesses her people with pollen and provides healing and individual blessings for those tribal members who wish it.

The Navajo have a similar puberty rite for girls-turning-into-women, known as the Kinaalda ceremony, which involves dry-paintings (see pages 218–221) and forms part of Blessing Way, a cycle of ceremonies that encompasses all the Navajo rites of passage. During the ceremony the girl enacts the part of the figure of Changing Woman, the daughter of First Man and First Woman, and the ancestor of the Navajo, who is responsible for fertility coming into the world.

SEEKING A VISION

One of the most widespread adolescent rites of passage was that concerned with the acquisition of spiritual power, or guidance from the spirits, through an altered state of consciousness brought about in a vision quest.

A vision could come about naturally through a high fever and a loss of consciousness, or it could be artificially induced. In addition to the quest-related measures of depriving oneself of food, water or sleep, visions might result from inflicting pain; taking an hallucinogenic substance; dancing, chanting, drumming; or some other form of repetitive self-hypnosis.

Among the Plains peoples, the vision quest was seen as a form of prayer (known to the Lakota as a "lamentation") that lay at the heart of their way of life and everyone sought a vision at least once in their lifetime, while many undertook regular vision quests. In the lamentation, a person stands humble and powerless before the "Great Mystery" (Wakan Tanka). Visions are sought under the guidance of experienced elders, and recounted to them afterwards for interpretation. The aim of the quest is to gain a clear insight into the future. In Plains culture, the vision forms the basis of most rituals (such as the Sun Dance), and it provides guidance in times of traumatic change. Any vision endowed the individual seeker with personal power, while the tribe's visions taken as a whole added to its communal store of spiritual power. Great leaders had visions that affected the entire community (see below).

The Pawnee word for vision means "to learn by being touched". An individual who experiences a vision while in a waking state or in a trance can usually see or talk to the powerful spirit, which may sometimes appear in concrete form, as an animal or ancestral being, but is more likely to be a nebulous "presence". Visions may reveal events of the past, present and future, but usually they cannot be interpreted without help from a knowledgeable elder or holy person.

The renowned warrior Crazy Horse gained his name from a momentous vision, in which the horse he was riding through an ethereal spirit landscape began to prance about erratically.

Commonly, vision quests are a lifelong activity and the first is performed as a child – boy or girl – nears puberty (although some cultures allow children as young as four to seek a vision), and the final one might be undertaken in old age. Vision quests require preparation, which usually means a ritual purification accomplished by fasting and taking a "bath" in a sweatlodge or steam hut. The intensity of the fast is directly related to the power of the vision being sought. Children receive guidance about which spirit they are to seek. For example, a boy might be told to take a bow on a quest to help him receive a vision of a hunting spirit. A girl might acquire plants or charms to be used for healing or preparing food. If the quest is successful, the child is not supposed to acknowledge it publicly until he or she is older. It is also important that young people call upon the aid of the newly acquired power only in serious situations.

For the Lakota, solitary vision quests are often conducted at the highest point in a locality. A small area of chosen ground might be marked out with stones and covered with sage or hide, accompanied by offerings such as strings of pouches of tobacco or strips of cloth representing sacred colours. Through good weather and bad, day or night, the individual fasts and prays until a vision comes or a spirit visits in the form of an animal. The renowned warrior Crazy Horse gained his name from a momentous vision, in which the horse he was riding through an ethereal spirit landscape began to prance about erratically. Another vision warned Crazy Horse always to stay mounted if he wished to remain invincible. Thus reassured, he became a fearless fighter. True to the vision's warning, he finally met his death while dismounted.

Vision quests remain a major part of religious practice for most Native Americans, who draw on the power of the supernatural forces around them: on mountains and hilltops, near sources of water, in the depths of the forest, and even in areas where dangerous spirits dwell.

IN PRAISE OF NATURE'S CHANGES

Alongside rituals celebrating individual rites of passage, Native Americans hail change and regeneration in the world as part of the cyclical nature of time and life. This is expressed in countless personal rituals, as well as collective ceremonials of renewal.

Nowhere is change more obvious than in the human life cycle, as naming practices demonstrate. Among the Cheyenne, a trusted elder, holy person, or grandparent carefully selects a name for an infant, often from a memorable experience or a dream. Childhood brings with it many changes in physical appearance, character and deeds, and therefore a child may be given a new name as he or she grows up. Although in most tribes females kept their names for life, males might have several through their teenage years, finally settling on a fixed name only in adulthood. For example, a young warrior who shot an enemy behind the ear might be renamed Behind the Ear. One who had spoken with the sun god in a dream or vision might become Brings Down the Sun.

EARTH-RENEWAL CEREMONIES

At the core of long-established Native American beliefs is one that the rhythms of the universe are like those of a steady drumbeat. In order to be renewed, the rhythms and cycles of nature require human participation in the form of rituals that mark important points in the cosmic cycle. Such Earth-renewal rituals are usually based upon the seasons, or crucial times in the food-supply calendar. These first-food ceremonies are profoundly important – celebrating fertility and marking the renewal of a subsistence cycle, which incorporates everything from the appearance of the first salmon or buffalo to the growth of corn.

In the villages of the farming peoples of the arid Southwest it is believed that the rain-bringing *katsinas* – the spirit

▶ George Catlin's 1836 portrait of Wah-Chee-Tee, the wife of the Osage chief Clermont, with their child. Catlin commented on the fact that the Osage applied pressure during infancy to compress the occipital bone at the back of the skull, thus modifying the shape of the head.

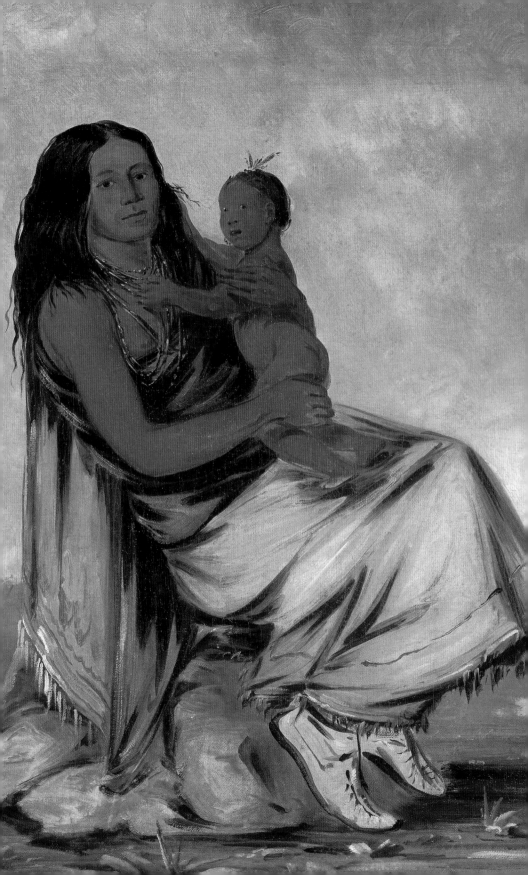

essences of all life on Earth – descend in winter from the cloud-topped San Francisco Peaks to spend six months in their villages. The dance ceremonies are held to mark crucial stages in the crop-growing cycle.

Among the Hopi there is a midwinter ceremony known as the *powamu*, or bean dance, which celebrates the germination and growth of such staple crops as beans and corn, and is also used to initiate children into the *katsina* cult. The sixteen-day-long festival begins with the planting of seeds in beds of moist sand inside a steamy *kiva* (see page 215). Dances then begin, and when the seeds have sprouted they are used in a performance by carved puppets that mimic the dancers. On the final day of *powamu*, the new crop of beansprouts is harvested and carried through the village.

Although the *katsina*s bring rain, a vital element of life on Earth, the home of these spirit beings – which can represent anything from a revered ancestor to a natural phenomenon – is the Land of the Dead, according to the Zuni. The *katsina*s remind people that everything has a life-force and that individuals have obligations to all the objects that fill the universe in addition to their own specific communities.

Other spirits are more benign, such as those accorded elaborate honours on the occasion of the Green Corn ceremony, which was held every late summer or autumn by the tribes of the eastern woodlands – from the Iroquois to the Seminole, although perhaps best known among the Creek and Cherokee, who still practise it today with the attendant fasting and a variety of dances. The ceremony is tied to the ripening of the corn, or maize, crops. (Green Corn festivals were also practised by the peoples of the Mississippian culture as part of their Southeastern Ceremonial Complex.)

Among the Seneca, during the dance when the corn spirits were being accorded elaborate honours, one of the prominent tribal elders would address the servants of the "master of life" who had sustained the people through the year. This long speech began with an expression of collective happiness

Moreover, we give thanks to the visible sky. We give thanks to the orb of light that daily goes on its course during the daytime. We give our thanks nightly also to the light orb that pursues its course during the night.

"because we are still alive in this world". The thanksgiving continued: "Besides this act, we give thanks to the earth, and we give thanks also to all the things it contains. Moreover, we give thanks to the visible sky. We give thanks to the orb of light that daily goes on its course during the daytime. We give our thanks nightly also to the light orb that pursues its course during the night. So now we give thanks also to those persons, the Thunderers, who bring the rains. Also we give thanks to the servants of the Master of Life, who protect and watch over us day by day and night by night."

THE SUN DANCE

For Plains tribes, the summer solstice is the major time of renewal and versions of the Sun Dance tend to play a key role in these celebrations. The Lakota performed the rite annually, but the Blackfeet only did so every few years. Held from late spring to early summer, the dance's main purpose is to celebrate the sun as the creator deity and source of power, and to allow people to renew their faith in the spirits that guide the world. The dance was also believed to guarantee a plentiful supply of buffalo in the coming year.

In the past, every year a Plains tribe would gather, normally in early summer, to celebrate its beliefs in a series of ceremonies, chants and other devotional practices. At the heart of this festival lay the grand public spectacle of the Sun Dance itself, at which those who wished to draw spirit power to themselves and their people performed a ritual dance before the entire tribe. The event could last up to two weeks and it involved fasting, banquets, communal games and healing sessions. Participants would implore the spirits to give them and their families protection.

For most Plains peoples, the central feature of the Sun Dance was not a single performance, but a four-day cycle of rituals and sacred dances that relate to the forces of creation. The tribe would assemble in a wide ring around a pole made from a cottonwood tree, which symbolically linked the world

above the Earth with the world below. Around this pole the male dancers would perform until they collapsed in a frenzied trance or from sheer exhaustion. Most dances are long ordeals. The warriors fast and dance around the sacred tree for hours each day. On the last day, those dancers who have opted for self-torture are attached to the tree by leather thongs tied to wooden skewers that are pushed through deep gashes in the flesh of their chest, back or shoulders. They must endure this agony throughout the twenty-four songs of the dance, which takes several hours. At the climax of the dance, the exhausted dancers lean outwards to put the maximum strain on the skewers until they rip from their torn flesh, symbolizing a release from the bonds of ignorance. A dance is considered to be successful if a participant experiences a trance or vision during his protracted ordeal.

Some devotees also used the skewers to drag heavy buffalo skulls around the camp circle. Warriors would stand or dance for hours, or even days, staring into the sun. Participants in the ritual gained great prestige, especially among the Lakota, and warriors would display their Sun Dance scars proudly for the rest of their lives.

In the nineteenth century, white observers were shocked by the self-torture associated with the Sun Dance, and in 1881 the practice was outlawed, partly because it was viewed as a focus of resistance to government policies. This was a great blow to the Plains Indians, who believed that without this essential element the Sun Dance would not be effective and the world would not be renewed. Afterwards, some Indians took to performing public Sun Dances for white people, simulating the piercing of the flesh by using harnesses. However, many other groups continued to hold traditional dances in secret, complete with the piercing, while lookouts kept watch for officials. Others turned to another ritual in the form of the Ghost Dance (see pages 260–261). When this in turn was suppressed in 1890, Shoshoni and Ute shamans, guided by dreams, shifted the focus of the Sun Dance towards healing.

▶ In the 1830s George Catlin witnessed a Sun Dance, which was described to him as a "looking at the sun", taking place near the banks of the Teton River. The participant's body he described as painted with white and yellow clay, but trickling with blood. The rite he believed was "disgusting and painful to behold".

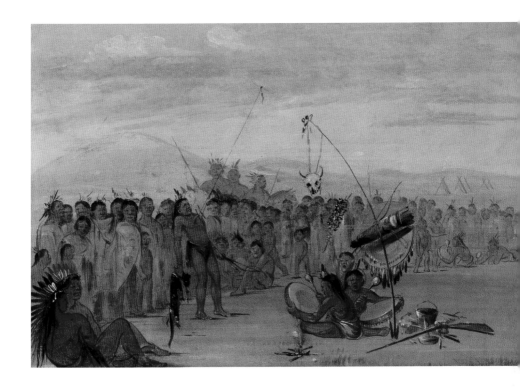

Piercing was permitted again under the 1934 Indian Reorganization Act, but a full revival only took place in the 1960s with the growth of Indian militancy and the reassertion of cultural identity. Sun Dances have become a major religious event and take place today on most Plains reservations and in some urban areas where there are Indians of Plains origin.

Although the Sun Dance was traditionally held to ensure the fertility of the buffalo herd and success in warfare, its significance was not confined to hunting or battle. Rather, the ritual lay at the very heart of religious observance, as a form of prayer in which a person offered himself up as a sacrifice for the renewal of the world. Mortification of the flesh was central to the ritual, especially on the Plains, because it signified humility before the Great Spirit, stressing that the only thing that a person had to give was his body.

THE SACRED PIPE

The communal smoking of a sacred pipe is an ancient ritual that confirms the bonds linking family, tribe and universe. The pipe represents creation and it connects the people with the past.

The *lela wakan* ("very sacred") bundle that was delivered to the Lakota by White Buffalo Calf Woman is arguably the most important event in Lakota history, and the two-piece holy pipe of red stone from the bundle remains central to Lakota ritual to this day. The smoke from it performed a dual function, both carrying prayers to the spirit ancestors as it drifted upwards and imparting strength to the smokers of the pipe.

The holy woman demonstrated how to present the pipe to the Earth, the sky and the sacred directions, before explaining that the circular stone bowl of the pipe, with its carving of a buffalo calf, represented Earth and all the four-footed animals that walked upon it. Its wooden stem, rising from the centre of the bowl, stood for everything that grows and represented a direct link between the Earth and the sky. Twelve spotted eagle feathers hanging from the pipe represent all creatures of the air. "Whenever you smoke this pipe", the woman said, "all these things join you, everything in the universe: all send their voices to Wakan Tanka, the Great Spirit. Whenever you pray with this pipe you pray for and with all things."

▷ A red stone Lakota pipe in the form of a seated woman. According to Black Elk (*c.*1860–1950), White Buffalo Calf Woman presented the first pipe and said: "With this pipe you will send your voices to Wakan Tanka, your Father and Grandfather, during the years to come. With this sacred pipe you will walk upon the Earth; for the Earth is your grandmother and mother, and she is sacred. Every step that is taken upon her should be as a prayer."

Along with the sacred pipe, White Buffalo Woman also imparted seven rites ("The seven circles on the stone represent the seven rites in which the pipe will be used."). The first rite, the "keeping and releasing of the soul", is used to "keep" the soul of a dead person for a number of years until it is properly released, ensuring a proper return to the spirit world. The second ritual is the "sweatlodge", a purification rite. The third, "crying for a vision", lays down the ritual pattern of the Lakota vision quest. The fourth ritual is the communal ceremony known as the Sun Dance (see pages 233–235). The fifth is the "making of relatives", a ritual joining of two friends into a sacred bond. The sixth is the girl's puberty ceremony. The final ritual is called "throwing the ball", a game representing Wakan Tanka and the attaining of wisdom.

The ceremonies of the Lakota enacted her injunction to revere the Great Spirit. The pipe ritual was performed in two stages. A dried herb was lit from fire that burned in the centre of the lodge, and the first smoke passed through the stem and up to heaven. In this way Wakan Tanka was the first to smoke. The pipe was then filled with tobacco and offered to the west, north, east and south, and to heaven and earth.

The Buffalo Calf Pipe and its bundle is kept by a member of the Looking Horse family, who live on the Cheyenne River Reservation in South Dakota. Today, the sacred pipe bundle is kept by its nineteenth keeper, Chief Arvol Looking Horse.

The components of the pipe ceremonies point symbolically to Wakan Tanka as the unifying power of the universe. The ceremonial lodge was constructed to represent that universe, its twenty-eight poles represented the lunar month: two of the days represent the Great Spirit; two are for Mother Earth; four are for the four winds; one is for the spotted eagle; one for the sun; and one for the moon; one is for the Morning Star; and four are for the four ages; seven are for the seven great rites; one is for the buffalo; one is for fire; one for water; one for rock; and, finally, one is for the two-legged people.

STATUS OF THE WARRIORS

Native American warfare relied on stealth, surprise and the supernatural. A warrior's martial power would have been granted to him in a vision; a plan could be laid according to how a dream was interpreted. Once attired for war the Indian brave's décor was rich in symbols and patterns, which offered protection or invoked attributes.

Despite the stereotype of Native Americans as seasoned fighters, wars of conquest with high numbers of deaths were actually a rarity. In fact, raiding was the most common form of aggression practised by Indian warriors. Forays were mounted to capture women, and expeditions might even be organized simply for the honour and glory involved in such a venture, with its opportunities for prestige. Such renown could be acquired by "counting coups" on an enemy – an act of extreme bravery that involved getting close enough to an enemy to touch him with a hand or a short coup stick, without harming him, and then getting away again unharmed. But the post-contact conflicts with Euroamerican colonizers introduced a kind of warfare in which conquest rather than honour was the primary goal. As settlers pushed in, tribes were forced out into neighbouring territories and the levels of intertribal conflict and killing increased.

Introduced during the sixteenth century, horses became both a means of waging warfare and a cause of it. Because horses became sources of wealth as well as practical assets, the practice of raiding to capture them developed, which further increased intertribal conflict. Some Indian groups – such as the Comanche – achieved legendary status as horsemen.

In many Indian cultures a man achieved status as a warrior meritocratically, through acts of valour, but in some cultures a man was born into the role. The Mohave had the *kwanamis*, or "brave men", a special class of fighters who received warrior powers from dreams that were said to begin in the womb.

▶ Wash-ka-mon-ya, or Fast Dancer, an Iowa warrior posed for this portrait by George Catlin in 1834. He was one of a group of 14 Indians who visited London with Catlin in the 1840s. The handprint on the face probably means that he had killed a man in hand-to-hand combat.

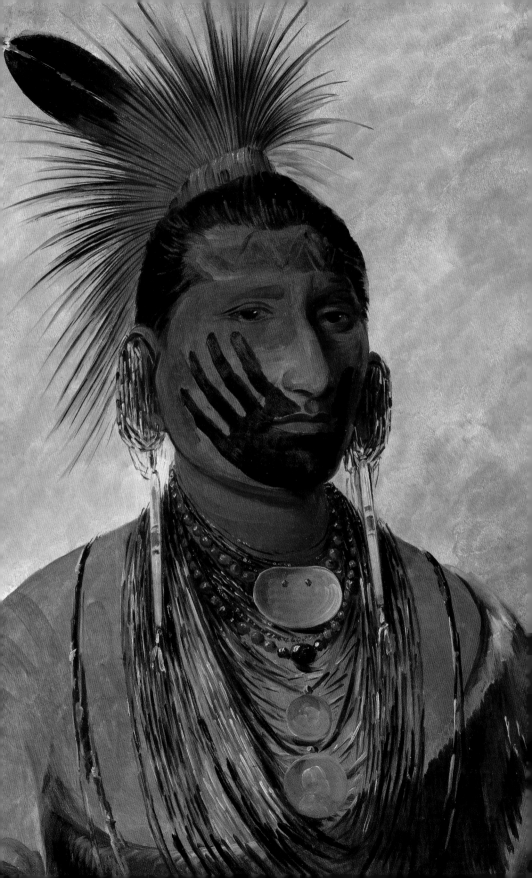

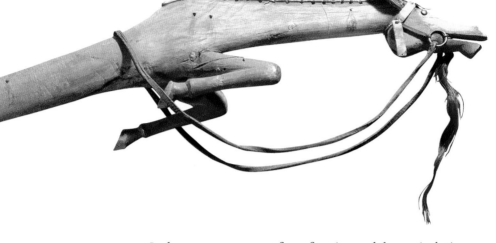

Such men were exempt from farming and domestic duties so that they were at liberty to wage war.

ADORNMENT OF THE BRAVE

Warfare in some Indian societies was as much a sacred undertaking as it was an act of violence, and the warriors who went into battle or on raids were infused with spiritual power. For three days before any conflict, Chickasaw warriors would purify themselves by fasting until sunset, then drinking a purgative brew of snakeroot. Among many groups, the medicine man conducted ceremonies and watched for bad omens to ascertain whether war plans had the blessing of the spirits. He sometimes went along on raids in order to use supernatural means to thwart the enemy, and might also treat wounds. Many communities held a war dance to boost the warriors' morale.

Battle clothing was normally kept to a minimum so as not to impede movement: a breech cloth, a medicine bundle and an eagle feather or two (different birds of prey were valued for different attributes: vigilance, swiftness, keen eyesight, and so on), as well as weaponry and a shield. However, what clothing and weaponry there was would almost certainly be decorated with a personal talisman for protection or to invoke success in battle. (Later, returning warriors might undergo purification

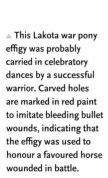

This Lakota war pony effigy was probably carried in celebratory dances by a successful warrior. Carved holes are marked in red paint to imitate bleeding bullet wounds, indicating that the effigy was used to honour a favoured horse wounded in battle.

WARRIOR "COUPS"

In the course of his life as a warrior, a Lakota male would enhance his military status through various acts – known as "coups" – that demonstrated his personal bravery in battle. Each category of coup entitled the warrior to wear a different style of feather, which was either trimmed, clipped or dyed according to the specific accomplishment.

A feather dyed red indicated a wound in battle – like a Purple Heart today. A feather with a red spot denoted an enemy killed. A feather with a notch meant the wearer had cut an enemy's throat and scalped him. A feather with a jagged edge meant the warrior had accomplished four coups, while a feather partly stripped indicated that five coups had been achieved.

rituals.) The warrior's body would probably also be heavily adorned, perhaps with permanent geometric tattoos, or temporarily painted with highly personal designs on the face and torso, which were believed to offer him supernatural aid.

RECORDING BATTLE EXPLOITS

The more elaborate garb that a warrior wore for ceremonies would be something that could be "read" by the audience. It might consist of a war shirt decorated with depictions of deeds in combat or symbols of the attainment of supernatural force, such as bear power (the bear being respected for its fierceness); or an eagle-feather warbonnet to signify high status, perhaps earned by demonstrating bravery against the enemy.

Pictographic records of events from the lives of Native Americans have existed for thousands of years, the earliest examples being devoted to what scholars call "ceremonial art". However, later on there developed "biographic art", which featured storylines of people's lives in action scenes, ranging from warfare to contact with Europeans and Americans.

This form of art made the transition from rock art to "winter counts" – hide paintings on which people documented the key events of each tribe's year (including raids and military engagements). Recounting one's exploits in battle around a campfire was, of course, the privilege of any great warrior, and

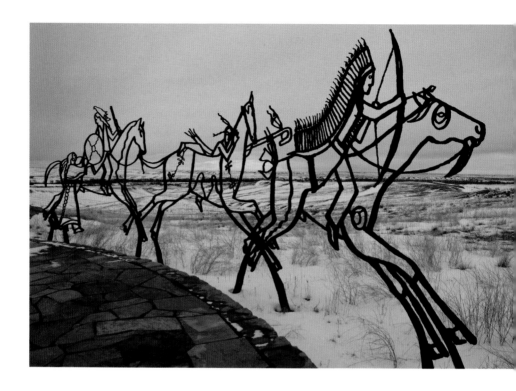

In the 1990s, the Custer Battlefield was renamed the Little Bighorn Battlefield National Monument and in 2003 the Spirit Warriors memorial (above) was dedicated to honour the Indians who had fought there. Sculpted by the Lakota artist Colleen Cutschall, the work captures the warrior's role as protector and provider. On the left a woman hands a shield to the man on the horse – a reminder that there were families in the village.

many such deeds were recorded during the Reservation period, when agents and missionaries gave ledger-book paper and cloth to Indian warrior-artists so that they could document their own story or that of their tribe. Those individuals used the medium skilfully and often incredibly accurately, although at the time many Indian accounts were dismissed as fanciful.

In fact, Europeans' perceptions of the world were so utterly different from those of Native Americans that their outlooks were separated by a chasm. Settlers looking to take personal possession of the land had little interest in reaching an accommodation with the Indians, and they saw not a rich diversity of fascinating cultures but people who seemed to live rudimentary lives. Some argued that Native Americans belonged to a lower order of beings and, for many, there was little sense of common humanity. That the Indians might have

their own, revealing story to tell took many years to emerge, and a good example of it is the Battle of the Little Bighorn, otherwise referred to as Custer's Last Stand, and which the Indians remembered as the Battle of the Greasy Grass.

The legend of this famous episode is riveting and seductive. On 25 June 1876, a detachment of US Cavalry was ambushed on the Little Bighorn River in Montana and surrounded by Plains Indian warriors. Greatly outnumbered, the soldiers fought gallantly until there was only one man left: General George Armstrong Custer. With his golden hair down to his shoulders, he stood on the crest of a hill, surrounded by the bodies of his men and horses, his guns still blazing, the last man to die. The battle became the most famous event of the Indian Wars, an ignominious defeat transformed into an example of the indomitable pioneer spirit. This accepted version of events was constructed by army officers, officials, artists and historians. According to the legend, no one had lived to tell the tale, and in the absence of eyewitnesses white Americans were content to accept the account as official.

In fact, many Sioux, Arapaho and Cheyenne warriors and their families had survived the battle. Their testimony was ignored, but first-hand accounts retained in Indian oral tradition present a consistent picture of the battle, and it is one that tallies with the evidence from modern archaeology. There are also numerous Indian illustrations of the battle, on hide, muslin and paper. For example, White Bird, a Northern Cheyenne and a member of the Dog Soldier military society, produced a work on muslin in which he depicted a scene from the battle, using the imagery of horseshoes to show the battlefield movement of the combatants. Archaeological analysis of the site has revealed that Indian veterans essentially got it right in their first-hand accounts and drawings of the famous encounter. The Little Bighorn was no protracted and glorious Last Stand but a disorderly rout, over in half an hour – a defeat typical of battlefield disintegration when faced with overwhelming and terrifying odds.

inkpataw.tiaw.to Keya
aWi'ca Ktepiw Kiw he he pi
he le oswapiw he ce reiw de
Ku Wapiw Waxpa a wi'ca
Wi'ca diyamiwiwi to Keya
i'Kiye la Ku wa awi'ca yapi
Aya'a al o wipiw

JOURNEY TO THE AFTERLIFE

Most accounts of the origin of death accept the logic that space is limited on Earth and room needs to be made for new life. On the whole the afterlife is regarded as a place much like this one but with more game, corn, or whatever was prized.

Although beliefs about death and the customs and rituals surrounding bereavement are varied among Native Americans, certain common themes emerge – for example, most groups thought that the dead represented a danger to the living, and therefore the deceased were treated with respect and caution. Almost all Indian peoples believed in some plane of existence beyond the realm of the living, but descriptions of the afterlife differed greatly, and the issue of what happens to the soul after death was a highly complex one for many tribes.

For the Navajo, death happened when the wind of life that came into the body at birth departed. Deaths were generally feared, because although a dead person's goodness contributed to the balance and harmony of the universe, bad qualities remained behind in the form of a ghost that could harm the living. The people most threatened by the dead were those closest to them in life, and so, among the Tlingit of the Northwest Coast, mortuary rituals were often handled by those of another kinship group. As happened to people during other rites of passage, the dead were placed apart and their connections with the living world severed.

▲ **Pages 244–245.**
The opening of the Battle of the Little Bighorn, as depicted by Amos Bad Heart Bull (c.1868–1913) who drew his pictures as a young man and based them on many accounts he heard from Indian participants in the momentous battle.

DISPOSAL AND GRIEVING

Many groups believed that if the corpse was taken out through the doorway then those still living might soon follow in the deceased's footsteps. The body might be taken out through the smokehole, or through a temporary new opening. Those involved with the disposal took care not to offend the deceased and they ritually purified themselves after their duties.

It was widely believed that the dead were drawn back to where they had resided when alive. The Mohave and Yuma peoples burned down the house of the deceased in order to prevent his or her ghost from trying to return there. The Navajo simply abandoned the dwelling. In a similar vein, all the deceased's possessions might be given away to non-relatives, or even destroyed.

A corpse might be cremated, buried, or left to decompose in the open air on a scaffold or in trees. The resulting bones might be left on the ground or later gathered for interment in a conical or linear burial mound. Both scaffolds and burial mounds were sacred areas deemed by some to be spiritually dangerous. Among the Lakota, *wanagi* ("things of the shadow") spirits are said to guard graves and can harm anyone who disturbs the dead.

However, other peoples saw the remains as objects to be cherished. According to these groups, for a set time after death the deceased continue to "live" near their relatives and need to be cared for. In Alaska, the Koyukon maintain small houses where the body is placed and in which the late person's spirit resides for a period. After the winter has passed, the house is repaired or painted, and a favourite food of the deceased is burned in a fire so that the smoke can feed the dead.

Peoples who bury their loved ones often have special rituals. Such is the case with the Hopi who inter the dead in a sitting position facing west and surrounded by grave offerings. Some groups preferred cremation – the Luiseño of California used fire to release the soul into the sky, where it was thought it would become part of the Milky Way.

Because the dead often suffered anguish at being separated from the living, the living endeavoured to ease their pain. The rituals accompanying death may be as simple as taboos in which the name of the dead cannot be uttered or may involve demonstrating how much a person was missed by enacting public displays of grief. Among many Plains groups,

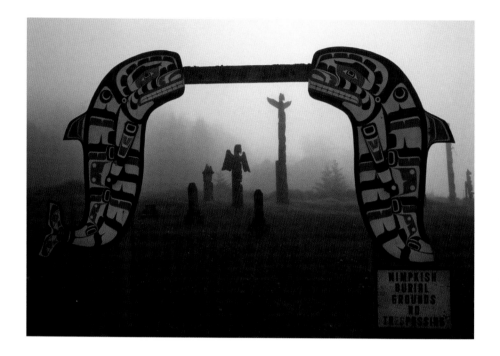

▲ A gateway leading to the Nimpkish burial grounds at Alert Bay, which is located on Cormorant Island in British Columbia. The Nimpkish are a band of the Kwakwaka'wakw (Kwakiutl) nation and these figures are memorial totems.

▶ A Tsimshian heart-shaped charm which, when opened, reveals an owl that represents the soul of one who recently died. In the Southwest, the owl was also associated with death.

mourners cut their hair and wear it short for a year, slash their arms or chests, cut off a fingertip, or wear mourning clothes. Many grieved for a period and others carried out simple, gentle ceremonies, such as offering food to ease the dead person's passage into the afterworld. In some tribes, people make lengthy speeches to the spirit of the deceased and request that he or she stays away from the living.

AFTER DEATH

The Hopi have the notion of punishment after death. On the path to the place of emergence (*sipapu*) in the Grand Canyon, the "breath body" of the deceased traveller is met by a guardian called Tokonaka. If he judges the traveller to be good, he lets him or her proceed to the town of the dead. Otherwise, a spirit traveller might have to journey on a forked trail leading to a series of up to four fire pits. If the spirit can be purified in the first pit, it can return to the trail of the good. The incorrigibly evil are burnt in the fourth fire pit.

THE ETERNAL SOUL

Most Indian cultures believe in an afterlife, with most tribes contending that each body has at least two souls; one is free and can leave the body to roam the world during dreams or illness, while the other is corporeal and remains with the body at all times. At death, one soul might journey to the spirit world, while another might die with the body or be bound to it for an indeterminate time, perhaps until the mortal remains are burned or fully decomposed. Some Lenape believe in three souls: a blood soul that becomes a small ball and remains present in out-of-the-way places; a body soul that eventually joins the Creator to pass eternity in the afterlife after journeying through twelve cosmic layers; and a ghost that roams the Earth until the person it has once been passes out of the memory of the living. The Northwest Coast Quileute argue for five souls, with complex rules controlling their relationships in both life and death.

Most native groups are agreed that the afterlife is out of the reach of the living. In most cases, it is believed that one of the dead person's souls would eventually join the Creator for eternity.

For some peoples, the afterlife is a contrary realm, where rivers run backwards, seasons are mixed up and people dance with crossed feet. For others, the afterlife is little more than a rest stop because the possibility exists that "dead" souls can, at some unspecified but favourable time, be reborn on Earth. Thus one Inuit view is that the Raven Man hero who, at the beginning of time, perfected the creation, will return after a universal holocaust with the souls of the dead and re-establish life in its primal goodness. Smohalla, who inspired the nineteenth-century Dreamers Cult of the Northwest Coast, enlisted the help of the sacred spirits of the ancestors in an attempt to bring about a return of the old ways, declaring: "All the dead men will come to life again. Their spirits will come to their bodies again." A generation later, Smohalla's vision was echoed by Wovoka, the prophet of the Ghost Dance movement of the Plains (see pages 260–261).

THEN & NOW

In accordance with Native American concepts of the "living past", Indian festivities reflect the belief that what happened in time gone by remains a vital, active, invisible presence in the life of the people today.

Native American ceremonies and rituals acknowledge more than just the particular context in which they are held, or the re-enacted sacred events that they may incorporate. These rituals may be simple, individual and personal. For example, every morning a Shoshoni holy woman rises just before dawn and prays to the east. Each phrase of her prayer ends with, "Now, then, bless the people". The simple phrase "now, then" represents a thanksgiving for the continuation of her own life, a recognition of the cycles of nature, and a commemoration of her people's past and journey into the future.

Some commemorations may take the form of traditional communal festivals, such as the potlatch (see page 61). The Kwakwaka'wakw (Kwakiutl) potlatch, which includes songs, dances and sacred rites that have altered little over the centuries, has also been used for a long time to mark the transfer of power from one generation to the next. Valued material objects, such as a large, flat piece of copper incised with the image of a totemic animal, are handed over to a new chief as a symbol of his power and of its transmission from the ancestors and other beings in the past.

Other celebrations combine ancient elements with new formats. An example is the annual Choctaw Fair, held every summer on the Pearl River Reservation in Mississippi by the descendants of Choctaws who refused to be moved from their ancestral homelands. Choctaws come from all over the United States to commemorate their past, traditions and very survival as a nation. The fair, held at around the time that the Choctaw used to hold a corn-ripening ceremony, includes storytelling, dancing and their traditional ballgame *ishtaboli*.

▶ Detail of the bone breastplate and ceremonial eagle feathers worn by tribal leader and author Herman Agoyo of San Juan Pueblo, New Mexico.

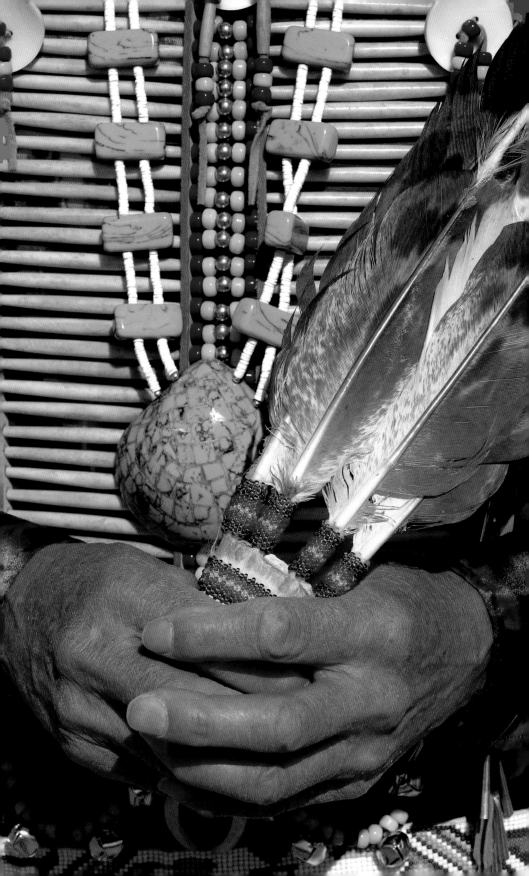

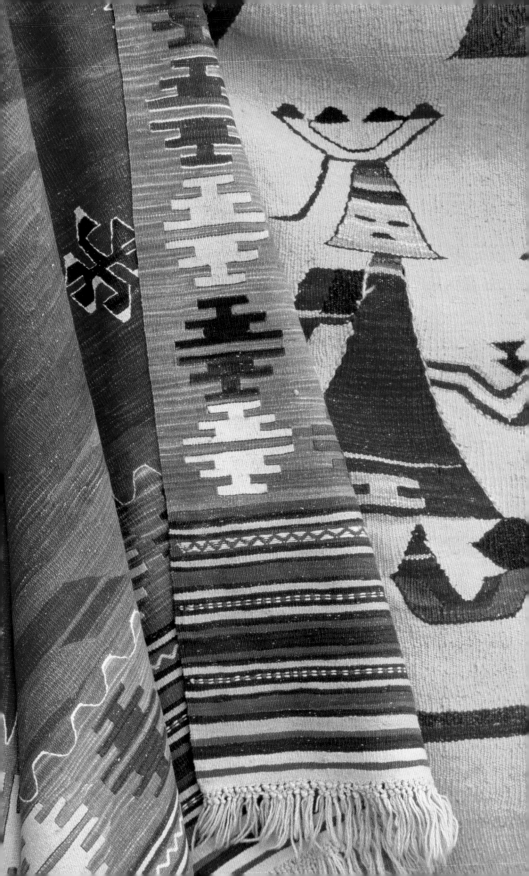

THE SURVIVAL OF THE SACRED

For Native North Americans, the disruption wrought by Europeans and their American successors was often sudden, violent and far-reaching. Within less than a generation, a people's way of life had changed radically. Diseases devastated populations, and forced relocation not only disrupted family life but shifted groups to landscapes with which they were unfamiliar and which did not feature in their sacred stories.

Displacement led to confrontation not only with whites, but also between Indian groups who were thrown together and forced to compete for ever more meagre resources. The eradication of the buffalo destroyed the subsistence base for countless groups of peoples.

In these adverse circumstances, Indians tried to hold on to their traditional ways of life for as long as possible. But change was inevitable if Indian groups were ever to adjust to the new situation and survive as distinct cultural entities. New, pan-Indian religious movements arose, some of them millenarian, predicting the end of the white ascendancy and the return of the old ways. Other spiritual movements – such as the Native American Church (see pages 81 and 259) – held dear the traditional relationships between people, nature and spirit, but coped by adding elements of Christianity. Yet even the efforts of the missionaries failed to weaken this core traditional belief; as the Lakota affirm at the end of traditional prayers, *mitakuye oyasin*! ("we are all relatives!")

NOTHING EVER ENDS

The circle symbolizes "connectedness," or the sacred unity of all things, perpetuation and renewal, linking the present and future with the past, which is why this motif remains powerful among Native Americans.

Among American Indians, time itself is seen as circular, and the various cycles of nature are evidence of the eternal circle of existence. Each day follows a cyclical rhythm, and although the heavens change they do so with a marvellous regularity, which some tribes represented by creating medicine wheels.

Most tribes have a ceremonial cycle that reflects the endless repetition of the seasons – the new growth of spring, followed by the maturation of summer, the decline of autumn, and the death of winter. Various groups devised their own ways to mark these changes. The Hopi select a human "sun watcher", whose task is to observe the sun's movements each day and calculate when the last frost of the year will occur from the timing of the winter solstice.

Each person's life is similarly a cycle of birth, growth, maturation, death and regeneration, punctuated by rites of passage. Native Americans believe that nothing ever really ends. Instead, when living beings complete a cycle, they move to the past – remaining "out there," immanent and near by, rather than distant.

"The two circles" is the name given to the movement established in the late 1970s by the Traditional Circle of Indian Elders and Youth, supported and sponsored by the American Indian Institute. The aim was to forge a living repository of indigenous wisdom from grassroots religious leaders throughout the Indian nations with the purpose of renewing and transmitting traditional culture and spiritual values to the next generation – not a geographic community but a community of shared interest, which is dedicated to the survival of indigenous heritage.

▲ Page 252. Native American blanket, Colorado, USA. Weaving remains a source of income for many Native Americans.

▶ Hoop dancing at the Heard Museum in Phoenix, Arizona. In a dance that symbolizes renewal, hoop dancers may use one or many hoops, twirling them around their arms, legs, or neck as they dance to form shapes such as the sun, the moon and thunderbirds.

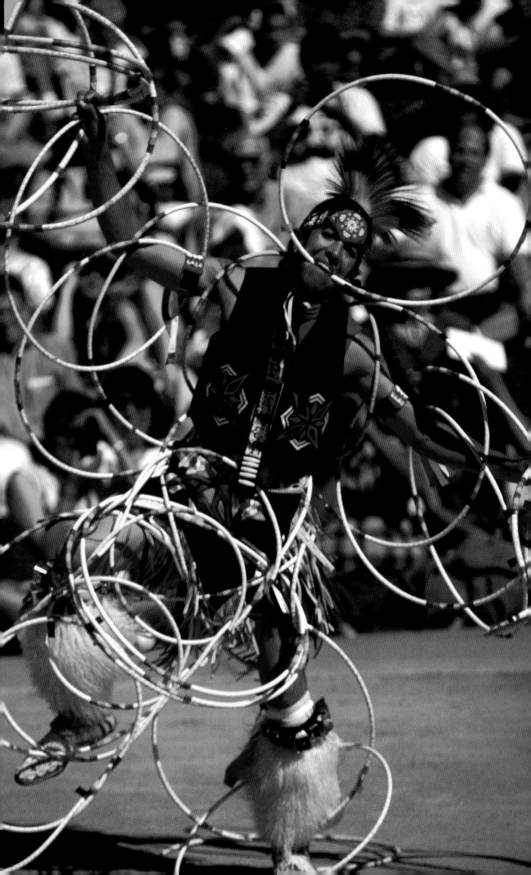

NATIVISTIC MOVEMENTS

Many spiritual movements arose to help Indians to come to terms with the upheaval caused by the arrival of Europeans and to reaffirm indigenous values and culture in the face of pressure to assimilate.

There were two types of nativistic movement, the "revitalization" and the "millenarian". Both were syncretic – in other words, they adopted some of the beliefs and practices of the dominant culture, although to different degrees. In the first type, Indians were able to defuse much criticism of their values by adopting some Christian forms and symbols and eliminating other elements that the missionaries denounced as heathen or superstitious. Some revitalization movements, such as the Handsome Lake Movement and the Native American Church, took congregational forms similar to those of the Christian churches and allowed a core of traditional belief to survive by camouflaging it. The second, and generally more confrontational, type of nativistic movement arose when subjugation was so rapid that traditional culture was in danger of immediate collapse.

Revitalization movements were sometimes, but not necessarily, headed by prophetic figures, whereas millenarian movements almost always began with a prophet preaching an imminent, sometimes cataclysmic, end to the current order and a return to traditional ways.

Some scholars have argued that nativistic prophets arose due to contact with the Christian prophetic tradition. Millenarian movements in particular appear to have been inspired by the promise made by Jesus that God would sweep away the current order and establish a spiritual kingdom that would last a millennium. However, other scholars argue that Native prophets had their roots in a type of pre-contact ceremony called a "prophet dance", a communal dance at which prophesying, exhortations and trances occurred.

Handsome Lake's vision included a heaven and a hell for Indians alone. Those who believed in his "Good Message" met for weekly worship in a tribal longhouse.

Whatever the case, the Native prophets were innovators, willing to bring new beliefs and practices to their people. Prophets usually arose in the worst of circumstances, such as those which beset the Seneca before the rise of Handsome Lake. Many were holy people, such as the Paiute prophet Wodziwob (see page 261). Other prophets had no sacred training at all, but possessed oratorical or political skills. Most became prophets as a result of personal visions or dreams.

FOLLOWING THE PROPHETS

The first great revitalization movement, the Handsome Lake Movement, or Longhouse Religion, arose in the Northeast in 1799 among the Seneca, a people of the Iroquois League. After the American Revolution, in which the Seneca had sided with Britain, Seneca lands were confiscated, sold or stolen. Food became scarce and alcoholism threatened social collapse. It was at this point that Handsome Lake, aged sixty-four and the half-brother of the chief Cornplanter, dreamed of an encounter with spirits, who advised the Seneca to give up alcohol and all dancing except a "worship dance". The spirits also urged peaceful accommodation with whites. Handsome Lake's vision included a heaven and a hell for Indians alone. Those who believed in his "Good Message" met for weekly worship in a tribal longhouse. The religion was very successful among the Six Nations, and by the middle of the nineteenth century about one-quarter of the Iroquois had become followers of his teaching, which is practised to this day.

Other movements came to the fore in the early nineteenth century. One was Lalawethika, the younger brother of the Shawnee chief Tecumseh, who became known as the Shawnee prophet. During the early 1800s, Shawnee culture was in crisis. The people were in continual conflict with whites on the frontier, their lands had been overhunted, and disease and alcohol had taken a severe toll. In 1805, Lalawethika fell into a series of visionary trances during an epidemic. Previously

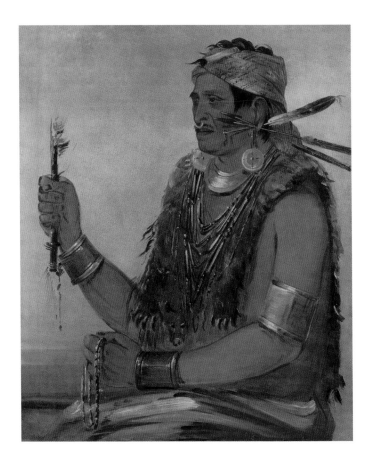

▲ George Catlin's 1830 portrait of Ten-squat-a-way (Tenskwatawa or Open Door), known as the prophet, brother of the Shawnee chief Tecumseh. In 1826 Tenskwatawa established a village where modern-day Kansas City now stands.

a lazy, boastful drinker, he emerged from his visions a new man. He declared that the "Master of Life" had shown him a paradise full of game and fertile cornfields, which could be theirs if the Shawnee returned to the path of virtue. Many of the virtues preached by Lalawethika, or Tenskwatawa ("Open Door") as he now called himself, were traditional Shawnee teachings, but others drew on Christianity. Tenskwatawa attracted many converts, including Tecumseh. By 1807 the brothers had established a settlement called Prophet's Town, and the US government began to look upon the movement as a threat. In 1811 the prophet engaged federal troops at

THE NATIVE AMERICAN CHURCH

The Native American Church is one of the most important revitalization movements, and with about 250,000 members, it is also a pan-Indian one. Initially, the movement spread across the Plains from Oklahoma after the collapse of the Ghost Dance and was endorsed by the famous Comanche chief Quanah Parker. Church members eat the mildly hallucinogenic entheogen peyote, a spineless cactus, as a sacrament. Led by a "peyote chief" or "roadman" who travels between groups, meetings are often held in a *tipi* from dusk to dawn and involve rattles, bone whistles and other Native elements. Church doctrine is a mix of Christianity and traditional belief, having evolved among different Indian groups. God is a great spirit and Jesus is a guardian spirit. The ideal of brotherly love and some of the Ten Commandments are among core beliefs. Members do not drink alcohol. Peyote remains outlawed in the United States except for its sacramental use by the Native American Church.

Tippicanoe, outside the town. The Shawnee were routed and Tenskwatawa abruptly lost most of his influence. Tecumseh took over until his own death in battle two years later.

There was also a nameless, charismatic Ojibwe prophetess who apparently visited the northern Columbia River region. She may have inspired Smohalla, who was among the best-known prophets from the Plateau, Great Basin and Northwest Coast areas. A holy man from the Wanapum people, in 1860 he proclaimed a message that he said came from the land of the spirits: the fortunes of the Indians would be restored if they refused to follow white ways that "wounded" Mother Earth, such as mining and ploughing. Smohalla's prophecies became the foundation of many Ghost Dances of the Northwest Coast and Plains (see pages 260–261).

Smohalla also inspired several movements in California, where there was severe cultural disruption in the late nineteenth century. The Bole-Maru combined Native values with Christian-inspired dualistic ideas of heaven and hell, God and the Devil. Individuals known as Dreamers, who were privy to messages from the Creator, conducted the rituals. The Bole-Maru movement is still active among California's Indians.

THE DANCE OF DESPAIR

The most popular of the Native revitalization movements was the Ghost Dance, a cult born out of desperation; it featured a circle dance in which the participants were said to visit dead relatives in a visionary trance.

In 1870 in present-day Utah, a *wovoka*, or "weather doctor"(one said to possess powers over natural phenomena), dreamed that he was given the power to bring back the souls of those Paiute who had recently died from disease. According to this dream, the people had to paint themselves and perform circle dances. The *wovoka* became known as Wodziwob, the Paiute term for an elder, a curer or a doctor. When the people rested, Wodziwob would fall into a trance, during which, he claimed, he visited the dead, who promised to return to their loved ones

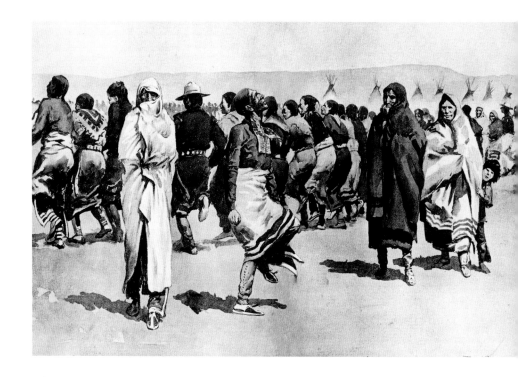

A GHOST DANCE REVIVAL

In 1973, members of the militant American Indian Movement (AIM) occupied Wounded Knee for several weeks. The spiritual leader of the takeover, Lakota holy man Leonard Crow Dog, had always believed that the Lakota emissaries to Wovoka had misunderstood his message. They should not have thought that they could bring back the dead, but should have seen the circle dance as a means of keeping traditional ways alive by creating a link with the past and the ancestors. During the protest, Crow Dog conducted a Ghost Dance in the place where it had died in 1890. Women worked throughout the night to make Ghost Dance shirts out of burlap and curtains, painting them in traditional ways. Many dancers wore American flags upside down, a recurrent form of AIM protest. Since 1973, Crow Dog has continued to practise the Ghost Dance on Crow Dog's Paradise, his family land on the Rosebud Indian Reservation in South Dakota.

soon. News of Wodziwob spread into California, the Great Basin and the Plateau, but the Paiute Ghost Dance came to an abrupt end in 1872, when Wodziwob declared that he had been tricked by an evil witch owl. The revival came in 1889 when another weather doctor – who came to be known simply by the title Wovoka – experienced a trance in which he claimed to visit the land of the dead, where God told him to preach peace. Wovoka said that Native people could meet the dead and visit the former world of traditional Indian ways during circle dances. He preached that Indians must not fight and could even adopt some white ways for the sake of peace.

Many Plains groups sent emissaries to Wovoka. The Lakota said that Wovoka was the son of the Great Spirit, who had risen from the dead after being killed by whites. Eventually, all whites would be swept away in a fiery cloud, the dead and the bison would return, and a new world would come into being. Like other peoples, many Lakota wore special Ghost Dance shirts, which they believed would protect them from bullets.

The US Army used the spread of the Ghost Dance as an excuse to disarm any Plains Indian groups still seen as presenting a potential threat.

◄ The Ghost Dance spread through the Plains during the late 19th century. But at Wounded Knee, Pine Ridge Reservation, South Dakota, in December 1890, US troops massacred at least 200 Lakota men, women and children – an action for which the US Army awarded 20 Medals of Honor. For Indians, the events at Wounded Knee stand to this day as an example of the cruel white suppression of Native culture. In 2001 the National Congress of American Indians began a campaign to get the government to rescind the medals.

THE STORYTELLERS

In Native American philosophy, the roundness of a drum is a circle that binds all people and the beating of the drum represents the eternal rhythms of nature. These rhythms are echoed in the speech of traditional storytellers and the stories of modern Indian writers.

Native American oral traditions encompass a wide range of genres, from simple moral tales to powerful oratory. Contact with other cultures and the development of written Native languages have enabled Native peoples to expand their forms of expression even further. In recent times, the keen storytelling that is a feature of many Native cultures has provided a foundation for the growth of written creativity and the appearance of a Native American literature. Indian literature has not only served to keep tribal traditions alive, but has also acted as a bridge between Native culture and mainstream society.

NATIVE LITERATURE

The autobiographical tradition provides perhaps the most direct means of communicating the realities of Indian life to outsiders. The first book in which an Indian author translated the Native experience for non-Natives was probably *Son of the Forest* by William Apess, a mixed-blood Pequot of the Northeast. In this autobiography, which appeared in 1829, Apess wrote of the abuses he and other Indians had suffered at the hands of whites, and about his personal religious beliefs. Apess has been followed notably by Luther Standing Bear (Lakota), Charles Eastman (Santee Dakota), John Rogers (Ojibwe) and Paula Gunn Allen (Laguna Pueblo). Biographical works have also been influential – for example, John Neihardt's *Black Elk Speaks* (1932), about the life of the Lakota visionary Black Elk. However, the genuinely Indian character of this and other, similar works is doubtful. In such works, a non-

A group of young Native American children gather around a storyteller at the school on the reservation of the Barona Band of Mission Indians, in Lakeside, California. The Barona Indian Charter School believes that education is the key to successful cultural relationships, and the school is well resourced to fulfil its mission as a result of revenue from gaming.

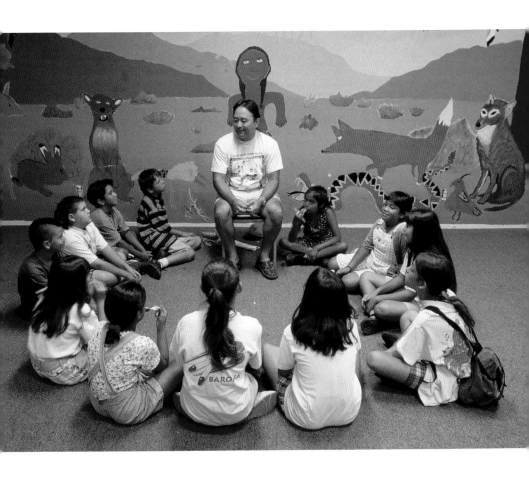

Indian author has imposed a narrative structure that is not its subject's own and thus may lack authenticity.

The first novel written by a Native American author was *Wynema* (1891) by Sophie Alice Callahan, a mixed-blood Creek. Her work addressed important tribal issues of her day, such as the Ghost Dance (see pages 260–261) and the massacre at Wounded Knee. The novel has proved a particularly fruitful genre for Native writers, a prominent theme for many of them being the problem of Native identity and how to cope with the dominant white culture. Since the 1960s, the modern Native

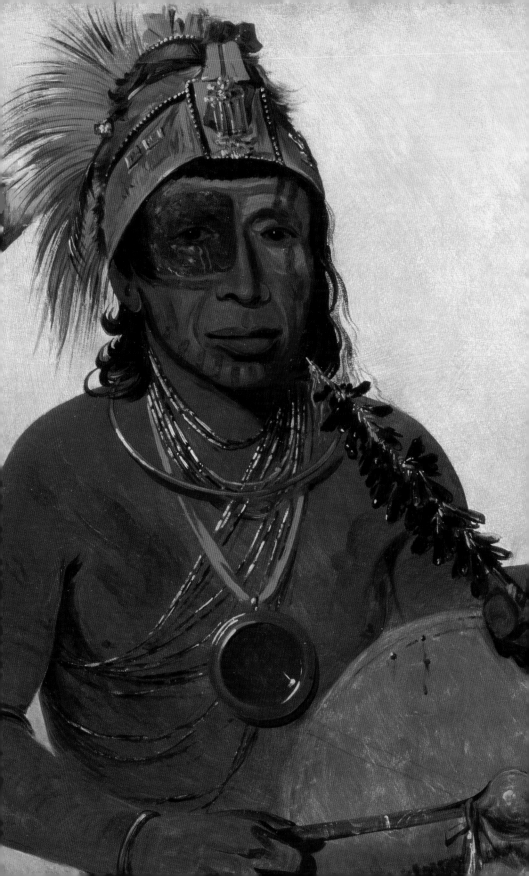

American experience has been the subject of several notable novels, such as *House Made of Dawn* (N. Scott Momaday), which won the Pulitzer Prize for Fiction in 1969, *Ceremony* (Leslie Marmon Silko) and *The Death of Jim Lonely* (James Welch). A situation of conflict is immediately established in the fact that the central characters are (like their authors) of mixed blood and are torn between reservation and city life. However, the conflict is ultimately resolved when the characters restore their relationship with the land and its tribal traditions. Similarly, for the authors the very act of writing is a cathartic reaffirmation of their Native roots.

The telling of stories and myths is integral to the healing process. The message of much Indian literature is that white people are out of sympathy with the land because they are driven to conquer and dominate it, whereas the Native approach is to listen to what the land has to say and discover a way of living in harmony with it. In a disorienting world, such literature aims to make people whole again by reference to ancient patterns of order and meaning that are enshrined in the oral tradition of storytelling.

House Made of Dawn has been identified as the catalyst for a surge in literature with a Native American perspective. In 1983 the critic Kenneth Lincoln labelled the explosion of Indian literature a "Native American Renaissance". Whether or not such a movement is identifiable, among the best known of contemporary Indian novelists is Louise Erdrich, born in 1954 of an Ojibwe mother and a father of German descent. Her works, often set in the region of North Dakota where she grew up, have received critical praise both in the US and abroad. Erdrich explores some of the central issues facing modern Native Americans, in particular the struggle to retain their Indian identity in the face of the almost overwhelming pressure to assimilate imposed by the dominant white culture. This problem, and the strain that it puts on relationships between and within the older and younger generations, forms the basis of Erdrich's acclaimed four-volume family saga consisting of

◀ George Catlin had begun painting in the 1820s, and around that time, after a delegation of Indians had visited Philadelphia, he dedicated himself to commemorating "the history and customs of such a people", adding "nothing shall prevent me from visiting their country and becoming their historian". His striking portrait of holy man Blue Medicine was painted at Fort Snelling, Minnesota, in 1835.

Love Medicine (1984, the winner of the National Book Critics' Circle Award and the Los Angeles Times Book Award), *The Beet Queen* (1986), *Tracks* (1988) and *The Bingo Palace* (1993).

Native poetry has more direct links with the oral tradition, and poets such as Gerald Vizenor (Ojibwe) and Joy Harjo (Creek) seek to capture the emotional intensity and rhythms of the spoken Native language. Many others have received American Book Awards, including Wendy Rose (Hopi–Miwok) and Maurice Kenny (Mohawk). Contemporary poetry, like most Indian literature, is written in English, but nonetheless seeks to preserve the speech patterns, spirit and content of Native tongues. This is a difficult endeavour, as the oral tradition does not easily lend itself to translation into the written word. A Washo story tells how, in 1910, a man who later became a medicine man was cured by his uncle, who pulled a piece of printed matter out of his patient's head and told him that he had fallen ill from studying books, which belonged to the white people's world. By contrast, the contemporary Native poet Duane Niatum (S'Klallam) has written that a Native American writer "must train himself to become sensitive to the many facets of the English language, with the same devotion that a shaman had for his healing songs a thousand years ago".

THE TRADITIONS LIVE ON

The written word is important, but it has not displaced the oral tradition, which thrives as a means of expressing ancient wisdoms and contemporary conditions, especially in the form of elders telling stories to an audience of children. The written and the spoken genres have a shared goal: to record and to clarify the Native American experience, which outsiders have often distorted or dismissed as being of no significance. However, many have currency, such as Joseph Bruchac's (Abenaki) best-selling "Keepers of the Earth" series, which integrates environmental science with traditional storytelling. Sherman Alexie (Coeur d'Alene) often uses biting humour in his work, which includes the film screenplay for *Smoke Signals*.

Contemporary poetry, like most Indian literature, is written in English, but nonetheless seeks to preserve the speech patterns, spirit and content of Native tongues.

TO THE "SEVENTH GENERATION"

Seven is a number with great significance in the traditions of many Indian nations. For example, the Lakota speak of seven "origin people" and had Seven Council Fires. Seneca wisdom distinguishes "seven talents". The Pawnee used the position of the Seven Stars (the Pleiades) to determine the beginning of the ceremonial year. Above all, many Native Americans recognize a profound responsibility to those who will come after them, down to the "Seventh Generation". This means that a person's behaviour is guided by consideration for the future (below, a father teaches his daughter about eagle feathers). Some Indians look to the future by keeping alive traditional themes in new, perhaps non-traditional ways – for example, by writing novels and plays, or through art. Others struggle to restore what they regard as the world's balance by demanding the return of the remains of ancestors and other ancient relics stored on museum shelves, and by reclaiming land illegally taken. Some strive to provide employment where it is needed, or to protect their culture by educating the young in their own traditions (such as at the annual fairs that include powwow dancing, Indian games and other traditional events, all of which reaffirm tribal identity and pass on their heritage), while also giving them the tools that will enable them to compete in the modern world.

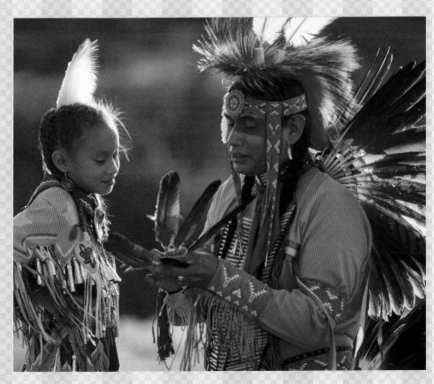

THE DRUM IS A HEARTBEAT

Native dancers move to a drumbeat that, for Indians, symbolizes the human pulse and the fundamental rhythms of all life. For this reason, performance has always played an important part in Native expression, and both dance and music have undergone an extraordinary renaissance in recent years.

Traditional Native arts such as storytelling and dancing are often recast in modern idioms – for example, non-traditional forms such as the theatre and visual forms such as fine art. Many songs and dances are intertribal, and form part of the repertoire of such ensembles as the American Indian Dance Theater, one of many combined Native American dance and theatre groups. Many Native musicians – for example, R. Carlos Nakai and Kevin Locke – have received international acclaim for their flute playing, compositions and dancing. Alongside thriving traditional forms are contemporary ones such as Indigenous, a Inhanktonwan blues-rock band; Pamyua, an Inuit fusion group; and Tru Rez Crew, a Six-Nations hip-hop group. Each has international followings and their lyrics reflect contemporary themes, especially resistance.

Each September, in Sioux Falls, South Dakota, the Northern Plains Tribal Arts Show draws artists from the entire region and thousands of visitors over four days. The success of the event, which includes dance and music, and the establishment of Native galleries across North America, testifies to the wide interest prompted by the Native artistic resurgence.

Native theatre is also flourishing. Indians have been depicted in the theatre in Canada since the early seventeenth century, when Marc Lescarbot's stereotypes amused French colonists. Since 1986, the works of Tomson Highway, a Cree novelist and playwright, have sought to shatter the overworn illusions about Native people by presenting modern life as it is really lived on "the rez" (an Indian reserve). Highway became

▶ Traditionalist and keeper of the sacred pipe, Lakota chief Arvol Looking Horse on reservation lands dusted in snow. Green Grass, Cheyenne River Sioux Reservation, South Dakota.

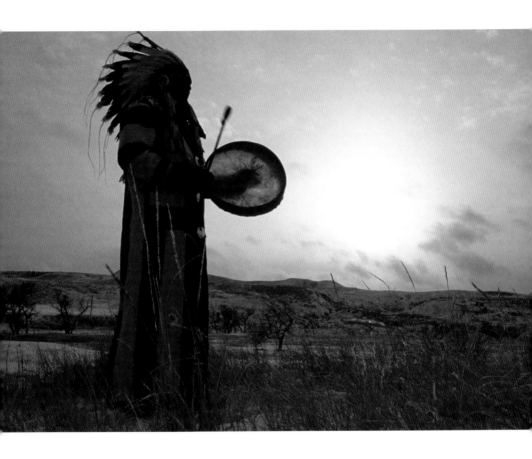

artistic director of Native Earth Performing Arts, based in
Toronto, which performs plays by noted Indian writers, such
as Joyce B. Joe, Daniel David Moses and Drew Hayden Taylor.
Each year the company holds the Weesageechak Festival as a
showcase for emerging Native theatre artists. In 2001 Highway
was awarded a National Aboriginal Achievement Award for his
contributions to arts and culture.

The acceptance of Native American theatre among non-
Indians has been difficult to achieve. However, through the
work of Highway and others, the voices of Native playwrights
and actors are increasingly to be heard in mainstream theatre.

RECLAIMING THE PAST

Once Native lands had been seized and settled, the indigenous peoples became objects of curiosity. In the nineteenth century, with the growth of interest in natural history and anthropology, scholars became keen to study people who, it was believed, would soon disappear.

In 1867, US Army personnel were ordered to obtain Indian skulls for study at the Army Medical Museum, and thousands were then collected from battlefields and burial grounds. In the following decades, private collectors looted graves and sold remains and funerary goods as curios, or exhibited them to tourists, and several important museums and universities collected skeletons and burial goods for study and display.

For Native North Americans, such actions are sacrilegious. Many traditional Indians believe that the dead continue to exist, but in a different world, and that to remove their remains is an affront to the dignity of the ancestors and a threat to the delicate harmony of nature. For decades, Indians fought to have remains repatriated for reburial, and in 1990 the US Congress passed the Native American Graves Protection and Repatriation Act (NAGPRA). Under this act, any organization associated with the government must return all remains,

▼ Cathedral Spires in Black Elk Wilderness area, which is part of the holy Paha Sapa, or Black Hills, in South Dakota. The area contains Harney Peak, where Black Elk received his great vision when he was just nine years old.

THE CROW CREEK MASSACRE

The Crow Creek reburial provided a model for consultation between Indians and archaeologists on the issue of ancient graves. In 1978, University of South Dakota archaeologists at the ancient Crow Creek village site on the Crow Creek Sioux Reservation discovered the bones of 500 victims of a massacre that took place in about 1325 during warfare among ancestors of the Arikara.

The Arikara and the Lakota (Sioux) were traditional enemies, but they collaborated to secure the future of the remains. Both tribes insisted at first that the bones should not be touched, but when looters began to damage the site they agreed to let the bones be removed for study, as long as they were returned. In 1981, the bones were reburied in five different ceremonies, two traditional and three Christian.

grave goods and sacred objects to the peoples from which they were taken, and must consult with tribes directly before excavating any Indian sites.

Indians have had more mixed success in their struggle to regain lands that were lost by treaty or conquest. In the 1960s and 1970s there were many protests over land rights. In November 1969 around 200 Indians claimed and occupied the former island-prison of Alcatraz in San Francisco Bay, shortly after the prison had been closed. The group based their claim on land treaty clauses that promised to return territory to Indians should it ever become surplus to federal

requirements. The siege lasted until 1971, when federal marshals expelled the last demonstrators. But other protests followed, including a march on Washington, DC, in 1972 called "The Trail of Broken Treaties", during which the Bureau of Indian Affairs was occupied for six days.

The legal fight had begun in 1946, when the US Congress set up the Indian Claims Commission (ICC). The ICC set compensation for illegally taken lands at the value of the land when it was seized, plus interest. It could not restore land to the tribes. This brought considerable financial gains to peoples whose claims were allowed. For example, the Passamaquoddy of Maine received enough money to develop housing, industry and education programmes. However, some peoples have refused to accept money on the grounds that the earth is sacred and cannot be bought and sold. The outcome of such cases is uncertain. Furthermore, any acceptance of a monetary offer meant that a tribe renounced the right to raise the claim again in the future. The commission expired in 1978, whereupon any claims not adjudicated were transferred to the US Court of Claims.

THE BLACK HILLS

One claim subsequently dealt with by the court concerns the Black Hills, Lakota ownership of which had been specifically acknowledged in the Fort Laramie Treaty of 1868. During the 1870s increasing numbers of settlers and miners (in search of gold, discovered in 1874) were entering the area in breach of the treaty, which had recognized the Black Hills as part of the Great Sioux Reservation. Eventually this provoked warfare in 1876–1877, during which the Battle of the Little Bighorn took place. The defeat of the Indians and the seizure of the region by the United States was a violation of the 1868 treaty and the appropriation has never been accepted by the Lakota.

For the Lakota, the Black Hills and the nearby Badlands form a mirror image of the spirit world. The Lakota believe that at one time there were no hills on the vast, uninterrupted

▶ The medicine bundle of the Weasel Chapter of the Crow Tobacco Society. Such sacred objects – many contain items said to go back to the first people – contribute greatly to the upkeep of traditional ways and culture.

▼ Pages 274–275. Various tribes of New York state picketing the capitol building in Albany for the return of wampum belts. The campaign finally bore fruit in the 1990s.

Plains. This was a chaotic realm, where humans and animals preyed on one another. Humans changed this by summoning all the animals to take part in a race that followed a circular path outlined on the flat ground. The frenzied animals ran round and round the path so many times that the commotion caused by their pounding feet not only disturbed the spirits but also began to cause the path to sink into the Plains. The "racetrack" can still be seen encircling the hills. The ground within the circle rose up to form the mountains, which eventually burst with dust and rocks, killing many of the animals, including the Unkcheghila giants, whose large bones can still be found in the Badlands. Humans survived, thus earning the right to prey on the other animals. However, the hills – now called the "heart of everything that is" – remain to remind humans of their insignificance in comparison to the inhabitants of the spirit world.

In 1980 the US Supreme Court ruled that the Black Hills had been taken illegally and that remuneration should be paid. That sum, plus interest, remains in an account and totals some one billion dollars. The Lakota have refused the settlement for three decades, not wishing to validate the theft of their sacred land and wanting it instead to be returned to them. Whether this sum can be resisted in the longer term – the prospective beneficiaries are among the poorest people in the entire country – remains to be seen.

Unlike the US, Canada recognizes that Indians have rights based on traditional occupation. The government pursues comprehensive agreements that involve land deals and financial settlements. The most notable result of this policy has been the creation of the Inuit territory of Nunavut. However, just as in the US, there are many unresolved cases.

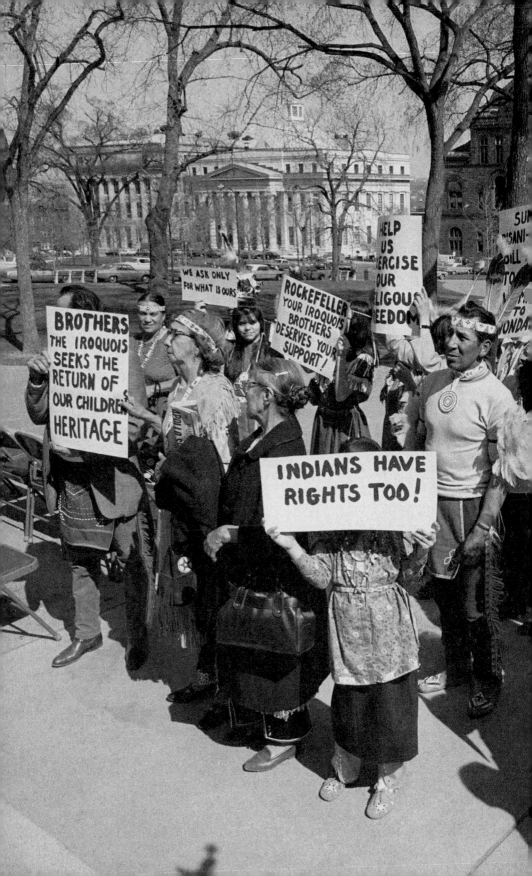

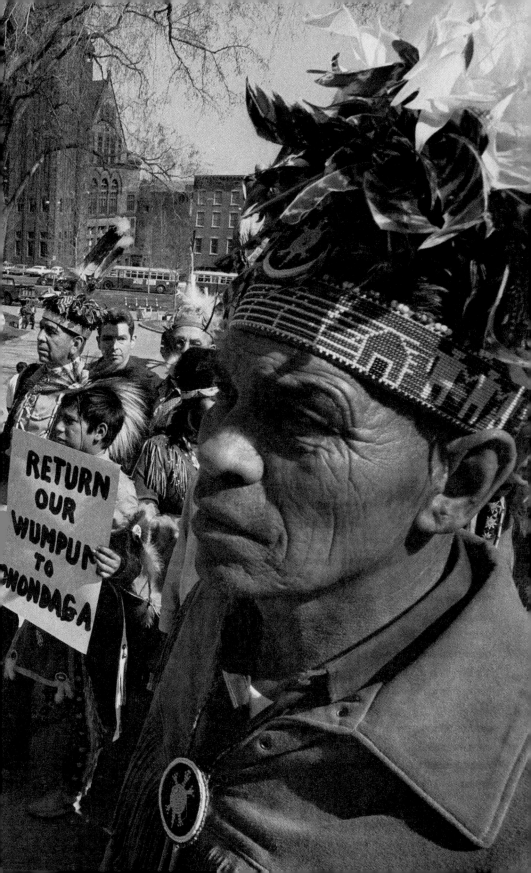

NATIVE SCHOLARS

Historically, Native people learned from their elders. Indian children sat at the feet of storytellers, whose tales served as lessons in morality, philosophy and religion. Schools tried to end to these traditional ways of learning.

Located on or near reservations, the tribal colleges serve more than 20,000 Indian students at any one time in programmes ranging from vocational and technical subjects to post-graduate degrees.

Reservation schools and boarding schools, which separated children from their families for up to ten months a year, attempted to assimilate Indians by disconnecting them from their culture. These alien institutions meant that Native youths did not begin to learn the responsibilities and skills of adulthood as they were understood by their parents, such as how to gather and prepare plants for food and medicine, to hunt, and to make clothing and tools.

Indian education policies may be less harsh today, but almost all young Native Americans still attend public (state) schools. Systematic, school-based learning is inconsistent with the more flexible and individually oriented traditional tribal method of learning. But the main problem is that the state system reflects the heritage and values of the dominant society, which often contradict traditional teachings. As a result, for generations, many Indians have left school ill-equipped to deal effectively with either culture.

To provide education that is more sensitive to Native traditions, groups such as the American Indian Movement (AIM) sought to establish model schools for Indians. In 1971, in Minneapolis, AIM opened the first Native peoples survival school, which sought to help young Indians to adjust to white society without losing touch with their own culture. The Indian Education Act of 1972 gave Indians control over educating their own people and it represented a radical change from the boarding school policy, ushering in a new era of active participation in determining their own future, further bolstered by the Indian Self-Determination and Education Assistance Act (1975) and the No Child Left Behind Act (2001).

Native-run elementary and secondary schools have blossomed since that time. About 120 community schools operate under contract from the Bureau of Indian Affairs (BIA) and thirty-six tribally controlled community colleges have been opened. The BIA still runs about sixty schools, which all have Indian school boards with a voice in how the institution operates.

In Native schools, curricula take into account traditional festivals and other events. For example, at the Nunamiut School in Anaktuvuk, Alaska, classes in October are organized around traditional Inuit activities such as cranberry picking.

The problems encountered in Native schools also applied to tertiary education. There were no Native colleges before 1968, when the Navajo Community College (NCC) – now known as Diné College – was established at Tsaile on the Navajo Reservation in Arizona. It was the first college on any reservation to be founded and run by Indians, and other tribes soon followed suit. In October 1972, six tribal community colleges formed the American Indian Higher Education Consortium (AIHEC), which today has nearly forty members in the US and Canada. The AIHEC has proved an effective tool for Indian economic development and the continuance of cultural tradition. Located on or near reservations, the tribal colleges serve more than 20,000 Indian students at any one time in programmes ranging from vocational and technical subjects to post-graduate degrees. Above all, Native colleges place great emphasis on Indian culture. For example, Sinte Gleska University on the Rosebud Sioux Reservation in South Dakota now offers degrees in Cultural Resource Management, which trains tribal members to collect and manage oral history as well as to locate and protect archaeological and historical sites. In the 1980s Navajo tribal educational policies declared that the Navajo language was an essential element of the life, culture, and identity of the tribe and mandated school instruction in both Navajo and English.

CONTEMPORARY CURING

European diseases ravaged the Native American peoples. Western-style medical care was first introduced by traders, missionaries and doctors with the military, and by the 1870s more than twenty treaties guaranteed some form of medical services to individual tribes.

From these arrangements there arose the Indian Health Service (IHS), which today provides primary care on most reservations. Nevertheless, the standard of health care among Indians still falls short of that among the general population. Although many Indians recognize the benefits of Western medicine, it has not always found acceptance. Western medicine is entirely secular in character, whereas Native curing is associated with holy people (see pages 132–137). For this reason, Western medicine has often been seen as a means of undermining Native culture and spirituality. Over the years, traditional curers have been denounced as witchdoctors and their healing methods ridiculed. As recently as the 1970s, missionary doctors ordered Navajo families to burn their medicine bundles. For many Indians, such attitudes are patronizing and, above all, sacrilegious. In most Indian communities, people usually rely on a variety of health care resources, from traditional Native American healers to private non-Indian physicians and government hospitals.

Old Native methods of curing remain important to many people, but the decline in traditional education means that it is more difficult today to train healers (although several Indian educational institutions, such as the Diné College, offer courses). Many communities recognize that they must assume greater responsibility for directing their own health care, and seek an approach that can accommodate traditional methods and values as well as Western medicine.

One way to improve the standards of Indian health care and to decrease the suspicion felt by many towards Western

Indian holistic healing methods may be the best way to deal with some of the most common maladies that affect Native people, such as diabetes, hypertension and alcoholism.

TRADITIONAL MEDICINE

Indians use a wide range of plants in their healing (even tobacco – depicted, right, in *Making Medicine* by Stephen Monope), and Western medicine has adopted several indigenous discoveries. For example, a headache cure made from poplar or willow bark contains salicin, which is used in aspirin. For muscular aches, curers extracted an astringent, later known as witch hazel, from the shrub *Hamamelis virginiana*. The bark of the shrub *Phamnus purshiana* has been used in a popular laxative since 1878. Many aromatic plants, such as sage, have long been used for ritual fumigation, with people "bathing" in the smoke or inhaling it. The Numlaki of California use the sage variety *Salvia columbariae* for curing and other purposes.

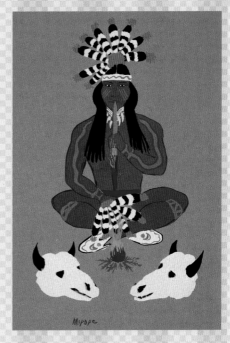

medicine is to increase the number of Native health professionals in Indian communities. The IHS funds a programme called Indians into Medicine (InMed), begun in 1973, which seeks to expand the ranks of Indian health care professionals (to date, about 200 doctors have graduated through the scheme). The IHS is attempting to return control of health care to Indian communities, emphasizing traditional values. For example, Indian holistic healing methods may be the best way to deal with some of the most common maladies that affect Native people, such as diabetes, hypertension and alcoholism. These are considered to be "white man's diseases" that are related more to social factors (that is, lifestyle) than to physiological causes. A return to Native values in treating such problems is the aim of the numerous "Red Road" schemes that have grown up in recent years (see pages 292–293).

THE NATIVE ECONOMY

Dispossessed of their lands, with their hunting and trapping lifestyle destroyed, and largely forced into a life of dependency on the reservation, most Native Americans at one time faced a bleak economic future.

The destruction of traditional Native economies meant that many Indians faced working in cottage industries: skilled woodcarvers made axe-handles; the weavers of fine baskets made laundry hampers. Not every Indian nation saw a decline in its traditional economy: the Northwest Coast peoples still had access to the wealth of the sea, and the Navajo transformed their lands into a rich agricultural area for cattle, sheep and a wide variety of crops. However, many peoples of the forests and Plains, forced to attempt to farm on infertile, marginal land in forests and on hot, dry prairies, were left with little prospect but to assimilate or starve.

In 1934, the US government partly awoke to this situation and passed the Indian Reorganization Act (IRA). It allowed Indian nations to conduct their own affairs, enabling them to act as corporations in order to borrow money and operate businesses. Gradually, and almost always in a hostile climate, Indians began to develop new economic bases that were more in line with the white society that surrounded them.

Today, Native business as a whole is increasing as part of the broader resurgence of Indian self-confidence and pride. Even the arts and crafts industry (see pages 286–291) has spread beyond the tourist stalls, and is now heavily commercialized. However, unemployment remains high in Native American communities, approaching 90 percent on some reservations. This situation will radically improve only when there are sufficient numbers of Indian professionals, skilled technicians and entrepreneurs to enable Native people to take complete control of their own economies and compete freely in the marketplace.

▶ Morongo Casino Resort & Spa in California. The reservation of the Morongo band of Mission Indians was one of nine small reservations set aside by President Grant by executive order in 1865.

INDIAN GAMING COMPLEXES

The most successful Native-owned businesses in the US are casinos or gaming complexes. Organized gambling is banned in most states, but Indian reservations are quasi-autonomous and outside state law. This decision was confirmed by a US Supreme Court ruling in the 1970s and since then Native entrepreneurs have created a multi-billion-dollar industry.

One of the largest and most successful casinos in the world is Foxwoods Resort Casino on the Mashantucket Pequot Reservation in southeastern Connecticut. In addition to gaming tables, bingo and thousands of slot machines, the casino incorporates a 1,500-seat theatre, speciality shops and restaurants. There is even a hotel with more than 1,400 rooms.

In California, on a reservation at the foot of the San Gorgonio and San Jacinto Mountains, the Morongo Indians started a modest bingo hall in 1983. Twenty years later, in 2004,

a $250 million facility opened – the Morongo Casino, Resort & Spa – and it is one of the largest tribal gaming facilities in the USA. With its diversification into non-gaming businesses, the Morongo tribe has become the largest private sector employer in the region and is a major contributor to the Coachella Valley economy. The tribe now employs more than 3,000 people, and Morongo businesses have put several billion dollars into the regional economy. The Morongo tribe's progress is a case history that illustrates how combining a proactive tribal government with sound economic development can enable tribes to turn their lives and communities around and have a dramatic impact on the surrounding economic region.

In 1988 the Indian Gaming Regulatory Act (IGRA) was passed and a federal agency, the National Indian Gaming Commission (NIGC), was established to regulate the gaming and to try to ensure smooth relations between states and sovereign Indian nations. In 2004 the Indian Gaming Working Group (IGWG) was set up with the specific purpose of identifying and coordinating any action against criminal activity in relation to Native gaming.

Gaming has greatly altered and revitalized tribal economies, with nearly two-thirds of Indians belonging to a tribe with gaming operations, although there are many sovereignty disputes and significant negative side effects from gambling and the effects on Indian cultures. Money from gaming stimulates the tribal economy, increases tourism, raises the incomes of enrolled tribal members and reduces welfare dependence. By 2005 it was estimated that gaming earned tribes nearly 20 billion dollars – approximately one-quarter of all gaming revenue in the entire United States.

In accordance with Native American traditions, the wealth produced by Indian casinos has generally been redistributed among the various Native communities of the reservation. Only a few tribes have distributed their revenues on a per capita basis. Most have taken a longer-term view and used funds to improve the poor tribal infrastructure by building

▶ Film posters for *Custer's Last Fight* (1912) and *The Last of the Mohicans* (1992). Although the early Custer film claims to feature Indian veterans of the battle, for many years Westerns featured white actors playing the Indian roles, speaking broken English. In recent decades many Native American actors have emerged, such as Wes Studi, and the dialogue is often in Native languages.

schools, roads and museums. In 1998 Cherokee Nation Enterprises made one million dollars in gaming profits; by 2008 this had reached 116 million, much of which (70 percent) was reinvested in businesses within the Cherokee Nation to create more jobs – deliberately using gaming as a tool to create self-sufficiency for Cherokees. The remaining 30 percent was spent on social and community services.

Casinos cannot be the answer for every tribal economy. Much depends on location – for example, gaming failed at the highly impoverished (but large and isolated) Oglala Lakota reservation of Pine Ridge, no doubt owing a great deal to the fact that the nearest major city is hundreds of miles away.

Many critics argue that Native gaming will destroy tribal culture. It is true that most jobs actually go to non-Indians, but there are also many examples of the revenues being used to

support language programmes and other cultural projects, as well as contributing to the tribe's financial independence from federal government.

"WALKING IRON"

One example of a Native community adapting to a specific economic requirement of the mainstream is provided by the Mohawk people and the steel industry. Since the late nineteenth century, Mohawk men have had a reputation for being first-class workers on high steel, and after generations of building bridges and skyscrapers an erroneous belief has taken root that the Mohawk have no fear of heights. Not true at all: it is only that they have learned how to deal with it better.

This relationship began in 1886 when the Canadian Pacific Railroad recruited Mohawks to work on a bridge across the St Lawrence River, one end of which stood in the reserve. The employers were impressed by the way the Indians coped with the dangerous work. After this reputation had spread, many Mohawks and other Iroquois from upstate New York and Canada (notably Kahnawake and Akwesasne reserves) became employed in the construction of Hell Gate Bridge in 1916, then the longest steel arch bridge in the world. Following that success Indian men worked on nearly all of the major steel-framed skyscrapers that were to dominate the New York skyline, including the George Washington Bridge, the iconic Empire State, Chrysler and the World Trade Center.

By the 1960s, a sizeable Mohawk community of hundreds of families lived in the city, each one supported by men who were erecting buildings. The Mohawk developed a camaraderie and an inter-generational intimacy that allowed them to develop Native pride in "walking iron", as they called the work.

Over time the work in New York fell away but the Mohawk were in demand elsewhere in the US: for example, they worked on San Francisco's Golden Gate Bridge and they still leave their families and communities for the work, returning at weekends and upon completion of the job.

◀ Mohawk Indians have worked in the high-rise construction industry for generations. This is Walter Goodleaf from Kanawake Reserve outside Montreal, photographed in 1970. After this picture, Goodleaf's gang moved on to build the Twin Towers in Lower Manhattan, the debris of which the Mohawk helped to clear up in 2002. A major exhibition was held in 2004 at the Smithsonian to honour the Mohawk role in erecting the New York skyline.

TOURISM & CRAFTS

Tourism was an inevitable consequence of European expansion westwards. For most whites, Indians were terrifying savages who nevertheless possessed a peculiar nobility. The romanticized "Wild West" was created to satisfy the fascination of a largely urban white public in the eastern United States and in Europe.

The "Wild West" proved a great tourist attraction. Buffalo hunts, Indian warriors and, of course, heroic cowboys were all packaged for popular consumption. Artists such as Karl Bodmer and George Catlin, with their vivid images of Indian life, and photographers such as Edward S. Curtis created set pieces that lent Indian people a haunting beauty that reflected the Victorian preoccupation with the "noble savage". If people could not go to see Indians, the Indians might even come to them: William "Buffalo Bill" Cody hired Native people – including such famous warriors as Sitting Bull (see page 24) – to appear in his immensely popular Wild West Show, which toured North America and Europe.

With the advent of "Western" films in the twentieth century, the Plains' chief, resplendent in his feathered warbonnet, was established as the enduring image of the Native American. Some Indians adapted in order to make a living, and even today some pose for photographs at tourist sites wearing buckskin and headdresses ("chiefing" is the disparaging Native American term). However, the days when communities staged ceremonies as tourist entertainments are largely past.

Importantly, Native people are now taking control of the Indian tourist industry. Inuit companies offer dog-sledding, nights in an igloo and North Pole expeditions. Visitors to the South Dakota Badlands can stay at a lodge run by the Oglala Lakota and those who travel to see the iconic Monument Valley can enjoy the view from the only accommodation there, the Navajo-owned View Hotel (see illustration, page 288).

Bear Butte is revered as a holy place by a number of Plains peoples, including the Lakota Sioux, who call the outcrop Mato Paha ("Bear Hill"), and the Cheyenne, who call it Noavasse ("Medicine Lodge").

There is an increasing number of cultural and historical tours, well organized by knowledgeable Indian guides, along the lines of Go Native America.

However, the issue of land ownership can still create tensions. A notable example is Bear Butte, which rises 4,426ft (1,350m) above the plains of South Dakota and commands startling views of the contested Paha Sapa (Black Hills) to the west, while open plains stretch to the eastern horizon. Bear Butte is revered as a holy place by a number of Plains peoples, including the Lakota Sioux, who call the outcrop Mato Paha ("Bear Hill"), and the Cheyenne, who call it Noavasse ("Medicine Lodge"). The Cheyenne culture hero Mutsoyef (Sweet Medicine) is said to have held a council on the butte during which he received four sacred arrows from Maiyun, the Great Spirit. Every year, many Lakota and Cheyenne go to the butte for a period of prayer and fasting, following which visitors may see coloured cloths attached to pine trees along with tiny pouches of tobacco – these represent a prayer made to the spirits and are left as sacred offerings.

The butte is the focus of conflict with non-Indians who wish to develop the area for tourism and recreation. It forms part of Bear Butte State Park, run by the state of South Dakota. The state closes the summit to visitors during important Indian ceremonies, and prohibits anyone except Indians from using fasting and vision-quest areas and ceremonial trails. However, many Indians maintain that the park authority has desecrated the butte by developing parking lots and campsites on the lower flanks and a tourist climbing trail on the hill itself. Also, despite the safeguards, sacred areas have been violated, and the butte attracts other worshippers to whom the Indians object. In 1994, the Lakota protested against the use of the sacred mountain by "New Agers", who conduct summer solstice rituals at the site that combine Lakota ceremonial with paganism, shamanism and other non-Indian practices that are considered sacrilegious by many Lakota.

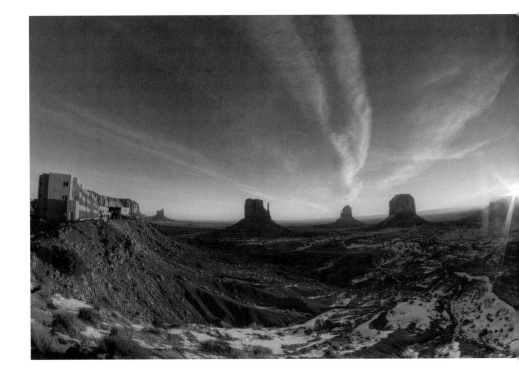

Lakota and Cheyenne spiritual leaders took the state to a federal court under the American Indian Religious Freedom Act (1978, later amended 1994). The court found that Indian interests were outweighed by the state's obligation to improve public access to a geological and historical landmark and to guarantee the safety and welfare of visitors. In 1983, the US Court of Appeals upheld the decision, although the Indians continue their fight to secure this and other sacred sites.

▲ The View Hotel, which opened in December 2008, is the only hotel in the Monument Valley Navajo Tribal Park, USA. The 95-room, eco-friendly establishment is owned by and staffed mostly by Navajo.

ARTISTIC TRADITIONS

Traditional Native American art encompasses more than the individual's creativity – for Indians, art represents the Earth and all its inhabitants by means of both the materials used and the rich symbolism that is inherent in each culture's history; the art provides a means for people to connect to the sacred.

The inspiration for art was – and is – often a spiritual experience. For example, a dream might reveal a design for a warrior's shield or part of a dancer's regalia. The symbols and patterns that adorn many Indian objects are not seen as mere representations: a deer etched into the shoulder of a pot is thought actually to be a deer; a killer whale painted on a plank house is invested with the spirit of the killer whale. Although all traditional Indian art reflects the surrounding world and has religious significance, it also has a purely aesthetic one. Finely made objects are considered worthy of praise and can be appreciated in their own right. The best artists and craftspeople are prized and they enjoy great social prestige.

Native art is diverse. A wealth of motifs embellish objects made from every conceivable natural material. Fibres from plants and trees are plaited into baskets; animal hair is spun and woven into patterned cloth and blankets; clay is turned into pottery and incised or painted; and stone, bone and wood are exquisitely carved. Jewellery may include quillwork, beadwork, fur, metal, bone and colourful stone, all used in a variety of ways – from geometric motifs to wonderful floral forms. Realistic depictions of nature are not always the cultural norm; for the Northwest Coast tribes a stylized representation of an animal's key identifying characteristic, such as the dorsal fin on a killer whale, is more important than realism. In the Southwest, prehistoric Mimbres pottery used geometric decorations to frame stylized animal and human forms. Contemporary artists now use the old Mimbres motifs in many new ways to decorate a range of ceramic objects.

Modern Indian artists mostly work according to established traditions, but are able to experiment within acceptable limits. Some cultures may restrict artists based on clan, gender, age or some other consideration. For example, members of a particular clan can be prohibited from using motifs owned by another clan, or from depicting the totem of their own clan. Women may not be allowed to work with materials that are considered ritually polluting or dangerous, such as the blood,

fur, or bones of animals such as the bear. There may be a sexual division of labour: for example, with pottery, in the Pueblos of the pre-contact era men were usually the artisans, but now women often do such work and receive the most recognition for fine ceramics – which may be etched, painted, or burnished, and are executed in colours that range from browns and natural reds to creams, black, and white.

In a region peopled by agriculturalists, pots and jars are made out of the Earth's most basic elements and they contain or process life-sustaining seeds and water. The craft strengthens the link between the culture and its environment. This relationship can be seen in many places, with each culture area being known for particular art forms because the local environment provides specific raw materials and the inspiration for the embellishment (see also pages 72–73). Along the Northwest Coast, with its abundant cedar forests, woodcarvers create totem poles and masks that feature stylized representations of sea animals. The women of the Huron, Micmac and other tribes of the densely wooded Northeast and Great Lakes used quills sourced from the abundant porcupine to decorate utilitarian objects with floral patterns.

Native American crafts have always been highly adaptable – tribes were trading materials over vast distances for centuries before white people arrived. Then, as brightly coloured trade beads became available after contact, they replaced or were combined with porcupine quills in intricate patterns. Colours also changed as new dyes became available. Modern-day Meskwaki (Fox) men and women have become experts in appliqué, using shiny fabric to replace the floral patterns once made from quills or beads.

While tourism has had a negative effect on some Indian arts and crafts traditions, it has ensured that many other Native American skills and styles have survived into the present. In 1990, the US Congress sought to stop Native work being exploited by non-Natives by passing the Indian Arts and Crafts Act, which, controversially, gives Indian tribes control

▶ A Hupa woman weaving a basket in California. Once an everyday essential, used for everything from carrying babies to storing food, baskets today are a marker of Native American cultural pride and inheritance, as well as a valuable source of income.

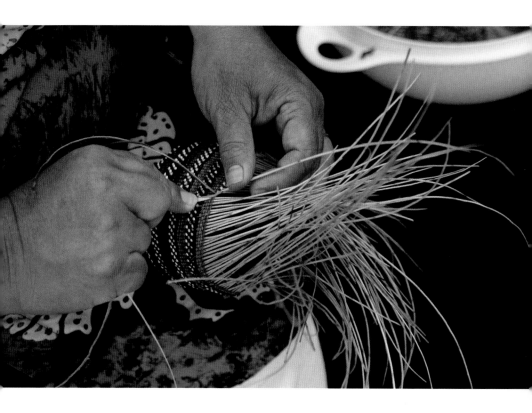

over the definition of a Native artist. However, the act should ensure that genuine artistic traditions continue to thrive.

These adaptations are typical of the ways in which Native artistic traditions have expanded as new media, materials and techniques have been borrowed from the colonizers. In the 1930s the Santa Fe Boarding School began to teach students how to transform millennia-old themes of spirit, environment, community and family into contemporary fine art. The Eiteljorg Museum in Indianapolis and the National Museum of the American Indian in Washington, DC, house extensive collections. Still usually segregated into "Indian art" shows and galleries, many pieces now sell at very high prices. But many are shown in exhibitions held at some of the world's great museums – because they are fine art, not "Indian art".

THE "RED ROAD"

In a famous vision by the Lakota holy man Black Elk, a figure speaks of the "Red Road", which is "the road of good, and on it your nation shall walk". The Red Road today can be understood as the "Indian way" – an approach to the modern problems of being an Indian that draws upon traditional Native American values.

▶ Big Meadows, Shenandoah National Park, Virginia. A common thread in Native American attitudes to the natural environment is that the Earth possesses a consciousness of its own. Every living person is believed to gain a sense of belonging and historical continuity by learning about their specific locality, the place where their ancestors lived and died.

The Red Road helps to reaffirm Indian identity and it is a way for Native Americans to take control of their own destiny. Several Red Road programmes have been developed to tackle modern social problems, such as alcoholism, which affects many families on some reservations. For example, Gene Thin Elk's Red Road to Recovery programme in South Dakota rehabilitated people through traditional Native ceremonies, the use of sweatlodges and so on. Thin Elk's initiative achieved a greater level of success than Alcoholics Anonymous and it has since been used in forty-five states and Canada.

The 1934 Indian Reorganization Act imposed representative government on tribes, which often violated traditional forms of consensual government. Today, although all tribes must retain their elected councils for dealing with federal or state agencies, some Indian nations have sought to return to more traditional forms of tribal government working alongside that. For example, the Ihanktonwan (Yankton Sioux) tribe has all its enrolled members directly involved in the drafting of any laws or rules, which range from the allocation of casino revenues to measures concerned with the preservation of traditional culture.

The often troubled relations between Natives and non-Natives can also benefit from the Red Road. Not all Indians approve the idea of opening sacred traditions and practices to outsiders, but some, such as Lakota holy man Wallace Black Elk (not a blood relative of the earlier Black Elk), have worked to foster the Red Road among whites. South Dakota and

Minnesota, where relations between Indians and whites have often been tense, have adopted the Red Road as the basis of inter-ethnic reconciliation programmes.

The success of Red Road initiatives shows that traditional Indian ways are capable of being applied successfully to the problems of the present day. For many Indians, the Red Road is the key to the survival of Native American ways of life.

Advocates of this path are encouraged by more general developments, such as the growth in the environmental and ecological movements. The rise of those sentiments offers renewed hope for Native American peoples with an ancient and distinctive view of the relationship between human beings and the Earth they inhabit, and of the continuity between past, present and future generations.

NATIVE MEDIA

American Indians have sought to break the cycle of negative stereotyping of themselves by non-Indians and to resist the pressure to assimilate by developing radio, television, newspapers and other media to produce their own Native-centred versions of life and history.

Many Indians are also trying to improve transcontinental communications on issues such as Native American legal rights and the preservation of cultural heritage. It is hoped that this will increase understanding of the positive qualities of "Indianness" – as defined by Indians and not outsiders. One small practical example of this new-found assertiveness was the success of descendants of the Lakota hero Crazy Horse (Tashunka Witco) in getting a beer withdrawn which was being marketed using the name of their ancestor, who had famously spoken out against the drinking of alcohol.

Priority is given today to the development of Native-run print and electronic media. Ever since the establishment in 1828 of *The Cherokee Phoenix*, North America's first bilingual Native newspaper, there have been continuous efforts by Indians to address the need of their communities for reliable and balanced sources of information. In 1984, a group of Native American journalists met in Oklahoma to discuss ways of developing Native communications. They agreed three goals: an increase in the number of Native journalists; the establishment of training programmes and of support services for Indians already in the field; and an improvement in the general media coverage of Native American issues.

... the web is helping to accelerate the development of pan-Indian – and pan-aboriginal – approaches to common problems that face many First Nations in the modern world.

One consequence of that conference was the establishment of the Native American Journalists Association (NAJA), which launched Project Phoenix, a summer journalism programme for Indian high school pupils, and introduced a national writing competition for high schools. In 2001 the NAJA established a journal, *The Native Voice*. Membership is open to

Native Americans working in radio, television and electronic media, as well as to Native journalists in Canada.

Other Native publications include high-circulation intertribal newspapers such as *Indian Country Today*, and the weekly native newspaper, *Turtle Island News*, produced in Canada's Grand River Territory of the Six Nations in Ontario. At tribal level, there are newsletters such as *Akwesasne Notes*, the quarterly magazine of the Kahniakehaka (Mohawk) nation of New York State, Ontario and Quebec.

Many Indian nations are now served by one or more Native-run television networks, such as Aboriginal Peoples Television Network in Canada, and radio stations such as KILI, which broadcasts to several Lakota reservations. Koahnic Broadcast Corporation, a Native Alaskan media centre, is typical, creating popular programmes such as "Native America Calling" and "National Native News". Streaming their content on the Internet allows them to reach international audiences.

The development of the World Wide Web ("the Web") has boosted the fragile unity of Indian peoples across North America. The growth of electronic communications in general and of the Internet in particular has become a potent medium through which Native Americans can speak to each other, as well as to other indigenous peoples around the world. The Web offers easy access to text, sounds, pictures and short films, and it provides a growing body of information on Native art, literature, languages, journals, videos, organizations, museums and government resources. Although stereotypes abound, Native people are using the Web to tell their own stories and to correct misconceptions. Most importantly, perhaps, the Web is helping to accelerate the development of pan-Indian – and pan-aboriginal – approaches to common problems that face many First Nations in the modern world.

New social media, such as Twitter and Facebook, have also become tools in the quest for sovereignty, skilfully used in everything from political campaigns to heritage preservation.

FOR REFERENCE: POPULATION

Scholars have long debated what the aboriginal population of North America was before the arrival of Europeans. Recent calculations using depopulation rates produce figures varying from 10 million to 18 million, and most experts now accept that the pre-contact population stood at less than 10 million.

One fact that most scholars agree upon is the dramatic decline in the Native population due to diseases brought to America by the first Europeans and Africans. Epidemics hit the Indians hard because they had had no prior contact with the illnesses and therefore no bodily immunities against them. Diseases such as smallpox, influenza and measles had the worst effect, often wiping out entire villages. For example, four outbreaks of smallpox and whooping cough between 1781 and 1856 reduced the population of the Arikara, Mandan and Hidatsa in their farming villages along the Missouri River, from more than 35,000 to fewer than 2,000. Diseases such as diphtheria, scarlet fever, typhoid, mumps and cholera also claimed many Indian lives.

Disease was the most significant factor in the decline of the Indian population, but warfare and attempted genocide, including forced removals, relocation and starvation, also played their part. Not all disease was introduced by accident. For example, in 1763, the British military commander in Pennsylvania deliberately arranged for smallpox-infested blankets to be sent to Indians. Even in the late twentieth century, Indian Health Service doctors are said to have performed involuntary sterilization on Indian women. In addition, the general destruction of traditional ways has reduced the effectiveness of traditional curing.

By 1900, the Indian population had fallen to below one million. Considering the immensity of this decline, Native populations have made a remarkable recovery during the twentieth century. In part, this results from better health care.

Intermarriage with non–Indians and increased fertility have also led to a higher birthrate for Indians than for the general population. According to the 2010 US census, the population of American Indians and Alaska Natives is three million people. Taking into account Native Canadians (Indians, Inuit and Métis), there are now approximately four million Native North Americans.

WHO IS INDIAN?

However, present–day figures are difficult to ascertain because of problems associated with identifying who is or is not Indian. The number of people now calling themselves Natives has increased dramatically. According to one estimate, nearly seven million Americans have Indian blood, and the recent popularity of Native North American culture has made more people willing to declare their ancestry.

The federal Bureau of Indian Affairs operates a "blood quantum" system whereby a person is usually required to possess at least one Indian grandparent in order to qualify as "Indian" under its rules. But tribes have their own criteria. Some require members to be at least half–Indian by blood, but other tribes will insist only on one Indian great–great grandparent. A few require only documentation of Indian heritage. Some have become more strict and use DNA testing to prove heritage.

In Canada, a Native person has to be registered as a Status Indian in order to enjoy the recognition that is accorded under the Indian Act of Canada. Non–Status Indians are unregistered, either because they have never done so or because they have given up that status in order to become enfranchised (that is, to possess the same rights as any non–Indian Canadian). The US government recognizes more than 570 tribes receiving services from the Bureau of Indian Affairs. Other groups are currently seeking recognition, and more will probably do so in the future. In Canada, there are 615 recognized Indian bands.

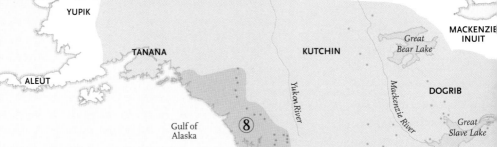

MAP OF NATIVE NORTH AMERICA

INUPIAT

YUPIK

MACKENZIE INUIT

TANANA

KUTCHIN

Great Bear Lake

DOGRIB

ALEUT

Yukon River

Mackenzie River

Great Slave Lake

Gulf of Alaska

⑧

1 The Northeastern Woodlands & Great Lakes

TLINGIT

2 The Southeastern Woodlands

3 The Great Plains

TSIMSHIAN

4 The Southwest

Alexander Archipelago

5 California

6 The Great Basin

HAIDA

CARRIER

7 Plateau

Queen Charlotte Islands

BELLA COOLA

8 The Northwest Coast

PLAINS CREE

9 The Subarctic

KWAKIUTL

BLACKFOOT

10 The Arctic

LILOOET

Badlands

NOOTKA

SHUSHWAP

Vancouver Island

COAST ⑦ SALISH

Native American Reserves

PACIFIC OCEAN

MAKAH

GROS VENTRE

OKANAGAN

KOOTENAY

Black Hills

CHINOOK

SANPOIL

SPOKANE

FLATHEAD

CROW

KLAMATH

NEZ PERCE

ROCKY MOUNTAINS

This map shows the main areas of Native population in present-day North America. The largest concentrations of Indian peoples in the United States are in Oklahoma (the former Indian Territory, to which many tribes were removed), California, New Mexico and Arizona. About one-quarter of all Indians live on 278 federal and state reservations, in pueblos and rancherias, or on tribal trust lands. The Navajo Reservation has the largest population, with 180,000 Indian residents. About 64,000 (60 percent) of Alaska's Native peoples live in Alaska Native Villages. In Canada, the largest concentrations of registered Indians are in Manitoba, Saskatchewan, British Columbia and Ontario, with about 70 percent living on the 2,272 Canadian government reserves. An increasing number of Indians have moved to urban areas in recent years, mainly to enhance job prospects. In the United States, many have been encouraged by government financial incentives to leave the reservations and find employment in the cities.

MODOC

NORTHERN PAIUTE

Snake River

YUROK

HUPA

⑥

Great Salt Lake

NORTHERN SHOSHONI

WESTERN SHOSHONI

Great Salt Lake Desert

POMO

Colorado River

SIERRA NEVADA

⑤

Death Valley

Grand Canyon

HOPI

NAV

CHUMASH

Painted Desert

Black Mesa

Chaco Canyon

Mojave Desert

Sonoran Desert

LUISEÑO

PAPAGO

④

PIMA

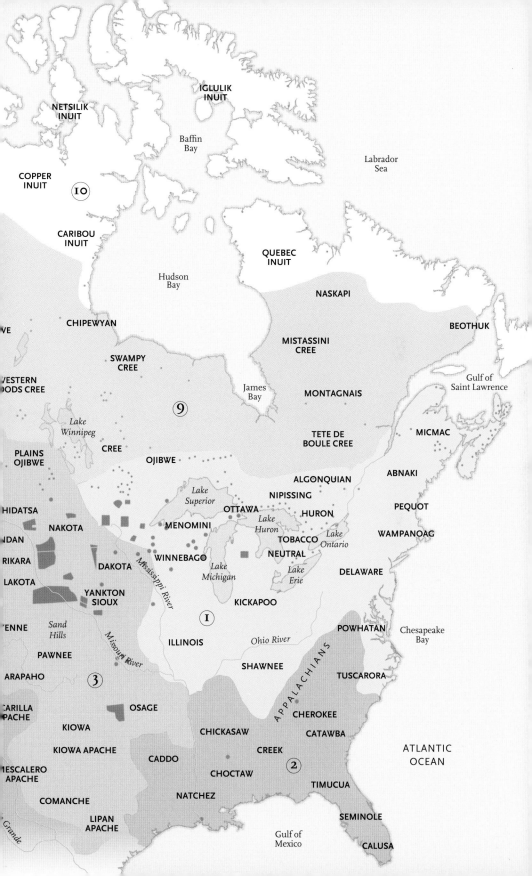

NETSILIK
INUIT

IGLULIK
INUIT

Baffin
Bay

COPPER
INUIT

10

Labrador
Sea

CARIBOU
INUIT

QUEBEC
INUIT

Hudson
Bay

NASKAPI

CHIPEWYAN

BEOTHUK

·VE

SWAMPY
CREE

MISTASSINI
CREE

·VESTERN
·ODS CREE

James
Bay

MONTAGNAIS

Gulf of
Saint Lawrence

9

Lake
Winnipeg

MICMAC

TETE DE
BOULE CREE

PLAINS
OJIBWE

CREE

OJIBWE

ALGONQUIAN

ABNAKI

HIDATSA

Lake
Superior

NIPISSING

PEQUOT

MENOMINI

OTTAWA

Lake
Huron

HURON

·IDAN

NAKOTA

Lake
Ontario

WAMPANOAG

·RIKARA

WINNEBAGO

TOBACCO

DAKOTA

Lake
Michigan

NEUTRAL

LAKOTA

Lake
Erie

DELAWARE

YANKTON
SIOUX

KICKAPOO

·ENNE

Sand
Hills

1

POWHATAN

Chesapeake
Bay

PAWNEE

ILLINOIS

Ohio River

·ARAPAHO

3

SHAWNEE

TUSCARORA

·ARILLA
·PACHE

OSAGE

CHEROKEE

KIOWA

CHICKASAW

CATAWBA

KIOWA APACHE

CREEK

ATLANTIC
OCEAN

·ESCALERO
APACHE

CADDO

2

CHOCTAW

TIMUCUA

COMANCHE

NATCHEZ

LIPAN
APACHE

SEMINOLE

·Grande

Gulf of
Mexico

CALUSA

APPALACHIANS

Mississippi River

Missouri River

PEOPLES & REGIONS

Native North American tribal names can be confusing. Many names simply mean "the people", "the human beings", or "the real people" – an ethnocentric view of society that forged group cohesion. Names can reveal particular power relationships. A name that is in common use among Western historians and others may not have been used by the native people themselves. Some names were used by one tribe for another but were not complimentary. And a number of names were applied by Euro–American colonizers that were not necessarily approved of by "the people" themselves.

With hundreds of native nations and bands, this list is selective and is concentrated on those groups commonly written about. In this list, tribes appear by their pre–contact culture area (see map, pages 298–299). The first name cited is the most common one, but it is sometimes followed by others. Where it is known or can be reasonably worked out, a transliterated version of the name used by the people themselves is given. Where there is doubt over the derivation it is followed by a question mark (?).

A SELECT LIST OF INDIAN NATIONS BY REGIONS

THE NORTHEASTERN WOODLANDS & GREAT LAKES

Abenaki: Wabenaki, St Francis Indians
Delaware: Lenape
Fox: Meskwaki, Mesquaki
Huron: Wendat, Wyandotte, Wyandot
Iroquois: Kanonsionni, Haudensaunee (a confederacy)
Cayuga
Mohawk: Kaniengehawa
Oneida
Onondaga
Seneca: Onotowaka

Kickapoo: Kiwegapaw (?)
Menominee: Manomini
Micmac: Souriquois (?)
Ojibwe: Anishiabe, Ojibwa, Ojibway, Chippewa, Mississauga, Slateaux
Sauk: Sac, Oskaiwugi
Wampanoag (but also Pokanoket, Nauset, Sakonnet)
Winnebago: Hochunga, Ho–Chunk, Puants

THE SOUTHEASTERN WOODLANDS

Caddo: Kadohadacho, Natchitoches (a confederacy),
Hasinai, Adai, Eyish
Cherokee: Ani–yun–wiya, Tciloki
Chickasaw
Chitimacha
Choctaw: Chahta, Pafallaya (?)
Cree: Ininiw, Nehiyawak, Atheneuwuck, Sackaweéthinyoowuk
Creek: Muskogee (but comprised of many tribes)
Seminole: Miccosukee, Oconee, Yamasee (several tribes)
Shawnee: Shawanwa, Ouchaounanag, Chaouanons, Satanas, Shawano

THE GREAT PLAINS

Arapaho: Inuna-ina
Arikara: Ree
Assiniboine: Stoney (in Canada),
 U Sin, U Pwawa
Blackfoot: Pikuni (Piegan),
 Kainah (Blood), Siksika
 (Blackfoot proper), Sakoyitapix
 or Nitsitapix (all)
Cheyenne: Tse-tsehese-staeste
Comanche: Numinu
Crow: Absaroke
Hidatsa: Gros Ventre, Minitari,
 Ree
Kiowa: Ga-i-gwu, Ka-i-gwu
Omaha: Umon'hon
Osage: Ni-U-Kòn-Ska
Pawnee: Chahiksichahiks (bands
 consist of Panimaha [Skidi],
 Kitkehaki [Republican], Chaui
 [Grand], Pitahauerat [Tappage])
Sioux: Dakota, Lakota, Nakota
 (signify three linguistic
 designations, but there are
 13 subdivisions called Oceti
 Sakowin or Seven Council
 Fires)
Wichita: Kitikitish

SOUTHWEST

Apache or Chiricahua: Ndee,
 Dinèé (includes Apache
 peoples or groups known
 as Cibecue, Lipan, Jicarilla,
 Mescalero, White Mountain,
 San Carlos, Mibreño, Northern
 Tonto, SouthernTonto)
Colorado Indian Tribes
Havasupai: Pai
Hualapai: Pai, Walapai
Hopi: HopituhShi-nu-mu
Hopi-Tewa
Maricopa: Pee-Posh, Pipatsje
Mohave or Mojave: Tzi-na-ma,
 Aha-makave
Navajo: Diné, Dineh
Pima: Pi-nyi-match, Akimel
 O'odham
Pueblo: Acoma, Cochití, Isleta,
 Jémez, Laguna, Nambe,
 Picurís, Pojoaque, San Felipe,
 San Ildefonso, San Juan,

Sandia, Santa Ana, Santa Clara,
 Santo Domingo, Taos, Tesuque,
 and Zía
Tohono O'Odham: Papago
Yaqui: Yoeme
Yavapai: Enyaé Pai
Zuni: Ashiwi

CALIFORNIA

Cahuilla: Iviatim
Chumash: recent name, Santa
 Barbara Indians
Hoopa or Hupa: Natinook-wa
Karok or Karuk
Maidu: Konkow (Northwestern),
 Nisenan (Valley)
Mission Indians: (various groups,
 such as Luiseño)
Miwok: Tuolumne Me-Wuk
Pomo
Shasta: Konomihu, Okwanuchu,
 New River Shasta
Yokut: Tachi Yokut, Choinumni,
 Chukchansi, Wukchumni
Yurok: Olekwo'l
Wintun: Wintu (Northern),
 Nomlaki (Central),
 Patwin (Southern)

THE GREAT BASIN

Shoshoni or Shoshone: Wind
 River, Bannock (Nomo),
 Western (Newe), Gosiute
Ute: Nunt'z
Paiute: Numa
Washo: Washiu
Yuma: Euqchan, Quechan, Hokan

PLATEAU

Coeur D'Alene: Skitswish
Flathead: Salish, Sèlic
Kalispel: Pend d'Oreilles
Klamath: Maklak
Kootenai: San`ka
Modoc: Maklak (same as Klamath,
 who called them Moatokni)
Nez Percé: Nimipu,
 Tsoop-Nit-Pa-Loo
Spokane, Spokan: Spoqèind
Umatilla
Yakama or Yakìma: Waptailmim

NORTHWEST COAST

Bella Coola: Nuxalkmx
Chinook
Haida
Kwakiutl: Kwakwaka'wakw,
 Kwakwala
Salish: Lummi (Central Coast
 Salish), Nisqually (Southern
 Coast Salish), Nooksak
 (Central Coast Salish), Puyallup
 (Southern Coast Salish), Quinault
 (Southwestern Coast Salish), Comox
 or Catlo'ltx (Northern Coast
 Salish), Suquamish (Southern
 Coast Salish) and other bands
Makah: Kwe-net-che-chat
Nootka: Nootkans (?)
Quileute
Tlingit
Tsimshian (four main divisions:
 Coast, Southern, Nishga,
 Gitksan)

THE SUBARCTIC

Beaver: Deneza, Dunne-za
Carrier: Takulli
Chipewyan: Dene
Cree: Ininiw, Muskegon,
 Woodland Cree
Dogrib: Thlingchadinne
Hare: Kawchottine
Ingalik: Deg Hian, Koyukon
Kutchin or Gwich'in: Dindjie
Kaskapi/Montagnais: Nenenot,
 Innu
Slavey or Slave: Dinèé, Etchareottine
Tanaina or Dena'ina: Knaiakhotana

THE ARCTIC

Alutiiq: Aleut, Sugpiaq
Inglulik
Inuit or Inupik
Baffinland Inuit: Nunatsiaqmiut
Caribou Inuit: Nunamiut
Copper Inuit: Netsilik
Labrador Inuit or Ungava: Inuit
 Kapaimuit
Inupiat
Unangan: Aleut
Yupik or Yup'ik

LANGUAGES

As disease destroyed entire Indian nations, many languages and dialects became extinct. The pressure to assimilate also harmed mother tongues, and in schools run by churches and government agencies, Indian children were often punished for using their first language. However, despite these depredations indigenous languages are still spoken by many people – for example, Navajo, which has about 170,000 speakers. In other cases, a language such as Osage may be spoken by only a handful of elders.

For such a relatively small Indian population (upwards of three million), there is considerable linguistic diversity. It has been estimated that there may be as many as 300 distinct Indian languages, which may be subdivided further into perhaps 2,000 dialects. The languages can be grouped into at least fifty-seven families, such as Athabaskan, Iroquoian, Muskogean, Salishan and Siouan. California alone is home to twenty language families and is therefore more linguistically diverse than the whole of Europe. A further seventeen language families occur west of the Rocky Mountains, with the remaining twenty covering the rest of the North American continent. It is widely accepted by scholars that the fifty-seven families can be grouped into six macro-families, or phyla: Eskimo-Aleut, Na-Dene, Macro-Algonquian, Macro-Siouan, Aztec-Tanoan and Hokan. A few scholars go even further and posit a single macro-phylum, "Amerindian", the ancestor of all Native languages. They have sought to relate Amerindian to Asian languages, but most scholars regard Amerindian as too hypothetical for this exercise to be truly fruitful.

This enormous range of languages arose in part from the geographical isolation of many peoples, which led to sharp divergences in related dialects, as among the Tsimshian, whose various dialects are mutually unintelligible. The possibility of several migrations from Asia at different times

may also be a factor. However, the biggest single reason was the movement of peoples within the continent. Relationships can be detected between the languages of peoples who have ended up as far apart as the Dogrib of the Northwest Territories and the Navajo and Apache of the southwestern United States, all of whom speak Athabaskan tongues.

There was much cross-fertilization of languages. Some words, such as the Siouan *tipi*, entered the vocabulary of Indians and whites alike. Other Indian words became part of North American English – for example, "powwow" and "caucus". US and Canadian place-names are often of Indian origin, such as Connecticut ("Long River"), Ontario ("Sparkling Water"), Chicago ("Place of Onions") and many other names of provinces, states, towns and physical features. Linguistic borrowing led to the development of lingua francas and hybrids for trade and other purposes. The most famous lingua franca was the Plains Indian sign language. In the Northwest Coast, European words combined with Chinook to form "Chinook Jargon", widely used in trade.

Today, English is the most widespread lingua franca, and it has displaced several Native tongues altogether. Many argue that Native languages are essential for the renewal of Indian culture and identity, and that a language such as English cannot express the same relationships to the sacred. Indeed, this is one reason why many languages are undergoing a revival, including some that were thought to be extinct. For example, Gros Ventre had ceased to be spoken before some recordings were found in a museum; Gros Ventre youngsters are now learning the language. Many Indian schools teach their language as a standard subject and are developing family-related immersion programmes. Some universities have incorporated Native languages into their curricula – for example, four are taught at Oklahoma. The well-known actor Wes Studi is a language activist, spokesman for the Indigenous Language Institute and author of children's books in Cherokee.

CURRENT LAND ISSUES

Between 1784 and 1871, Native Americans ceded nearly two billion acres (810 million ha) in 370 treaties that were often signed under duress or as a result of deliberate trickery. The 1887 Dawes General Allotment Act (the Dawes Act, see pages 16–19), and amendments to it into the early 1900s, further reduced Indian lands in the US from 139 million acres (56 million ha) to only 34 million acres (14 million ha) by 1934. Nearly half of this area was subject to federal supervision.

Indians eventually went to the courts to seek justice, and their cases clogged the judicial system. The US Congress established the Indian Claims Commission (ICC) in 1946 to hear the claims brought by Native Americans. None of the claims that it investigated were for the return of land, but for financial compensation for lands taken. The ICC sat until 1978, when it was wound up after completing more than 500 cases, leaving more than a hundred cases unresolved, which were transferred to the US Court of Claims.

THE WESTERN SHOSHONI

Among the most enduring land claims is that of the Western Shoshoni, whose ancestors signed the Treaty of Ruby Valley in 1863. The ancestral land that the Western Shoshoni are claiming includes one-third of the state of Nevada, home to many sensitive government installations. The Shoshoni claim that the Treaty of Ruby Valley did not give their land away, but simply allowed whites passage. The case was examined by the ICC, which found in 1962 that the treaty had indeed resulted in the illegal appropriation of 24 million acres (10 million ha) of Shoshoni lands. The ICC offered the people a settlement of about $1.05 per acre (42¢ per ha), the 1863 price. However, the Western Shoshoni did not wish to accept money for the land because many believe that Mother Earth should not be bought and sold – also, to accept would be to give up the right to the

ancestral homeland. In 2004 the federal government passed the Western Shoshoni Claims Distribution Act, which effectively tries to force the purchase of the land for 145 million US Dollars (the original 1979 award of 26 million US Dollars with accumulated interest) despite most of the tribal councils still refusing it, and in 2006 a lawsuit filed by the tribe seeking quiet title was thrown out. The Shoshoni are currently seeking to prevent the distribution and resolve their territorial claims. The dispute forms the backdrop to an acclaimed 2008 documentary *American Outrage*, which traces the Bureau of Land Management's persecution of two elderly Western Shoshoni sisters grazing livestock on their land.

JAMES BAY AND NUNAVUT
Similar problems exist in Canada. Among the most tragic, difficult and protracted cases in Canadian legal history is that of the 5,000 Cree Indians of James Bay who in the early 1970s began a struggle to protect their lands and way of life against the energy company Hydro-Québec, which wanted to construct around La Grande River the largest single hydro-electric project in North America. The struggle resulted in the Cree groups coming together in 1974 to form the Grand Council of the Crees, which now represents the Cree east of James Bay and south of Hudson Bay in dealings with the federal and Quebec governments.

In 1975 a territorial and financial agreement with the Cree and Inuit was agreed, and by 1986 the first phase of construction had completed: Hydro-Québec had put about 4,400 square miles (11,400 sq km) of land under water, which allegedly had an ecological impact on another 6,800 square miles (17,600 sq km). It is said that mercury contamination from decomposing trees and plants affects the fish that are caught and eaten by the Cree, and some elders have been found to have more than twenty times the acceptable level of mercury in their bodies. The government's response was to

advise the Cree to stop eating fish. In 1984, a sudden release of water from the Caniapiscau Reservoir during the migration of the George's River caribou herd drowned more than 10,000 animals. Ongoing environmental problems have strengthened Cree opposition to further development and reinforced the tribe's demands for more intensive environmental reviews before any new dams are built. By 1996 phase 2 had completed, affecting a further 620 square miles (1,600 sq km), during which time Hydro-Québec had proposed an additional project on the Great Whale River. This aroused fierce opposition from the Cree; however, it was not that but rather New York State's withdrawal from a power purchasing agreement that resulted in the additional project being suspended in 1994.

In 2002 a nation to nation landmark agreement was reached with the Cree that ensured the completion of the last phase of the original James Bay project, affecting an area of 230 square miles (600 sq km). In 2004 it was agreed to conduct environmental assessments prior to a possible diversion of the Rupert River, which was agreed in 2007.

The resolution of one Canadian case in particular stands out as a positive development in the recognition of Native land rights. In June 1993, Canada's parliament approved the Nunavut Land Claim Agreement, which had been ratified by the Inuit in 1992. A new self-governing territory, Nunavut, ("Our Land" in the Inuktitut language), came into being on 1 April 1999. Nunavut is the ancestral home of the Inuit, who have lived in the eastern and central Arctic for thousands of years. Under the agreement, they received title to 136,000 square miles (350,000 sq km). The deal gave them federal funding of more than Can $1 billion over fourteen years, the right to harvest wildlife and equal representation on new bodies to manage wildlife, resources and the environment. They now share royalties from gas, oil and mineral exploration on Crown lands. The Inuit control mineral rights on about ten percent of the land and can negotiate with industry on Inuit lands. The territory also has three new national parks.

THE HOPI–NAVAJO DISPUTE

Some land issues are between Indian nations, and they are rooted in cultural differences, the reservation system and population growth. The disputes are often complicated by the involvement of government and the energy companies. One well-known argument involves the Hopi of Arizona whose traditional land overlaps that of the Diné (Navajo). Each group claimed to have its origins in the sacred land and the treaty of 1882 that created the Hopi Reservation also promised "protection" for other Indians who lived there. In 1882 there were around 1,800 Hopi and 400 Navajo on the shared reservation. After 1900, the Navajo population as a whole grew more sharply than that of the Hopi (in 1900, there were about 2,000 Hopi and 7,500 Navajo, whereas today there are some 7,000 Hopi and nearly 200,000 Navajo in the Navajo Nation, whose reservation territory surrounds the Hopi).

In 1950, the Navajo on the Hopi Reservation outnumbered the Hopi, and by 1968 tribal tensions were beginning to boil over. In 1974, the US Congress intervened and formally partitioned the Hopi Reservation. The Navajo received more than 900,000 acres (364,000 ha) of Hopi land and 400,000 acres (162,000 ha) elsewhere to compensate for the land lost by 5,000 Navajos who were obliged to relocate from the new, smaller Hopi Reservation. The Hopi lost half their reservation, but only 100 Hopi were obliged to relocate from the lands given to the Navajo. However, years of legal wrangling, resistance to relocation by a number of Navajo in the Big Mountain area and constant media attention mean that the controversy is far from over, despite an attempt in 1996 at a "fair and final settlement". The issue has set a precedent for tribes to receive land instead of money as compensation for lost territory. But many problems are unresolved, the most important being the fact that the Hopi have received neither land nor money for the loss of their lands. The social cost has also been high, in terms of the upheaval caused especially to relocated Navajo.

SOCIAL ORGANIZATION

The stereotype of North American Indians includes Eurocentric ideas of the family and of group organization. In fact, such ideas were often imposed by missionaries and government officials. In cinematic depictions, Indian families are usually male-centred and nuclear: husbands head the family, couples are monogamous and live with their children in a single dwelling. Tribal organizations are seen as essentially democratic, but headed by a chief who oversees internal affairs and acts as the liaison between the tribe and outsiders.

However, this type of social organization was far from typical. Families were usually extended rather than nuclear, that is with several generations living in the same household. Nor were marriages usually monogamous: in most Indian groups, a person could have several spouses as long as they could be supported economically. Clan relationships were as important as the individual family and often formed the basis for political structures. Groups were governed in a great variety of ways, ranging from a consensual approach to the "dictatorship" of an all-powerful chief or king, such as the hereditary "Sun Kings" of the Natchez in the Southeast.

Hunting and gathering groups tended to be patriarchal and patrilineal in structure, which meant that males controlled most of the wealth and decision-making, and inheritance was traced through the male line. Many groups of the Plains, Arctic, Subarctic, Plateau and California practised variations on this pattern. The family unit was typically a patrilineal band of around fifteen to twenty-five people, usually consisting of a man, his wives and their children. The group might also include the man's sons and their families: the extent of the unit depended largely on what the land could support. Female children married out of the group. Because groups were small, they would band together to form larger units during seasons of abundance in order to carry out rituals, exchange marriage

partners and coordinate hunting, warfare, raiding, territorial disputes and other issues. Leadership was usually based on achievement, such as prowess in hunting or warfare. Any status that a leader possessed was accorded only during the time that a group needed his expertise and experience.

Groups that relied on agriculture tended to be matriarchal and matrilineal, with female lines controlling land use and wealth. Some of the farming groups of the Plains, such as the Mandan, and many of the nations of the eastern woodlands fit this general pattern. Family units were large and extended, usually consisting of a woman, her husband or husbands, their daughters and the daughters' families, all living in one residence such as an earthlodge or longhouse. The inheritance of horticultural land, political power and some sacred activities might be traced through female lines. Clans (groups of related families) were sometimes subdivided into halves, or "moieties", which were led by males who traced their ancestry through particular women. Moieties might control sacred bundles and be responsible for organizing warfare or peacetime projects for the whole group. Achievement was valued in a leader, but leadership was based more on ascribed or inherited status. Consensus was a governing principle for group action, but leaders had substantial power to make decisions for the whole group. For certain ritual or secular activities, complex kinship structures frequently worked in tandem with societies that cut across family ties.

An emphasis on social status or even a form of social class structure characterized several groups. For some, status might be based on wealth, but others laid less stress on material possessions. In such cases, status might be related to personal qualities, such as generosity, which most people prized because of its benefits for group survival. Through exchanges and giveaway ceremonies such as the potlatch, clans and social groups served as mutual aid societies, ensuring that no one would go without the essentials for survival.

GLOSSARY

adobe Building material made of earth mixed with straw and baked in the sun.

Algonquian A family of languages spoken principally in the Northeast and on the Plains; also used to refer to people speaking an Algonquian language, such as the Algonkin (in the Great Lakes region), Cree, Micmac and Cheyenne. Also spelled Algonkian.

Anasazi An ancient culture of the Southwest that flourished *c.*700–1300CE.

Athabaskan A family of languages spoken principally in the Subarctic and the Southwest; also used to refer to people speaking an Athabaskan language, such as the Beaver and Navajo. Also spelled Athabascan, Athapascan and Athapaskan.

Arctic The culture area stretching from the eastern tip of Siberia along the northern coastal regions of Alaska and Canada to Greenland. It is the homeland of the Aleut and Inuit peoples.

buffalo The North American buffalo, or bison.

butte A flat-topped hill, geologically similar to a mesa but covering a smaller area.

California The culture area incorporating most of the present-day state of California in the United States and the Baja (Lower) California peninsula in Mexico. It is the homeland of the Hupa, Chumash, Luiseño and many other peoples.

caribou A large species of ungulate inhabiting the northern tundra. The domesticated form of the animal is known as reindeer.

clan A group comprised of a number of related families from several households; the most important unit of social organization among many Native American peoples, notably on the Northwest Coast.

corn Maize, one of the most widely grown crops of North America, also known as Indian corn.

crest An image that is typically a blend of animal, human and supernatural, used as a heraldic device by clans and families, who trace their origins back to their encounter with such beings.

culture hero A being which assists humans in their primeval struggles – for example, by bringing them fire and daylight and by eradicating dangers such as monsters (see pages 182–195).

earthdiver A being which, in one common type of Native creation myth, dives to the bottom of the primeval waters to retrieve soil, from which the first dry land is then formed (see pages 146–149).

Euroamerican An American of European descent; of or pertaining to European American culture.

Great Basin The culture area that covers a vast desert basin of the western United States, bounded on all sides except the southwest by the Rocky Mountains, the Sierra Nevada and other ranges. It is the traditional homeland of the Ute, Paiute, Shoshoni and other peoples.

Great Lakes Lakes Erie, Huron, Michigan, Ontario and Superior and the adjacent regions.

hogan A traditional Navajo dwelling, usually constructed of logs and earth or adobe.

Iroquoian A family of languages spoken principally in the Northeast; also used to refer to any people speaking an Iroquoian language, such as the Iroquois and the Huron.

Iroquois The collective name given to several Iroquoian-speaking peoples of the northeastern United States and southeastern Canada. Specifically, it refers to six Iroquois peoples who formed an alliance known as the Iroquois League or the Six Nations (the Cayuga, Mohawk, Oneida, Onondaga, Seneca and Tuscarora).

katsina Among the Hopi and other Pueblo peoples, a katsina (formerly spelled *kachina*) is a benevolent ancestral spirit or deity. *Katsina*s participate in important festivals in the form of masked impersonators in dance rituals.

kiva A partly subterranean chamber used for important rituals and ceremonies by the Hopi and other Pueblo peoples. The term is also used for similar structures characteristic of the ancient cultures of the region, such as the Anasazi.

longhouse A type of rectangular dwelling that is home to several families. Longhouses were formerly characteristic of the Iroquois and other peoples of the Northeast.

medicine bundle A bundle of holy objects that are believed to possess special significance or to be a source of "medicine" (spirit power) for an individual. It is similar to a sacred bundle.

mesa A flat-topped elevated region (typically in the Southwest), similar to a plateau but covering a smaller area.

Northeast The culture area encompassing the temperate woodland regions of what are now the northeastern United States and southeastern Canada. It is the homeland of most Algonquian and Iroquoian peoples.

Northwest Coast The culture area covering a narrow coastal belt extending from northern Alaska down to northern California. It is the homeland of the Tlingit, Haida, Kwakiutl, Tsimshian and other peoples.

pan-Indian Of, pertaining to or involving all Indian peoples in general, as in "pan-Indian movement".

Plains or Great Plains The culture area covering the great expanse of plains and prairies that form the heartland of the North American continent, stretching from central Canada to Texas and from the Rocky Mountains to the Mississippi River. It is the homeland of many peoples, including the Blackfoot, Mandan and Lakota (Sioux) in the north, the Cheyenne and Pawnee in the centre and the Kiowa and Comanche in the south.

potlatch A ceremony, common on the Northwest Coast, in which an individual affirms his prestige or rank by giving away or even destroying material possessions; important transactions are also witnessed at potlatches.

pre-contact Of or pertaining to the period before the first contact between Europeans and indigenous Native American people.

prehistoric Of or pertaining to the time before written historical records, in other words, any period for which our knowledge is based primarily on archaeology. In Native American terms, this may refer to any time before the arrival of Europeans.

pueblo (Spanish: "village") 1. A traditional Southwest town or village constructed of adobe or stone. 2. (With a capital "P") A people of whom such settlements are characteristic, such as the Hopi and the Taos.

sacred bundle A bundle of holy objects that are believed to possess special significance or to be a source of great spirit power for a tribe or group. It is similar to a medicine bundle.

Siouan A family of languages spoken principally on the northern Plains; also used to refer to any people speaking a Siouan language, such as the Lakota (Sioux) and the Winnebago.

Southeast The culture area covering the southeast of the North American continent, from present-day eastern Texas to Virginia. Like the adjacent Northeast region it is largely forest, but the climate is warmer, wetter and in parts subtropical. It is the traditional homeland of the Cherokee, Creek, Seminole and other peoples.

Southwest The culture area that covers the arid lands south of the Great Basin and west of the Plains and extends into northern Mexico. It is the homeland of the Navajo, the Apache and the agrarian Pueblo peoples.

Subarctic The culture area stretching the width of northern North America south of the Arctic and east of the Northwest Coast. Characterized by lakes, rivers and hardy coniferous forest, it is the homeland of the Kutchin (Gwich'in), Beaver, Cree and other peoples.

sweatlodge A building in which community members are purified or ritually cleansed by sweating using heated stones; it takes the form of either a wigwam-like structure or a large semi-underground lodge (the Lakota structure is an *inipi*).

tipi A conical tent of buffalo hide or (later) of canvas. It is of Plains origin but was adopted by some other tribes owing to the ease with which it can be dismantled and transported. Also spelled teepee.

tribe To anthropologists, a community that shares cultural traits and has a specific geographical location. Native North Americans apply the term broadly to entities as small as a clan, or as large as the inhabitants of an entire reservation.

wigwam A domed tent of bark or matting, formerly the characteristic dwelling of many Algonquian peoples.

Yei Navajo "holy people", a class of gods who were prominent in the creation of the world.

FURTHER READING

Basso, Keith H. *Wisdom Sits in Places.* University of New Mexico Press: Albuquerque, 1996.

Bierhorst, J. *The Mythology of North America.* William Morrow: New York, 1985.

Billard, J.B. *The World of the American Indian.* National Geographic Society: Washington, DC, 1974.

Brody, H. *Maps and Dreams.* Pantheon Books: New York, 1981.

Brody, H. *Living Arctic.* Douglas and McIntyre: Vancouver, 1987.

Brown, Dee. *Bury My Heart at Wounded Knee: An Indian History of the American West.* Simon and Schuster: New York, 1981.

Bruchac, Joseph. *Native American Stories.* Fulcrum Press: Golden, Colorado, 1991.

Chamberlain, Von Del. *When Stars Came Down to Earth: Cosmology of the Skidi Pawnee Indians.* Ballena Press: Los Altos, California, 1982.

Champagne, D. (ed.) *Native America: Portrait of the Peoples.* Visible Ink Press: Detroit, Michigan, 1994.

Cornell, S. *The Return of the Native: American Indian Political Resurgence.* Oxford University Press: Oxford and New York, 1988.

Cove, J.J., and G.F. McDonald (eds.) *Tsimshian Narratives I: Tricksters, Shamans and Heroes.* Canadian Museum of Civilization: Mercury Series, Ottawa, 1987.

Davis, M.B. (ed.) *Native America in the Twentieth Century.* Garland Publishing, Inc.: New York, 1994.

Deloria, V. *God is Red: A Native View of Religion.* North American Press: Golden, Connecticut, 1992.

DeMallie, R. (ed.) *The Sixth Grandfather: Black Elk's Teachings Given to John G. Neihardt.* University of Nebraska Press: Lincoln, Nebraska, 1984.

Downs, James F. *The Navajo.* Holt, Rinehart and Winston, Inc.: New York, 1972.

Dozier, Edward P. *The Pueblo Indians of North America.* Holt, Rinehart and Winston, Inc.: New York, 1970.

Driver, H.E. *Indians of North America.* University of Chicago Press: Chicago, 1961.

Dyck, N., and Waldram, J. *Anthropology, Public Policy and Native Peoples in Canada.* McGill–Queen's University Press: Montreal, 1993.

Echo–Hawk, Roger C. and Echo–Hawk, Walter R. *Battlefields and Burial Grounds: The Indian Struggle to Protect Ancestral Graves in the United States.* Lerner: Minneapolis, 1994.

Ewers, J.C. *Plains Indian Sculpture.* Smithsonian Books: Washington, DC, 1986.

Fagan, B. *Ancient North America.* Thames and Hudson: London and New York, 1995.

Fane, D., Jacknis, I. and Breen, L.M. *Objects of Myth and Memory: American Indian Art at The Brooklyn Museum.* The Brooklyn Museum in association with University of Washington Press: New York, 1991.

Farrer, Clare R. *Thunder Rides a Black Horse: Mescalero Apaches and the Mythic Present.* Waveland Press, Inc.: Prospect Heights, Illinois, 1994.

Gatuso, John (ed.) *Insight Guide: Native America.* APA Publications: Hong Kong, 1992.

Gill, S.D. *Beyond the Primitive: The Religions of Nonliterate Peoples,* Prentice Hall: Englewood Cliffs, New Jersey, 1982.

Gill, Sam. *Mother Earth: An American Story.* University of Chicago Press: Chicago, 1987.

Hardin, T. (ed.) *Legends and Lore of the American Indians,* Barnes and Noble Inc.: New York, 1993.

Hasselstrom, Linda. *Bison: Monarch of the Plains.* Graphic Arts Center Publishing Company: Portland, Oregon, 1998.

Jahoda, G. *The Trail of Tears.* George Allen & Unwin Ltd: London, 1976.

Jonaitis, A. *From the Land of the Totem Poles.* American Museum of Natural History: New York, 1988.

Josephy, A.M. *Now that the Buffalo's Gone: A Study of Today's American Indians.* University of Oklahoma Press: Norman, 1985.

Josephy, A.M. (ed.) *America in 1492.* Vintage Books: New York, 1993.

Josephy, A.M. *Five Hundred Nations: An Illustrated History of North American Indians.* Hutchinson: New York, 1995.

Kehoe, A.B. *The Ghost Dance: Ethnohistory and Revitalization.* Holt, Rinehart, and Winston: Fort Worth, Texas, 1989.

Kehoe, A.B. *North American Indians: A Comprehensive Account.* (3rd edition.) Prentice Hall: Englewood Cliffs, New Jersey, 2005.

Keyser, James. *The Five Crows Ledger: Biographic Warrior Art of the Flathead Indians.* University of Utah Press: Salt Lake City, 2000.

Kopper, P. *The Smithsonian Book of North American Indians Before the Coming of the Europeans.* Smithsonian Books: Washington, DC, 1986.

Krupat, A. *For Those Who Come After: A Study of Native American Autobiography.* University of California Press: Berkeley, California, 1985.

Kupferer, H.J. *Ancient Drums, Other Moccasins, Native North American Cultural Adaptation.* Prentice Hall: Englewood Cliffs, New Jersey, 1988.

McLuhan, T.C. (ed.) *Touch the Earth: A Self-Portrait of Indian Existence.* Promontory Press: New York, 1971.

Martin, C. (ed.) *The American Indian and the Problem of History.* Oxford University Press: Oxford and New York, 1987.

Maurer, E.M. (ed.) *Visions of the People: A Pictorial History.* Minneapolis Institute of Arts: Minneapolis, 1992.

Maxwell, J.A. (ed.) *America's Fascinating Indian Heritage.* Readers Digest: Pleasantville, New York, 1978.

Mooney, J. *The Ghost Dance Religion and the Outbreak of 1890,* University of Nebraska Press, London, 1991.

Murie, James, and Parks, D. (eds.) "Ceremonies of the Pawnee" (parts 1 & 2) in *Smithsonian Contributions to Anthropology* (vol. 27). Washington, DC, 1981.

Nelson, Richard K. *Make Prayers to the Raven: A Koyukon View of the Northern Forest.* University of Chicago Press: Chicago, 1983.

Niehardt, J. *Black Elk Speaks.* University of Nebraska Press: Lincoln, Nebraska, 1979.

Powers, W.K. *Oglala Religion.* University of Nebraska Press: Lincoln, Nebraska, and London, 1975.

Price, J. *Indians of Canada: Cultural Dynamics.* Sheffield Publishing Company: Salem, Wisconsin, 1988.

Pritzer, Barry. *Native Americans: An Encyclopedia of History, Culture, and Peoples.* ABC-CLIO: Santa Barbara, California, 1998.

Radin, Paul. *The Trickster: A Study in American Indian Mythology.* Schocken Books: New York, 1956.

Radin, Paul. *The Winnebago Tribe.* University of Nebraska Press: Lincoln, 1970.

Ridington, R. *Trail to Heaven: Knowledge and Narrative in a Northern Native Community.* University of Iowa Press: Iowa City, Iowa, 1988.

Ridington, R. and Hastings, D. *Blessing for a Long Time: The Sacred Pole of the Omaha Tribe.* University of Nebraska Press: Lincoln, 1997.

Schlesier, K.H. *Plains Indians, AD500–1500.* University of Oklahoma Press, Norman, Oklahoma, and London, 1994.

Sturtevant, William C. (series ed.) *Handbook of North American Indians.* (17 vols.) Smithsonian Institution: Washington, DC, 1978–2007.

Trigger, Bruce G. *The Huron.* Holt, Rinehart and Winston, Inc.: New York, 1969.

Trimble, S. *The People: Indians of the American Southwest.* School for American Research Press: Santa Fe, New Mexico, 1993.

Vastokas, J.M., and Vastokas, R.K. *Sacred Art of the Algonkians.* Mansard Press: Peterborough, Ontario, 1973.

Waldman, Carl. *Atlas of the North American Indian.* Facts on File: New York, 1984.

Wallace, A.F.C. *The Death and Rebirth of the Seneca.* Vintage: New York, 1972.

Weatherford, J. *Indian Givers: How the Indians of the Americas Transformed the World.* Fawcett Columbine: New York, 1988.

Weatherford, J. *Native Roots: How the Indians Enriched America.* Fawcett Columbine: New York, 1991.

Will, G.F. and Hyde, G.E. *Corn Among the Indians of the Upper Missouri.* University of Nebraska Press: Lincoln, Nebraska, 1917.

Woodhead, H. (series ed.) *The American Indians.* (23 vols.) Time-Life Books: Richmond, Virginia, 1994.

Zimmerman, Larry J. and Molyneaux, Brian L. *Native North America.* Duncan Baird Publishers: London, 1996; and University of Oklahoma Press: Norman, 2000.

INDEX

PICTURE CREDITS

The publisher would like to thank the following people, museums, and photographic libraries for permission to reproduce their material. Every care has been taken to trace copyright holders. However, if we have omitted anyone we apologize and will, if informed, make corrections to any future edition.

KEY

AA The Art Archive, **AKG** akg–images, **AWL** awl–images, **BAL** The Bridgeman Art Library, **RHPL** Robert Harding Picture Library, **Scala** Scala Archive, **Smithsonian** Smithsonian American Art Museum, or the Smithsonian Institution, both Washington, DC, **WFA** Werner Forman Archive
l = left, r = right, a = above, b = below

PAGE 1 Provincial Museum, Victoria, British Columbia/WFA; **2–3** Ocean/Corbis; **5** Brooklyn Museum, New York/WFA; **7** Smithsonian/Art Resource/Scala; **8** Michele Falzone/AWL; **11** Glenbow Museum, Calgary/WFA; **13** Lonely Planet Images/Alamy; **14–15** Barry Sweet/ZUMA Press/Axiom; **17** IAM/World History Archive/AKG; **18** The Philadelphia Museum of Art/Art Resource/Scala; **20** Gift of F. Ethel Wickham in memory of W. Hull Wickham/Brooklyn Museum of Art, New York/BAL; **21** Craig Aurness/Corbis; **23** Chicago History Museum/BAL; **24 (l)** Interfoto/Alamy; **24 (r)** White Images/Scala; **25 (l)** Smithsonian; **25 (r)** Christopher Felver/Corbis; **27** Chris Cheadle/Photolibrary; **29** Kirk Mastin/Aurora Photos/Corbis; **32** Private Collection/AKG; **35** Mike Grandmaison/Corbis; **36** Ohio State Museum/WFA; **39** Jay Dickman/Corbis; **40** Boltin Picture Library/BAL; **41** White Images/Scala; **42–43** Ken Canning/Getty Images; **44–45** WGBH Stock Sales/Scala; **46** Ann Ronan/Heritage Images/Scala; **49** Manfred Gottschalk/Getty Images; **50** Maxwell Museum of Anthropology, Albuquerque/WFA; **52–53** Walter Rawlings/RHPL; **57** Stapleton Collection/BAL; **58–59** Design Pics/Axiom; **62** Marilyn Angel Wynn/Nativestock Pictures/Corbis; **65** Rolf Hicker/All Canada Photos/Corbis; **67** AlaskaStock/Corbis; **69** British Museum, London/WFA; **71** Smithsonian/Art Resource/Scala; **72** Nativestock Pictures/BAL; **74** Yves Marcoux/Getty Images; **77** Arthur Meyerson/Getty Images; **78** Smithsonian/WFA; **81** Stapleton Collection/BAL; **83** Danita Delimont Stock/AWL; **84** Field Museum of Natural History, Chicago/WFA; **87** Nativestock Pictures/BAL; **88–89** Jake Rajs/Getty Images; **93** Cosmo Condina/SuperStock; **97** Kevin Fleming/Corbis; **98** Smithsonian/Art Resource/Scala; **100** Canadian Museum of Civilization, Quebec/WFA; **101** H.F. Robinson, Courtesy of Museum of New Mexico/Neg. No. 21603; **102–103** Bill Ross/Corbis; **105** Bettmann/Corbis; **106** North Wind Picture Archives/AKG; **108–109** Jeff Vanuga/Corbis; **111** Ohio Historical Society; **113** Marc Adamus/Aurora Photos; **114** Boltin Picture Library/BAL; **117** British Museum, London/WFA; **119** Seattle Art Museum/Corbis; **120** Gilles Rigoulet/Hemis/Corbis; **123** Harrison Shull/Aurora Photo /Corbis; **124** Private

Collection/WFA; **127** Centennial Museum, Vancouver/WFA; **130–131** D. Hurst/Alamy; **133** Christie's Images/Corbis; **134** Museum of Anthropology & Ethnography, St. Petersburg/WFA; **137** Washington State History Museum, Tacoma/Wendy White/Alamy; **140–141** Marilyn Angel Wynn/Nativestock Pictures/Corbis; **143** Grant Faint/Getty Images; **144** Mike Brinson/Getty Images; **147** Field Museum of Natural History, Chicago/WFA; **151** Provincial Museum, Victoria, British Columbia/WFA; **153** Peabody Museum, Harvard University, Cambridge/WFA; **157** The Metropolitan Museum of Art, New York/Art Resource/Scala; **158** Field Museum of Natural History, Chicago/WFA; **160–161** David Muench/Corbis; **162–163** Kul Bhatia/Corbis; **165** Field Museum of Natural History, Chicago/WFA; **166** Smithsonian/Art Resource/Scala; **167** William Channing/WFA; **169** Jeffrey R. Myers Collection, New York/WFA; **170** Marilyn Angel Wynn/Nativestock.com/Scala; **173** Steve Terrill/Corbis; **174** Schindler Collection, New York/WFA; **177** Smithsonian/Art Resource/Scala; **178–179** Field Museum of Natural History, Chicago/WFA; **181** Smithsonian/Art Resource/Scala; **185** Tom Bean/Corbis; **187** Chris Coe/Axiom; **189** Smithsonian/WFA; **191** Private Collection/Boltin Picture Library/BAL; **192** Gift of Mr and Mrs Joseph M Katz/Buffalo Bill Historical Center, Cody, Wyoming/48.59.27/AA; **195** RHPL/Alamy; **196** Field Museum of Natural History, Chicago. Museum no. 14800/WFA; **201** Arthur Rothstein/Corbis; **204–205** John Coletti/AWL; **206** Francesco Dazzi/Getty Images; **208** Smithsonian/Art Resource/Scala; **211** Private Collection/WFA; **212** Smithsonian/Art Resource/Scala; **215** Greg Probst/Corbis; **216** Musee du Quai Branly/Patrick Gries/Scala; **217** Seattle Art Museum/Corbis; **219** Ted Spiegel/Corbis; **220** Geoffrey Clements/Corbis; **223** David W Hamilton/Photolibrary; **224** Museum of the American Indian, Heye Foundation, New York/WFA; **226** Stephen Trimble; **231** Smithsonian/Art Resource/Scala; **235** Smithsonian/Art Resource/Scala; **236** Museum of the American Indian, Heye Foundation, New York/WFA; **239** Smithsonian/Art Resource/Scala; **240** Robinson Museum, Pierre, South Dakota/WFA; **242** Dan Leeth/Alamy; **244–245** Stapleton Collection/Corbis; **248** Ron Sanford/Corbis; **249** Provincial Museum, Victoria, British Columbia/WFA; **251** Danita Delimont/Getty Images; **252** Walter Bibikow/AWL; **255** Chris Coe/Axiom; **258** Smithsonian/Art Resource/Scala; **260** The Granger Collection/TopFoto; **263** Bob Rowan, Progressive Image/Corbis; **264** Smithsonian/Art Resource/Scala; **267** Warren Morgan/Corbis; **269** Maggie Steber/National Geographic Society/Corbis; **270–271** Scott Smith/Corbis; **273** L. Larom Collection, Plains Indian Museum, Buffalo Bill Historical Center, Cody, Wyoming/WFA; **274–275** Bettmann/Corbis; **279** Stapleton Collection/BAL; **281** Richard Cummins/Photolibrary; **283(l)** Swim Ink 2, LLC/Corbis; **283(r)** Morgan Creek /The Kobal Collection; **284** David Grant Noble; **288** Kerrick James/Corbis; **291** Marilyn Angel Wynn/Nativestock.com/Scala; **293** Pat & Chuck Blackley/Alamy.